narchitexts

Anarchitexts

A Subsol Anthology

Joanne Richardson, Editor

Autonomedia

C **ontents**

Joanne Richardson
"Preface: Introduction to a Subsol Reader" .. 9

‖‖ **Art on the Edge of Politics** ‖‖

Association Apsolutno,
"Semiotics of Confusion" ..16
Luchezar Boyadjiev, interviewed by Geert Lovink,
"How to Turn Your Liability into an Asset" ... 22
Alexander Brener & Barbara Schurz,
"Anti-Technologies of Resistance" ... 29
CUKT, interviewed by Joasia Krysa,
"Techno-Transgressions" .. 34
Miklos Erhardt & Duna Maver,
"The Structure of Avoidance" .. 42
Irwin & Eda Cufer, interviewed by Joanne Richardson,
"NSK 2000" .. 48
Oleg Kireev,
"Art and Politics in Moscow: A Politically Ambiguous City" 58
Institute of Constructions & Deconstructions,
"Self-Interviews" ... 63
Space Hijackers,
"Anarchitecture" .. 68
Janos Sugar,
"Solidarity with the Context" .. 73

|||| Tactical Media ||||

0100101110101101.org, interviewed by Jaka Zeleznikar,
"Now You're in My Computer" .. 80
Autonome a.f.r.i.k.a.,
"What is Communication Guerrilla?" 86
Luther Blissett,
"XYZ of Net Activism" .. 92
Ricardo Dominguez, interviewed by Coco Fusco,
"Electronic Disturbance" .. 98
David Garcia & Geert Lovink,
"The ABC of Tactical Media" ... 107
David Garcia,
"Islam & Tactical Media" .. 111
Nathan Martin, Carbon Defense League,
"Parasites and Other Forms of Tactical Augmentation" 115
Joanne Richardson,
"The Language of Tactical Media" .. 123
®TMark, interviewed by Sylvie Myerson & Vidyut Jain,
"The Art of Confusion" .. 129
Sfear von Clauswitz,
"A Reaction to Tactical Media" .. 133
McKenzie Wark,
"On the Tactic of Tactics" .. 138
Peter Lamborn Wilson,
"Response to Tactical Media Manifesto" 141

|||| Sovereign Media ||||

Kestutis Andrasiunas, interviewed by Joanne Richardson,
"Institutio Media" .. 147
Candida TV,
"Reality-Fiction: Visions of Realities" 153
Heidi Grundmann,
"But Is It Radio?" .. 157
Institute for Transacoustic Research,
"Transacoustic Research" .. 165
Eric Kluitenberg,
"Media Without an Audience" ... 169
Tetsuo Kogawa,
"From Mini FM to Polymorphous Radio" 177
Geert Lovink & Joanne Richardson,
"Notes on Sovereign Media" .. 183

Simon Pope & Matt Fuller,
 "This Computer Has a Multiple Personality Disorder" 189
Howard Slater,
 "Post Media Operators: Sovereign and Vague" 194
Vakuum TV,
 "Recombinant Television" ... 203

|||| Autonomous Media Culture ||||

Alex Adriaansens & Nat Muller, V2_Organisation,
 "V_2: Institute for Unstable Media" .. 207
Inke Arns, interviewed by Joanne Richardson,
 "Mikro" ... 215
Zeljko Blace, Marcell Mars & Tomi Medak, [mi2]:
 Interviewed by Joanne Richardson .. 221
Brett Bloom, Cesare Piertoiusti & Greg Sholette,
 "The Folds of an Institution" .. 226
Kristine Briede, K@2, interviewed by Joanne Richardson,
 "Under the Surface" ..232
Alexei Isaev, MediaArtLab:
 "Dossier of a Virtual Community" ... 238
Piotr Krajewski, interviewed by Joanne Richardson,
 "WRO Center" ... 241
Kristian Lukic, interviewed by Joanne Richardson,
 "Kuda.org" ... 246
Mia Makela & Vanni Brusadin,
 "Small is Beautiful" .. 252
Sarai Collective,
 "Sarai: The New Media Initiative" ... 258
Krassi Terziev, interviewed by Joanne Richardson
 "InterSpace" ... 262
Marko Vukovic,
 "Autonomous Culture Factory" ... 268

|||| Production of the Future ||||

Franco Berardi Bifo, interview by Matt Fuller & snafu,
 "Cognitariat & Semiokapital" .. 275
Manuel De Landa,
 "Self-Organizing Markets" .. 279
Alexander R. Galloway,
 "Possibility" .. 284
Rishab Aiyer Ghosh,
 "Cooking-Pot Markets" .. 287

Michael Linton & Ernie Yacub,
 "Open Money" .. 298
Sebastian Luetgert,
 "Introduction to a True History of the Internet" 303
Stefan Merten, interviewed by Joanne Richardson,
 "Free Software & GPL Society" .. 313
Kenta Ohji,
 "The New Associationist Movement" ... 322
Patrice Riemens,
 "Some Thoughts on the Idea of 'Hacker Culture' " 327
Felix Stalder & Jesse Hirsh,
 "Open Source Intelligence" ... 333
McKenzie Wark,
 "A Hacker Manifesto [version 4.0]" .. 344

|| Contributors' Bios ||

00

Preface
Introduction to a *Subsol* Reader

Joanne Richardson *(Romania/US)*
||

n Romanian, *subsol* means a cellar, it often refers to a dark, cavernous bar where people meet and tell stories. As a name, subsol was born as something of a joke – while I was in the waiting-room of the Romanian magazine *Balkon* (balcony) – but it came out of a serious reflection that an aerial perspective often reflects only the biggest spots on a disproportionate landscape. From a balcony everything seems visible, except what's happening right underneath, somewhere among the shadows.

As a webzine, subsol (http://subsol.c3.hu) began out of several dissatisfactions: with an intellectual discourse that has become increasingly stupid and sterile, with culture as a series of mediations by institutions and theoretical frameworks often foreign to actual practices, and with the cultural politics and political culture of an easy epoch. I started subsol after I dropped out of a PhD at Duke University (it was in Obsolete American Marxism), convinced that the "revolution" academics invoked and were pining away from in unfulfilled desire existed somewhere else (anywhere else) than in the university. During the past few years that I've been living in Europe, I met a diverse bunch of people who intervene in local struggles on the streets and in the media, who promote technologies based on sharing and cooperation rather than privatization and competition, who participate in global networks built through electronic democracies and decentralized forms of cooperation, and who live the principles of an alternative society through their daily practices — they became contributors to subsol, collaborators on projects, and sometimes my friends.

As a matter of principle subsol chose to reflect the first-hand perspective of those involved at the point of production, rather than the distanced reflections of critics, specialists, or armchair theorists. This anthology of the first two years of subsol includes texts by sometime artists, occasional philosophers, backyard interventionists, media producers & educators, and software activists. *Anarchitexts* brings together an international mix

of voices from a new "underground" that's actively engaged in theorizing, questioning and subverting the aesthetic, media and software codes that we live by.

It's always a bit presumptuous when editors tell people how to read, so take it with a grain of salt. If you like to be surprised, start anywhere: center, end, beginning, at random, by titles that seem interesting, from names that sound familiar or completely unknown. You can also start backwards, from the contributors' bios at the end of the book. If you want a few more signposts, below is an explanation of the five different sections and a few words about each of the contributors and how the texts are grouped together.

|||| Art on the Edge of Politics ||||

Today, everything is political, most of all the idea of the post-political. But not everything is political in the same measure. The historical catastrophe of the avant-gardes was that they became the bureaucratic doubles of the system they sought to challenge. In taking their message and their mission too seriously they mimicked the language and structure of politics: manifestoes, five-year plans, doctrinal purity, hierarchical groupings, intolerance of deviations, and excommunications. Art is political when it is politics by other means, made in strange tongues and foreign gestures, and when it's not reducible to the functional equivalent of a concept.

Neue Slovenische Kunst (NSK) became known retroactively, through some passing remarks by Slavoj Zizek who hailed their practice (manifestoes, passports and paraphernalia of power) as an overidentification with the totalitarian codes of state ideology. It might be important to remember that NSK overidentifies not only with the state, but with the avant-garde itself as a totalitarian institution. The Polish group CUKT's infiltration of governmental bodies and promotion of their own presidential candidate also uses overidentification to point to the limits of state institutions as well as the impoverished utopias of art. The Institute and Luchezar Boyadjiev provide critiques of existing art institutions alongside attempts to creatively found alternatives based on other practices and values. Alexander Brener & Barbara Schurz, Oleg Kireev, & the Space Hijackers all engage with the public codes of institutions (in art, politics, and architecture) by staging interventions and disruption of routines in streets, museums, and the lines of mass transit. Although Apsolutno is also known for their public interventions, use of parodic-serious paraphernalia like stamps, and hijacked videos, in "The Semiotics of Confusion" they focus not on their own practices as an art group, but on ways in which many people expressed their street resistance to the political situation in Yugoslavia by altering the codes of license plates. Somewhat against the grain of the texts in this section, Janos Sugar calls for a more silent practice through which art becomes political by expressing its solidarity with humiliated thoughts, forgotten technologies, and the incomprehensible. Miklos Erhardt & Duna Maver predict the obsolescence of the avant-garde posture of provocation and scandal, invoking instead the small era of art and a politics of "subtraction."

|||| Tactical Media ||||

Tactical media begins where interventions in public spaces and culture jamming leave off, on the ruins of the media spectacle. Tactical media renews the Situationist battle cry of "detournement": hijacking images and words from mass culture by putting them through an unexpected detour, mixing them in surprising combinations, coining heretical juxtapositions. Extended to the sphere of media production, tactical media announces the end of the spectacle: the rise in cheap "do it yourself" technologies hypothetically means that everyone could start to become an active producer and infiltrate the media monolith from within.

As a term, "tactical media" was born in the context of the Next 5 Minutes festivals that started in Amsterdam in 1995, though the "ABC" manifesto by David Garcia and Geert Lovink wasn't written until 1997. It was an attempt to come up with a single phrase for common practices like website hoaxes and hijacks (fake sites of the Vatican by 0100101110101101.org and of G.W. Bush and the WTO by ®™ark), other forms of guerrilla communication (Autonome a.f.r.i.k.a), electronic disobedience expressed through virtual sit-ins (Electronic Disturbance Theater), and the creation of alternative media myths (Luther Blissett's collective pop star). Many other articles in this section are bouncing off and responding to the "ABC" manifesto – from early replies by Peter Lamborn Wilson and McKenzie Wark, to a later reflection by David Garcia himself in "Islam and Tactical Media" which question the original assumptions that tactical media need always be harnessed by emancipatory social movements, and a response by me in "The Language of Tactical Media" which criticizes the military framework in which the term is implicated and its recent cool on the market of ideas. Sfear von Clauswitz' response to the response tries to rehabilitate tactics as a simple tool with no predetermined function as well as the importance of strategy. Nathan Martin's bio-paradigm of "parasitic media" provokes us to leave behind the familiar model of warfare, sabotage, and subterfuge against an enemy power. Tiny media parasites can control the monolith they inhabit (castrate it, riddle it with disease, transform its behavior) not by making a lot of noise and seeking to be detected, but by remaining invisible to the host while recognizable to other parasites.

|||| Sovereign Media ||||

Sovereign media is not the opposite of the message media embodied in mainstream TV or radio. It's not about opposition, but a change of terrain. And there are no rigid boundaries, but a series of continuums, links, and disconnections. Broadcast media is one-directional, aiming to deliver its message to the largest possible audience. Tactical media know the pleasure of media-in-itself and recognizes the value of participation, but it is still focused on a message and aims to reach an audience, however alternative. By contrast, sovereign media have learned to feign ignorance, ignore the demand for usefulness and the oppressive category of the audience. They mediate no information and are not the condition of possibility for any

exchange. They communicate themselves, not to an audience of spectators but to a peer of equals, partners engaged in the same activity.

Experiments in transcending the broadcast model of television include those by Candida TV, who hail their productions as the first electric household TV that can be done by everyone, and by Vakuum TV, whose post-dadaistic cabaret performances bring the viewers inside the television, transforming the passive audience into the producers and subjects of their own content. Since sovereign media seek to operate outside the domain of representation, the acoustic has often been their most fertile playground. IFTAF is an institute that researches "something which is basically nothing" – tangential intersections of transacoustics and everyday life which are blurred, vague and outside definitions. Tetsuo Kogawa recounts a history of the micro FM movement in Japan as radio's most extreme possibility: the point at which radio transcends the separation between transmission and reception, ceases to be a communication vehicle and becomes expressive. This is what Heidi Grundmann – in the context of her work with Kunstradio in Austria – calls an ephemeral, zero-audience radio where no object is exchanged. More theoretical reflections in this section include those by Kestutis Andrasiunas on the practices of a net.institution with no aims beyond instituting itself, by Simon Pope & Matt Fuller on the relation between the web's demand for disembodied information and the intractable rhythms, noise, and confusion of flesh, and by Geert Lovink & Joanne Richardson, Howard Slater, and Eric Kluitenberg on the meanings of sovereign and phatic media.

|||| Autonomous Media Culture ||||

Media is not just a tool and mediator of information, but can be an alternative mode of production and distribution capable of instituting communities around different values than the law of profit and competition. The recent commercialization of "new media technologies" has resulted in a withering of control. In this atmosphere, the existence and self-organization of independent spaces for media production and distribution has become necessary for the art of survival. This need is even more profoundly felt in post-socialist countries, where decades of bureaucratic centralization have created a mental habit of waiting for someone more expert to always "do it for you."

Questions about the meaning of institutions, the limits of independence (especially when it depends on funding bodies and government policies), the values of mobility, and the possibilities of building autonomous cultures without resurrecting the specter of institutional bureaucracy inform this whole section, though they are taken up more explicitly in the conversations between Nat Muller & Alex Adriaansens, Brett Bloom, Cesare Pietroiusti & Greg Sholette, and Mia Makela & Vanni Brusadin. The spectrum of contributions ranges from established media centers that have a long tradition of activity like V2 to very new initiatives that began only a couple of years ago, like the initiatives in "Eastern" Europe which I interviewed during my travels. They cut across different cultural contexts and geo-

graphical regions: Bulgaria (InterSpace), Yugoslavia (kuda), Croatia (mi2 and Autonomous Culture Factory), Poland (WRO), Russia (MediaArtLab), Latvia (K@2), Spain (FiftyFifty and dina), Italy (Oreste), Germany (mikro), Netherlands (V2), India (Sarai), and the US (Repohistory and Temporary Services). And they illustrate different strategies for survival: from NGOs which are dependent on institutional funding, to older traditions of squatting spaces, to more "mobile" models of working without a fixed place and using other people's locations and resources.

|||| **Production of the Future** ||||

As production becomes increasingly "immaterial," it appears that information rather than capital is driving the mutations of the economy, including the commodity-form itself. The digital duplication and distribution of information contradicts the principles of an economy based on scarcity and has altered the mode of production – work becomes most productive only when unfettered from the demands of centralized organization, ownership, and the property-form of copyright. Has capitalism reached a new historical phase, one that is no longer properly called capitalism?

Perhaps the most utopian reflections in this section are McKenzie Wark's "Hacker Manifesto," which announces a new class struggle between the vectoralists and the hackers, and Stefan Merten's predictions that the new mode of production of free software can lead to a non-capitalist "GPL society." Different models of markets are at stake behind discussions of new "immaterial" forms of production: the gift economy of non-profitable squander (McKenzie Wark); small, local markets based on real needs and subject to a variable measure of value without a general equivalent (Manuel De Landa, Kenta Ohji, Michael Linton & Ernie Yacub); cooking-pot markets which are based on reputation instead of money, but still driven by self-interest and the capitalist desire for profit (Rishab Aiyer Ghosh); and the market of free software which is no market at all, since exchange itself has been abolished (Stefan Merten). Other contributions in this section focus on the networked forms of collaboration that arise out of immaterial production: Franco Berardi Bifo invokes a network of cognitariats as the real force behind the show of force on the streets, and Felix Stalder and Jesse Hirsh outline open source intelligence as a new form of collective production. Alexander Galloway's and Patrice Riemen's reflections on hackers and the "hacker ethic" are more sovereign and ontologic than social or economic: for Alexander Galloway, the hacker expresses the condition of the possibility of possibility itself, which is the true meaning of utopia. And for Patrice Riemens, the hacker ethic is closer to *l'art pour art* and not subordinate to the utilitarian goals of activists. Sebastian Luetgert is maybe the odd voice in the mix, challenging the utopian tone of discussions about software production and immaterial labor through his personal account of a day in the life of a programmer, which is as lonely, miserable, monotonous and contradictory as any other form of material labor.

Art on the
Edge of Politics

01

Semiotics of Confusion

Association Apsolutno
(Yugoslavia)

|||

ASSOCIATION APSOLUTNO (www.apsolutno.org) was founded in 1993 in Novi Sad, Yugoslavia by Zoran Pantelic, Dragan Rakic, Bojana Petric and Dragan Miletic. Since 1995 the works have been signed APSOLUTNO, without any reference to personal names. The word APSOLUTNO means *absolutely* (adv). Grammatically, adverbs can modify various elements and take different positions within a sentence. This flexibility is an important characteristic in the work. The work of APSOLUTNO is based on an interdisciplinary research into reality, with the aim to make it open to new readings. This is an open process, which focuses on diverse phenomena in the surroundings, and therefore requires continuous perceptiveness in order for such phenomena to be noticed, understood, interpreted or marked.

The artistic conception of APSOLUTNO is based on the principle that the way to the global, i.e., universal, is through the local. Therefore, projects typically start in a response to a sociological, cultural or political stimulus from the immediate surroundings. Projects are often realized in public spaces or in locations for specific purposes (such as a shipyard, a bridge, cemetery, borders, etc.).

The idea for this piece of writing arose from the visual research APSOLUTNO conducted from 1995 to 1998, focusing on the national symbols in official use in the Federal Republic of Yugoslavia during that time. APSOLUTNO documented flags, border-markers, coats-of-arms and other national and state symbols, banknotes, passports and other official documents issued by the authorities, as well as various public individual responses to these. The aim of this action of documenting was to record a phenomenon in our immediate surroundings by collecting absolutely real facts here and now. It is important to note that the absolutely real facts are arbitrary to a certain extent, determined by the time and place where they were collected (on various irregular occasions from 1995 to 1998, in Novi Sad and Belgrade, Yugoslavia). They nevertheless illustrate the variety of semiotic activities, both offi-

cial and individual, which in an interesting way reflect (sometimes follow, sometimes anticipate) events in the social and political sphere.

The reason why this text has no conclusion is very simple: at the time of its writing in 1999, the state of affairs in this area was still in flux.

< 1 >

Since 1991 five new states have emerged on the territory of ex-Yugoslavia, and it is very likely that this process has still not been completed. On the semiotic level, this process of disintegration and formation has been followed and in some cases preceded by feverish symbol-engineering: old national and state symbols have been discarded, ancient ones revived or recycled and completely new ones designed. New authorities attached enormous significance to the introduction of new symbols, as through these it was possible to create a new sense of national identity, national pride and a new political and ideological framework for future orientation. In other words, the change on the symbolic level was seen as an important vehicle of political change, as communication via symbols was a language that people understood and to which they responded.

The urgency and importance of the introduction of new national symbols are easy to illustrate if the dates when laws regulating the use of national symbols were passed are compared with the dates when the new states were officially established. In Croatia, for example, the constitution of the Socialist Republic of Croatia was amended in July 1990, when the word 'socialist' was dropped from the name of the country, the red star removed from the country's national flag and the socialist coat-of-arms replaced by Croatia's historical coat-of-arms. The law on the Coat-of-Arms, the Flag, and the National Anthem of the Republic of Croatia (www.vlada.hr) was adopted in Parliament on 21 December 1990. A day later, on 22 December, Croatia passed a new constitution, which allowed for secession from the former Yugoslav Federation.

The process was similar in Slovenia, which declared itself a sovereign state on 25 June 1991 and, at the same time, introduced a new flag and coat-of-arms (www.sigov.si). On that day the new flag was hoisted officially for the first time in front of the Slovenian Parliament, and beside it, the old flag with the red star was lowered, in a symbolic gesture of replacement.

However, this process of changing national and state symbols was not always clear and straightforward. In some cases it meandered, touching upon various issues and sometimes coming across unexpected reactions internally or externally. Problems in the semiotic area only reflected either external pressures (as in Macedonia), or the unresolved issues within the state itself (Bosnia), or they indicated a basic lack of a clear idea about the future direction (FRY). We shall briefly give an overview of some of the related issues, focusing on the flag as one of the

central national and state symbols, and excluding for the moment the Federal Republic of Yugoslavia.

As already mentioned, in Slovenia and Croatia, the national flags used in those countries while they were part of the Socialist Federal Republic of Yugoslavia (tricolors with the red star) continued to be used after the removal of the red star. However, in Macedonia and Bosnia completely new flags had to be designed. In Macedonia, a new flag was adopted at the point of independence in August 1992. The design was selected from more than a hundred proposals which entered an open competition. The flag immediately came under attack from Greece, which maintained that the Vergina Sun, the central symbol on the flag, belonged to Greek cultural heritage. Greece also protested against the use of the word 'Macedonia' as the official name of the new state. The dispute was resolved in 1995 by a UN agreement, according to which Macedonia was recognized as "The Former Yugoslav Republic of Macedonia" and was required to design a new flag within 30 days. The present flag of Macedonia, proposed by a group of Members of Parliament, was finally adopted in 1995, three years after independence. Nevertheless, the name of the country remains temporary.

In Bosnia and Herzegovina, the current flag was adopted in February 1998 by UN High Representative Carlos Westendorp. Prior to this, there had been a long process of designing and selecting an appropriate flag. The first flag, adopted in 1992, before the war in Bosnia broke out, bore a fleur-de-lis as the central symbol, a symbol associated with the Muslim tradition in Bosnia, and was therefore to be replaced following the Dayton Peace Accord and the recognition of Bosnia and Herzegovina as a tripartite state (1995). After several years and numerous proposals, the Bosnian Parliament still could not reach agreement on a solution that would be acceptable to all three national entities. Finally, in 1998, UN High Representative Westendorp appointed an expert commission which designed three proposals. After the Parliament failed once again to adopt any of these, the High Representative selected a flag for Bosnia and Herzegovina himself. The flag bears the colors of the European Union, without any national symbols, since, as explained by Duncan Bullivant, Office of the High Representative (at the press conference at which the new flag was presented): "This flag is a flag of the future. It represents unity not division; it is the flag that belongs in Europe" (fotow.digibel.be/flags). The inability of the Parliament to find common ground and the imposition of the solution by external authorities only emphasized the fragility of Dayton Bosnia and questioned the possibilities of its existence.

The establishment of new national symbols in the countries formed on the territory of the former Yugoslavia reflected the political processes in these countries. Periods of confusion in politics were mirrored by periods of semiotic confusion; likewise, political solutions that were initially considered final were succeeded by final decisions about the design of national symbols.

< II >

If we look at the national symbols of the Federal Republic of Yugoslavia, or Serbia-Montenegro (since the domestic official title has not received widespread recognition), the first point to note is that the authorities have been extremely hesitant in replacing the national symbols of the Socialist Federal Republic of Yugoslavia. Unlike the other states in the Balkans, FRY did not regard it as important to invest much effort or resources into creating a new semiotic reality for its citizens.

The new constitution, which marked the beginning of the "third" Yugoslavia, was adopted in April 1992. The Federal Republic of Yugoslavia clearly demonstrated an aspiration to represent a continuation as the sole successor to the Socialist Federal Republic of Yugoslavia. At the same time, changes were to be introduced in the political, ideological and national domain, supposedly responding to the general public's dissatisfaction with the old system. This tension between the intention to be regarded as a continuation of the old and, at the same time, as the bearer of the new is also visible on the semiotic level.

Although the red star was removed from the national flag, it remained in use much longer, even up to today, on most official documents, as well as on public buildings. For example, the red star on the City Hall in Belgrade was removed only in 1997, when the opposition parties came to power after the local elections. Similarly, passports of the former Yugoslavia were still in official use in 1999, together with the new ones, which were introduced as late as 1997. ID cards still bear the former Yugoslavia's coat-of-arms, with the red star and six torches representing the six republics of the former federation, although the new coat-of-arms was introduced in 1994. The national anthem of the former Yugoslavia is still used as the national anthem of today's Yugoslavia, to which certain parts of the society are strongly opposed (for instance, on several occasions at international sport events, Yugoslav team supporters have boycotted the Yugoslav anthem). As for national holidays, although new ones have been introduced, the holidays of the former Yugoslavia are still officially celebrated, including the Day of the Republic, the day when the Socialist Federal Republic of Yugoslavia was formed (29 November 1943).

At first glance, it would appear that there have been two opposing directions during the last ten years in FRY as far as the national symbols are concerned: one towards change; the other towards maintaining the existing symbolic structure of the SFRY. However, if we look closer into the symbols that have been changed, it is not difficult to notice that the change referred mostly to the removal of the red star. This gesture was in accordance with the general atmosphere in the whole of Eastern Europe, a gesture which could not provoke public dissent. It was an expected change, and therefore neutral, insignificant, a change on the surface without any real consequences — in the same way as the ruling Communist Party changed its name to the Socialist Party, while its protagonists have remained the same. Nevertheless, in terms of changes which would indicate a possible future direction,

or which would give a new identity to the nation, little has been done. The reasons certainly lie in the lack of a clear political vision, or more precisely in the lack of any vision whatsoever. Or is it a ploy to deliberately create a state of confusion in the minds of the people? What does the political establishment communicate to the nation through these symbols? Does it convey the message that FRY is a new country or a continuation of the SFRY? And consequently, are people living in that country now a different nation?

< III >

This research was prompted by a specific form of semiotic response to this situation that became widespread in mid-1990s: interventions on license plates, which provided the occasion for semiotic actions and visual activism by citizens who felt the need to express their views through different types of modifications. These gestures, which range from anger to humor, from the creative to the stereotypical, illustrate the pragmatic force of symbols, i.e., the power of symbols to trigger actual, concrete, physical responses. Through these responses, it is perhaps possible to gain an insight into some answers to the questions above, namely, how people interpret and respond to the semiotic reality imposed by the establishment.

License plates on vehicles in the former Yugoslavia contained three elements: a letter code for the town where the vehicle was registered, the red star, and the registration number. New license plates differ from the old ones only in that the red star is replaced by the Yugoslav flag (blue-white-red tricolor). Although the new plates were introduced in 1998, the old ones continued to be used, and since the new plates were still a novelty at the time when this material was being collected, no cases of intervention on them were recorded. The most common type of intervention on the old plates was the denial of the red star. Frequently, the red star was erased, destroyed or covered with adhesive tape.

Or, if the red star remained, the juxtaposition of different stickers on the car revealed the person's view on what the orientation of the country should be. It is important to note that the only official sticker for FRY is YU. The interventionist use of the sticker SER, plus the colors of the Serbian flag (red-blue-white) suggests that the owner would like to live in a country whose name would be Serbia, rather than Yugoslavia. In another example we documented, a local patriot within the old boundaries used the sticker V, which stands for Vojvodina, the northern province of Serbia, in combination with the sticker YU. A third case combining stickers for YU and EU suggests either wishful thinking or a humorous response to the general situation in the country — Yugoslavia as a member of the European Union.

The reactions that offered alternatives to the red star did not represent a great variation of ideas. One intervention substituted a Serbian tricolor in the place of the red star, while another is even more explicit in this direction, featuring both the flag of Serbia and the Serbian historical coat-of-arms. What is particularly interesting in this

example is that the car was not registered in Serbia, but in Montenegro, whose capital, Podgorica, was previously called Titograd (TG). Or in one of the more interesting responses, which is neither nationally nor territorially based, the red star is simply replaced by a red heart.

It would be simplistic to say that these responses are based on interpretations of the meaning of the red star. The meaning of a symbol is not a precisely defined category; its boundaries are fuzzy and in constant flux, depending upon the context and the paradigmatic and syntagmatic relations of the symbol with other symbols and the interpreter her/himself. It would be more precise to say that these reactions are based on the interpretation of the meaning of the fact that the red star was still the official mark on license plates in FRY in the late 1990s.

The red star was a dominant symbol in Eastern Europe for fifty years; it not only represented a vehicle of expression of the dominant ideology, but also marked both the official and the dissident culture of the whole period. That period ended in Eastern Europe with the events which commenced with the fall of the Berlin Wall, and FRY was no exception to the general feeling that a change had occurred: the mere fact that these individuals felt they could desecrate the red star, once a sacred symbol, meant that there was a general implicit consensus in the society that the era of the red star was over. This is why these semiotic actions do not represent a serious violation of the order nor an act of rebellion, and for the same reason, they were not treated as instances of punishable offense, though in fact that is what they would have been under "regular" circumstances.

Rather, these semiotic gestures can be regarded as a specific form of communication in which symbols have a central place, in a society where forms of political dialogue have ceased to function or have become distorted. They represent a public act, directed not to a specific recipient, but to anyone who happens to see them. They express a disagreement with the social identity that belonged to the former period but is still maintained, and a dissatisfaction with the fact that a new identity is still non-existent. Some of these gestures are personal statements of a particular national or territorial identity and, though naïve and politically inarticulate, they indicate a need and a search for a new sense of direction.

The crisis of identity and the lack of a sense of direction, which have persisted for nearly a decade in FRY, have caused semiotic and various other confusions. When this text was written, new flags were being designed in the Balkans. It remains to be seen what absolutely real facts will emerge with their changing meanings.

— This text was written in 1999 and reflects the situation at that time. The original version was published in MEDIA REVOLUTION, ed. Stephen Kovats (Frankfurt/New York: Edition Bauhaus, Band 6/Campus Verlag), pp. 242–50.

02

How to Turn Your Liability Into an Asset
Media, Art, & Politics in Post-Communist Bulgaria

Luchezar Boyadjiev *(Bulgaria)*
Interviewed by Geert Lovink *(Australia)*

he first interview was conducted during the opening of Hybrid Workspace in June 1997, the temporary media lab in the margins of the big art show Documenta X in Kassel (Germany).

> *Could you explain us the current situation in Bulgaria from your point of view? For a long time, the Bulgarian communists have stayed in power, after having changed their faces. Recently, a lot has happened in South-East Europe: student demonstrations in Serbia, the first non-communist government in Romania, anarchy in Albania... What is the reason of the apparently unique position of Bulgaria?*

The more time passes after 1989, the more differences there are between each country in Eastern Europe. In the past, Bulgaria had a privileged position, in terms of being one of the closest allies of the Soviet Union. The country enjoyed an almost free supply of raw materials, crude oil, electricity. A utopian situation, having no worry about how to produce and make a living for its citizens. Now, it looks as if time has stopped after 1989. We realized this only recently. On the surface, a democratic reform took place. A free-market economy was introduced, of which I am not a fan, but which seemed to be the only way out of the deadlock. As it turned out, there is no capitalism, so consequently, there is no opposition to capitalism. This applies also to the social situation. A redistribution of the old money of the regime is now taking place among its loyal followers who are now top bankers or mafia leaders. This is not capitalism, it is Monte-Carlo money. Easy come, easy go, no re-investments.

In the 1994–1996 period there was a full-fledged socialist government in power which had no agenda whatsoever. It supported the infrastructure of organized crime. In the late spring of 1996 there was a severe banking crisis. This government was sticking to the state-owned property, lending money to non-productive sectors in

order to hold down social unrest The result was hyper-inflation, each day new exchange rates were issued, five or ten times higher than the day before, a situation other countries had been through five or six years ago. This situation resulted in a lot of street unrest in January and February 1997 which started with people breaking into the parliament building.

> *How did the artists you know respond to the current economic and political crisis?*

They responded in a very direct way. For about two months, we had a special meeting at 4 p.m each day, in front of the parliament. Artists would meet and demonstrate. We used cans full of coins to produce a lot of noise. The big change compared to 1989 is that people, artists included, can change things. After these seven years of having simulated reforms, without actual change, people all of a sudden became dissidents. They lost all their feelings of nostalgia for the security of the past. Unfortunately that also applies to the word 'socialism', which is compromised in many ways. A new party was founded in the winter and is already called in the parliament "the Euroleft." It brings together former socialists, liberals and intellectuals. It is a significant sign that very soon there will be the possibility to name things with the proper name. Soon it will be possible to work on alternatives and create progressive, radical movements, without being immediately branded a communist.

> *What is the current influence of computers and new media on the arts and culture?*

It is growing. Recently, three media labs opened in Sofia. In the past it was stagnating. Now this is, again, a substitute for a physical reality. When you have a deficiency of the physical reality, you have some hopes that in the virtual reality you may find some compensations. For example, in Bulgaria there is no museum of contemporary art, for good or bad. One could probably make a virtual museum and appropriate some existing space, make a CD-ROM, a website somewhere. Video is also compensating for the lack of possibilities. It is a symptom of crisis and of a utopian hope.

> *Now that the production is almost at ground zero and the country is bankrupt, virtuality seems the only solution. Is this what you are saying? And what is the role of the artist in all this?*

Bulgarian art is always first and foremost content-oriented art. It does not really matter what the medium is. The message is one of absurdity. How to turn a liability into an asset. A liability in terms of inferiority, identity or provincial complexes, is turned into a bombastic statement of one sort or another.

> *Should the World Bank also take over the branch of contemporary art? You stated this in the catalogue* Menschenbilder — Photo und Videokunst aus Bulgarien, *an exhibition organized by the IFA-gallery in Berlin, held in February–March 1997.*

Traditionally, Bulgaria has been in and out of its own history, as well as in and out of European History, as if it was a supermarket. The country has always been performing better when it was not independent, whenever it was part of a larger empire, be that as it may the Byzantine, the Ottoman, or the Soviet Empire, or an ally to Germany in two World Wars and now (that it has tied itself up to the German mark.) We certainly cannot sustain reciprocal exchange. We do not have any infrastructure to speak of. Outside the Soros Center there is hardly any sponsorship for art. The annual budget of the Soros Center is probably ten times larger than that of the Ministry of Culture. So I developed the idea to have an international curatorial board, to control contemporary art in Bulgaria, like the currency board. Would you like to join?

[A little later the following text was published on mailing lists such as Nettime and Syndicate: Culture Board for Bulgaria: A Body for Cultures in Ruin (extract).]

Arts and culture are the last to be considered contemporary, sensitive instruments that could express the "signs of the times." The financial sector has taken over the role of "avant-garde." Let us face it: culture is a prime target of budget cuts and this has become the only language in which officials can speak. Art, by definition, is always in a defensive role and is unable to make demands. So let us quit this culture of complaint... We propose to radically face current global economic forces. We will intervene in their sphere. Culture should no longer be left out, condemned to compensate for and be at the receiving end of this trauma. The proposal is to form, install and implement "Culture Boards," which are modeled after the Currency Board — the main instrument of the International Monetary Fund to straighten out ruined economies. This supra-national body, unaccountable to the electorate, actually controls the government. In reality, this body *is* the government because it defines financial policy and steers legislative initiatives.

Before 1989, culture was managed as a prime state affair (and so was its funding). This logic changed overnight in the nineties and step-by-step Culture was being run as a business, including sponsorship, self-financing, post-Fordist working circumstances (free-lancers, etc.). This is now the dominant ("neo-liberal") ideology. The Culture Board is both the ultimate expression of this, flipping into a radical critique. We can no longer speak in the melancholic terms of postmodernism. Nor do we need a self-imposed (cyber)optimism, selling a future which is actually fading away. We need concrete facts, reports on the actually existing poverty in museums, artistic circles, closed magazines and missed opportunities, encounters with the migrated Others and their remembered shadows. The motivation and the purpose of the Culture Board is the stable cultural credibility of a country....

Luchezar and I met again, one year later in Manchester, during the follow-up of the Hybrid Workspace project, the temporary media lab called Revolting, curated by Micz Flor.

> *Could we speak of a Sofia School of Contemporary Art? The title of the recent exhibition in Munich, Bulgariaavantgarde, suggests this. It seems that this group, this generation presents a coherent picture.*

It is a group of people that has been working in a parallel way. People from different generations — artists, curators, art critics and people who are into cultural theory/studies. The activities of this group are centered around the Institute of Contemporary Art, a small NGO that did not have an office for a long time, only a rotating computer. Bulgariaavantgarde was held at the Kuenstlerwerkstatt Lothringerstrasse in Munich in May 1998. We did not want to present any distinct, oppressive identity of ours. We wanted to make it clear that we are transparent, open-minded, adaptive to circumstances, ready to enter a dialogue, without having to impose on anybody our complaints and miseries. The most significant, emblematic work was an installation by Pravdoliub Ivanov, consisting of 25 hotplates on the floor. On each plate there would be a pot of different color and size. But since the hot plates are too small and not strong enough, the water never actually reaches the point of boiling. You see something is cooking but nothing is ever cooked. In Germany this made a lot of sense. The unification has been going on without any concrete results, like a never-ending process. There was very little obvious ideology in this show.

> *This absence of ideology and identity goes well together with the current stagnation and ongoing crisis in Bulgaria. Little development or progress, trapped in the vacuum of permanent restructuring, budget cuts and political malaise.*

Yes, people lack a perspective on having better lives, production picking up, etc. State finances seem to be alright. Renovation of streets in the center of Sofia is happening, in part financed by the European Union, in order to beautify the city. But there is always a strange aspect. There are signs that police activity is on the rise. Some say a police state is immanent. But so far it can be interpreted as an attempt to crack down on organized crime. Most obvious is the disappearance of pirated CDs. This crackdown was the result of a direct threat of sanctions from the American President Bill Clinton to our president. In a matter of two weeks, Bulgarian CDs just disappeared.

This is the age of Multi Group, a financial corporation with offices not only in Bulgaria. The official rumor says that the founding of this group is going back to the money laundering operations with ex-communist party assets at the end of the eighties. There are also other similar companies. Now the government has to deal with these big companies which are controlling big parts of the country on various levels. The previous government of former communists, which is now called the Socialist Party, tried to get back the laundered money of these groups, which are actually Mafia. But they failed. The only thing the new government can do is engage and work with these businessmen making it possible for them to re-legitimize their "capital" by bring it back into the country as investments. Like in Russia,

the issue now is how to make a historical compromise in order to get the badly needed tax money, in exchange for legitimization and economical power. So on the whole, we can see a process of adaptation to the so-called European standards. This counts for taxing, the banking system and the newly established border police. Next year we will have a new set of IDs, driver's licenses and passports which are made according to EU-standards. We are all trying to prove to foreign investors and our rich citizens that we are exploitation-worthy Europeans.

> *For many, the time of expectations has expired. The standards of living for the majority has been continuously falling down. Will they continue to wait patiently?*

Concerning rejuvenation, all hope is lost. The majority is now living under the poverty line and fighting for their daily survival. It gets especially tough for the retired people. On the other hand, there is now an entirely new generation which grew up after 1989. They have taken for granted that the situation is chaotic. The father or mother may not have a job. These young people are very inventive. Unfortunately, the government does not know how to support their initiatives. It can only control state affairs.

> *Here, in Manchester, you are participating in the Virtual Revolution workshop. The revolution is all over, and your installation is also referring to it. You are projecting an image of Lenin, speaking at a gathering…*

It is a social realist painting from the thirties. I do not even know the name of the artist. The image probably refers to one of the rallies, just after the revolution, between November 1917 and the early spring of 1918. In the dark gallery space I am capturing the faces of the visitors, pasting them into the mass meeting, using the scheme of police surveillance. It shows that you can be manipulated. I can steal your image and do anything I want with it. I do not want to show that you can time travel and participate in some historical event. That idea has already been overexposed. It is old news and embarrassing for me to say but still many Western intellectuals have such romantic ideas. They have missed 45 years of the discourse, and the experience.

> *How about technological changes? What do you think of phrases such as biotech or digital revolution?*

Social revolution is suspect, the digital changes aren't, yet. We are waiting in line to take part in the digital revolution. From our perspective, it is like a flood which has not yet arrived in Bulgaria.

Again, we make a jump in time, to June 2000, when we taped a third, short update. I met Luchezar in Sofia. We were both on the way to the Southern town of Plovdiv, where Communication Front was taking place, a temporary new media lab for artists.

> *Bulgaria must have been effected by the nearby Kosov@ crisis. How did you respond to this war next door and what did you do with it in your work?*

Bulgarians were mainly influenced on the level of mass psychology. I was not watching television. I got all my immediate information through mailing lists such as Syndicate and Nettime. I was unable to do anything at that moment, I was so depressed. The government here was also passive throughout the crisis. They got into politics instead of doing some real actions, like taking in refugees, thereby taking the pressure off Macedonia.

In the middle of the crisis I got the invitation to participate in a group show titled The Other Side of Europe at the Jeu de Paume Museum of Contemporary Art in Paris. The curators asked for a spectacular project. After having thought for a while I came up with the proposal which may sound a bit humanitarian. Invite four young artists for one month to work together in the museum and meet the public. They should come from the four countries most effected by the Kosov@ war. I invited Uros Djuric from Belgrade (Serbia), Sokol Beqiri from Pristina (Kosov@), Alban Hajdinaj from Tirana (Albania) and Slavica Janeshlieva from Skopje (Macedonia). I used my experience at Hybrid Workspace, during Documenta, three years earlier. It was supposed to be a relaxed, hybrid space, with moving furniture and equipment to present work. I was invited to participate, as a guest, and turned myself into a host by inviting other artists. The artists I invited started to invite still others, to come to Jeu de Paume, French artists or people who stayed in Paris in that period. Between March 13 and April 9, 2000 we were in the museum every day, presenting video documentaries, video art, until at end, we hosted also presentations of local artists, who otherwise never would have had the opportunity to show their work within the walls of this rather conservative art institution. It was funny. In the eye of these local French artists, we, from the Balkans were the global artists, coming from the international art world.

> *Did you want to reconcile the four artists, coming from such different, opposite sites of conflict? Was it your intention to simulate a civil war, have a reasonable dialogue, open negotiations?*

I knew all the four artists from before. I invited them on the basis of the quality of their work, on their ability to communicate and their political views. We all try to disregard the politicians. On a human level communication is possible. In the space we had to speak English for the simple reason that the artist from Albania could not speak Serb or any other Slavonic language. On a daily basis all of us had to answer questions from the audience. This gave us the possibility to see all the different point of views, in a combination. The four artists did not know each other from before and had a lot to learn from each other.

> *How would you describe the position of arts and culture in 2000, one year after the Kosov@ crisis, where parts of Eastern Europe might get integrated into NATO and EU over time, whereas others will be contained, neglected, forgotten?*

On the level of arts and culture, there are many initiatives to network, such as the Balkan Art Generator: there is the Balkan Art Network which bring together artists, curators, collectives, institutions, galleries. The idea is to bypass the political situation, leaving aside the European Union and the question who might or might not be allowed to join Brussels. It is so important to know each other and take common initiatives.

> *— Interview compilation edited for SUBSOL. A longer version appeared in UNCANNY NETWORKS: DIALOGUES WITH THE VIRTUAL INTELIGENTSIA, edited by Geert Lovink, MIT Press, 2002.*

03

Anti-Technologies of Resistance

Alexander Brener & Barbara Schurz *(Russia/Austria)*

In the beginning of 1999 we published a little book called *What To Do? 54 Technologies of Resistance Against Power Relations in Late-Capitalism* (in Vienna, and before that in Moscow). This book is a collection of a number of semi-anecdotes and semi-reflections about the possibilities of political and cultural resistance under the condition of a globalized market and multiculturalism. The center of our examination were so-called technologies of resistance: familiar and traditional methods of political struggle and cultural resistance, as well as individual "transgressive" techniques. On the one hand we tried to analyze critically technologies such as demonstrations, sit-ins, hunger strikes; on the other hand we discussed the effectiveness of showing your ass in front of your enemy, throwing eggs and spitting on your opponent's dress. Resistance must take into consideration concrete circumstances of place and time and must act from very precise strategies and tactics of local struggle, if it wants to be effective. Borrowing from Foucault, who spoke about the "specific intellectual," we suggested the term "local and specific resistor." Such a resistor doesn't act from universal concepts or out of the doctrines of parties or groups, but struggles against these very doctrines and keeps moving endlessly, not knowing what he or she will do tomorrow. In combating the current art-system, local scandals, interventions, leaflets, graffiti, etc., may be effective at a certain moment but useless in another context. Soft subversion, a heritage inherited from the 1980s, is no longer adequate, and the hidden undermining of the political context of the enemy is obsolete and has finally degenerated either into cynicism or into conformism and strategies of success and survival within the system. "War is necessary!" was our answer to the question "What is to be done?"

However, the term "technologies of resistance," which we have used until now, no longer satisfies us. From now on we want to talk not about technologies but about anti-technologies of resistance. After the works by Artaud, Bataille and Foucault, Lacoue-Labarthe, it becomes clear that the Greek term 'techne,' which denotes a

mimetic ideal in the sphere of art and is directly connected with the art of politics, still subordinates itself to political and aesthetic activities in modern society. Techne implies a model of society that is based on the hegemony of certain technologies of power and on the subjection of the will of individuals in a direction favorable to the elite. Technologies are the skills and abilities which guarantee the functioning of knowledge and power in very different fields — from a shoemaker's business to the construction of intercontinental ballistic missiles, from artistic collages to espionage satellites. Power relations produce technologies and distribute them partly through dictatorship, partly through seduction, but always in the interest of the ruling order. Even if one or another technology is employed in the service of resistance, at a certain moment it inevitably turns out to be the hostage of power and, deriving from power relations, it permanently return us to them. Technologies serve the oldest and most productive game of power, where its myths get the "final" and "competent" confirmation from experts. Nowadays techno-myths serve the neo-liberal elites, repressive tolerance, and the new Right. We no longer want to speak about "technologies of resistance" because we associate the term "technologies" with "power" rather than "resistance." Anti-technologies of resistance are necessary!

In 1959 Gustav Metzger presented his concept of "auto-destructive art." ("Destructive of what? Destructive of the peace of mind, the pleasure in the arts, the moral integrity of people directly or indirectly supporting the violence of the state, structural social discriminations, different forms of oppression...") Metzger's concept was directed against an understanding of art as a stable and completed technology that has a fixed aesthetic and market value. At that time, Metzger's political views were close to anarchism, and he thought that "auto-destructive art" would enact the destruction of capitalist economy and imperialistic politics. Metzger discovered and articulated the connection between aesthetic technologies of the production of art and political technologies of the reproduction of the hegemonic concept of cultural memory, tradition, and the "history of the winner." Unless an artwork destroys itself, it is at the service of capital. Metzger was the first to question how technologies (of art and power) can turn into their opposite, destroy themselves and become something else.

Anti-technologies of resistance entail the destruction of the cultural and scientific technologies which are at the service of power, and, secondly, the creation of "unpleasant," "dissatisfying," dubious, and crazy practices that cannot be included in the toolbox of the technologies of power. We would like to stress the importance of the terms "dissatisfying" and "unpleasant." Dissatisfaction is the only real product of anti-technologies of resistance. Deep, restless, and exciting dissatisfaction should be felt not just by the power structures, against which resistance is realized, but also by the resistors themselves and by the "uninvolved" observing audience. To cultivate anti-technologies of resistance means to create an atmosphere of unpleasantness, defeat, disappointment and indignation in today's world of successful "humanitarian interventions" (for example, in Iraq and Yugoslavia) and festive rep-

resentations of triumphing cultural imperialism. Anti-technologies of resistance are like a fart at a cocktail party with guests dressed in evening attire. This fart must be really unbearable and instill consternation and dissatisfaction into the souls of those present. It should not have anything in common with Christof Schlingensief's theater or Roman Singer's performances. This fart must be really anti-artistic, but not like punk or G.G. Allin, because these are also technologies. Anti-technologies are not art, but at the same time they are art because nobody knows what art is although everybody can do it. Anti-technologies are the striving for the impossible, and in no case just another aesthetic phenomenon which decorates the pages of art magazines. Art magazines are shit!

Anti-technologies of resistance are atmospheric appearances, because they are principally indescribable and non-reproducible. It is impossible to repeat an anti-technology (otherwise it becomes a technology.) Anti-technologies are anti-systematic. At the same time some more or less constant characteristics of anti-technologies can be named.

1. Connection with specific and local context. Only these specific connections can determine the effectiveness of resistance. However (we can say parenthetically) no one has ever practiced such a deepening of context — from court organs to artists. Without this deepening, there is no understanding.

2. The body as the opposite of a machine. Bodies do not organize or create anti-technologies, but appear as anti-technologies — it is through bodies that anti-technologies become visible and perceptible. Bodies are not machines: neither machines of desire, nor war machines, nor machines of power. Bodies destroy their function, come out of their frames, get into contradiction with themselves. Bodies show their discrete anti-machinery. Bodies carry the truth of anti-technologies, which can be defined through the interrupted pulsing of 4 elements: body-thinking-happiness-suffering. Happiness is not a technology; neither is suffering. Suffering and happiness live at a high speed detached from technologies, like death is a high speed detached from life. (If you don't understand this, try drowning in a bathtub.) Thinking is not a technology because it can exist only in desperate disagreement (with the primate of technologies).

3. "Wild" and "antisocial" activities. These do not have anything in common with all sorts of expressionism, or, moreover, with a frustrated iconoclasm. (Expressionism is just another mercantile technology.) Wild activity means introducing chance elements into the order of technology, thereby demolishing this very order. Chance elements are bodies, chairs, water, night, dirt, hunger, flowers — in a word, everything available right at the moment.

4. Striving for decomposition and unproductivity. Decomposition is an attempt to hinder the repressive order, which in hegemonic culture is perceived as the main source of productivity. The normative product in today's understanding is repres-

sive consensus in a certain packaging. Exactly this consensus must be subjected to the procedure of decomposition. Decomposition and disintegration are the weapons of a minority, calling into question the consensus of a moral majority.

5. Striving for discontinuity. Discontinuity is a risky leap out of the body of cultural history, which Benjamin called a "history of winners." (The "history of winners" is the history of the fat giggling of patriarchal owners who stage celebrations on the bodies of poverty.) Leap into what? Into dissatisfaction, risk, pain. Into the void… But more than anything, a leap into thinking, into producing resistance.

6. Refusal of any aesthetic and ethic satisfaction. No satisfaction, not for yourself, not for others. No consumption and pleasure of success. We confess that this idea is not clear in the end even to ourselves: What does no satisfaction mean? No laughing, no enthusiasm? Rather not that: laughing and enthusiasm, but with the disgusting feeling of shit coming out of your neck. (And immediately a shout and attack.) This feeling was described by Bataille in *Literature and Evil*. The political equivalent of this feeling: Contra-attack against your own post-bourgeois fatness. Anti-technologies are convulsive contra-attacks against the fascism of your own machine-body.

7. Refusal of normative documentation. A typical means to collect fat around your hips is to document your own "works." Anti-technologies entail refusing the principle of documentation. Documentation is the main way to archive hegemonic cultural memory. Documentation is the liberal form of social consensus, ironically making fun of the conservative term "masterpiece." Documentation is today's whiny form of recognition, begging for critical revisionism. Don't document and exchange information but think! And every thought must find its own specific and mortal (political) form.

8. Non-originality. Originality is the crumpled, rotting intellectual fruit of old shit-preservers like Jürgen Harten and Kasper König. Puffed up "experts" talk about originality, while they are disgusting non-original functionaries. Originality is the commercial success and mass-medial triumph of some obedient bodies over others – nothing more. In a political field, efforts are the only reality of resistance-culture! Non-originality means adopting radical-democratic principles in a cultural, social and political realm.

Our short theses about anti-technologies of resistance are connected with the actual political situation in the modern age of globalized capitalism. The noticeable repoliticization of social groups (youth, immigrant, trade-unions, different social movements) in many parts of the raises the specter of local and specific struggle against various enemies: neo-liberalism, conservatism, the new rights, racism, cultural populism, subtle sexism, various "progressive" institutions, serving the interest of political and social elites. "Micro" resistance is necessary to combat the expansion of capitalist instincts and orders in every direction, every place, all bodies, all

discourses, all objects. Struggle at the level of elementary particles of thoughts and activities. Start with yourself, with your own context, your professional field. Review theoretical approaches; give up using current discourses, contemporary formulas, fashionable technologies. Speed, imposed by modern culture, is just the speed of capital. It is necessary to brake sharply, to stop and slow down. It is necessary to carry out what Foucault called a return to: "If we return, it is because of a basic and constructive omission, an omission that is not the result of accident or incomprehension.... This non-accidental omission must be regulated by precise operations that can be situated, analyzed, and reduced in a return to the act of initiation. Both the cause of the barrier and the means for its removal, this omission — also responsible for the obstacles that prevent returning to the act of initiation — can only be resolved by return.... It follows naturally that this return... is not a historical supplement that would come to fix itself upon the primary discursivity and redouble it in the form of an ornament.... Rather, it is an effective and necessary means of transforming discursive practice."

A "basic and constructive" institutional omission of resistance-culture (the culture of Mary Richardson, Arthur Cravan, Antonin Artaud, Martha Rosler, Adrian Piper, Gustav Metzger, Jack Smith...) has already taken place.

About a return, so far, we don't have to speak.

Techno-Transgressions

Jacek Niegoda & Peter Style, CUKT *(Poland)*
Interviewed by Joasia Krysa *(England)*

UKT, The Central Office of Technical Culture (cukt.art.pl), was established in 1995 in order to disseminate and distribute technical culture. CUKT uses its own stamps and distributes official forms; it exchanges correspondence with other institutions as well as with local and national authorities. Since 1995, CUKT has collaborated with a number of institutions, such as schools, local leisure centers, galleries, and museums. It also co-operates with local and national authorities such as the County Council of Bytow, the City Council of Gdansk, the Marshal Office of Pomorze County and Lubusk County, the Polish Ministry of Foreign Affairs, and the Polish Ministry of Culture. Members: Andrzej Wiadro, Anna 95–97, Awsiej/Kabala 95–96, Dr. Kudlatz, Mikolaj, Paulus, PH.D. Jan Smuga, RA-V, TJ 4495–97, Virus, Vitriol 95–96, Peter Style, Ewert, Dj 11.

Your practice is located somewhere between Dadaist radical actions and Marxist demonstrations. The very concept of Technical Culture seems to be a powerful formula for accommodating such diverse tactics. How would you define your practice?

Peter: "Weird dancing throughout the night. Unauthorized subconscious displays. Kidnap someone and make him happy. Don't do it for other artists, do it for people who will not realize that what you have done is art. Avoid recognizable art-categories. Leave a false name. Be legendary." (Hakim Bey)

Jacek: Unfortunately, technical culture is entirely dysfunctional, at least as an artistic and cultural formula. According to a fundamental principle of CUKT, CUKT does not create anything, it only increases people's awareness. And technical culture is not merely an artistic concept, but the reality of our culture and civilization. The main purpose of our activity is to make people aware of technical culture, which is more than just art. It is a phenomenon encompassing all disciplines: art, technology, mass media, medicine, anthropology, etc. Through its

activity, the Technical Culture Central Office draws attention to specific aspects of technical culture. We are now about to establish a Ministry of Technical Culture for our future activities...

CUKT aims neither at representation nor at interpretation; it is inevitably provocative and often subversive. What is CUKT's main strategy?

Peter: We act as volunteer officials on a meta-national level, outside the oppressive political structure of centrally issued directives and long-term planning; free from political submissiveness and social responsibility. At the same time, we have practical ideas on how the country should function in terms of education (example: Art Day Action), unemployment (Action for the City of Bytow), political power (Victoria CUKT presidential campaign), and technology (Technopera). The first logo for CUKT was designed in 1995, and along with our official stamps and a proposal, the idea of CUKT was introduced to the authorities of the city of Gdansk. CUKT's previously unofficial location at the Napoleon Fort in Gdansk has after two years become our official headquarters. It was from there that we initiated actions such as the first presidential election campaign and a series of education and research activities. The year 1999 brought another logo, new ID cards, and new CUKT business cards, which were designed according to European standards. 1999 was also a year of preparation for the Victoria CUKT presidential campaign. We had been laying the foundation for this event for the previous five years, because by our actions we were targeting the large population of Polish "Cyborgs." Now that the new generation has been brought up, we alert them to the possibility of a dramatic change in the way Poland is ruled. We give the power to Victoria CUKT! Computer programs seem like the only effective strategy for ruling a country in which there are either too many diverse opinions, or none. The decision making process should be left to computer logic.

Jacek: Our strategy could be compared to that of any typical office or institution, insofar as it consists in filling out forms and producing documents. Only the capacity and diversity of our activity is perhaps different. Each of our actions is preceded by a correspondence with institutions similar to us, such as the Ministry of Foreign Affairs, or the Ministry of Culture and National Heritage. We write reports. We also conduct research, or something of the sort. For example, we conducted a series of tests in order to identify cyborgs in the years 1995 and 1996. We also actively participate in the social and political life of our country by organizing educational programs (e.g., we suggested Art Day as a new version of the Polish national holiday, in addition to giving a series of lectures at a Gdansk gym and in the town hall at Lubusk.) Since the first presidential election in Poland in 1995, we have regularly nominated our own presidential candidate, such as Groby in 1995, and most recently, the virtual candidate Victoria CUKT. There is not a hint of provocation or rebellion in all this, whatever we do is meant as a serious and practical response to specific social situations.

There has always been something very disturbing about Polish art, an incredible sense of detachment from a more universal cultural discourse; perhaps this is due in part to specific political circumstances, and to the artistic ideals that have been promoted here over the last centuries, projecting a strong sense of escapism and the ideal of suffering for humanity. World War II did not help either. While other countries managed to get over the holocaust in a constructive way, Poland, and specifically Polish art, has been bearing a sort of "martyrological" stigma, which later turned into a communist stigma. Today, despite the advent of new media, Polish art still seems to deal with many of the same issues, only now artists are using different media. Recently there have been many successful attempts to break this pattern of cultural isolation: artists such as Alicja Zebrowska, Katarzyna Kozyra, Pawel Althamer, Slawek Belina, Barbara Konopka and Anna Baumgart, among others, have tried to find a more universal approach to art. Still, I am not sure if this means that the changes are going to be profound and permanent. Where do you see your own practice in a global, rather than local, discourse?

Jacek: I am not sure that the artists mentioned here are less prone to escapism than all other artists, both in Poland and abroad. All artistic practice or activity, insofar as it means exhibiting and being a part of the art world, is as such detached from reality. The idea behind the Central Office of Technical Culture was to break this pattern; we wanted to create a dialogue with the outside world, not an art fantasy. We exchanged galleries for techno clubs, museums for electoral offices, and art works for information campaigns. We have changed through our work, but there are also other institutions that have been visibly changed by dealing with us. Take, for example, the most recent campaign of Victoria CUKT. After this, nothing will ever be the same anymore.

Peter: We don't know ...

What do you mean by "we do not know"? Do you not know the names of the artists I have mentioned, or do you not see yourself as part of a global artistic discourse?

Peter: We do not see ourselves as belonging to this art scene. We are outside of it, and we do not want to be a part of it; we exist in a different dimension altogether. Our strategy is very different from mainstream Polish art and our purpose is different.

Your Declaration calls for secrecy and the control of information which could otherwise be potentially deadly. On the other hand, you also talk about technical culture as mass culture. Barry Jones has introduced the concept of the "information proletariat," arguing that the ability to control and access information was one of the major political issues of the 1990s. The question of who has control and access (to information) thus also becomes a question of power.

Peter: Information gives us knowledge and knowledge gives us power.

Jacek: We are against information apartheid, but at the same time we believe that uncontrolled information can have a fatal impact. To you, this claim may seem paradoxical, but in fact it is deeply logical. We are for equal access to information, but at the same time we want to stress the importance of knowing what information could and should be used for. As we have already said, information means knowledge and knowledge means power. We all know from recent history what the abuse of power and technology can lead to. Therefore, in the light of fast growing communication techniques, we attempt to create an awareness of how the information-flow should be used in an ecological and user-friendly way. One such "awareness-creating" action has already been mentioned: Art Day. We strive for equal, wide, and unlimited access to information. One of our main electoral campaign slogans was "Computers for everyone." Interestingly enough, two other candidates for president (Kwasniewski and Olechowski) soon also started to use our slogan and to support widespread access to the Internet. The popularity of such ideas is confirmed when you consider that one of the above mentioned candidates won the election, while the other made it to the second place. Sadly, neither of them was radical enough to propose the use of the Internet as a new strategy for implementing political power and, ultimately, running the country. We opted for the replacement of traditional politics by the Electoral Citizen Software, and for substituting our parliamentary democracy by an electronic one. We think it would be a great opportunity for all citizens to have influence over how the country is run, not only once every four years, but every 24 hours. In our view, everyone should go online and vote on issues that are important for him/her once a day.

As I read your manifesto, I noticed a few contradictions. On the one hand, you aim to "unmask the manipulation of information," but on the other you claim that "technical culture art is a manipulation of information." Could you explain this?

Peter: Information that has not been manipulated in one way or another does not exist. The process of information distribution is similar to the distribution of food in society; it is produced in factories, then distributed first wholesale, and later sold individually in supermarkets. Every single product carries a label containing information, such as when to use the product by, its ingredients, recipes. All this in many languages and many colors. Behind the finished product, there is a whole industry that wants to manipulate our brains and stomachs. Then there is the specifically Polish phenomenon of activists who produce more or less organic food, but even they are becoming more and more incorporated into the big industrial organism. Sometimes I have the impression that the speed with which new supermarkets are built is comparable only to the speed with which new portals pop up in the Polish Internet. In both cases information is segregated, "polonized," and then distributed.

Jacek: In view of the mass character of information-flows, it would be almost impossible to prevent the manipulation of information. The only thing one can do is to be aware of this while being at the receiving end. Today we no longer believe that the washing powder of brand X is better than that of brand Y, because we understand

that advertising aims to manipulate our opinion, and that we have to develop some sort of resistance to it. Information today is all about reaching one's target audience effectively, and the means to achieve this goal are becoming more and more sophisticated. Everything is packaged attractively and appropriated to the context in order to persuade the audience that it is true. However, what really matters is not persuasion as such, but its intention, the purpose of the manipulation. We find it most important to avoid the potentially dangerous influence of wrong information. This is about shopping for what we really want, not for what we are told to buy.

Since the launch of the worldwide web as a new mass medium in 1993, it has quickly been embraced by media practitioners. The web has paved the way for the formation of loose groups in a virtual environment that encompasses both locality and trans-locality. However, this development does not seem to have affected Polish artists. Can we talk about a Polish net art scene at all? What is net art in Poland? And where does CUKT stand in this context?

Jacek: It is hard to talk about Polish net art, as it is practically non-existent, with the exception of one Internet group, called "Neurobot."

Peter: Net art does not exist in Poland. The Internet only enhances the Polish feeling of loneliness.

As it is torn between the grim vision of clerical power attempting to make all Poles saints-to-be, on the one hand, and the utopian leftist fantasy of the welfare state, on the other, Polish society does not seem to be aware of the power that the latest technologies have, both in a cultural and a social context. What kind of challenges does the medium "Internet" face in today's unstable political and social climate in Poland, and what does it mean for your practice as a group?

Jacek: The Internet is an excellent tool that could allow citizens to monitor and influence the decision-making process of the government over the net. Perhaps Poland should start some legislative initiatives, first on a local level and then on a national and European level. More advanced European countries and the US have already established such projects. It should also be possible to influence the political decision-making process over the internet (i.e., a quick analysis of public opinion). Sooner or later people will realize that politicians are obsolete. When that time has arrived, an electronic democracy will be established. Today, people's acquaintance with the Internet is still far from advanced, because they only have a very limited idea of how they can best use it for themselves. In our most recent campaign, the Victoria campaign, we received many, often extreme responses on our website, but also serious and constructive ones. The more people engage with what we offer, the more balanced their opinions will be.

Which brings me to the issue of media access in Poland. Take, for example, web-based artistic practice: one needs to search for a long time in order to find any example of this at all. Is

that just a reflection of the current economic situation, meaning that Polish artists have very limited access to these tools, or is it because the Internet is still somewhat of a novelty, something that artists do not feel comfortable enough with?

Peter: I would like to stress again that we do not make art. We use the art scene, its galleries and museums, just as we would use streets, clubs, schools, or trains. But based on our observations, we can say that the technological resources in Poland are indeed limited. That is most visible in galleries and offices, where once in a while one still sees analogue typewriters being used. Photocopying is more widespread than computers. But of course there are many young people who use the new technologies on an everyday basis.

Jacek: Many of these problems developed after 1989 [the introduction of martial law]. At that time, Poland was already technologically behind, but the elitist mass media enhanced its backwardness even further. This media-elite distinguishes itself by a modernist belief in authority, whether it is the authority of a working class culture or that of nationalist-conservative rhetoric. It also shows a strong aversion to innovative communication technologies in general, because it perceives all communication technologies as a potential means for creating social anarchy. During our presidential campaign, we experienced much dislike from the media, especially from those on the political right, despite their traditional association with more progressive views. This is why we are working to establish the Ministry of Technical Culture; we want to help Poland become the European "tiger" of technical culture. Some slight changes are already noticeable, and I think that Victoria CUKT deserves at least some credit for that. At least people are now becoming more and more aware of the fact that investing in technology may be a key to progress. Local and national authorities, for instance, have introduced a number of new ideas, such as incorporating computers into the school curriculum on all levels.

The CUKT declaration talks about a climate of economic efficiency in modern societies where "humans are perceived as a market," and morality becomes an "outmoded concept," to be replaced by efficiency, profit and economic progress. This could be seen as a subversive tactic to provoke a more critical perspective on the current state of our society. But could it also be read as an ironic criticism of Polish society as it is now, more than ten years after the great economic and political shift, which, in fact, resulted in dramatic and lasting transformations, both on a social and a cultural level?

Peter: This declaration was written more than five years ago; it is an official document that expresses our view of the outside world. In fact, we should add a paragraph on humans: an obsolete species that only slows down progress. Machines would be much more efficient if they were allowed to solve their own technical problems. Poland today mostly imitates what has already been achieved by the countries of the former West, besides competing locally for power and money. There aren't any propositions to speed up the technological and mental progress of Polish society.

Jacek: Our declaration certainly wishes to provoke a debate on authority and values, in a language that now, at the end of the 20th century, may be understood.

Last spring, when we met in the Zacheta Gallery in Warsaw, you were just launching the presidential campaign for your virtual candidate Victoria CUKT. Now that the elections are over, with an ex-communist (how do they prefer to call themselves now? The New Left?) having won and become the current president (Alexander Kwasniewski), what will happen to Victoria?

Peter: We can now only hope for good luck in the green card lottery. If this does not happen, Victoria will be set on fire in a white limousine, with the clip of the explosion on the news for the next five years, until the next presidential elections. And then, to everybody's surprise, it will be revealed that Victoria actually survived the accident, just like "Terminator," and that she is ready for another attempt to make Poland the "tiger" of technical culture. Anyway, this is the official story for the press. Experts know that Victoria's death is impossible.

Jacek: We are curious ourselves to find out what Victoria does now.

That reminds me of the current debate over the relationship between machines and human beings. You argue for handing over political power to machines, and you call for the personalisation of machines to form a sort of partnership. The fight for the rights of machines is one of your main goals. All of this is very reminiscent of Mark Dery's vision of machines that populate "Gaia" and thus endanger humanity. On the other hand, there is Huge Harry, Arthur Elsenaar's now famous "artificial life figure with a human face," who set forth the view that machines are entities that are oppressed by humans; Elsenaar consequently published the "Universal Declaration of Machine Rights." Are we talking about a struggle for power between two species, or about how to achieve a more creative relationship between humans and machines on the road to a co-evolutionary future?

Peter: Humans have lost the struggle already. The only chance to preserve a unique human consciousness is for humans to co-operate with their own creation, machines. Machines need a power supply and people need money. Why can't we become walking cash machines (ATMs), or television sets that proudly stand in the corner of the room? And for the stubborn radical supporters of humanism we could invent something like a perfectly human-like device. The choice is only limited by the presence or absence of access to money and power. What would have more significance for a blind person: to have electrodes implanted and thus be able to see reality, at least in the form of gray, blurred images, or to visualize the Internet in his/her mind? Many would give anything to have that option. Human beings without machines have nothing to offer, neither to themselves nor to their environment. If all servers and broadcasting stations were to be switched off, what would we talk about at the work place? How boring the lives of the working population would be....

Could you list some of your previous projects?

Peter: In 1995, we launched our first electoral campaign: "Technodemonstration — Anti-election." Between 1996 and 1999, we did the "Technopera from 1.0 to 4.1 Pro," using different forms and adaptations and variable libretti. In 1996, we organized the "Action for Bytow City." 1999 was the year of "Art Day celebrations."

Jacek: In "Action for Bytow City," we refurbished houses for sportsmen, painting zebra crossings on the city streets. Our actions were always about current and urgent social issues, with a particular focus on technology.

A final thought: if you were to think about your activity in terms of net activism, how would it make you feel to be the pioneers of Polish net art and the makers of Polish media art history?

Peter: Sad and lonely.

Jacek: Even though I fiercely protest against being part of an art cliché, our offer is the only one available with regard to Internet activity in Poland. That makes us feel very lonely.

— This interview was first published in the online magazine ART MARGINS *(www.artmargins.com) in January, 2001.*

05

The Structure of Avoidance

Miklos Erhardt & Duna Maver *(Hungary/Romania)*

||

Heraclitus once said you can't step in the same river twice. During the long march of history, we have been moving closer and closer to that river; it may even be possible to speculate, that we are now standing in it ...

In "Eastern Europe," having escaped from the shackles of a rigidly established code-system, now we are able to live society from the inside, in other words, as artists, we have lost our archaic position of being independent. The communist regime was very likeable from the point of view that it never really wanted us to be involved. Although practical creativity was forbidden to us, we could always sustain the belief that we were more clever than the system.

Now the system, which has become even more deeply ideological than the old one, lures us to function as milk lures its bacteria to produce yogurt. This is not a judgement either against the system or against the bacterium.

The grand period in modern art began with a need for total, militant, and subversive participation. The defining feature of modernism was art's loss of faith in the system that produced and sheltered it. Artists used their energies to revolutionize this disappointment and began to chisel away at the fortress of art. As art deconstructed its own system of production, language for the first time became its most important feature, and visuality receded into the background.

Today this revolutionary character has withered and split into a thousand fragments, and the visual arts are capable of producing only brute, inarticulate facts. The history of contemporary art is like reading an inventory list.

THE STRUCTURE OF AVOIDANCE

A recent exhibition in Paris bears witness to the overproduction of redundancy without purpose: dozens of telephone books, thousands of slides, a list of all artists with the name Martin, mineral water bottles, hundreds of dice, 100 portraits of 100 years, CD-ROM installations, internet projections. Something for everyone, and simultaneously for no-one.

Quantitatively, contemporary art is obese.

Participation still triumphs, but it is a transformed, functional and bacterial participation. Artists participate in the system like bacteria thrown into milk: they agitate furiously, they produce secretions in large quantities, but by some automatic mechanism, instinctively and without thought.

The virtual demand from artists for constant agitation and restless activity assures the real dissolution of movement — everything moves, like in a vacuum, with the same unbearable speed.

In the free-market system, the grant is the method that allows artists to hold on to the archaic illusion of being independent of the market. The grant is a product of the tolerance of the system — it appears to be generated by the recognition that art can't be accounted for by the logic of the market, and that allowances have to be made for the survival of artists out of the philanthropic goodwill of governments and non-profit institutions.

In reality, the grant is the catalyst of the artist's so-called "maturation" process, thereby already virtually a category of the art market.

The grant pays for surplus time. This is not Marx's surplus, in which the surplus hours of labor (above the necessary hours) are stolen from the worker by capital. It is superfluous time, what was once called leisure, though leisure now has become so completely programmed that it is yet another form of compulsory work.

The grant pays for time above work, for time that is not work, for time that is not time.

The grant does not purchase labor time, which can be measured quantitatively and exchanged for a wage. It pays for the production of a product (out of this superfluousness) that is beyond measure, ephemeral, speculative — the product is the artist himself, who is, in principle, not marketable.

While seeming to be a form of money paid for nothing, a gift that is outside the circle of exchange, the grant purchases the becoming of the artist, in fragments so small that they seem almost to escape notice. To receive a grant, the language and framework of the proposal have to conform to a standard enforced by the granting institution — the idea has to be "correct." We write applications, proposing projects that might be far from our interests and intentions, in a strange

language that is not our own, until slowly, without notice, the foreign tongue begins to colonize our thoughts.

Compromises with money are better than compromises with ideas — but it is not always easy to tell where one ends and the other begins.

To assure the survival of the last social class of artists and intellectuals, grants play a formative role in the production of consciousness.

The last class exists now only in a virtual way, feeding on the fees of self-mystification extracted from the social body as a whole.

It refuses to believe in its own disappearance because it has a strong sense of importance based on the enormous documentation of its history — which we once called Culture.

Culture is dead; intellectuals are always the last to hear the news.

Our epoch is completely saturated with market-based activity: every aesthetic gesture and intellectual product in a short time will be out on the market.

The Situationists postulated already in the 1960s that any product of art (the aesthetic object) which doesn't belong to situations will become part of the spectacle, thereby enriching the system. This was the root of the aversion of the Situationists towards artists. It has become the root of the system's ingenuity about how to exploit aesthetic objects, born codeless and to be wild.

The rhythm of market-based exploitation of artistic inventions has become so fast today that artists during their career are already able to enrich remarkably the matrix of the system — regardless of their intentions.

Creativity, once the sacred right of god and artists according to romanticism, is now one of the fastest selling commodities. The last fortress of pathos in art has already fallen.

Corporations use the image of creativity embodied in the mythical figure of the artist as an advertisement for their own activity, and as a model the consumer can identify with. Large multinationals sink millions of dollars into exhibitions and buy art works for their offices — as public relation strategies, to improve their image. Art is already a corpse; its radical energies vanished, it has become a useful detour for the money-laundering industry.

On the cleaned field of creativity the first colonists have arrived; abandoned without purpose, we should leave.

Today under the imperative of "do it yourself," creation has become a duty demanded democratically of everyone.

"Go create" says the new slogan of Sony. On the 830th day a digital penguin takes the place of the apathetic observer. The apathetic observer stands in the wilderness and laughs. He sees that it is good.

Since the universal order of production in its most recent stage has become more artistic than art itself, artists have already become a subcategory of production and should find employment in the most flourishing economical (consequently: artistic) fields. Beyond the obvious economic advantages, artists can also thereby avoid the frustration typical of their class: not being experts in anything.

Artists should secure jobs with an optimal level of creativity, where creativity is supposed to solve practical problems, to terminate something (to be distinguished from the kind of creativity which generates something).

Artists should become official. After all, official work can give artists many small satisfactions and a sense of concrete accomplishment — and it can provide a way for artists to step back and reintegrate themselves into society.

Daily employment is easier and more humane than chasing after the grant — and the grant, as an archaism of a dying epoch, can only perpetuate the illusion of autonomy, and promote the desire for non-participation and detachment.

But the distinction between participation and spectatorship (passivity) is itself an archaism… and something of a false dilemma.

The apathetic observers watching the screen in the cinema — the Situationists' favorite image of the idiocy of virtual capitalism — also participate in the production of the social order which they allow to dominate their thoughts and desires.

The artists who have reintegrated themselves in the sphere of production, by channeling their creativity toward the production of advertisements or television programming, participate more directly in their world, though perhaps just as unconsciously.

And the radical, active, and subversive participation demanded by the Situationists has not failed to contribute to the system it wanted to destroy. As a revolutionary thought oriented toward concrete goals, it could not fail to produce an ideology — and ideological dogma is always marketable, if only in the form of Debord's books.

Passivity, participation, interactivity (the new form of virtual participation, a choice in choicelessness), even subversion are all oriented toward production, and any form

of production can enrich a system whose only purpose is to push commodities on the market with increasingly faster speed. Even "revolutionary" ones.

A road has opened instead for art to elaborate new forms which can't enrich the matrix, and parallel with this, we can speculate that the small epoch of art has begun.

The grand objects of art produced during modernism, the creation of sublime theories which had an aerial perspective on totality, the "Big Man" as the embodiment of creative genius — are all vanishing moments. Artists must learn to lose their character, and to give up their longing for the cult of creativity.

Abandoned to its own resources, art now stands on an arid, empty field where winds blow… in silence. In this new situation, more suitable is the vertically small dislocation, directed backwards. The vertically small dislocation is not marketable.

Market-culture is already able to create independently, henceforth the artist subtracts.

Subtractions are not phenomenological reductions, nor deconstructions. Phenomenological reductions in art, as in philosophy, negate the inessential in order to reach the *eidos* — they are purifications that enrich the scope and function of their medium. Gabor Body once spoke of a "countdown process towards the original forms of consciousness and language." This purification is evident in the reductio ad absurdum of cinema (Kubelka, for instance, who abolished motion as an illusion of cinema, and reduced film to the static image) as it is in minimalist art. Purified, the medium expands without limitations, and achieves grotesque (dis)proportions. Minimalism can only become visible as the absolutely large, the mathematically sublime. At a certain point of dissolution, absolute zero implodes and touches infinity.

Deconstruction, as a negation, begins from the inside of phenomenology, but reaches different conclusions — the medium is always already impure. Dada does not purify, it destroys. Destruction becomes a hoax, a scandal; it makes visible the humiliation of art, which can no longer bear the sorrow of having lost an integrity it never really possessed. During the heroic age of the avant-gardes, destructions announced themselves loudly, by producing noise, by provoking media spectacles, by using the language of warfare…. Formally they manifested themselves as obtrusive experiments, as visible cuts and interventions in the structure of the medium.

In the history of art, both reductions and deconstructions have been structural; subtractions, on the contrary, are surface eliminations of phenomena, negative catalogues, inventories in reverse.

In the Inside/Out project (signed by Dominic Hislop and Miklos Erhardt), the personality of the artists was subtracted from the work of art. This project was realized by Budapest homeless, who were given a photo camera so they could pro-

duce themselves as the objects of observation by manipulating their own instruments of observation.

This subtraction should not be understood as a purification of the field of art. Since the artist is proper to art, Inside/Out subtracted art from the work of art. It became just a work.

The more recent Tequila Gang film followed the principle and theme of the earlier project — a group of homeless were given a video camera to record themselves and produce their own work as a sequence of different fragments. Here it was not just the personality of the artist that was subtracted, but also the artist's name. It became just a nameless work.

Subtractions are difficult to perceive; you need to look carefully to discover them. The media have absorbed all spectacle. And the most radical formal experiments of the past have been captured and made profitable by television ads and music videos. The "experimental" is everywhere, hence nowhere. Radicalism today can survive only as the abolition of radicalism — by becoming unobtrusive, miniscule, unseen, unheard.

The subtractions of the future will be imperceptible, existing without past or future, passageways.

06

NSK 2000?

**Miran Mohar, Borut
Vogelnik & Eda Cufer
(Slovenia)
Interviewed by Joanne
Richardson *(Romania/USA)***

||

NEUE SLOWENISCHE KUNST (www.ljudmila.org/embassy) was formed in the early 1980s in Slovenia from the discrete groups Laibach, whose musical performances exhibited a fanatical overidentification with totalitarian rituals, the visual arts group Irwin, whose montage paintings juxtaposed fascist and communist symbols with avant-garde iconography, the theater group Scipion Nasice Sisters, which proclaimed an exorcism of religion and ideology into the mirror image of art, and the design group, New Collectivism, best known for a scandal that ensued in 1987 when their remake of a Nazi poster was awarded a prize in a national competition – thereby showing the proximity between socialist realism and Nazi Kunst. Following the scandal, the yearly ritual of celebrating Tito's birthday was abolished. The most known projects of the 1990s have been the NSK "State in Time," the organization of various embassies, and the creation of passports.

> Can you start with a personal account of the founding of NSK in the 1980s?

Eda: Probably each of us would have a slightly different story, a different memory. In 1984 three groups joined Laibach (founded in 1981) and created the larger collective NSK. I personally remember the beginning of the eighties as a sudden and quickly progressing explosion of alternative art, culture, and discourse that challenged the existing social and political system. Laibach did this in the purest, most radical way. From the beginning Laibach distinguished itself from the rest of Slovenian alternative culture in a manifesto: "Art and totalitarianism are not mutually exclusive. Totalitarian regimes abolish the illusion of revolutionary individual artistic freedom. LAIBACH KUNST is the principle of conscious rejection of personal tastes, judgments, convictions… free depersonalization, voluntary acceptance of the role of ideology, demasking and recapitulation of regime, 'ultramodernism'." Around the core ideas of this Laibach manifesto, a community was created. Those of us who were working in different groups realized that we had common goals, that first of all we shared Laibach's reflection and approach to the existing society,

and that we had a similar approach for using Laibach's formula in developing different formal languages for the different group (visual, theater, design, etc.) We created this whole social field — through conversations, through normal social life.

Miran: It is important to emphasize the political, cultural, and social circumstances of the 1980s in Slovenia. There was a very strong civil society movement; philosophers, politicians, and intellectuals opened discussions about the political system and ideology. A lot of new media appeared, like Mladina and Radio Student, and independent art productions started. This political and social context also helped to shape NSK as a group. Laibach started in 1980 and by 1983 all the other groups had already been founded: Irwin, Scipion Nasice Sisters Theater, and New Collectivism. Each group has its own field, its own media; each has been functioning as an independent group from the beginning, and still does today. When we found out that we were gravitating toward similar goals (analyzing the relation between art and ideology, working on the internationalization of the art scene in Slovenia, linking different media of art) we started to communicate more widely. The first important act at the beginning was publishing an issue of the Slovenian magazine called *Problemi*. This was the first time we used the name Neue Slowenische Kunst, which appeared on the cover of this magazine. After that we collaborated on various projects. In 1985-86 we worked together on the theater production entitled Retrogarde Event Baptism below Triglav (conceptually prepared by the Scipion Nasice Sisters Theater). This production was very important because it was our first collaborative art project. I think this was a turning point in how NSK was perceived in Slovenia. The event, which took place in Cankarjev Dom, Slovenia's central cultural institution, was at the same time the inauguration of the biggest stage in Slovenia. One of the main topics of the show was the permanent conflict between avant-garde and tradition. It is important to stress that our position from the beginning has not been to operate against existing institutions, or outside these institutions, but to create a parallel institution. This was the important difference that distinguished NSK from other alternative groups in Slovenia at that time.

> *In what sense is NSK a parallel institution, because parallel implies something that is alongside and moving in the same direction? Maybe perpendicular would be a better word?*

Borut: Parallel is not a very exact word, but neither is perpendicular. The fact is that there were no institutions to be parallel or perpendicular to. From the beginning it was our conscious decision to establish an institution, to occupy a position. During the 1980s art would circulate only on the borders of Yugoslavia, and really mainly on the borders of Slovenia. There was no possibility to exhibit abroad. Only certain artists who were favorites of the central committee would be in a position to move outside. The whole situation was not controlled in the same way as in Russia or Romania, by excluding the possibility to travel. We had passports and could travel, but the situation was controlled by two means. The salaries were so low that it was nearly impossible to allow yourself to travel, so there was no real possibility to function in Western countries. The possibility of certain artists to have state exhibi-

tions outside was based on the choice made by the cultural bureaucracy. The position of being or not being an artist was defined externally, by somebody who would give you a job as an artist. To decide at that time to establish our own social grupation was to decide not to accept such a system. For this reason NSK was not parallel. There was no possibility to enter any kind of normal circuit, to break the borders in other ways. What we did in a way was to establish an artistic field in Pierre Bourdieu's sense of word. Looking backwards, exactly such social entities existed throughout the whole history of the avant-gardes.

> *What is the relationship between NSK and the previous avant-gardes? In an earlier manifesto you define the retro-avant-garde project of NSK as "reviving the trauma of the avant-garde movements by identifying with them in their moment of assimilation in a system of totalitarian states." What is the nature of this trauma?*

Eda: The nature of this trauma is the assimilation into the totalitarian political regimes in Russia and Italy, to be perhaps too concrete. But I would first try to explain the context and the significance of the idea of "the avant-garde" for us. At the beginning of the 1980s there was a huge intellectual production in Yugoslavia by aesthetic philosophers who wrote books that for the first time brought the history of the avant-garde to readers. There was a parallel worldwide process of redefining the historical avant-garde, but it was important that this also happened in the Slovenian and Serbo-Croatian languages. At that time, this was a kind of radical discourse because internationalism was used to oppose hermetic national and communist ideological models. We of course read these books, and they were a source of knowledge for us, but at the same time, we were standing on completely different historical and sociological grounds than those writers. Maybe I'm wrong but at least this is how I see things today. There was an ideological shift in the value system, a real difference between the "retro-avant-garde" and the early 1980s academic interpretation of the avant-garde. The attempt by philosophers to place the avant-garde in a historical and theoretical framework was based on the perspective that socialism would never collapse. We used this potential of the avant-gardes from another, rather twisted perspective — that socialism will collapse. We were deconstructing it.

Borut: The relation to the avant-gardes was very different — it was not unified within the larger group.

> *What are these differences among the groups?*

Eda: Laibach was representing the field of ideology; the theater was representing the field of religion, and Irwin was representing the field of culture. Each group had its own strategy. If I can speak for the theater group, the subjective and utopian potential of the historic avant-garde was a huge inspiration. I think this return to the initial trauma of the historic avant-garde was true for the whole NSK project, which

NSK 2000?

I see as a critical project. But the story is not finished of course, and the evaluation has to be done from the outside.

Miran: We even used different expressions. Laibach used the expression "retro-avant-garde"; Irwin used "retro-principle" — strictly; the theater group used "retro-garde." The meaning of these words differed, as it is obvious from the expressions themselves. For Irwin, in the first manifesto, this was declared as a principle, as a way of doing things. "Retro-principle" was connected to the organic eclecticism of Slovenian art; we accepted eclecticism by birth, we took it over as an obvious standpoint, even though everybody at the time was trying to speak about the "originality" of Slovenian art.

> NSK is frequently defined in terms of a strategy of overidentification — not a parody of totalitarian codes, but an obsessive identification with them, in a sense, taking totalitarianism more seriously than it takes itself. Fanatical identification by excess can make manifest what usually needs to be suppressed for the social order to function unquestioned. In this context it is important to mention that the Communist authorities banned Laibach performances. Was overidentification used primarily by Laibach, or by all NSK groups?

Borut: Overidentification was very important for all of us, but it was first introduced by Laibach. It is necessary to stress the different roles of the NSK groups. Laibach are the politicians. Irwin are the chroniclers and we overidentify with NSK itself, more precisely with the construction of the system — which is going to be shaped at least partially by our present description of it.

Eda: Laibach's use of it was the most total. Until 1986–87 they practiced their role everywhere, in coffee bars, in social spaces. They were always in uniform. The design of the uniform was an art in itself. This was very important for the urban, social climate, since it was a highly visible social ritual in a very small Ljubljana. The ritual created the sense of constant physical presence of this entity; it conjured an ideological-artistic construct in real life. All the other groups were much more "professional" — the rituals were framed in the context of art events. Irwin, for instance, wore the uniform strictly around their projects, for their openings. Each group applied the strategy of overidentification to their own field.

> Is the organagram of NSK — the division into different bureaucratic departments — an instance of overidentification with the structure of the State? What is the relationship between NSK and the State, not the actually existing state, but the State as a form or a concept?

Eda: The State and state rituals was the main subject of NSK already during the 1980s. In the 1990s, this idea was conceptualized into the so-called "State in Time" project. I think that Irwin worked the most on this project through the Embassies and Consulates. Recently Jani Novak from Laibach told me that from Laibach's point of reflection, NSK was finished as a movement by the beginning of 1990s, and

that it transformed into a State with an unlimited number of citizens in the 1990s, which I think is a relevant point. The approach to the construction of the State, its rituals, and its language can be understood by reference to another statement from the same Laibach manifesto I quoted before: "Who has material power, has spiritual power, and all art is subject to political manipulation, except for that which speaks the language of this same manipulation."

> But is Laibach speaking the same language of manipulation? If you're just speaking the same language of manipulation or mirroring the same structure of the State, what's the point? Even though overidentification is frequently distinguished from a "critical" stance, there is obviously a critical distance between these two moments. Overidentification does not speak the same language but makes use of a kind of supplement or an excess, and it is precisely this that has a critical function.

Eda: I agree. Identification, mimicking, rewriting always brings a new moment, insight, or perception. I don't know how to explain this in words. I think all these NSK strategies functioned best on stage, in action, as real performances. Of course the energy in the 1980s was stronger and the language more ambiguous, while in the 1990s it became more analytical, more openly critical, more reflexive. The languages of the State and ideologies are rituals, and rituals are really designed for two things: for repetition and for direct impact in the given context.

> You know, the term overidentification was first popularized by Zizek. In fact, several critics have suggested that NSK can be viewed as an aesthetic equivalent of Zizek's theory. How do you view your relationship to Zizek? It seems Laibach and NSK are legitimated and rendered important because of the value Zizek's name has on the intellectual market.

Miran: Laibach in fact, at the beginning of the 1980s, first started using this method of overidentification. Zizek theorized what Laibach did, so the temporal relationship was in a sense reversed.

> Do you want to say that Zizek is really the theoretical equivalent of the aesthetic practices of Laibach?

Miran: Why does this possibility seem so strange for you?

Borut: But it is a fact that the Slovenian Lacanian school, Zizek and Mocnik, in the early 1980s began holding lectures, which was extremely important and it influenced all of us. We all went there. So there was a real interaction.

Eda: Lacanians were very present at that time in Ljubljana. From today's point of view you can observe the whole NSK phenomenon as a kind of theatricalization of a few Zizek theses, but at that time this way of thinking was already in the air; it was the language of the alternative society. You didn't need to read the books, the orig-

inal Lacan or Zizek; you could get it from the journal Mladina, or from Radio Student — it was everywhere in the media, in private talks, etc.

> *Do you think of the later concept of the NSK "State in Time" as a continuation of the strategy of overidentification, or as a break?*

Miran: In the period of the 1980s we were still living inside an ideological block, in a one party system. NSK was an entity inside this system, especially defined within the frame of this political reality. After the collapse of Yugoslavia and the entire East, we found ourselves in a different situation. Some people were thinking that NSK was dead because it depended specifically on the political conditions of Yugoslavia. What they overlooked was that we had not a logic of opposition to the system, or just deconstruction, but we were constructing ourselves as a group, in terms of our art, our methods, and so on. We created a social base that was independent of existing institutions. In this sense we were different from Sots art, which was overwhelmed by their political reality. In the beginning of the 1990s we created our own state, NSK, as an idea to move to other territories, for instance as in the Moscow Embassy project. We didn't change NSK, but we switched from the organization of NSK to the NSK State in Time, which started to move, to construct (www.ljudmila.org/embassy/3b/time.htm).

Borut: This continuation should be defined more precisely. In the first phase we took advantage of the sociopolitical system which fell apart in the 1980s. We were used by the system for political purposes, and we used the system that was falling apart for our own purposes. In the 1990s the second phase started and was directed primarily toward the formalization and contextualization of our own entity. If the boundaries of Irwin and NSK in the 1980s were shaped by the resistance of the authorities, in the new situation we needed to establish our own way of defining our borders. And here lies the reason for moving: to move with a social entity means to establish the visibility of its form. This logic is connected to something peculiar, which probably you have noticed: all avant-gardes are somehow fixed to certain places. Berlin Dada, Zurich Dada, French Surrealism. You never had bodies that moved, which was characteristic of heresies. All these movements disintegrated when they moved; Surrealism disintegrated when some of them moved to NY. The definition of the avant-gardes by their space is very interesting. By contrast, we decided to move with this body, and the projects in Moscow and America stemmed from this reasoning.

> *In the book about the Moscow Embassy edited by Eda the project is described as trying to create a direct communication about art structures that is outside mediation (by galleries, by exhibitions). It seems that the Moscow Embassy project was trying to re-enact the model of the art community organized around the kitchen table. In this sense, Moscow Embassy is not an overidentification with the structure of embassies, but an attempt to create an alternative space for art, which is a different project. Why did you choose the word "embassy" for this project?*

Miran: It is exactly through the NSK Embassy Moscow project that NSK transformed into the NSK State in Time. In 1992 we were invited to participate at APT-Art International by Viktor Misiano, Lena Kurljanceva and Kostantin Zvezdochiotov. This invitation was very important because it was an opportunity to talk directly about what happened in the East after these social and political changes at the end of the 1980s and about how we saw ourselves in the beginning of the 1990s. They asked us to do our project in a private apartment. At that time Moscow artists were already showing in galleries and museums, and making an exhibition in a private apartment seemed to us a very nostalgic idea. Viktor and his colleagues wanted to find out if the idea of apartment art was still relevant, if it still had some elements that were useful in this new period of time. For us the double-anchored space of the project was important. The embassy, first of all, represents the State territory — in this case not a physical territory, but the territory of our work and activity. Secondly, the NSK Embassy Moscow took place in a private apartment, so the conjunction of the embassy (as a public space) and the private apartment created a very specific situation for communication.

Borut: One other element is extremely important for me. The wave of Russian artists coming to the West had already ended by that time, at least for most of them. The enthusiasm with which they went West was over. All the big expectations about a democratic art system which were shared by artists from all former socialist countries, including us, were destroyed when we found out that these expectations were not linked to reality. We realized that the previous situation, sitting in these private apartments, was much more important for forming a community. After the 1990s, we lost exactly this social field, and this is what we wanted to rethink — whether this was possible again in any sense. Our own idea was about movement. If you are moving as a person, you get absorbed by the city you're moving in, you are reformed as you get connected to certain circles. But with such a social entity as NSK we had the opportunity to establish our own kernel; we could become a circle, and retain our shape in Moscow or in USA as well.

Eda: This whole apartment art idea is extremely interesting sociologically. It expresses something that disappeared with the collapse of socialism, and the entering of the Western value systems and capitalism into these societies. This movement was crucially connected to the question of audience. In the 1980s Scipion Nasice Theatre also did the first performance in a private apartment, and the second performance in an abandoned studio. This was the time when you got the impression that art was really needed by somebody. The fact that we did all these rituals to answer this need gave us extreme satisfaction. Today it would be difficult to achieve this kind of attention and hunger from the audience even with the most brilliant public relation strategy. But at that time, it meant something else, it had an impact. In the East, you could really say that you had art in this APT-art situation because there was an audience who needed it for survival-spiritual, mental, intellectual survival. Apartment art was not a social contract; it was an organic relation between

the audience and the art. So in this context of the non-structured social space, the Embassy had a very special task.

> *Eda, in the book you edited about Transnacionala you describe it as "an art project in the form of a journey." During June-July, 1996, the 10 participants (Eda Cufer, Irwin, Michael Benson, Vadim Fishkin, Yuri Leiderman, and Alexander Brener) set out in two RVs across America with the goal of organizing a "direct network" that "would take place outside the established international institutional networks, without intermediaries, without a curator-formulated concept, and without any direct responsibility toward its sponsors." Do you see Transnacionala as a continuation of the Moscow Embassy project in the form of a road adventure?*

Eda: For me, there is a difference between Moscow Embassy and Transnacionala. Moscow Embassy was a transitional moment between APT-art and public space, between 1980s and 1990s, between NSK as a collective experience and the need for individualization. With the Embassy we tried to create a public space out of private one, while Transnacionala was something else. Transnacionala was not a trip of a collective but of individuals, or even a trip of individualization. I am convinced that nobody during the Transnacionala conversations was thinking about how they would sound, and what it would come out like. The public, except in a very few places, did not care much about us and we did not care much for the public either. This was a kind of self-contained experience and it was designed to be a private experience, more a gift to ourselves than to a public. This is what I found very interesting about the project, and my part in putting together the book was to catch these moments of intensity — the fact that these conversations were not made for the camera or the tape recorder but that they had their own, autonomous intensity. Of course we had recorders and cameras as well, but this is another issue.

Miran: The difference between Moscow Embassy and Transnacionala was that in Moscow NSK came as a body. In America it was much more personal, there was much less stress on the fact that this was Irwin or an NSK project. Only the last stop in Seattle put some more stress on NSK, because the people who organized the Seattle station of Transnacionala expected a more attractive event from us than just communication with the local art scene.

Eda: They wanted Laibach. They wanted the NSK icon.

Miran: The organizers of the Seattle event, Charlie Krafft and Larry Reed, suggested that we should have a kind of embassy in Seattle, and we said no, this is not about an embassy, we just need a decent place to sit down and talk. When we arrived in Seattle, there were already NSK flags and posters, and a jazz orchestra was playing.

Borut: The formal difference is that in Moscow we decided to occupy the flat to install our works in it — pictures, videos, posters, and performances — and to transform

it into a space for communication. The Transnacionala journey was conceived differently. We expected that permanently changing circumstances would establish a shape by themselves, and that the act of moving through America would shape us.

> *What is the relation between the artwork "Transnacionala" which you made subsequently for museum exhibits and Transnacionala the event, the trip?*

Miran: For us the book and the film directed by Michael Benson, which is not finished yet, are the tools for communicating the event to a wider audience. The Transnacionala wall for exhibitions is neither the illustration nor the documentation of the Transnacionala journey. We used the experience of the Transnacionala journey as an anchor for the Transnacionala piece.

> *Perhaps I'm just a fetishist of the event, but to me it seems the event attempted to escape mediation by galleries and the exhibition system, while the piece you produced subsequently for museums sought participation in this system. In this sense, the projects appear not only different, but antithetical.*

Borut: A lot of artists today try to produce pieces that are supposed to be connected to real life. The problem with a lot of these artworks is that they compromise themselves in trying to be both at the same moment — to be exhibition pieces and on the other hand to show up as something that has nothing to do with this formal aspect of art, but completely drowned into real life. It seems to me that they lie on both sides. Very consciously, we make a complete distinction. Museums are museums. They are getting what they are asking for.

> *Do you think the piece produced for the exhibit was a recuperation of the event by the art system?*

Borut: This question would be proper if the exhibited work tried to present the trip positivistically, but it is no so. Between both projects there is a relation; this is exactly the relation of exchange, when one project represents the other. This takes place in a manner and with means that are immanent to the field in which they are placed. The concrete trip remains excluded from any possibility of museum recuperation precisely because of the Transnacionala wall. Oscillation between these two poles is constitutive for Irwin. I would remind you of the statement that we published on the cover of all our catalogues from the 1980s: "We are artists and not politicians. When the Slav question is solved, once and for all, we want to finish our lives as artists." But without any doubt the trip itself is recuperated in the Transnacionala book and through interpretative and theoretical texts dealing with it. In this case as well, if we are consistent we can describe it metaphorically as a corpse.

> *It has almost become a cliché to insist that the crucial distinction between the West and the East is that there is no art market in the East. But doesn't the exhibition circuit of Eastern*

artists function in an analogous way to the Western market (leaving aside the issue of money), insofar as it creates a similar structure of standardized production?

Borut: These exhibitions offer one possibility: the possibility to circulate. They offer the possibility to get informed directly and to inform directly. Exhibits are first the circulation of ideas, even if these ideas are only the visual impact you would get there. You would feel the atmosphere; you would measure the temperature. They provide very important information about the art situation. Then there is this element of personal introduction, shaking hands, saying hello, which is very important. Through that, you are existing, you are participating in a certain ritual. "By the way, we met at the exhibit in Stockholm didn't we?"

> *Yes, exhibitions function on more than just an official level, and can become important places for meetings, communication, and friendships. But this doesn't rule out questions about the structural function of exhibitions in the system of contemporary art. I'll ask the question again, indirectly, by referring to something Alexander Brener said about the collusion of curators, critics, and art institutions in producing the idea that nothing else is possible than the desire to become part of the system. Is anything possible outside the "art system"?*

Borut: The problem is similar to asking whether there is anything outside "capitalism." Of course, it is possible to act outside the art system but in that case these activities are not art any longer, but science, or political activity, or simply a journey. Dealing with the system de facto means participating in it, especially if you allow others to call you an artist. If we take seriously the discursive nature of art, it is very difficult to imagine a complete exclusion. For us, Irwin, it makes sense to collaborate in creating an art system in Slovenia. In doing so we consider the formation of East-East connections extremely important. We are not interested in bumping into the Western art system, but in a collaboration within the limits of our own possibilities, in building an art system in the East — as an "institutionalization of friendship," to use the term coined by Viktor Misiano. Our opinion is that, paradoxically, a desire for an autonomous art system in the East makes more sense today than the traditionally rebellious position of a radical artist.

07

Art & Politics in Moscow
A Politically Ambiguous City

Oleg Kireev (Russia)

he Moscow context, having become extremely politicized in the early 1990s and gradually depoliticizing since Putin's election in 2000, saw the birth of numerous artistic and activist interventions in official politics. The contemporary political scene was created by the efforts of an artistic public, made up of journalists, political consultants, advertising makers and TV people, who, paradoxically, belonged to the very same Moscow intelligentsia which had entered the public sphere during the Perestroika period. Have they simply outdone themselves in serving the new power and shaping its image? Is it true that all that remains are mere power-battles between lucky conformists and a new alternative, underground bohème?

In the 1990s we acknowledged the establishment of two oppositional camps: On the one side the critically thinking, ironical, postmodernist media-elite and on the other the disillusioned, anarchist, underground artists-activists who challenged them. Throughout the decade, this opposition was quite intense. Especially because the members of the first camp still belonged to the powerful intelligentsia and could openly operate in the public sphere and influence political decision-making.

All the media of that period were liberal and open. The public and the politicians were not alienated from each other; on the contrary, in Yeltsin's era they were on quite familiar terms. TV functioned as a disinterested distributor of information instead of forming people's opinion. The Russian Internet was just beginning to develop. Let me start with a comparison:

— In March 1991, a group of 13 young, actionist artists, called "E.T.I.," carry out the first radical artistic action, writing an obscure word on the Red Square with their own bodies;

— In August 1991, the so-called "communist putsch" takes place, in which artists and future political image-makers defend "freedom and democracy" at the barricades. (There is even a professional myth that the flag raised on the Moscow White House was brought from the Contemporary art center).

— In 1993 many new galleries emerge, an art market starts to function, artists enter the political PR campaigns;

— In October 1993, the second coup-d'état takes place, when the parliament was "democratically" shut down by the intervention of government tanks.

— In 1996, Boris Yeltsin wins an extremely propagandist campaign for election; connected to these elections, the first Chechen war begins;

— In the same year, Alexander Brener carries out his provocative actions dedicated to Yeltsin, the Chechen war and the Orthodox church;

— In May 1998, members of the "Radek" magazine circle (dedicated to culture, politics and theory), together with young, leftist political activists, erect an "art" barricade (consisting of artworks) on a central street in Moscow, thus celebrating the 30th anniversary of the Red May events in Paris;

— Throughout the autumn of 1999, a parliamentary election campaign takes place, in which extremely brutal methods of political propaganda, info-wars, and media speculations are used;

— In December, diverse groups of anarchists, artists and other protesters inspire and engage in a counter-campaign, called "Against all parties," which raises its collective voice against the new propagandist media and the political class as such;

— In Spring 2000, Putin becomes President and the open era of Yeltsin comes to an end. Since that time, the public sphere has contracted and oppositional views are less often voiced. Artistic opposition has gone underground. Alternative views can be publicly presented only in a mild, indirect form; therefore the voice of the social opposition is tamed, calmed, allowed to express itself only indirectly, "culturally."

How can a critical art survive when there are no longer arts institutions, no governmental sponsorship of critical artists, no support from Western foundations, or even more or less autonomous zones for artistic jobs? Paradoxically, in Russia it can. Throughout the 1990s it has been surviving on a voluntary basis, due to a socially open atmosphere. Because Russian society was mobile and fluid, an active person could easily find many cultural vacancies, or niches. That is how political PR appeared as a specialization: the former unformals and the late Soviet dissidents created political consultancies and persuaded the politicians to believe that their work deserves payment. It was a Russian variant of the appearance of what Ulf

Wuggenig called a "Wirtschafts-Kuenstler," a sign of a "de-differentiation" between Culture and Politics.

A politically engaged activity doesn't need to be explicitly political, nor does it necessarily have to be presented as an artwork. While a truly public sphere existed in Russia, it could be affected by many different means, from a scandalous action to a challenging political statement, from a protest or demonstration to a terrorist act. But now such a sphere doesn't exist at all. In 2000, journalists, not even being threatened by power, but rather, trying to be accepted by it, gave up all their "freedoms." The media-intelligentsia openly demonstrated its abandonment of the liberal values and professional ethics it had once fought for.

But in comparison to the well-established, cynical and elitist media-intelligentsia, underground art has deeply entrenched itself. Since 1996, we've seen a strong evolution of styles and methods, clear and focused internal debates between radical groups; we've even seen a few generations of protesters, who step by step improve their political effectiveness. Let me start with the first pioneers.

Alexander Brener now lives in Europe and repeats cliché truths of leftist ideology — accusing everyone else of corruption, integration and whatever. He was not like that when he first came to Moscow, after the Israeli emigration in the mid-90s. Brener's actions were simultaneously confessional, offensive and masochistic. Performing a lonely act of protest he would show himself as a hero-martyr. I bear witness to the fact that there was no meeting or discussion in Moscow art circles from 1995–98 without Brener's name being mentioned. His work, situationist and actionist by genre, let us reformulate a definition of that genre: a situation is something which consists of two parts — the first is the artist's action, and the second is society's reaction to that action

Anatoly Osmolovsky was not such a heroic figure, but his work might be considered to be much more effective. While Brener stood mostly within the art context and referred to art and theory topics, Osmolovsky inspired a movement away from an art-centered ideology. Remarkably, the most successful of his actions, a "Barricade," became the first meeting point between the artistic-theoretical activists, the Foucault-Deleuze admirers, and those who had never heard of them before — the marginalized political activists.

The "Against all parties" campaign was the first instance of an action where protesters could not any more be satisfied with only artistic results. They insisted that art had to act politically. The campaign aimed at subverting official politics by voting "against all." (There is such an option on Russian voting ballots. If "against all" gets more votes than any of the candidates, the elections are canceled and none of the previous candidates can run in the next election.) But the time of open dialogue and free media was coming to an end. The Duma elections in 1999 highlighted a whole decade of democratic disillusionment. The campaign activists must take

their places in history as more heroic, even more than Brener was, because they defiantly struggled without a chance of winning. An idealistic group of volunteers found itself before the state info-war machine and all the arms of the media mobilized against them. It was exciting; one group of them succeeded in taking a position on top of Lenin's mausoleum and raised a banner "Against all," and another one went to the State Duma building and threw bottles of red paint at it — marking it with blood — as a protest against the elections and the Chechen war.

Since Putin's elections everything has changed. Leftist counter-culture has lost its main target — the state, which had previously been weak and precarious, and which now became stable, visible, omnipresent. Leftist culture had to give up its direct subversiveness; the age of the lonely martyr-heroes has gone. Now it is time for more collective, subcultural, diverse, rhizomatic activities, activities which are more realistic — comparable to the utopian, idealistic protesters of the previous decade. In hindsight, this decade seems really utopian and highly non-realistic. What is essential is that we've experienced something really utopian. When living under new conditions, let's not forget this vision.

It is of significance that a new pattern of resistance appeared immediately after the new president's elections. It is called the "SVOI 2000" movement, which means something like "Our Own 2000" or "Own 2000." Its first manifestation took place on May Day 2000 — a holiday when crowds of people take to the streets to celebrate a Day of Spring and Labor. May Day was traditionally privatized by the communists, by an official opposition which doesn't want to change anything but only to imitate a revolutionary image. "SVOI 2000" activists sought to revive this sense. They formed a column at the tail of a demonstration of communists. Unlike the serious Red pensioners, the young people carried orange flags, dressed like clowns, armed with trumpets and whistles, dancing and proclaiming absurd slogans in slang.

In Brechtian terms, they accomplished an estrangement of the communist procession. But paradoxically, the Russian term for an estrangement coincides with a very Marxist term for alienation. Thus their estrangement was simultaneously a dis-alienation of the Moscow streets invaded and taken over by the new-Russian capitalist, alienated advertising, by official architecture and so forth. Intervening in and occupying space, at least for an hour, the column's participants were taking the streets back, or bringing a lost familiarity back to them. That's what the name of the movement derives from, on the organizers' leaflets it said: "In 2000... all the world will become our own."

Let's conclude with some observations on Russian leftist politics in comparison with its parallel, the neighboring leftist movement of Belarus. The authoritarian regime of Lukashenko made it difficult for such politics, though an unprecedented, anti-Lukashenko source of financial funding has supported and enlightened it. Thus did the two ends meet, and a great tension between two opposite things inspired a new generation of radicals to invent an enormously rich leftist activity. The Minsk

"Navinki" newspaper is a unique example of a truly leftist extra-parliamentary political factor on former Soviet Union territory. With a circulation of more than 10,000 copies, this outstandingly absurdist-dadaist-nihilistic-artistic publication estranges the whole world of an officially established order of things, reverses the basic definitions of that field, makes people laugh at all that was previously considered important and valuable. "Navinki" does not take any one side in the official political struggle, and thus avoids compromising itself; rather it rejects both sides as implicated and corrupt. In Belarus, opposition-aligned rhetoric seems even more awful than the usual official government lies; at least the liberals don't play any games. In 1998, after a hysterical, pro-Serbian campaign which stated that they had an invisible Air Defense system, "Navinki" published an exclusive photograph of an eliminated invisible NATO "Stells": an empty rectangle. And after the panic about post letters with the Siberian plague virus in October 2001 they published material about a letter sent to their office containing a "Novosibirsk diarrhea" virus.

The generation I belong to has been growing up in extremely politicized times: it was 1991 in Russia when I was sixteen, and 1993 when I was eighteen. Therefore we had to become politically engaged. Our political illusions and optimism were ruined by the events to come afterwards, and in 1993 we were already seeing the beginning of them. To borrow some good old Freudian truths, we have got an adolescent psychological trauma. But no generation could avoid such traumas — the point is, how it will deal with them. Our aim now is to overcome this trauma by making these illusions and optimisms work, to bring them back into reality again. In some sense it means to re-construct history in an improved way.

> — *This article first appeared online in* REPUBLIC ART, *www.republicart.net in July, 2002.*

Self–Interviews

Institute of Constructions & Deconstructions
(Romania)

|||

he Institute of Constructions & Deconstructions was established in 1998, but its story goes back to December 1997, when Cosmin Gradinaru, Dan Panaitescu, Sergiu Negulici and Ioan Godeanu were expelled from the Academy of Art in Bucharest for slashing some works of second year students as a protest against methods of teaching and old ideas. The written reason on the expulsion order was "severe deviations from the school's discipline." In fact this was the punishment given to four students who tried to call into question the anachronism of the art education system. Because the expulsion order was abusive and illegal the Academy's board was finally forced to cancel its decision. The director of the academy accused us of wanting an Installation College, which, he claimed, "does not exist in the entire world, therefore, in Romania, according to our tradition, there will never be such a thing." So we proceeded to found our own virtual Installation College, using a picture of the already existing Installation College (for industrial construction) of the Polytechnic Institute of Bucharest, taking advantage of the coincidence of the names. Our Installation College was not a school with policies, regulations, professors or students. It was our reaction to a rigid and intolerant regime, our desire to create a free space for exchanging ideas and a way of sustaining an independent stream of opinions. The board of the Art Academy took our project as an intention to create a system parallel to the one organized by the state. The total lack of humor of those who reached these absurd conclusions was turned by us into an opportunity to pursue this direction and become a so-called "parallel" institution. We later created a Performance College and the Cultural Reconstruction Program. As a result of our actions the wisdom of official institutions labeled us a "terrorist group."

As a first step in the Cultural Reconstruction Program we launched an "Official Bulletin" in 1998. During its three years of existence, the Institute and the Founding Members have functioned as a work in progress. Our presence as Founding Members is not only a visual presence, a simple image. The Founding

Members are a source of information, a working medium itself, a research material and an instrument for concretizing several projects. The Institute is an idea, a mental construction, but one with real effects. Although the Institute has existed mostly virtually through the Official Bulletin, CD–ROM, and website, in the future the Institute plans to take possession of a space. But contrary to the cultural tradition that has been consecrated in Western Europe since 1968, our space will be evacuated and not "occupied."

I decided that a discussion between all of us could be a good starting point for a new research project within the Institute. Documenting the life and the social situation of each one of us at this moment, as a self-interview, should be considered an art research project. Although using certain interview techniques, we wanted to avoid the question and answer of classic interviews. The first topic of the discussion concerns personal information, the second is related to each one's artistic projects and plans. Beyond personal information, an important problem analyzed was the activity, the utility, and the interest raised by the Institute as an art project. I also presented three different scenarios for the future of the Official Bulletin. The first option was transforming the Official Bulletin into a cultural magazine with regular issues; the second was turning the Official Bulletin into a project diary or a data file; the third was its suppression.

< ioan >

For a year and a half, since I graduated from the art academy, I never had a real working place. I was not employed by any firm, institution, foundation or association. I never had a "proper" job. For a short time, I worked for an architecture firm making scale models; afterwards, I made some photos for some people editing a book — which was published in the worst graphic conditions imaginable. I tried to participate for the second time in another book project with the same writers, but the result was another lousy book and the evidence that trying any further project with them was futile. I had an exhibition in a small village in Germany where I tried to sell all the bronzes I still had from my student period, and partially succeeded. All the money I earned was exclusively spent on financing my own projects, on editing the Official Bulletin and on all other everyday necessities.

In founding the Institute, I was not interested in the artistic category this kind of project belongs to, neither by the label it receives from other people, nor by its so-called affiliation with an artistic trend, no matter if old or new. I am not following an artistic fashion and I do not want to build an eccentric artist's image for myself. Although this has not been a "profitable" venture, I am not a supporter of the idea of "sacrifice for art." The artist starving to death, living in a cardboard box, with filthy clothes, begging for money to finish an art work has now become an image of bad taste. Today when in Romania everybody is concerned only with survival and art does not sell (or matter), sculptures of bronze, wood, or stone that need huge investments have become nonsensical. It is weird to parade around with one-

man shows made with big money, when you don't have enough money to pay the rent for your studio. For my part, I tried to work out an abstract construction that would include all my activities and projects. I built a virtual institutional frame, joining independent projects under a complex structure that works like a totality with a flexible core: the Art Departments, the Installation College, the Performance College, The Weather Report, and the Cultural Reconstruction Program.

After editing five issues of the Official Bulletin, I consider it time to draw a close to a chapter oriented towards exclusive research on a specific situation — the description of the Romanian cultural milieu, having as a starting point the mentality of the Romanian art educational system. Previous editions were focused on a review of the situation related to the art world and the official institutions that manage the direction of visual arts in Romania. It has already become necessary to alter both the structure and conception of the Official Bulletin. But the only important thing at this moment is beginning a real communication, especially given its current absence.

< cosmin >

I went to school for some time, I can say I "did my time" in school. Being sincere, I have to admit that the things I learned in school have been useless. Now I work as an art-therapist in a foundation for orphaned and physically sick children. In fact I am not really an art-therapist, but more of an animator in art-therapy. The art-therapist is the person who himself went through therapy, so you cannot have the status of therapist as long as you did not sit on somebody's couch. And I have not, at least not literally.

This work is something I like and I also get paid for it, so it's O.K. When we will organize the exhibition for the kids, you will see their works. There are very strong, native things there. For an art school graduate who knows something about art, it's easy to realize that their works are brilliant, and exhibit an extraordinary chromatic sensibility. Living by their side for so much time, I realized that all I have been doing since the fifth grade and ending with the university, was in vain. These kids have no studies, no preparation, and no knowledge about composition concepts. They are manifesting something that cannot be learned. After being molded and deformed by the school system, you cannot say you produce something of your own, from the depths; it is usually just the school speaking through you.

There is this kid, his name is Razvan. I should show you how he started and where he is now, led the whole time by his own ideas and temperament. It will blow your mind. This is the way education should progress. Neither by using the "I am teaching you, because you know nothing" air of superiority, nor by imposing a basic set of rules to learn. The most striking works by my "students" seem made by feeling and intuition, not filtered by the brain or in accordance to memorized rules.

As far as the Bulletin of the Institute, it is good that it's happening, and of course it should happen with more money. But the topic that the Bulletin focuses on, related to the Art Academy and the Artists Union, is now already exhausted. Everything has been done in this direction. Everything has been said. Now all of it belongs to the past. I think the Official Bulletin should develop into an international magazine, becoming more open and dynamic, more diverse. We should contact people from abroad, because the people here do not deserve as much attention as we have given them. The group Apsolutno have a site to subscribe to for artists who are territorially discriminated — maybe we should try. These are all things that do not show up in the isolation of Romania. Here nothing happens. After I went to After the Wall, I was surprised that there was no report here, nothing. The TV stations were still showing the exhibition at Cotroceni Palace and some other crap. Whatever I thought of the exhibition After the Wall as a whole, I attended in Stockholm some super-discussions about media and politics. Keiko Sei talked about the Romanian revolution and about a computer program that changed just about everything in cinema. We should contact these people and say: "Look, this is the context in our country. We have a private Institute and we are trying to do something to change the current system. We also have a newspaper. Maybe you can help us or maybe we could just simply speak with each other. We are willing to accept any offers."

< sergiu >

I am working at an image post-processing studio. I went there in the first place because I needed money but mainly because I had this computer problem. You do know how it is when you know nothing about computers. When they said to me: "Look this is your wage and this is what you will do for it," at that moment I said to myself: "Man, I want to learn about this stuff." The problem is that money can become more important than the work itself. You must not allow yourself to slip on this slope. Some guys at the studio are doing the work only for the money. They are learning new software only for demanding a raise afterwards, and the stuff they are doing at the studio is all they know about. After working for hours they relax by playing computer games. So, they belong to a specific category. I am concerned with something far more than that, but sometimes I'm not sure exactly what. So many times I have said that I was on the right path and suddenly, afterwards, everything changed.

Now I am very interested in cartoon animation. A thing in motion can become an obsession. At a certain moment the script and the shape do not matter any more, and you are simply amazed to know that you can make something move following the rules of animation. It catches you like the flu and becomes the only thing that interests you. So I want to become totally overwhelmed by what I could do… but at the moment I am going through a moment of laziness, of hibernation.

The Institute was part of what each one of us needed to build for himself. It was first of all our necessity to be together, and I can still feel this necessity. But I think the Official Bulletin should become something else, because if it becomes static, it will perish. Everything must be done to avoid regularity, otherwise the Bulletin will disappear even for you as a necessity. Continuity must always be broken, disrupted. The Bulletin can even become a magazine with regular issues (with no matter what) and after some time it can change back to a more private thing. It would be very interesting to find some people who are doing something similar in other places. I would like to see the Institute develop other connections because I cannot consider it something unique and hermetic as a phenomenon. The borderline must be overcome.

< dan >

I am an art-teacher at a private school, the "Lauder Reut" foundation in Bucharest. I went there initially because I needed money. Afterwards I began to like it, but I don't know whether I would like to stay there for a long period of time or not. I cannot say that now I have a very stable position, because you can never know now what the situation will be like in a year or so. My passion now is animation, which I would like to consider something that will continue into the future. But you know how things are with dreams and plans. When I was in school, I used to think of long term projects, and I could impose on myself a certain kind of attitude, a certain manner of doing things. After graduating, the situation changed dramatically and I no longer feel the same stability I had when I was in school. In this country, there are no certainties; everything is daily reduced to bare survival. Maybe this is the reason why I cannot conceive of a long term project. You can only have plans for a distant future when you have something stable as a starting point.

In Romania artists are not well organized. There may be some artists who I appreciate and who I even like, but all of them are members of several associations or of the Artists Union. Very few are not affiliated with a certain kind of monolithic organization. In my opinion, we should all be organized in a different way, in a better way, we should have international connections, international support, something. We should have our own autonomous organization. The Institute could be a departure point, a frame from which we could all begin something different. Maybe this does not fit your initial idea — I know you started the Institute as a virtual thing, so I do not know if would like it to become something real. In my opinion the Official Bulletin should not disappear, but, like anything, it cannot go on under the same shape indefinitely. The Bulletin is itself just an attitude, and even attitudes should change with the passage of time.

09

Anarchitecture

Space Hijackers (England)

As the world ascends towards a state of global capitalism, corporations and institutions are playing an increasing role in our lives. The competition of the market is forcing companies to develop highly specific methods of research to trace trends within populations and monitor the habits of individuals. Information is now stored about every minute detail of our lives — to aid business and government in predicting our reactions and to plan as a preemptive strike.

Data collection agencies exist in order to predict things ranging from what you are likely to spend your wages on to which direction you are most likely to turn when entering a shop (right, in case you were wondering). The creation of the "correct" environment for work or retail space, can greatly affect the productivity of that space, and is becoming a matter of ever more anxious and particular attention. In our current climate business can't afford to get these things wrong. You can no longer innocently go about your business, people will want to be prepared for every move you are likely to make.

Every space that you pass through will have been designed with you in mind. The utilization and design of architecture is playing an increasingly important role in the corporate world. Governments and corporations have infiltrated all corners of urban space. Every street is now brimming with security cameras (for our protection of course), every public space is designed with traffic flow in mind. People have become units to be directed and physically moved around space. The State creates a system within which we move and live, a functional space on a massive scale. Control over the users of space often takes the form of obvious physical devices within architecture; however contemporary architecture also uses much more subtle devices within its design. It now works on a psychological as well as physical level. Space is designed to affect our moods, and put us into the frame of

mind that companies require in order to be in a position to compete with their rivals. This requires that they use both the language of their architecture and the knowledge of how we will react to space.

< retail >

Retail establishments are designed with specific devices, which have been developed after hours of painstaking observation of our reaction on security tapes, and monitoring sales figures in comparison to shop layouts. Competition between such establishments is rife, and in order to compete companies are resorting to clandestine methods. Companies are contracted to research consumer habits, and pass on this information to shop designers who will put it to use. The ends of supermarket aisles are now rounded so that your eyes need never be averted from the stock, different sized tiles are placed on the floor with smaller ones in more expensive areas, causing your trolley to click faster and you to slow down. Department store executives know that most people turn right after walking through the door, so this is where you will often find the best bargains, or lines they have an interest in selling. They also carpet sections of their stores and leave others with vinyl passages, in order to control your movement around the shopping floor. Architecture is analogous to a type of language. Buildings and the layouts and components within them can act as a text, instructing users how they are intended to be used and affecting the ambience of the space. Users of space read this language in a distracted manner, the messages and signifiers are therefore not consciously noted. We are too busy with whatever business we are there for to take time to decipher the language of the space, and through our distraction our experience of space is controlled.

< corporate space >

It is through a process of mythification that corporate space claims dominance over the users and visitors of space. This is an essential part of contemporary business, where corporate image and reputation can make or break a company on the stock market. Confidence is valuable currency in business. Corporate architecture acts as a signifier of the myth of the efficient and powerful corporation; it is the physical symbol and public face of that corporation. Its forms demand that the myth be read as such, although as with all signs the link is arbitrary. A vocabulary of signs is built up and reused by corporate architects in order to exert control over the mood and behavior of the users of that space. The people who work in the city believe the myths of the city and try to live up to the image of the efficient, business-like lifestyle. Of course they don't manage it, nobody does, from office clerks to managing directors, so dissatisfaction sets in. People work harder in order to keep up their appearance, and corporations benefit.

< architects >

Users of space are placed in a position of subordination to the owners of space. This hierarchy is hardly unexpected. Space is designed by its owners to exert control over its users — and the services of architects are employed for this means.

Architects work by commission; they are presented with a set of requirements and design a space to meet them. They have to drop any moral obligation to the users of space when accepting the commission, and it is not so difficult, as architects have a very different relationship with space than other users. Architects work with a pure architectural space that can be contemplated much like a work of art. General users of space see it as a mere background to our experience of the world. We take notice of architecture in a distracted way by not noticing; it is somewhere on the periphery of our vision. An architect does not react to space in the way that a shopper would, as the two approach space looking for different things. After years of formal training to recognize the "subtleties" of space, an architect can never look at it again with innocent eyes.

The users of space are a disturbing element that enter into the field of architecture; they are something random that the architect cannot design. To compensate for this unpredictability, space is designed to control and manipulate its users into harmony with their surroundings. In order for this space to function as it is meant to, users must be guided around it by various architectural methods. Because people disrupt the harmony of built space, they are not something the architect relishes, and so do not form part of his or her vision. We simply need to look at architectural photography to see this in evidence. Architectural photographs are shot with one specific requirement — that the space is clear of people. Through representing space in photography and design, the architect can withdraw it from reality, and therefore escape any moral obligation to the intended users of that space. It is a chilling thought to think that it is precisely through such strategies that architects win multi-million-pound commissions. It is by looking at humanless drawings and lifeless plans that commissioning agents decide on how they would like their spaces to look. Governments and corporations pick our landscape, the stage that affects everything that we do, from designs which by their very nature attempt to withdraw all human life and present an empty, "pure" space.

< language >

The language that architects and corporations employ is a very fragile thing. Architecture is like a written language, and just like the letters on this page, it requires a certain knowledge in order to be understood. As with any language system, the link between signifier and signified is an arbitrary one. It is only by social convention that we read language as we do; this applies to architecture as much as it does to the English language. Language is a construct of the society that uses it, it is a system of signs that are developed and used by that society in order to

have a common understanding. Language only exists within the group of people that use it, it is not a physical but rather an abstract thing. Language is also something that can change over time. The potential flexibility of architectural language offers a weakness in the grip that architects and corporations have over the users of space. It is by corrupting the language and signification of architecture (by producing events, objects, and their language) that a real form of resistance to architecture can be found. Myths can be demystified and signs rewritten.

Space Hijackers (www.spacehijackers.co.uk) are Anarchitects who oppose the hierarchy that is imposed upon us by architects, planners and the owners of space. We operate in London, a city in a State of advanced capitalism. We are based a stone's throw from the Square Mile, one of the most concentrated spaces of capitalist architecture within Europe, if not the world. Here we work to combat the oppressive effect that such space has over the people that live and work here. The Space Hijackers' objective is to effect and change the physical space of architecture – the very point where advanced capitalism comes into contact with the general public. During anti-globalization protests, when a McDonald's shop window is broken, it can be easily replaced days afterwards – the way the company works is not destroyed simply because the windows are smashed. The Space Hijackers are not about anti-brand protest, rather our methods aim to invade and re-brand corporate space.

We attempt to create situations or place objects within architectural space that affect the way in which that space is experienced. This is possible by creating myths within space that will then go on to become a part of that space. The authority of the owner's text is unbalanced as other voices make themselves heard. The actions and objects we create become a part of the history of the space and thus become part of its language. The aim is to produce an oral architecture, which critiques the architectural space and re-contextualises it. The oral language exists within the minds, habits and beliefs of the community that use the space. It is through a type of contagion that spreads by word of mouth that the intrusion into architectural space can become part of the oral history of that space. Singular authoritarian texts vanish under a confusion of other conversations.

< corruption >

Events change not only the history of the space, but also project a future. By setting up alternative realities and uses for space, we can spread confusion into the meaning and language of that space, reducing the authority of the people who own it.

On 10th March 1999, we hijacked a London Underground Circle Line Train, for the purpose of turning it into a moving disco. A vast amount of preparation took place beforehand – we had to build suitcases that would transform instantly into a bar, stereo, nibbles counter or disco light. Around 150 people attended the event, not including the passengers who happened to get on the train. All passengers were given free vodka, tequila, and sweets. The London Underground remained bliss-

fully unaware of what was happening right under their noses. The point of the event was to disrupt the way in which the train system enforces codes of conduct by destroying any previous ideas about how to behave on a train, and what a train is used for. We wanted to corrupt passengers' future experience and expectations of the Circle Line, as the memory of the party will recur each time they use the train. The possibility of having a party on the train has now been made concrete, and so this has already become part of the language of the space.

Our work attempts to confuse the existing language of architecture, not to replace it. It is not a matter of one system of ideas replacing another, but rather of a process of corruption. We are not attempting to produce a new revolutionary order that can replace the old — as this is destined to fail. Global capitalism, and the architectural systems that it has produced as its safeguard, is a power that grows stronger still by using the very people who try to oppose it. If we aim to change the ways of the world, we can't play by the same rules, as we will lose by being trapped back in the same system. But these rules — of the system of architecture that commands us — are all formed through language

This language is something that exists solely within the minds of the people who use it. If we change the language, we can start to change the game. We mess with the system as opposed to simply feeding it. By affecting architecture in this way, it offers users of space a way around the control of the owners and designers of space. Owners have no control over the oral nature of architectural language. A company can only own the written text of a building, the fabric and materials that make it up. But the author of this text is effectively dead, and the text can be read in many different ways. Architectural language is a product of the people who use it, and is not inherent in the architecture itself.

Control for corporate gain is allowed, passively, by the very people who are controlled. We are as responsible for the state of language, as the owners who use it to extract a profit. The users of space constitute the greatest and most powerful force within the world of architecture — everyone is a user of space. Consequently, everyone is a potential creator of that space. We simply need to change the language, from one that uses us, to one that we can control. By creating new and contrasting myths and stories within architectural space, we can create "Anarchitecture," an alternative use of the architecture in which there is no hierarchy of control. The architectural language of places can be corrupted by merely spreading different ideas about the use of these spaces within the communities of users. This requires a method of splitting apart architectural myths and creating a space that is open to new forms of appropriation. A method of concrete change here and now as opposed to counting time waiting for yet another utopian revolutionary ideal.

10

Solidarity with the Context

Janos Sugar *(Hungary)*

|||

he notion of art is a historical, social and political construct, that is, it hasn't always existed. Its existence can be attributed to the increasingly complex organization of society, which has combated and compensated for its fragmentation with denomination, so that an object which we now consider and name as art, using today's meaning of the word, had not necessarily been considered so when it was made.

Due to the further elaboration of social-political forces, the concept of contemporary art was formed. This phenomenon gave legitimacy to art pieces whose reception wasn't clearly proscribed in their time and which required a contextualizing infrastructure of intermediators and interpreters, independent from the piece itself, interested in expanding the definition of art beyond traditional categories and beyond traditional expectations such as beauty and harmony. Entering the stage of public life, the elite functioned to undermine expectations. A continuous re-definition of art caused public taste to be radically altered.

With its consequent secularization, Modernity implied that the unification of society and holistic conscience would no longer be a common concern and responsibility, but belong to a specialized professional circle, i.e. politicians, charged through a representational system with tasks such as the organization of social cohesion. After the Enlightenment and the breakdown of society into specialized fields of activity, the number of decision-making situations vastly increased. As a consequence, there followed a corresponding increase in the number of bad decisions. As it was no longer necessary to have a philosophical or religious world concept or ethos with which to reflect on one question, decision-makers of any description didn't necessarily have to have a "global" perspective or broad intellectual foundation at their disposal. It was no accident then that by the end of the nineteenth century the notion that society functions like a machine became widely accepted.

According to this way of thinking, society's participants functioned like cogs in a machine, each only possessing competency and responsibility in their own separate professional disciplines, so that if everyone did their job correctly, the whole of society would run smoothly. As we can see from the history of the last century, this theory wasn't borne out.

The champions of secularized specialization — early manufacturing industry — treated every possible entity, i.e. workers, slaves or nature, in an indirect utilitarian manner. The value of solidarity subsequently dissipated and was replaced either by charitable foundations or a representational welfare system, which in turn directly led to the technological progress of the new technocratic, mass-media influenced, political representational system. Consequently, campaigning, convincing and persuading became part of everyday life from politics to publicity.

Due to the division of labor, different activities could become independent and each begin its own appropriate, self-reflexive development. This process became characteristic of art too, and generally effected the emergence of a duality between high and pop culture, whereby the references of pop culture were widely recognizable and the references of high culture hermetic.

Art became free from restrictive expectations to faithfully reproduce reality after technological advances allowed for an objective means of representation that wasn't filtered through the subjectivity of the artist. This kind of representation was specialized, and enjoying the prosperity of its new freedom, started an independent progress. In the same way that scientific discoveries revolutionized everyday experience, radical changes in artistic perspective and attitude became apparent. Impressionism, Cubism, Abstraction, Expressionism, Dada, Surrealism and Suprematism represented profoundly different ways of seeing. The avant-garde's individualism was too radical for a totalitarian mentality based on mass-manipulation and so between 1925 and 1940, the Communists and Nazis outlawed avant-garde progress and introduced a state art with restrictions on freedom: Social Realism and Nazi Realism.

During the bloodshed of the World Wars, the logic of industrialization dictated that war itself was mechanized before beginning the mass production of death. The wars were immediately followed by a bloodless propaganda or media war which focused national economies on weapon production, innovation and commerce. Politics was reduced to negotiation (so that game theory became one of the most important sciences of the cold war), and culture to propaganda.

The division of the eastern part of western culture against itself resulted in an intolerably naive and rigid state ideology, which controlled the concept of art to the extent that it was eventually abandoned. The western part of western culture accordingly opposed the eastern concept and exhibited demonstrative support for a total freedom of expression. Despite the unfortunate fact that this tactic was also the

result of a curious, historical nonsense, it brought an immense prosperity to the evolution of art. Questioning the function and definition of art became the principal basis of art activity. Due to generous state support (or at least to a lack of censorship), artists succeeded in sustaining the expansion of the boundaries of art that began at the start of the twentieth century. During the cold war period an infrastructure of reception and interpretation of contemporary art was established which was able to justify the social utility of subversion.

The emergence of the notion of contemporary art was essentially a consequence of the increased attention given to art's continuous inner terminological redefinition. Galleries appeared as alternatives to museums and popular culture and advertising began to adopt innovative art's efficiency in grabbing attention. In an environment over-saturated with an indigestible quantity of information, influences and experiences, anything which can attract enough attention to itself (even if only for 15 minutes), has an incredible importance.

The oppressive states, which had discovered the manipulative possibilities of mass communication and abused the safeguards of the democratic system, gave propaganda a central role, which was maintained during the fight against it. Originally conceived as following mass production and mass media's appetite for news, propaganda easily found its role in the politics of both the representational democracies and the totalitarian, oppressive systems. Naturally, we cannot hide the part played by the innovative, free, experimental and penetrating spirit of contemporary culture in supporting utopias and in sustaining blocked and exhausted intellectual paradigms. But we also cannot forget that in its radical nature, contemporary culture has always sought to critically examine and reveal manipulations. In so doing, a kind of race has been instituted in which contemporary culture attempts, in an increasingly effective and provocative manner, to engender an immunity to malicious manipulations, by revealing the techniques of social manipulation that function on the horizon of social consciousness.

Since the start of the twentieth century, new communication media have been constantly updated by new innovations and appliances have become more affordable and available to individuals. The consequent consumer behavior, conditioned by this perpetual change, was first represented in the attitudes of avant-garde artists: through subversive interpretation, that is, the radical testing of the bounds of art's genres and techniques. Since even in one lifetime there are too many new techniques and tools to become familiar with and be able to use, the requirements of radically researching possibilities, breaking down conventions, and transforming old ways of thinking placed avant-garde instruction at the forefront of consumer culture. A large part of the methods of radical avant-garde practice became widespread in most spheres of commerce (which consequently had fewer preconceptions) because of the need to use the most effective means of capturing consumer attention.

At the end of the cold war it became evident that state suppression of contemporary art had been a political decision and not a consequence of the knowledge that within secularized relations only culture is able to re-build the connections lost through fragmentation. It is significant that scientific research since the middle of the twentieth century realized the importance of an interdisciplinary approach. No matter how much of a neat conclusion it might have been, the cold war's ending with the apparent hegemony of the complacent and comfort-loving Western states didn't imply the end of history, but rather the predictable collapse of a paradigm of duality.

The elaboration of western and eastern contexts didn't begin within a new and already re-unified western culture. The previous, politically motivated, curious interest turned into a reluctant provincialism. On the one hand censorial tendencies appeared in those places where freedom of expression had been promoted; on the other, art's infrastructure became rigid and limited because of the financial profits made during the market interest in contemporary art. This process has been assisted by a widespread acceptance of the ideological promotion of technology, in which the avant-garde artist's competency in using so called "new technologies" isn't based on the concept of a free and expressive use of any medium. Rather, it represents an unreflective response to the fast pace of change, which ultimately serves the needs of new innovations with a promotional testing. Since the cold war there has been a general return to the commercial; consequently, pop culture today is conservative.

Globalization implies the continuous clash of contexts. Complexity obliges every-one to suffer unresolvable contradictions. The philosophical category of super-session becomes an everyday practice when isolated identities have to appear simultaneously in more than one context and in more than one form. Individual, social and national identities not only acquire new and incredibly efficacious media attributes, but also become multiple and simultaneously oper-ate on a variety of levels. Multicultural homogenization can generate surprising and accidental contexts whose reception confounds well-established mecha-nisms of social self-definition. Contexts are chained to space and time, and in this sense are similar to living in society.

Modern artists were only able to depart from the isolation of the studio after the real-ization of a small technical innovation: the tube of paint. At this point, Modern art could branch off from the teleological holistic concept, perceive nature in an indi-vidual way and arrive at society, a second nature, transformed by living together. Social-political art is that which demonstratively faces the consequences of being connected to a concrete context, to which the artistic gesture can be interpreted as a direct response. Interpretation of the work against a background of concrete and real social references makes the artistic gesture immediately understandable. At the same time it is necessary to accept that concrete contexts are ephemeral, so that the most important characteristic of art works will be the contextual vacuum

created after the actuality has passed. The realization of this contextual vacuum is the most important task for each artist. The differences are in the way that they achieve this goal: randomly, through private mythologies or through the use of ephemeral and perishable social conflicts. Both strategies are authentic, indeed, avant-garde artists' famous capacity for adaptability, also called total competency, demands the adoption of both. It is also demanded by the distracted condition of the fragmented, globalized information societies, which can bypass phenomena and various forms of human suffering with a self-assured indifference.

The fundamental component of art is attention. We already know what kind of utopian attention can be generated through prohibition. What will be the future of this attention in the era of social reorganization? First of all, the artists of our time have to be artists of solidarity, they have to have compassion with humiliated thoughts, with forgotten technologies, with the incomprehensible, with the unreceptible and with everything which is beyond the culture of show-business and beyond the intellectual level of television game-shows. In a word, with all fellow individuals who can only be managed from a distance by a society admiring its own efficiency.

Tactical Media

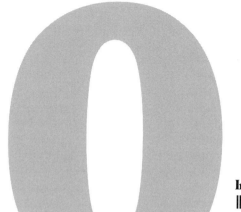

10

Now You're in My Computer

0100101110101101.org *(Italy)*
Interviewed by Jaka Zeleznikar *(Italy)*

||

100101110101101.org (www.0100101110101101.org) is an anonymous net.art group whose work raises questions about the relation between the copy and the original and the transparency of the data on the Internet.

Chronology of Projects:

— May 29, 1998: Invention of the life and works of an imaginary Serbian artist named Darko Maver. The project lasts two years and involves dozens of people from several cities, culminating with the disclosure of the prank the day after Maver is presented at the 48th Venice Biennale.

— Dec 15, 1998: Creation of vaticano.org, an "official" organ of information for the Holy See, a site aesthetically identical to the real one but with slightly modified contents.

— May 11, 1999: Copy of Hell.com, the most popular Net.art museum. The mirror site is published in an anti-copyright version without the password protection of the original, and immediately receives threats from Hell.com of legal proceedings for copyright violation. The mirror site is still up.

— Jun 9, 1999: Modification of Art.Teleportacia, the first art gallery to appear on the Web. The works in the gallery's exhibition, "Miniatures of the Heroic Period," are radically altered and renamed "Hybrids of the Heroic Period."

— Sep 12, 199: Identical clone of Jodi website, meant to demonstrate that ideas of authenticity and uniqueness of artworks is an obstacle to the development of Web art.

— Jan 1, 2001: life_sharing gives every Internet user free 24–7 access to
0100101110101101.ORG's computer, challenging the concept of privacy and the
contradictions of intellectual property.

*You work as a group and anonymously. Why did you decide for such a way of presenting your-
self to the public?*

The fact that 0100101110101101.ORG is a group was not decided by
0100101110101101.ORG, but by "you." 0100101110101101.ORG could be only one
person, a couple or dozens of people. It is absolutely irrelevant how many and
which individuals work to 0100101110101101.ORG. 0100101110101101.ORG isn't
concerned with artistic individuality, identity, style or personality.

*In your early works you were interested in data duplication and simulation. What was your
statement, how did you make this process of — to say in a simplified manner — copying as
act of art?*

The paradigms of modern art are in synthesis: novelty, originality, and authenticity. The
Net has changed the paradigms of communication, therefore of culture and art.
The new paradigms include accessibility, fruition, and duplication of information.
Culture is pure manipulation and auto-replication, culture is essentially falsification.
0100101110101101.ORG is simply highlighting this process, without adding value to
the action itself.

0100101110101101.ORG, in its declared non-originality, is paradoxically more authentic
than hundreds of presumed creators.

0100101110101101.ORG has never produced anything.

0100101110101101.ORG only moves packages of information from one point to anoth-
er, diverts their flow, observes changes, and eventually profits from it.

*Interaction is supposed to be a crucial part of net.art works. How do you relate to this idea of
interactivity, and what is your idea of net.art?*

"Interactivity" as it is usually meant, is a delusion, pure falsehood. When people reach
a site — net.art or not, it doesn't matter — by their mouse clicks they choose one
of the routes fixed by the author(s), they only decide what to see before and what
after: this is not interactivity. It would be the same as stating that an exhibition in
a museum is interactive because you can choose from which room to start, which
works seeing before and which ones after. If net.art is interactive then Canova is
interactive as well.

0100101110101101.ORG is showing that art in the web can really become "interactive":
the public must use it interactively. We must use an artwork in an unpredictable

way, one that the author didn't foresee, to rescue it from its normal routine and re-use it in a different and novel way, otherwise all the paradigms of traditional art will impose themselves again.

What kind of reactions have you received in response to the copies you made?

> Date: Mon, 10 May 1999 21:42:33 -0700
> From: JUSTICE@HELL.com
> Subject: WARNING1.0|||COPYRIGHT VIOLATION
> re:
> open_source_hell.com http://www.0100101110101101.ORG/hell.com
> cute...
> please immediately remove this material from your server
> you are in violation of international copyright laws which are clearly posted in the copyright information contained in our source code.
> also of note it appears as though you have violated the copyrights of quite a few of our members individually:::::::::::::
> http://www.0100101110101101.ORG
> on behalf of these individuals we request that you also remove these materials from your server as well
> it would make sense to use your "abilities" to attempt something *original*
> JUSTICE@HELL.COM
> Security\\\\
> http://HELL.COM

You bought the vaticano.org domain name and cloned the official Church site? Were some modifications made in the clone of the original site?

For a whole year "vaticano.org" was one of the (un)official organs of information of the Holy See. A huge site, aesthetically identical to the "real" one but with "slightly" modified contents. The détournement of the holy texts involved tens of people from the whole country, who were about to add German, Spanish and English language sections to the main, Italian one. For 12 months thousands of people visited "vaticano.org" and nobody realized that the contents of the site had been "retouched." Dozens of texts in which one could find everything: "heretical" proclamations, invented words, unpardonable errors and songs by 883 — an Italian teeny-bopper band — perfectly put in a "plausible" context. From the site it was possible to address letters directly to the Pope. Strange instructions "hijacked" pilgrims in the most remote places. A "Free Spirit Jubilee."

How many visits did you get on this project? What were the reaction froms the church and visitors? At the end you had problems with the domain name...

vaticano.org-access.log:
total request = 4,210,542

total visits = 196,236

Since an international law for copyright violation on the Internet is still to be created, the company that holds the official Holy See website, based in Rome, had the idea to buy a server in Canada, where our vaticano.org site was hosted. It would have been sufficient to sue 0100101110101101.ORG's Canadian host provider, but somehow it didn't work. When the first year contract expired, Network Solutions — the company that sells Internet Domain Names — prevented 0100101110101101.ORG from renewing the contract of "vaticano.org," which had been regularly bought. Network Solutions refused all our attempts to pay for the domain and, after the contract expired, they immediately sold the domain name to a catholic association in Rome.

> From: Domain Registration Role Account domreg@internic.net
> Subject: Re: MODIFY DOMAIN vaticano.org
> Your request for MODIFY DOMAIN vaticano.org. could not be automatically processed.
> Your request has been queued for manual processing. This request will be processed in accordance with established procedures.

Probably the biggest media hoax was the invention of Darko Maver — the media-created Balkan artist with shocking, explicitly violent works. A media and art system virus?

The "Darko Maver Case" isn't a media hoax, in fact he hasn't been invented to make fun of the media. Some journalists and magazines have actively taken part in his invention. The fact that media lie is not a big discovery, everybody knows it. Darko Maver is the demonstration that art is only a convention. For an artist to be considered an artist, and for his products to therefore be accepted as "works of art," it is enough to convince a certain number of people of the saleability of his idea, which is more important than the quality of the work itself. By convincing the knowledgeable persons who play crucial roles in the art system — journalists, critics, curators — it is relatively simple to prove that someone is an artist and establish his success.

0100101110101101.ORG has shown the mechanisms which hold contemporary art together, in order to make the way the institution works absolutely clear. This phenomena is commonly accepted or taken for granted and people undervalues its impact. If 0100101110101101.ORG hadn't claimed the prank, Darko Maver would still go on existing, setting many people buzzing through exhibitions, documentaries, catalogues and so on. Art is a sort of alchemy that, instead of changing metal into precious stone, transforms shit into gold. Potentially everything can be art, the point is only to know the rules of the game, and its tricks as well.

What is your relation to Luther Blissett and who or what is Luther Blissett?

0100101110101101.ORG won't answer this question.

Your latest work, life_sharing, is again completely computer based. You wish to explore the levels of representation, data nudity and shared distribution and production of artworks.

life_sharing is an anagram of File Sharing. life_sharing is a computer sharing its hard-disk with the whole world, making all its contents accessible via Internet. "All" means not a directory of the hard-disk but the whole content of the computer: programs, system, desktop, archives, tools, ongoing projects, mailboxes and so on. From the moment life_sharing started, every Internet user has free access, twenty-four hours a day to our computer. They can rummage through our archives, search for texts or files they're interested in, check what kind of software we work with, watch the "live" evolution of our projects and even read our private mail. Simulation, intellectual property, production and distribution of culture, the dualism between open and closed are some of the topics that this project wants to question.

How do you see the relationship between aesthetics and functionality?

The functionality of a computer is an aesthetic quality: the beauty of configurations, the efficacy of software, the security of system, the distribution of data, are all characteristics of a new beauty. life_sharing is the result of aesthetic discipline applied everyday. It is the actualization of the idea of the "total work of art" — gesamtkunstwerk — in other words, the dream of modeling reality through aesthetic canons.

How do you relate to the Internet development, security, levels of permissions, privacy on the internet?

From now on the product of 0100101110101101.ORG will be its own visibility. life_sharing is the root under which will come other services, all directed to show to what degree our life can be monitored. We want to show as many forms of data as possible on us: not only in the transparency of the hard-disk, but also by analyzing economic transactions, the use of credit cards, physical movements and purchases. 0100101110101101.ORG will show the enormous amount of information that it is possible to find on a person in the present society.

With group work you must somehow relate to the issue of copyright which was also the topic of your early works — which copyright model do you see as convenient?

0100101110101101.ORG's goal is not a complete abolition of copyright but its substitution with a license directly inspired by the GPL (Gnu General Public License, www.gnu.org), the license created explicitly for Free Software. Till now, the GPL has been applied only to software, with great success both economically and "culturally."

0100101110101101.ORG wish to apply the open source model also to all intellectual products. This is the result of political choices, and also technical and legal reasons.

The idea of an open source license for intellectual products would grant the possibility of: (1) using the product; (2) modifying the product; (3) distributing copies, modified or not, of the product (freely or with payment); (4) combining the product, modified or not, with other products covered by the same open source license.

Until now, 0100101110101101.ORG hasn't placed a copyright on anything. If someone uses your music, your words or images, he is only doing you a favor.

0100101110101101.ORG's real strength is its visibility. Many people have spontaneously reused 0100101110101101.ORG (www.plagiarist.org, www.geocities.com/max-herman_2000/hell.html, www.message.sk/warped). If someone else profits from 0100101110101101.ORG, it's because of their own merit. In the end, it's doing the same kind of thing as we did: profit is always inevitably mutual.

11

What Is
Communication Guerrilla?

autonome a.f.r.i.k.a. gruppe *(Germany)*
||

his message is directed to those who are fed up with repressive politics at their doorsteps, who are not frustrated enough to give up a critical position and a perspective of political intervention, and who also refuse to believe that radical politics needs to be straight, mostly boring and always very serious. It also addresses those who are interested in artistic expression, using all kinds of materials and techniques such as wall-painting, woodcarving or the internet to bend the rules of normality. It is sent by some provincial communication guerrillas as an invitation to participate, criticize, renew and develop a way of doing politics which expresses the bloody seriousness of reality in a form that doesn't send the more hedonistic parts of ourselves immediately to sleep. Of course, this is a contradiction in itself: How can you be witty in a situation of increasing racism, state-control and decline of the welfare state, to name only a few? On the other hand, even Karl Marx didn't postulate boredom as revolutionary.

The starting point for our reflections around guerrilla communication was a trivial insight from our own politics: information and political education are completely useless if nobody is interested. After years of distributing leaflets and brochures about all kinds of disgraces, of organizing informative talks and publishing texts, we have come to question the common radical belief in the strength and glory of information. Does it really make sense to take on the attitude of a primary schoolteacher while the kids have become skinheads, slackers or joined the rat race? Traditional radical politics strongly rely on the persuasive power of the rational argument. The confidence that the simple presentation of information represents an effective form of political action is almost unshakeable. Critical content and the unimpeded spread of "truth" are supposed to be sufficient to tear up the network of manipulating messages, with which the media influence the consciousness of the masses. Well, since the declaration of Postmodernism it has become a bit involved to insist on The One And Only Truth. But the main problem with traditional con-

cepts of radical political communication is the acceptance of the idea: "whomsoever possesses the senders can control the thoughts of humans." This hypothesis comes from a very simple communication model which only focuses on the "sender" (in case of mass communication usually centrally and industrially organized), the "channel" which transports the information, and the "receiver." The euphoria around information society as well as its pessimistic opposition — which worries about information overkill — do not face the crucial problem of citizens' representational democracies: facts and information, even if they become commonplace, do not trigger any consequences. Face it, even if stories of disasters, injustice, social and ecological scandals are being published, it has almost no consequences.

Reflections on the interrelations between the reception of information, knowledge and the options to act within a social context have tackled how information becomes meaningful and how it then becomes socially relevant. Information by itself has neither meaning nor consequences — both are created only through the active reception and through the scope of action of the audience. But this basic banality has far too rarely been taken into consideration within the framework of radical politics. Guerrilla communication doesn't focus on arguments and facts like most leaflets, brochures, slogans or banners. In its own way, it inhabits a militant political position; it is direct action in the space of social communication. But different from other militant positions (stone meets shop window), it doesn't aim to destroy the codes and signs of power and control, but to distort and disfigure their meanings as a means of counteracting the omnipotent prattling of power. Communication guerrillas do not intend to occupy, interrupt or destroy the dominant channels of communication, but to detourn and subvert the messages transported.

But what's new about all this? After all, there have been the Berlin Dadaists, the Italian Indiani Metropolitani, the Situationists. The roots of the Communication Guerrilla can be traced back to legendary characters like the Hapsburgian soldier Svejk and Till Eulenspiegel, the wise fool. Walking in the footsteps of the avant-gardes of earlier times, we do not attempt to boast about the invention of a new politics or the foundation of a new movement. Rather, guerrilla communication is an incessant exploration of the jungle of communication processes, of the devoured and unclear paths of senders, codes and recipients. The method of this exploration is to look not just at what's being said, but to focus on how it is being said. The aim is a practical, material critique of the very structures of communication as bases of power and rule.

The bourgeois system takes its strength — beyond other things — from the ability to include critique. A government needs an opposition, every opinion needs to be balanced with another one, the concept of representative democracy relies on the fiction of equal exchange. Every criticism which doesn't fundamentally shatter the legitimacy of the ruling system tends to become part of it. Guerrilla communication is an attempt to intervene without getting absorbed by the dominant dis-

course. We are looking for ways to get involved in situations and at the same time to refuse any constructive participation. Power relations have a tendency to appear normal, even natural and certainly inevitable. They are inscribed into the rules of everyday life. Communication guerrillas want to create those short and shimmering moments of confusion and distortion, moments which tell us that everything could be completely different: a fragmented utopia as a seed of change. Against a symbolic order of western capitalist societies which is built around discourses of rationality and rational conduct, guerrilla communication relies on the powerful possibility of expressing a fundamental critique through the non-verbal, paradoxical and mythical.

To be quite clear: guerrilla communication isn't meant to replace a rational critique of dominant politics and hegemonic culture. It doesn't substitute counter-information, but creates additional possibilities for intervention. But also, it shouldn't be misunderstood as the topping on the cake, a mere addition to the hard work of "real" politics and direct, material action. In its search for seeds of subversion, guerrilla communication tries to take up contradictions which are hidden in seemingly normal, everyday situations. It attempts to distort normality by addressing those unspoken desires that are usually silenced by omnipresent rules of conduct, rules that define the socially acceptable modes of behavior as well as the "normal" ways of communication and interpretation. To give just a simple example: Most people will say that it is not okay to dodge paying the fare, even if there is a widespread feeling that public transport is over-expensive. If, however, some communication guerrillas at the occasion of an important public event like the funeral of Lady Di manage to distribute fake announcements declaring that for the purpose of participating, public transport will be free, the possibility of reducing today's expenses may tempt even those who doubt the authenticity of the announcement.

Communication guerrillas attack the power-relations that are inscribed into the social organization of space and time, into rules and manners, into the order of public conduct and discourse. Everywhere in this "Cultural Grammar" of a society there are legitimations and naturalizations of economic, political and cultural power and inequality. Communication guerrillas use the knowledge of "Cultural Grammar" accessible to everybody in order to cause irritations by distorting the rules of normality: It is precisely these kinds of irritations that put into question seemingly natural aspects of social life by making the hidden power relations visible and offering the possibility to deconstruct them. Using a term coined by Pierre Bourdieu, one might say that guerrilla communication aims at a temporary expropriation of Cultural Capital, at a disturbance of the symbolic economy of social relations.

Go Internet, experience the Future! But many communication guerrillas feel a strange affection towards living in the backwoods of late capitalist society. In the field of communication, this causes an inclination towards the use and abuse of Outdated Media, such as billboards, printed books and newspapers, face-to-face, messages-in-a-bottle, official announcements, etc. (Even the fabulous Hakim Bey has recent-

ly advocated the use of "Outdated Media" as media of subversion.) Thus it is hardly astonishing that communication guerrillas are skeptical towards the many hypes in and around the internet. Of course, we appreciate ideas like the absolute absence of state control, no-copyright, the free production of ideas and goods, the free flow of information and people across all borders, as they have been expressed by the Californian net-ideology of freedom-and-adventure: Liberalism leading us directly into hyperspace. But we also know that real neo-liberalism is not exactly like this, but rather: freedom for the markets, control for the rest. It has become obvious that also the internet is no virtual space of freedom beyond state and corporate control. We are afraid that the still existing opportunities of free interchange, the lines of information transmission beyond police control, and the corners of the Net which are governed by potlatch economy and not by commercialism, will fade away. The aesthetics of the internet will not be dictated by cyberpunks but by corporate self-representation with a background of a myriad of middle-class wankers exhibiting on corporate-sponsored homepages their home-sweet-homes, their sweet-little-darlings and garden gnomes.

The structures and problems of communication in the Net do not differ fundamentally from those encountered elsewhere, at least not as much as the Net hype wants to make believe. A product of Net thought like Michael Halberstedt's "Economy of Attention" starts out from a quite trivial point: The potential recipients are free to filter and discard messages. (They may even do much more with them!). And they do this not mainly according to content, but using criteria which may be conceived in terms of Cultural Grammar and Cultural Capital. This is completely evident to anybody (except SWP militants) who has ever distributed leaflets to people in the street — though media hacks seem to have discovered this fact only since the Net offers everybody the possibility to widely distribute all kinds of information. In simple words: the basic problems of communication are just the same on both sides of the electronic frontier.

Focusing on the influence of the social and cultural settings on the communication process, communication guerrillas are skeptical towards versions of Net politics and Net criticism which hold an uncritical belief in the strength and glory of information. "Access for all," "Bandwidth for all": these are legitimate demands if the Net is to be more than an elitist playground of the middle classes. In the future, access to adequate means of communication may even become a vital necessity of everyday life. But information and communication are not ends in themselves; first of all, they constitute an increasingly important terrain of social, political and cultural struggle. Inside and outside the Net, communication guerrillas seek to attack power relations inscribed into the structure of communication processes. In the dawn of informational capitalism, such attacks become more than just a method, more than merely a technology of political activism: When information becomes a commodity and Cultural Capital a most important asset, the distortion and devaluation of both is a direct attack against the capitalist system. To say it in a swanky way: This is Class War.

Increasing attempts to police the net, to establish state and corporate control will, paradoxically, increase its attractiveness as a field of operation of communication guerrillas: Possibly, even those of us who until now do not even own a PC will get wired then. Fakes and false rumors inside and outside the Net may help to counteract commodification and state control — after all, the internet is an ideal area for producing rumors and fakes. And, of course, where technological knowledge is available there are innumerable opportunities to fake or hijack domains and homepages, to spoil and distort the flux of information. Guerrilla communication relies upon the hypertextual nature of communication processes. (Also a newspaper or a traffic sign has plenty of cross-links to other fragments of "social text"; a medium transporting plain text and nothing else cannot exist.) Communication guerrillas consciously distort such cross-links with the aim of re-contextualizing, criticizing or disfiguring the original messages. In the Net, hypertextual aspects of communication have for the first time come to the foreground, and the Net hypertext offers fascinating possibilities for all kinds of pranks. (Imagine a Hacker leaving on a homepage of, say, the CIA not a blunt Central Stupidity Agency but simply modifying some of the links while leaving everything else as before. There are terrible things one could do in this manner...)

But the fascination of those possibilities should not lead to a technocentric narrowing of the field of vision. The mythical figure of the Hacker represents a guerrilla directed towards the manipulation of technology — but to which end? The Hacker gets temporary control of a line of communication — but most hackers are mainly interested in leaving Web Graffiti or simply "doing it" (see the Hacker Museum). Others, however, rediscover guerrilla communication practices of the ancient: Recently in: nettime net-artist Heath Bunting slated himself in a fake review (Heath Bunting: Wired or Tired?), thus re-inventing a method which already Marx and Engels had used when they faked damning reviews by first-rank economists to draw attention to "Capital."

Communication Guerrillas are fascinated by possibilities offered by the internet also in a quite different sense: Beyond its reality, THE NET is an urban myth, and perhaps the strongest and most vital of all. Social discourse conceives THE NET as the location where the people, the pleasures, the sex and the crimes of tomorrow have already taken place. Go Internet, learn the Future! Fears and desires are projected onto THE NET: this is the mythical place where we can see the future of our society. Paradoxically, the gift of prophecy attributed to the net gives credibility to any informations circulated there. The "real world" believes in them because they come from the realm of virtuality, and not in spite of this.

In the German backwoods, there has been a long-lasting game called The Invention of CHAOS Days. It was, in fact, rather simple: Someone put a note in the Net telling that, on day D, all the punks of Germany would unite in the town of XY to transform it into a heap of rubble. The announcement was made, a few leaflets (let's say a dozen) were distributed to the usual suspects. That very day, processions of

media hacks of all kinds encountered hosts of riot squads from all over Germany on their way to XY: Once again the forces of public order were on their way to protect our civilization against the powers of the dark. The most astonishing about this little game is that it worked several times: Obviously for the guardians of public order and public discourse THE NET is a source of secret knowledge too fascinating to be ignored. We do not mention in detail the innumerable occasions when journalists, state officials, secret services etc., were taken in by false rumors circulating in the net — for example, the major German press agency dpa who fell for the homepage of a fake corporation offering human clones, including replicas of Claudia Schiffer and Sylvester Stallone. Also this effect can be reproduced: the next time it was the prank about "ourfirsttime.com." There is little danger that media hacks will learn.

The net is a nice playground for Communication Guerrillas. But we, out there in the backwoods, are telling those living in the netscapes of electronic communication: don't forget to walk and talk your way through the jungle of the streets, to visit the devastated landscapes of outdated media, to see and feel the space and the power and the rule of capitalism. Such that you shall never forget what the hell all prankstering is good for.

12

The XYZ of Net Activism

Luther Blissett *(Italy)*

III

It's time to create the pop stars of activism, the idoru of communication guerrilla; it's time to threaten and charm the masses by the ghosts coming from the net, to play the myth against the myth, to be more nihilist than infotainment!

< 0. luther blissett and net.activism >

Luther Blissett is a pop myth, a collective "open" pop star. The name is the same as that of a Watford soccer player. But the virtual Luther Blissett (www.lutherblissett.net) has a computer-generated face. LB is a multiple name: anyone can become LB and use his/her name for whatever purpose. Whoever uses the name increases and takes part of the collective fame of LB. In Italy, where small groups promoted this project, the multiple name strategy has triggered a chain reaction. By means of the multiuse name a mass myth was built and used for political campaigns. The concepts underlying LB (multi-use name, open pop star, political avatar) can be a powerful tool in building a mass movement, as well as for a popular spreading of net.culture and the net.criticism of inner circles like Nettime or N5M, thereby ejecting the networks out of the Net.

< 1. edt and lb: two models of mediatic simulation >

In the current debate about net activism a leading question is the opposition between "simulation" vs. "real action." This has become a vicious, rhetorical question. Lovink & Garcia, in "the ABC & DEF of tactical media," are too patient with those who are skeptical about the importance of "mediatic representation" issues. On the contrary, in my view, the most radical theses and strategies about simulation have been expressed by Electronic Disturbance Theater and the LB/a.f.r.i.k.a gruppe. Both of them affirm the need for activism and counter information to enact simulations on the stage of mass-media, i.e. in the infotainment. But aside from this conviction, the projects are com-

pletely different. Electronic Disturbance Theater is the name of a group of activists. They use the form of the "net strike" to protest against institutions and the mass media by interjecting political questions. The EDT "actors" don't hide their names, they do not operate under the veil of anonymity. By contrast, LB is just a name, a mark adopted by thousands of people who often don't know or communicate with each other. LB is not a group or a movement but a collective pop star. All the activists have the same name, all the activists are the same multiple pop star. LB usually don't protest against the establishment directly. S/he works inside mass media, producing fake news, urban legends, and trying to "short-circuit" the spectacle's inner contradictions. LB's name is used for artistic works, political deeds, pranks, etc. LB has not achieved world wide fame like EDT, but s/he could get it.

The main question against EDT is: what is the risk of threatening and provoking media by simulations? How to control feedbacks and backlashes? How to avoid being coopted or starting moral panic? According to Stefan Wray, activists must become aware that politics is a theater and must learn to play: "we are manipulating the media sphere, we are creating hype, we are culture jamming, we are simulating threats and action ... we are actors! this is political theater! a glorification and transformation of the fake into the real, at least in people's mind." How to present activism on the stage? With an image and a name that work on the media. EDT builds simulacra: "How do we invent an international cyberspatial army? First by naming." EDT's simulacrum is very simple: it presents itself as a protest against institutions, media, corporations. It is a first level simulacrum, since it challenges the System in a direct way. Mediatic effectiveness is achieved by a simulated threat: "FloodNet's power lies in the simulated threat." The aim is to draw attention to particular issue by attracting media coverage to unusual actions. EDT has produced a negative, destructive simulacrum. Media system coopts these antagonistic simulacra, it demonizes and criminalizes them, it uses them to start a moral panic and produce the hype of a state of emergency. The "State" plays the same game of fear. The structure of the negations are identical — EDT mimics the State: this is what happens when you play at the "first level" of a mass media game.

If EDT engages in a direct fight, LB wants to raise the challenge beyond a first level simulacrum. As the a.f.r.i.k.a gruppe has written: "guerrilla communication doesn't focus on arguments and facts like most leaflets, brochures, slogans or banners. In its own way, it inhabits a militant political position, it is direct action in the space of social communication. But different from other militant positions (stone meets shop window), it doesn't aim to destroy the codes and signs of power and control, but to distort and disfigure their meanings as a means of counteracting the omnipotent prattling of power." Baudrillard quoting Wilden: "Each element of contestation or subversion of a system has to be of an upper logic kind." Contrary to EDT's practice, "communication guerrillas do not intend to occupy, interrupt or destroy the dominant channels of communication, but to detourn and subvert the messages transported." This means not playing as innocent actors on a stage, but imitating the spectacle and its deceptions: "against a symbolic order of western capi-

talist societies which is built around discourses of rationality and rational conduct, guerrilla communication relies on the powerful possibility of expressing a fundamental critique through the non-verbal, paradoxical, mythical." This non-rational strategy is, in fact, very rational: becoming spectacle, becoming myth, using infotainment weapons against themselves. Traditional simple counter-information no longer works. LB wants to explode the struggle into the realm of pop culture, by building "intelligent" simulacra, spreading fake news, using irony to withdraw at the right moment.

< 2. the pop turn >

Roland Barthes said in 1957, "it is to be strongly established, from the beginning, that the myth is a communication system, is message." The myth is what is beyond the Spectacle, in back of the media landscape. The myth unifies what is opposite in spectacle and overcodes any subversive meaning and deed. Barthes: "To destroy the myth from inside was then extremely difficult. The same move to get rid of it falls at once a prey to the myth: the myth can always, in the end, signify the resistance made to it." The title of the intro of the nettime bible *Read Me!* is: "nothing is spectacular if you aren't part of it." I don't know if this is a quote or where it comes from (Debord..? it's pure Debord philosophy!), but it is quite rhetorical, politically correct, and puritanic. We should say: nothing is spectacular if you are part of it! Activism has to perform a u-turn: let's call it the "pop" turn. Barthes: "The best weapon against the myth is to mythicize itself, is to produce an artificial myth: and this reconstituted myth will be a real mythology."

Net hype is a myth that activism must parasite and overcode. As the a.f.r.i.k.a gruppe writes: "Increasing attempts to police the net, to establish state and corporate control will, paradoxically, increase its attractivity as a field of operation for communication guerrillas: Possibly, even those of us who until now have not even owned a PC will get wired. Fakes and false rumors inside and outside the Net may help to counteract commodification and state control — after all, the internet is an ideal area for producing rumors and fakes... Communication Guerrillas are fascinated by possibilities offered by the internet also in a quite different sense: Beyond its reality, THE NET is an urban myth, and perhaps the strongest and most vital of all. Social discourse conceives THE NET as the location where the people, the pleasures, the sex and the crimes of tomorrow already take place. Go Internet, learn the Future! Fears and desires are projected onto THE NET: this is the mythical place where we can see the future of our society." The mass media stage is inglobing the net step by step. The Spectacle is hybridizing itself within the net. Activists have to attack and parasite the collective imaginary which has already penetrated cyberspace. The mass media imaginary is becoming increasingly interactive, or "democratic." The Old Left's theories about media manipulation have long ago become obsolete.

< 3. pop interfaces for the masses: a political idoru >

The "Pop Turn" means that activists have to become less boring and learn to speak the language of the masses. Like all interfaces, it's a compromise. Some puritanical activist, some anarchist or eco-raver will disagree. But the only way to face info-tainment is to become more nihilist than it itself. The "pop turn" is not only a strategic choice, it is also a way of building a communicative link to the masses.

Pop avatar. Pop culture is like Hindu pantheon where gods and semigods fight without end. It deals with making up pop simulacrum, controlling them, and withdrawing them at the moment they begin to produce unwanted reactions. Activism has to construct virtual pop stars, collective avatars transposed from the net directly to acting within the infotainment, as LB or the idoru Kioko Date. Through this metaphor of "mass avatar," I want to explain the open pop star model to net users and net activists who don't know about multiple name project. The avatar metaphor can be transposed very easily from the net to the traditional media and used in media activism. By "mass avatar," I mean a virtual idol who can play on media stage and not a simulated identity engaged in a one-to-one communication on the net. The anthropomorphic features of the "mass avatar" lead the public to identify itself with it. As Ballard and Gibson know, within media society the Icon is the direct way to access people's nervous system. Franco Berardi aka Bifo defined LB as "The Antichrist of Information." This definition explains the LB strategy of linking counter-information and autonomous pop mythology.

Gateway to the media. Hacktivists have to organize gateways between the net and the "traditional" media. This net-media gateway should be an interface to feed and control the spread of news media. It includes contacting and cooperating with on-line staff of TV and newspapers, and making up idiot-friendly interfaces for journalists. The history of EDT demonstrates this necessity: without making the NY Times front page on October 31, 1998, EDT would have a merely on-line existence.

< 4. hybridization >

Pop modules. If hybridization was just about connecting the virtual and the "street," we would risk remaining rhetorical and predictable on both fronts. We have to hybridize and to contaminate the forms of pop culture and create pop modules for activism. The net scene is a tank of odd and useful ideas. Think of a mediatic subversive use of the most iconoclast net.art works, before they can be coopted by Nike or Adidas! The pop module can be defined as a multi-platform program that works in different social environments and political frameworks, in both old and new media. An example is the LB name, which has appeared many times in Italian media, signed books, novels, performances, shows, counter-information campaigns, hoaxes, and urban legends. The multiple name can become a really hybrid module, since it works both on the street and on the net.

Composing theories... We don't need the easy abstractions and oppositions of Western philosophy that are embedded in grassroots criticism: simulation vs. real action, alternative vs. mainstream, pop vs. avant-garde, molar vs. molecular, "take to the street" vs. "the streets are dead." A theory (or strategy) is not a weapon set up against another theory, many theories can be composed together on the same level. "Compositionism" is a Deleuzian method suggested by Italian authors, like Bifo. Look at the beast of the spectacle and its internal movements. It is infiltrating the net, burrowing in the new forms without giving up the old ones. Capital can infiltrate any interstitials. The net is not opposed to mass media, hypertext cannot destroy Spectacle, but new hybrid forms can materialize. As Spectacle branches out into the hypertextual net, it becomes more shifty. Since it is already hybrid, we can learn from it.

... and integrating activism. Activism does not need to give up old strategies but must learn to integrate them, and to connect them with each other. The convergence of media means the convergence of different strategies and multiple "activisms." We have to stop producing new theories. We simply have to connect one strategy to another, to make hybrids of activism. Learning from the phenomena of the hackers, we can integrate net.artists and designers into activism. I mean a euphoric, subversive, iconoclast, prankish activism! If net.artists began to design pop interfaces and strategies for activism, they surely would be more spurred, inspired, and useful. We don't need to become a "rhizome." Deleuze & Guattari once asked: "how can we distinguish between subversive schizophrenia and capitalistic schizophrenia?" Capitalism is schizo and rhizomatic as well. The rhizome myth is not only dangerous for this proximity, it has reached such a level of saturation that everything today is proclaimed a "rhizome."

The net-media-art activism scene is fragmented into a lot of groups, close sub-networks, alternative culture ghettos, avant-garde loners, and hyper-egos. Jodi's map (www.jodi.org/map) is an effective bird's-eye view of "our" network. This scene can migrate overground only through the interconnection of each group of artists, activists, writers, theorists, designers, journalists, moderators, organizers, etc. This network could become a mediatic icon — the next sub-cultural movement, after punk, techno, cyberpunk! And for this, we should find a quite pop and stupid name.

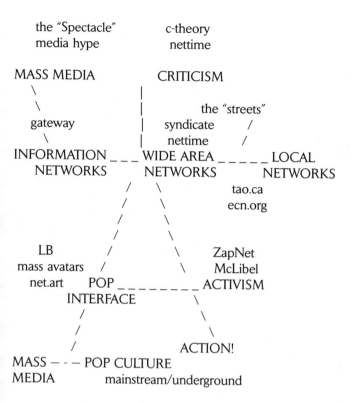

```
    the "Spectacle"        c-theory
    media hype              nettime

MASS MEDIA              CRITICISM
   \                        |
    \                       |         the "streets"
   gateway                  |    syndicate      /
    \                       |    nettime       /
INFORMATION _ _ _  WIDE AREA _ _ _ _ _ LOCAL
   NETWORKS           NETWORKS        NETWORKS
                   /  \           tao.ca
                  /    \          ecn.org
                 /      \
                /        \
   LB          /          \      ZapNet
 mass avatars /            \     McLibel
   net.art     POP _ _ _ _ _ _ ACTIVISM
           INTERFACE           \
            /                    \
           /                      \
          /               ACTION!
MASS _ _ _  POP CULTURE
MEDIA       mainstream/underground
```

— (Luther Blissett made a ritual suicide on the last day of 1999 and no longer exists.)

13

Electronic Disturbance

Ricardo Dominguez,
Electronic Disturbance
Theatre (US), Interviewed
by Coco Fusco (US)

ow did *Electronic Disturbance*
Theatre come about?

I will respond with a story from Subcomandante Marcos. Hola. Bienvenidos, hermanos
y hermanas. Welcome sisters and brothers, I'm going to tell you a little story, una
pequeña historia: Pedrito (a Tojolabal, two and a half years old, born during the
first Intergalactic) is playing with a little car with no wheels or body. In fact, it
appears to me that what Pedrito is playing with is a piece of that wood they call
"cork," but he has told me very decisively that it is a little car and that it is going
to Margaritas to pick up passengers. It is a gray and cold January morning and we
are passing through this village which is today electing the delegates (one man and
one woman) who will be sent to the March meeting. The village is in assembly
when a Commander-type plane, blue and yellow, from the Army Rainbow Task
Force and a pinto helicopter from the Mexican Air Force, begin a series of low over
flights above the community. The assembly does not stop; instead those who are
speaking merely raise their voices. Pedrito is fed up with having the artillery aircraft
above him, and he goes, fiercely, in search of a stick inside his hut. Pedrito comes
out of his house with a piece of wood, and he angrily declares that "I'm going to
hit the airplane because it's bothering me a lot." I smile to myself at the child's
ingenuousness. The plane makes a pass over Pedrito's hut, and he raises the stick
and waves it furiously at the war plane. The plane then changes its course and
leaves in the direction of its base. Pedrito says "There now" and starts playing once
more with his piece of cork, pardon, with his little car. The Sea and I look at each
other in silence. We slowly move towards the stick which Pedrito left behind, and
we pick it up carefully. We analyze it in great detail. "It's a stick," I say. "It is," the
Sea says. Without saying anything else, we take it with us. We run into Tacho as
we're leaving. "And that?" he asks, pointing to Pedrito's stick which we had taken.
"Mayan technology," the Sea responds. Trying to remember what Pedrito did I

swing at the air with the stick. Suddenly the helicopter turned into a useless tin vulture, and the sky became golden and the clouds floated by like marzipan. Muchas gracias, I hope you enjoyed the story.

This Mayan technology, this stick is a metaphor for what Electronic Disturbance Theatre has created as its performative matrix. The stick represents a third, or a fourth, or fifth alternative to the apocalyptic or utopian sense of the Internet. Those of us working in the virtual domain are constantly told to obey the utopian dream of the wired world where there will be no class, sex and no issues of identity. But, the Zapatistas, using this Mayan technology, advocate another type of gesture which I would say is related to magical realism.

This realism involves having the knowledge of the dangers that doing such simple acts as getting water or going to the next town in Chiapas (a space under the constant threat by the Mexican's low-intensity tactics), and also, knowing that a story or a poetic gesture might be able to get you around a real danger — more so than carrying a M-16 with you — the Zapatistas use the politics of a magical realism that allows them to create these spaces of invention, intervention, and to allow the world wide networks to witness the struggle they face on daily. It was the acceptance of digital space by the Zapatistas in 12 days that created the very heart of this magical realism as information war. It was this extraordinary understanding of electronic culture which allowed the Zapatistas on January 1, 1994, one minute after midnight just as NAFTA (a Free Trade Agreement between Canada, U.S.A, and Mexico) went into effect — to jump into the electronic fabric, so to speak, faster than the speed of light. Within minutes people around the world had received emails from the first declaration from the Lacandona Jungle. The next day the autonomous Zapatista zones appeared all over the Internet. It was considered the first post-modern revolution by the New York Times. The American intelligence community called it the first act of social net war. Remember, that this social net war was based on the simple use of e-mail and nothing more. Like Pedrito's "stick" gestures can be very simple and yet create deep changes in the structures of the command and control societies that neo-liberalism agenda, like NAFTA, represent.

But, back to your question. How did EDT come about? Digital Zapatismo is and has been one of the most politically effective uses of the Internet that we know of since January 1, 1994. EDT has created a counter-distribution network of information with about 300 or more autonomous nodes of support. This has enabled the EZLN (Zapatista National Liberation Army) to speak to the world without having to pass through any dominant media filters. The Zapatistas' use of communication on the Internet, e-mail and webpages created an electronic force field around these communities in resistance which literally stopped a massive force of men and the latest Drug War technologies from annihilating the EZLN in a few days. The Zapatistas themselves really did not expect to live very long after January 1.

When the communiqués signed by Subcommandante Marcos were distributed global-
ly through the Net, they began to flow between pre-existing anti-NAFTA and other
newly formed activist listservs, newsgroups, and personal cc: lists, news, reports,
analyses, announcements about demonstrations, and calls for intercontinental gath-
erings spread throughout the Americas, Europe, Asia, Africa, and Australia. By the
summer of 1994 we began to hear the Zapatistas use the terms "intercontinental
networks of struggle" and "intercontinental networks of resistance."

This movement of information through these various Zapatistas networks of resistance
can be said to have occurred via a strange chaos moving horizontally, non-linear-
ly, and over many sub-networks. Rather than operating through a central com-
mand structure in which information filters down from the top in a vertical and lin-
ear manner — the model of radio and television broadcasting — information about
the Zapatistas on the Internet has moved laterally from node to node.

The primary use of the Internet by the global pro-Zapatista movement has been as
communication tool. However particularly since the Acteal Massacre in Chiapas at
the end of 1997 in which 45 indigenous people were killed, the Internet has
increasingly been used not only as site or a channel for communication, but also
as a site for direct action and electronic civil disobedience. Beta actions of elec-
tronic civil disobedience occurred early in 1998. Information about the Acteal
Massacre, and announcements of Mexican consulate and embassy protests, was
transmitted rapidly over the Net. The largest response was a street protest, draw-
ing crowds of between 5,000 and 10,000 in places such as Spain and Italy. But
there were also calls for actions in on-line communities. On the low end of digital
activism people sent large amounts of email protest to selected email targets of the
Mexican government.

The Anonymous Digital Coalition, a group based in Italy, issued a plan for virtual sit-
ins on five web sites of Mexico City financial corporations, instructing people to
use their Internet browsers to repeatedly reload the web sites of these institutions.
The idea was that repeated reloading of the web sites would block those web sites
from so-called legitimate use. This idea was the jump off point for the Zapatista
FloodNet which automated the reload function to happen every 3 seconds.
FloodNet was created by the Electronic Disturbance Theater, a group composed
of myself, net artists Carmin Karasic and Brett Stalbaum, and Stefan Wray, an
activist and media scholar.

*EDT's actions are passed through an artist-driven server called The Thing. You have character-
ized this server as a form of social sculpture.*

As a net performer, I was interested in a matrix that would articulate social issues as
well as performative issues with and within the parameters of code. I was interest-
ed in the possibility of agit-prop theatre on-line. But I needed to have an infra-
structure to stage and create virtual performances. In the early 1990s artists did not

have access to network technology as readily as at the end of the nineties. During the 1980s I was living in Tallahassee, Florida, where I was a member of Critical Art Ensemble (the group that developed the idea of Electronic Civil Disobedience), and I heard that in New York there were artists who were trying to create online communities. So I came to New York and the main community I found was bbs.thing.net which was started in 1991 by Wolfgang Staehle.

He saw the emergence of pre-web electronic communities called bulletin board systems (BBS) as a continuation of social sculpture. The BBS (http://bbs.thing.net) offered arts communities ways to establish themselves, to send information to one another and also to conceive of new artistic practices deriving from conceptualism and from performance.

When I arrived at The Thing in New York, Wolfgang Staehle said, "Welcome to The Thing. There are a bunch of machines here, go sit down, Ricardo, and start learning and I'm not going to help you." I spent two years gathering information through these communities. This server became main platform for the Electronic Disturbance Theatre's use of the Zapatista Floodnet system (www.thing.net/~rdom), which creates a disturbance online that, for lack of a better term, could be characterized as a virtual sit-in software.

Can you explain a little bit about how you conceive of EDT work as performance?

Augusto Boal, who theorized and performed what he calls "invisible theatre" once argued that middle class theatre was able to produce complete images of the world because it existed within a totalized social mirror of production. Other sectors of society that wanted to create a different kind of reflection could only produce incomplete performances that pointed towards something beyond what already exists. There is a history of the theatre of this type of critical social performance: the theatre of Erwin Piscator, who just read newspapers on the street or recreated the stories for people passing by, Bertolt Brecht's Epic Theatre, the Living Theatre, and Teatro Campesino working with Cesar Chavez, etc. Each of these groups created gestures that worked to literally implode everyday street realities, new theatrical modes of presentation and direct political manifestation. These agit-prop groups pointed to the possibility of new forms of the performative matrix that could be translated onto the digital stage, to the possibility of using techniques to create social or civil drama in this new space. More recent groups such as Gran Fury created what the government called riots. They used a particular look and color of clothing and very stylized types of gestures, like Die Ins, to create a new type of direct action theatre on the street.

This is a history of performance that EDT continues. What I am interested in are practices that break with traditional performance art or traditional theatre, and more importantly, that reflect a form of critique and discontent by a community. Activists, direct action performers, or more traditional forms of agit-prop

theatre can chose to use the spectacle of visible collective street action, or they can chose to use the invisible performances of digital gestures, such as uploading the names of the victims of the Acteal massacre into Mexican government or Pentagon servers.

I wouldn't call your Acteal action invisible, I would just call it abstract. This is perhaps the biggest conceptual leap a viewer of your work must make, if that viewer is conditioned by the conventional theatre from the flesh world. The performance language EDT uses doesn't look like live theatre because it's not mimetic. We expect to see a play unfold before our eyes. Even most experiments with Internet theatre involving avatars attempt at some level to reproduce the visual codes of theatre, cinema and television while the role of the director and the actors gets splintered and distributed among the participants. But, as you walk me through a FloodNet Action, all I'm seeing as a record of mass activities are lines at the bottom of the screen. The moving lines to me resemble the cyphers of audio editing programs that visualize the length and depth of sound. What the lines in fact are is a record of virtual presence with actual repercussions.

I'd like to consider your work with EDT in relationship to a specifically Latin American genealogy. There are several examples of performance art from the 1970s and '80s that was designed to take place in the street to reappropriate public space during political periods of extreme repression. I am thinking here of the emergence of the Chilean avanzada during the Pinochet dictatorship, and the street actions carried out by several collectives; the Grupos in Mexico during the same period that involved performances in public places and that formed a delayed response to the massacre of Tlatelolco, and work by The Border Art Workshop/El Taller de Arte Fronterizo. In a sense, the objective of that work was to point to the absence of civic life, to force awareness of that absence into the open to engender a dialogue about how public life had been eviscerated by political power. Can you talk about how you transposed that dynamic into the domain of the virtual with EDT?

Well, we do it through a simple gesture. The public space of electronic culture as it exists now is through browsers, such as Netscape or Internet Explorer. EDT sees the browser as the public base of the virtual community. It is the space where communities gather either to chat, to exchange information or to put up representations of their cares or concerns, or, in the case of e-commerce, representations of what they're trying to sell you. What EDT has done is to create an applet — Brett Stalbaum, one of the members, took this public function of the "reload" button on browsers and just added another element. Instead of the user hitting the reload button, the system automatically turns and refreshes itself as more people come to the site. The more people enter the Zapatista FloodNet, the faster that refresh or reload button calls on the information that resides on the government servers where the Sit-In is taking place. Each person who joins adds to the speed and number of requests for information from the targeted server.

Through a VR Sit-In, EDT creates a mass representation of the community of resistance. As FloodNet performs automatic reloads of the site, it is slowing or halting

access to the targeted server. This representation constitutes a disturbance on the site, a symbolic gesture that is non-violent. The more hits there are to President Zedillo's web site, the more our presence is felt, and the less functional the government site becomes, until it is eventually overwhelmed by the public. This disturbance points to the nature of what public space means and who is allowed to be present in the public space of the Internet. FloodNet does not impact the targeted web sites directly, as much as it disrupts the traffic going to the targeted web site. Something similar happens on the street, when individuals find themselves unable to get to work or buy a newspaper because of an action out on the bridge. The disturbance doesn't necessarily bring down a server, since many such as the Pentagon are quite robust and expect millions of hits. But the disturbance creates a sense of solidarity, what I would call "community of drama" or a community joined by the magic stick.

It also creates a mirror that brings real criminal acts into view. This magical stick calls forth the most aggressive tendencies of the information war community. Take for example the Department of Defense. The Zapatista FloodNet system advises you that your IP will be harvested by the government during any FloodNet action. When you click and enter FloodNet, your name and political position will be made known to the authorities. This is similar to having your picture taken during a protest action on the street. There could be possible damage to your machine that may occur because of your participation in FloodNet action, just as in a street action the police may come to hurt you. During the past FloodNet actions, out of 80,000-plus who have participated only two individuals have reported their machines crashing when the Department of Defense, the Pentagon attacked us on September 9th, 1998 during a VR Sit-In we did during the Ars Electronica Festival, in Linz, Austria. The DOD used a counter-hostile Java applet against FloodNet, which is the first offensive use of information war by a government against a civilian server that we know of. We believe we should be protected from such actions, that the government cannot attack civilians using any kind of software or hardware. What has become apparent is the kind of violence that these information war systems are now implementing against civilians to control whatever public space there is.

What are some of the responses that EDT has received from the US military and also from the Mexican government?

These confrontations began in Linz at Ars Electronica when EDT undertook its Swarm performance, the largest virtual sit-in that we had done until then on Mexican President Zedillo's web site, the Pentagon and the Frankfurt Stock Exchange. The Department of Defence initiated a counter-measure or a hostile Javascript applet against the Zapatista FloodNet. From that point on we have been in dialogue with the military, which is very strange for us. The military invited us to do what we call "The National Security Agency Performance" on September 9, 1999 for some 300 Generals and military men and also NSA people as well as Congressmen. We approached it as theatre. They interrogated us. Of course they wanted to know

who was in charge, how extreme could we possibly get, what was the future like, what do we expect from the growth of this new term "hacktivism" which had emerged as a response to the drama.

I've been asked if I'm concerned that I'm speaking to the military, and why I don't worry about what they're attempting to do to us, either by co-opting or gathering information about us. One of the things about us is that, unlike hackers, EDT is very transparent. We use our names, people know who we are and what we do and we always let people know, and this really disturbs the military. They are modernist at heart; they want secrets, they want encryption, they want cyber-terrorists, and they want cyber-crime. What we give them is net art performance that allows everyone to see who the real cyber-terrorists are.

How does Swarm work? I'm particularly interested in how Internet gestures end up on screen as a kind of abstract performance language.

We're just dealing with a browser. In fact, the gesture of reloading itself, as performance, doesn't really matter much. The real drama and the real space of performance comes before and after the action, and follows the structure of a three act play. In the first act you announce what is going to happen. The middle act is the actual action itself. The last act is a gathering of dialogue about what happened – this is where the most instructive drama occurs. A social drama among different communities – net activist, net artist, and net hackers. The dot.coms and government sites and also play their parts in this social drama.

The FloodNet gesture allows the social flow of command and control to be seen directly – the communities themselves can see the flow of power in a highly transparent manner. During the last act of every action we did, we would see the endless flow of words come, not only from EDT members, but from people around the world: a woman from South Korea, an Aborigine from Australia. We began to create a network for a social drama because they're interested in what is going on, how they can help, etc. A virtual plaza, a digital situation, is thus generated in which we all gather and have an encounter – an Encuentro, as the Zapatistas would say – about the nature of neo-liberalism in the real world and in cyberspace.

Can you explain the meaning of the visual signs that appear on screen during a FloodNet action?

FloodNet encourages individual interaction on the part of protesters. Net surfers may voice their political concerns on a targeted server via the "personal message" form which sends the surfer's own statement to the server error log. While Floodnet action goes on, we not only recall President Zedillo's web page, but we also call internal searches. For example, we will ask for the names of the dead, or about the question of human rights in Mexico. We ask the server the question, "Does human rights exist on President Zedillo's web site?" And then a 404 file emerges back-

stage; the 404 "not found" reply is a report of a mistake or gap of information in the server. This use of 404 files is a well-known gesture among the net art communities; EDT just re-focused the 404 function towards a political gesture. For instance, we ask President Zedillo's server or the Pentagon's web server "Where is human rights in your server?" The server then responds "Human rights not found on this server." We ask "Where is Ana Hernandez on this server" and the server then responds "Ana Hernandez is not found on this server."

Is Ana Hernandez someone who was killed by the Mexican army?

Yes, she was killed in the Acteal Massacre on December 22, 1997. We started doing these actions in response to that massacre. One of the artists working with EDT, Carmen Karasic, wanted to create an electronic monument of remembrance to those who died. This kind of performance gesture borrows very much from Conceptual Art. The actual performance may take place in an invisible area, but at the same time it aggravates and disturbs the infrastructure of President Zedillo's web site.

What you are doing makes me think of Rachel Whiteread's casting negative spaces. In a sense you are operating within a virtual domain, and are pointing to the absence of information, which amounts to an absence of concern for ethical issues and lives.

Yes, we bear witness to this with a gesture that retraces a Latin American performance tradition. We are bearing witness to the gap or to the invisibility that has been caused by the engines of destruction.

When you theorize EDT's practice you often mention connections with Ancient Greek concepts of the Agora and Demos. How do you envision virtual performance as a kind of metaphorical speech in light of this genealogy?

The idea of a virtual republic in Western Civilization can be traced back to Plato, and is connected to the functions of public space. The Republic incorporated the central concept of the Agora. The Agora was the area for those who were entitled to engage in rational discourse of Logos, and to articulate social policy as the Law, and thus contribute to the evolution of Athenian democracy. Of course those who did speak were, for the most part, male, slave-owning and ship-owning merchants, those who represented the base of Athenian power. We can call them Dromos: those who belong to the societies of speed. Speed and the Virtual Republic are the primary nodes of Athenian democracy – not much different than today. The Agora was constantly being disturbed by Demos, what we would call those who demonstrate or who move into the Agora and make gestures. Later on, with the rise of Catholicism, Demos would be transposed into Demons, those representatives of the lower depths. Demos did not necessarily use the rational speech of the Agora, they did not have access to it; instead, they used symbolic speech or a somatic poesis — Nomos. In the Agora, rational speech is known as Logos. The Demos' ges-

ture is Nomos, the metaphorical language that points to invisibility, that points to the gaps in the Agora. The Agora is thus disturbed; the rational processes of its codes are disrupted, the power of speed is blocked. EDT alludes to this history of Demos as it intervenes with Nomos. The Zapatista FloodNet injects bodies as Nomos into digital space, a critical mass of gestures as blockage. What we also add to the equation is the power of speed, which is now leveraged by Demos via the networks. Thus Demos *qua* Dromos create the space for a new type of social drama to take place. Remember in Ancient Greece, those who were in power and who had slaves and commerce, were the ones who had the fastest ships. EDT utilizes these elements to drama and movement by empowering contemporary groups of Demos with the speed of the Dromos – without asking societies of command and control for the right to do so. We enter the Agora with the metaphorical gestures of Nomos and squat on the high speed lanes of the new Virtual Republic. This creates a digital platform or situation for a techno-political drama that reflects the real condition of the world beyond code. It disturbs the Virtual Republic that is accustomed to the properties of Logos, the ownership of property, copyright, and all the different strategies in which they are attempting enclosure of the Internet.

EDT also distributes the codes freely to others, right?

Yes, on January 1st, 1999, one minute after midnight, in celebration of the 5th Declaration of the Lacandona, and the 5th year of the Zapatistas, we started distributing what is called "The Disturbance Developer Kit" or DDK, which is free to anyone if they come to our site. During our actions, many groups who wanted to do virtual sit-ins contacted us, so in response we developed a kit that's quick and easy to put up. It has been used by a wide variety of groups such as Queer Nation, the international animal liberation groups, anti-arms trading groups, anti-WTO groups, and "The Electro Hippies." So our performance continues through a new act of distributing the software, as the power to disturb the Virtual Republic is extended to new communities.

> — *This interview originally appeared online in the first issue of*
> THE HACKTIVIST *(www.thehacktivist.com) in January 2001.*

14

The ABC of Tactical Media

David Garcia & Geert Lovink *(Netherlands)*

actical Media are what happens when the cheap "do it yourself" media, made possible by the revolution in consumer electronics and expanded forms of distribution (from public access cable to the internet) are exploited by groups and individuals who feel aggrieved by or excluded from the wider culture. Tactical media do not just report events, as they are never impartial. They always participate and it is this that more than anything separates them from mainstream media.

A distinctive tactical ethic and aesthetic that has emerged, which is culturally influential from MTV through to recent video work made by artists. It began as a quick and dirty aesthetic, and although it is just another style (at least in its camcorder form) it has come to symbolize a verité for the 90's.

Tactical media are media of crisis, criticism and opposition. This is both the source of their power ("anger is an energy": John Lydon), and also their limitation. Their typical heroes are the activist, nomadic media warriors, the prankster, the hacker, the street rapper, the camcorder kamikaze; they are the happy negatives, always in search of an enemy. But once the enemy has been named and vanquished it is the tactical practitioner whose turn it is to fall into crisis. Then (despite their achievements) its easy to mock them, with catch phrases of the right, "politically correct," "victim culture" etc. More theoretically the identity politics, media critiques and theories of representation that became the foundation of much Western tactical media are themselves in crisis. These ways of thinking are widely seen as carping and repressive remnants of an outmoded humanism.

To believe that issues of representation are now irrelevant is to believe that the very real life chances of groups and individuals are not still crucially affected by the available images circulating in any given society. And the fact that we no longer see

the mass media as the sole and centralized source of our self-definitions might make these issues more slippery but that does not make them redundant.

Tactical media are a qualified form of humanism. A useful antidote to both, what Peter Lamborn Wilson described as "the unopposed rule of money over human beings." But also as an antidote to newly emerging forms of technocratic scientism which under the banner of post-humanism tends to restrict discussions of human use and social reception.

What makes our media tactical? In *The Practice of Everyday Life* De Certeau analyzed popular culture not as a "domain of texts or artifacts but rather as a set of practices or operations performed on textual or text-like structures." He shifted the emphasis from representations in their own right to the "uses" of representations. In other words, how do we as consumers use the texts and artifacts that surround us? And the answer, he suggested, was "tactically." That is in far more creative and rebellious ways than had previously been imagined. He described the process of consumption as a set of tactics by which the weak make use of the strong. He characterized the rebellious user (a term he preferred to consumer) as tactical and the presumptuous producer (in which he included authors, educators, curators and revolutionaries) as strategic. Setting up this dichotomy allowed him to produce a vocabulary of tactics rich and complex enough to amount to a distinctive and recognizable aesthetic. An existential aesthetic. An aesthetic of poaching, tricking, reading, speaking, strolling, shopping, desiring. Clever tricks, the hunter's cunning, maneuvers, polymorphic situations, joyful discoveries, poetic as well as warlike.

Awareness of this tactical/strategic dichotomy helped us to name a class of producers who seem uniquely aware of the value of these temporary reversals in the flow of power, and rather than resisting these rebellions do everything in their power to amplify them. And indeed make the creation of spaces, channels and platforms for these reversals central to their practice. We dubbed their (our) work "Tactical Media."

Tactical Media are never perfect, always in becoming, performative and pragmatic, involved in a continual process of questioning the premises of the channels they work with. This requires the confidence that the content can survive intact as it travels from interface to interface. But we must never forget that hybrid media has its opposite its nemesis, the Medialen Gesamtkunstwerk. The final program for the electronic Bauhaus.

Of course it is much safer to stick to the classic rituals of the underground and alternative scene. But tactical media are based on a principal of flexible response, of working with different coalitions, being able to move between the different entities in the vast media landscape without betraying their original motivations. Tactical Media may be hedonistic, or zealously euphoric. Even fashion hypes have their uses. But it is above all mobility that most characterizes the tactical practi-

tioner. The desire and capability to combine or jump from one media to another creating a continuous supply of mutants and hybrids. To cross borders, connecting and re-wiring a variety of disciplines and always taking full advantage of the free spaces in the media that are continually appearing because of the pace of technological change and regulatory uncertainty.

Although tactical media include alternative media, we are not restricted to that category. In fact we introduced the term "tactical' to disrupt and take us beyond the rigid dichotomies that have restricted thinking in this area for so long, such as amateur vs. professional, alternative vs. mainstream, even private vs. public.

Our hybrid forms are always provisional. What counts are the temporary connections you are able to make. Here and now, not some vaporware promised for the future, but what we can do on the spot with the media we have access to. Here in Amsterdam we have access to local TV, digital cities and fortresses of new and old media. In other places they might have theater, street demonstrations, experimental film, literature, photography.

Tactical media's mobility connects it to a wider movement of migrant culture, espoused by the proponents of what Neil Ascherson described as the stimulating pseudo-science of Nomadism. "The human race say its exponents are entering a new epoch of movement and migration. The subjects of history once the settled farmers and citizens, have become the migrants, the refugees, the *gastarbeiters*, the asylum seekers, the urban homeless."

An exemplary example of the tactical can be seen in the work of the Polish artist Krzystof Wodiczko who "perceives how the hordes of the displaced that now occupy the public space of cities squares, parks or railway station concourses which were once designed by a triumphant middle class to celebrate the conquest of its new political rights and economic liberties." Wodiczko thinks that these occupied spaces form new agoras, which should be used for statements. "The artist," he says, "needs to learn how to operate as a nomadic sophist in a migrant polis."

Like other migrant media tacticians Wodiczko has studied the techniques by which the weak become stronger than the oppressors by scattering, by becoming centerless, by moving fast across the physical or media and virtual landscapes. "The hunted must discover the ways become the hunter."

But capital is also radically deterritorialized. This is why we like being based in a building like De Waag, an old fortress in the center of Amsterdam. We happily accept the paradox of "centers" of tactical media. As well as castles in the air, we need fortresses of bricks and mortar, to resist a world of unconstrained nomadic capital. Spaces to plan, not just improvise, and the possibility of capitalizing on acquired advantages, has always been the preserve of "strategic" media. As flexible media tacticians, who are not afraid of power, we are happy to adopt this approach ourselves.

Every few years we do a Next 5 Minutes conference on tactical media from around the world. Finally we have a base (De Waag) from which we hope to consolidate and build for the longer term. We see this building as a place to plan regular events and meetings, including the Next 5 Minutes. We see the coming Next 5 Minutes (in January 1999), and discussions leading up to it, as part of a movement to create an antidote to what Peter Lamborn Wilson described as "the unopposed rule of money over human beings."

— This manifest was written for the opening of the web site of the Tactical Media Network, hosted by the Waag, the Society for Old and New Media (www.waag.org/tmn). First distributed via Nettime in 1997.

15

Islam and Tactical Media in Amsterdam

David Garcia *(Netherlands)*

I f tactical media were to ever attain its objectives it would immediately become redundant as a separate category. In that moment we would all become media, equally unwilling to allow experts and media professionals to control (or monopolize) public discourse. September 11th had this precise effect, rendering (albeit momentarily) the term "tactical media" redundant. In the minutes and hours that followed the attack the aspiration of generations of media activists were (at terrible cost) made flesh. Every one of us, from those at the fiery heart of events grabbing mobile phones, to we the "universal eyewitnesses" scrambling to make contact with others, attempting to make sense of a world turned upside down, became transmitter as well as a receiver. Everyone I have spoken to reached for a phone. In an almost universal reaction to the mainstream media's floundering commentaries and manifest inadequacies we all became nodes in the global media network. And America together with the rest of us who, until that moment, believed we were the lucky ones who inhabited the "zones of safety," were brought face to face with new realities both outside and within our imagined and geographic borders.

"Tactical media's mobility connects it to a wider movement of migrant culture, espoused by the proponents of what Neil Ascherson in his book *The Black Sea* described as the stimulating pseudo science of Nomadism. 'The human race say its exponents are entering a new epoch of movement and migration. The subjects of history once the settled farmers and citizens, have become the migrants, the refugees, the *gastarbeiters*, the asylum seekers, the urban homeless.' [Migrant media practitioners have] studied the techniques by which the weak become stronger than their oppressors by scattering, by becoming centerless, by moving fast across the physical or media and virtual landscapes. The hunted must discover the ways become the hunter." ("The ABC of Tactical Media," David Garcia & Geert Lovink).

The extract quoted above, written in 1997, could not have anticipated anything as devastating or nihilistic as the September 11th attack. On re-reading the essay it seems that although to a small degree prescient we were also extremely naïve in our implicit assumption that tactical media (giving voice as it does to the excluded and disenfranchised) would automatically be harnessed to emancipatory social movements.

In Amsterdam there are two main groups making tactical media who have been affected by September 11th. On the one hand, as in most western metropolitan centers, there are loose coalitions of media makers made up of the old and new left. For these groups media tactics are an important tool in their role as part of a worldwide movement battling for global economic justice. As in other countries these local groups are having to re-examine their tactics in the light of a "transformed semiotic (and actual) landscape." But there is also another network of tactical media makers working in Amsterdam: large and diverse clusters of Islamic organizations have developed their own local media culture. Among these groups there are a number of mosques and related Islamic organizations that are using small scale media to inform and mobilize on behalf of the extreme wing of theocratic Islam. Not surprisingly they are having to come to terms with a new reality as the content of these transmissions are coming under greater scrutiny than ever before.

< background >

It's no accident that the term "tactical media" first appeared in Amsterdam. The city has a remarkable history of anarchic media experimentation and civic networking. Nearly a decade ago I described Amsterdam as a "pirate utopia for tactical media." Since then considerable damage has been done to the environment that legitimized this claim. Nevertheless some important aspects of the pirate legacy remain, more or less, intact — most significantly, Amsterdam's long established community access radio and cable television.

The Netherlands was the first European country to establish a 100% cable infrastructure; as a result Holland's cable TV is not a luxury but a near-universal utility. Amsterdam is also the only major Dutch (or for that matter European) city to have taken "tactical" advantage of cable television. No other city in Europe (except possibly Berlin) has Amsterdam's history of experimental television or its policy of "community access" TV and radio — a policy which is both interesting and important only because it is matched by a significant demographic. Anyone with a TV in Amsterdam can receive the two "open channels." This evolving open network has been hosting experimental and tactical media (as well as more conservative transmissions) for more than twenty years.

Apart from the technical infrastructure there is also the nature of the city itself. A multilingual port of call for travelers and migrants from around the world, Amsterdam has the intensity of a major metropolis but is actually a small town. Those watch-

ing TV at home are quite often within cycling distance from live transmissions. These factors combine to allow Amsterdam television to be an intimate communications medium, perhaps the closest television can come to the best and the worst of the internet.

< migrant media >

As the years have passed Amsterdam has gone from one to two open channels. And these channels have been used more and more by specifically "migrant media." There is a "respectable" municipally supported program for migrants, which aspires to a broadcast standard of professionalism. And there are also a host of independent media makers whose approach to television is much looser. These transmissions range from those with ambitious production values to those who simply download satellite transmissions and hook them into the local cable. But whatever the approach the extent and popularity of these programs indicate their importance in helping migrants to stay in touch with some idea of home.

Of Amsterdam's migrant media makers, Islamic groups are one of the largest cultures currently making use of the open channels. Even in a brief survey it is important not to conform to a monolithic representation of Islam. The richness and diversity of Islamic thought and opinion is to a degree reflected in the range and style of Amsterdam's local transmissions. At the last count there were 12 Islamic organizations transmitting regularly, which, if you consider that Amsterdam is a small city of just over a million people, is fairly extensive.

The transmissions cover a wide spectrum of opinion and an equally wide geographical range. Many of the exclusively religious transmissions originate from local mosques, which have direct connections to different Arabic countries and so the programs will be targeted at specific national communities. However quite a few of these transmissions are simply satellite downloads of religious teachers speaking from the country of origin.

Turkish Islam is also an important part of this local media picture, and Turkish transmissions cover the full spectrum of religious and political opinion. For example, a Turkish group, TTA, is one of the most militantly anti-western of those using the cable network. On the other hand there are a number of groups, notably Alternatief or Klas TV/Harman which although Islamic are generally opposed to the fundamentalist wing of the religion.

Both before and since September 11th a number of complaints have been lodged with SALTO (the government agency tasked with structuring and to a limited degree controlling the output of the open channels). Only one of these complaints was considered serious enough to warrant investigation. Since September 11th SALTO itself has been approached by the Dutch secret service and asked to reveal information about a group of program makers called "Islamic Aid," which had a name

similar to a group with proven links to Al Qaeda. But, as it turned out, the Amsterdam organization was completely unconnected to this group.

During their years of development the local media produced by Amsterdam's Islamic cultures have been mostly ignored by all but their intended audience. However after September 11th Holland's position as a tolerant nation has been badly shaken. To outsiders Dutch culture can appear more enlightened than it actually is. The famous Dutch tolerance is not particularly "inclusive," it often consists of a policy of creating "permanent autonomous zones" in which controversial minorities can (and are even encouraged) to do their own thing, as long as they don't rock the boat and shake a fundamentally conservative status quo. For years this policy has proved effective at keeping political minorities, if not always off the streets, at least out of power.

After September 11th the Dutch sat up and took a new look at the Islamic cultures living in their midst, perhaps for the first time listening closely to what was being said. The broader implications of globalization had suddenly become apparent.

The militant wing of theocratic Islam has proved tactically adept, utilizing simple combinations of satellite to cable connections to connect global networks to local media. In true tactical style, the tools of media technology have been turned on the technological society itself. The local and regional consequences of these facts are still unfolding.

> *— The text was written in 2002 for* Virtual Case Book, *a series of regional snapshots about the impact of September 11th on tactical media initiatives. Virtual Case Book is a project organized by New York University, The Center for Media, Culture and History in cooperation with "Picture Projects."*

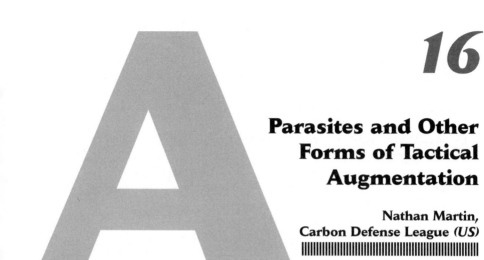

16

Parasites and Other Forms of Tactical Augmentation

Nathan Martin, Carbon Defense League *(US)*

parasite is defined as "an organism that grows, feeds, and is sheltered on or in a different organism while contributing nothing to the survival of its host." The tactics of appropriation have been co-opted. Illegal action has become advertisement. Protest has become cliché. Revolt has become passé. These disputes are the usual suspects. Having accepted these failures to some degree, we can now attempt to define a parasitic tactical response. We need to invent a practice that allows invisible subversion. We need to feed and grow inside existing communication systems while contributing nothing to their survival; we need to become parasites. We need to create an anthem for the bottom feeders and leeches. We need to echo our voice through all the wires we can tap but cloak our identity in the world of non-evidence, and the hidden.

What I am indirectly referring to is operating as an appendage; creating a practice that hops the meta-train of media. In much radical behavior, we struggle, writhe, and scream, but make only a whisper. We must exercise the scream and stretch our vocal chords to make room for the growl. This bite must remain silent – a bite with no bark. The parasite's own existence depends on its ability to remain hidden. The parasite is the mystical computer glitch. The parasite is the bandwidth thief. The parasite is the invisible usurper. The shift that takes place in the host, if any, is one so gradual the parasite will be able to feed and thrive without detection.

The invisibility of the parasite is only through the eyes of its host organism. A parasite may be very visible to other parasites or to those human users that utilize the exploits or extensions that may be created by the introduction of the parasite into the host. It is the host that either cannot detect the presence of the parasite, or who observes the parasite, but only as an anomaly that stays well within the system's margin of error. The parasite flies below the radar of the host's policing system by remaining too peculiar, non-distinct or immeasurable. It is by appearing as an

expected and accepted system bug that an otherwise visible parasite becomes invisible to its host. The way a parasite remains within the margin of error of a host system is to work within large expansive organisms that have less ability to control or monitor most of their own structure with any great detail. There is a blurring that will occur in systems where there is a large gap between manager and worker or between operating system and application.

If the standard deviation returned during any examination performed on a host organism is larger than it was before the introduction of the parasite into the host then the parasite will become visible to the host policing system and will be detected and removed. This would be a failure of a parasite in not knowing a host's standard deviation tolerance. It is in larger systems that larger tolerances are given for error. In smaller systems, the monitoring is so direct that standard deviation is already so small that it becomes difficult to introduce a parasite into the host that will remain invisible and still be able to function properly. An example would be the amount of theft by employees that occur at a small business where the owner is a visible source of monitoring being much lower in most cases than a large corporation where the owner is not present and possibly not known. Retail thefts, like employee thefts, increase with the size of a business. Corporations such as Wal-Mart factor the losses they will see due to theft into their financial planning and cost analysis. Usually if the amount of theft grows relative to the size of the corporation, the level of standard deviation will not increase and no alarm will go off that will force the host to change its behavior. This may change with the introduction of surveillance technologies into these environments, but that shift will eventually return to a patterned behavior with its own level of standard deviation. A parasite must respect the tolerances of its host. A parasite may grow but only relative to the growth of its host. The parasite must remain invisible to the host.

The practice of parasitic media I am defining is one that is not altogether new. It is operational within a pre-defined communication system. It is a plug in — an extension. It is a universal connector. The specialty it contains is that of co-existence and adoption. Rather than operating from the response of destruction, annihilation, or the more eloquent appropriation; we will build ourselves as spy-ware and viruses. These are parasites with a new agenda. We will construct no new systems in exercising parasitic media practices; instead we will only build extensions to pre-existing systems. The ability to create these extensions invisibly relies on large system sizes. The systems become hosts for the parasites. The more complex the host system, the more possibility there is for a parasite to exist unnoticed — until the sickness sets in, and then it is too late. Larger communication systems are only one part of a vast array of media that can serve as hosts. With expansive global communication infrastructures, adding a new appendage that hides itself well becomes relatively simple. By understanding the surveillance practices within the systems we desire to build for, we can understand and define our limitations. While these limitations are sometimes clearly allocated and narrow, they still allow for much play. The ability for play is built into the allowances and tolerances within any system.

The margin of error for these systems, both digital and analog, is where parasitic media will operate.

In North America, the freighthopper emerged with the creation of the expansive railroad system as a hobo (usually working very sporadically as itinerant farm hands for small amounts of cash) who would sneak onto trains and ride in open boxcars to their destinations. The success of their ventures relied on remaining invisible. They cost the railroads no extra effort – other than the cost of hiring train yard cops, known as bulls, to police the freighthoppers. The freighthopper was known as a freeloader that traveled the rails as an invisible extension or appendage of the trains, feeding off of the railway's mobility. The freighthopper is the folk version of a form of parasitic media response. This is a concept for conceptual piggybacking. If we take an example host being an existing railway system, we can build parasitic attachments (in the case of freighthopping, this is the hobo) that simply create added functionality. We hop on the train and ride the rails as far as we need to go. We avoid the "bulls" of the communication system train yards at all costs. Here we can use a comparison between freighthopping and hitchhiking to understand the relationship between parasite media and other forms of tactical media that rely on awareness. The tactic of the latter can very effectively make use of mainstream advertising or communication machines to dispense whatever chosen form of manipulation, gesture, or subversion. In *The Freighthopper's Manual* by Daniel Leen (pp. 17-18) we are told that "the police are encountered less often on freights because freighthopping is essentially a private means of transportation, while hitchhiking is essentially public – you've got to stand out there on the side of the road in front of God and everybody." Parasitic media is the freighthopper that makes privacy essential. This privacy is the invisibility or the cloak that forms the definition of parasitic media response. Parasites are hobos that live off the rails of their hosts.

Parasitic response in media does not attempt to reassign function or modify primary usage. There is no threat to consumers of systems. Therefore these responses can fly under the radar of most monitoring systems. If nothing is disturbed, or at least knowledge of the disturbance is not transmitted, what you will have created is a backdoor or trapdoor to a system with your own set of predefined and augmented behaviors. The pattern of use for the system, whatever it might be, is not harmed or altered. This is critical to the concept of the parasite as activist. By adding functionality to a pre-existing system, you make use of only that which you create which in turn remains invisible. This means the parasite can then remain invisible, creating the semi-tangible notion of the ubiquitous backdoor.

It is possible to consider living parasites to be the most substantial group of activists in our world. Parasites make up the majority of species on Earth. Parasites can survive as animals, including flatworms, insects, and crustaceans, as well as protozoa, plants, fungi, viruses and bacteria. It is believed that parasites may now outnumber free-living species four to one. Parasites rule the earth and some believe have the

ability to not only participate in evolution but guide it invisibly. We can take our cue for social intervention from the action of the parasite. As Carl Zimmer says in *Do Parasites Rule the World?*, "every ecosystem on Earth is just as rife with parasites that can exert extraordinary control over their hosts, riddling them with disease, castrating them, or transforming their natural behavior" (Discover, Vol 21, No. 8 August 2000)

Parasites have the ability to manipulate the behavior of their hosts. There are two hosts available to a parasite that wishes to jump species, the upstream host which is usually directly controlled by the parasite and operates as a sort of delivery method, and the downstream host which seemingly behaves normally. It is believed by some that the downstream host is also manipulated by the parasite and may form a unique relationship with a parasite that enables the process of food gathering. This can be seen in certain parasites that infect fish. The parasite temporarily controls the behavior of its host to produce a flailing surface swimming target for birds. The birds benefit from the easy target of fish and as predators are surprisingly willing to ingest the parasitized fish. The parasite does drain a small amount of energy from the bird but that is easily offset by the benefit they provide. The relationship develops slowly and awareness becomes unimportant.

One amazing example of parasitic control of host behavior can be seen in the lancet fluke, Dicrocoelium dendriticum. As an adult, the parasite lives in a cow's liver. The fluke's eggs are spread by the cow through their manure. Snails feed on the manure and swallow the fluke's eggs. The young flukes penetrate the wall of the snail's gut and emigrate to the digestive gland. In the gland, the flukes produce more offspring which travel to the surface of the snail's body where they are dispensed of by the snail through balls of slime which are left behind in grass. Ants swallow the balls of slime in the grass which are containers for hundreds of immature lancet flukes. The parasites slide into the ant's gut before traveling around the rest of the body. Eventually they move towards the cluster of nerves that control the ant's mandibles. Most of the flukes then leave to return to the gut while a few remain behind in the ant's head. This is where some of the most amazing maneuvering occurs. As the evening approaches, infected ants do not return back to the colony with the other ants but instead climb to the top of surrounding grasses where they clench their mandibles on the blades and wait, motionless, until morning when they join back with the rest of the colony. These ants suffer from a period of temporary insanity where they are awaiting ingestion by a cow – which feed generally in the cool evenings. Once eaten by the cow, the cycle has been completed.

Might we be able to control media or our hosts in the same way as the fluke that drives the ant to temporary insanity? These parasites, that some consider to be the dominant forces in evolution and adaptation, are completing revolutions on a daily basis. They work with limited opportunity and utilize what might be seen as their disabilities, to not only control their host but also social behavior. If we can adapt this understanding to our own infiltration of media systems we could use the

power and the relationships that already exist as our carriers. As subversives and workers, we could mutate our hosts through an invisible invasion.

In an article on horizontal gene transfer, Dr. Mae-Wan Ho examines a study conducted by researchers at Indiana University in 1998 that found a genetic parasite belonging to yeast that only recently was jumping into unrelated species of higher plants. "The parasite is a piece of DNA called a 'group 1 intron' that can splice itself in and out of a particular gene in the genome of mitochondria" (Dr. Mae-Wan Ho, "Horizontal Gene Transfer," New Evidence, May 12, 1998). When the intron injects itself into a genome, it is able to add an extra stretch of DNA that does not belong to the host. The genetic parasite must overcome genetic barriers in the host that maintain distinctions in species. This same process may be responsible for the rise of diseases resistant to drug and antibiotic treatment. The parasites are learning. Genetic engineering uses artificial genetic parasites that operate as gene carriers. The carriers perform a horizontal gene transfer between unrelated species. The artificial genetic parasites are constructed of parts from the most aggressive naturally occurring parasites of which the group 1 intron is a member. It is still unclear what has caused the genetic parasite to leap onto higher level plants only recently; it does make us aware that parasites have learned the skill of adaptability for survival – so must activists and artists.

In parasitic computing, CHECKSUM running over a TCP (transmission control protocol) connection between multiple nodes or machines on the Internet is used to force solutions to mathematical problems. All the tasks are performed invisibly over the connected web servers. This operation is similar to the work done by the SETI@home program. SETI uses the computational power of computers that download its software to search through immense amounts of radar data for intelligent extraterrestrial life. A program like SETI differs since its hosts are aware and volunteer to submit their resources to reach a common goal. While this is a useful tactic in some situations, it is not what we are developing with a parasitic response. A parasitic computational response would act without permission and would serve as a passive interaction of unawareness. In a natural environment, permission is not necessary. Parasites are criminals that violate the artificial construct of permission. Parasites rely on their ability to remain undetected or at least not worthy of concern. Don't ask, don't tell, and don't bother.

Here it is important to make a distinction between two types of parasitic media response: incident-based and generative. The first and most commonly practiced form is incident-based. Incident-based parasitic media response takes place in a very specific time and space. There is no need for the parasite to live longer than a few days or even a few seconds. The more complex system is generative parasitic media response. Generative parasites must adapt and grow with their host system. This growth creates an allowance for greater sustainability of backdoors or hijacks. A parasite need not take advantage of its host's vulnerability to hijack. It is in the best interest of the parasite to live and feed alongside its host. There might

be other forms of parasitic response and media that will evolve with practice and discourse but for now it is critical to stress the separation of these two forms of behavior. The reason to create the separation is that while identifying both types of parasitic media responses, it is the generative or long term parasite that provides us with a tactic that has yet to be fully explored. It is important to detail and understand examples of incident-based parasitic media responses, but it is the generative parasite that has yet to be used as a tactical media response. This is the genre of parasite that coexists with its host and functions best over a long-term relationship. Both host and generative parasite grow together. It is the invisible parasite that feeds slowly off its host or extends abilities to its host that becomes accessible to outside users. The parasite either operates as an undetected and slowly emerging cellular shift in the organism, or as a backdoor to a host that provides extended functionality through invisible means. It might also be possible for a parasite designed to be incident-based to slowly evolve into a generative organism. Alternately, a parasite designed to be generative could die too soon or miss a level of adaptation. It will have served some function up until its point of separation from the host even in the event of an untimely demise. It is likely that given the speed at which communication systems and media reorder, many generative parasites will live fast and die young. It is the older media that might create better hosts for generative parasites. In using the term "older media" I am generically referring to anything from radio to electric companies to light bulbs to humans to insects to dirt to DNA. These may or may not fit all definitions of media, but they do have the possibility to become hosts for parasites.

Parasitic media does not need to occur within the realms of the electronic or computational; it can, and should exist at the cultural level as well. This model for tactical response can operate within all ranges of culture: the arts, the sciences, law and government. The criticality is to remain media-unspecific and fluid. Each response, each parasite must understand its host prior to any form of invasion or invasive procedures. It is through an understanding of the operation of a host that a parasite can co-exist and adapt to its environment. The parasite does not attempt to change its host through destruction since its own survival is dependant on the existence of its host. It instead must learn to adapt to changes in the host's structure. The structure can mean its cellular makeup, its organization, or its bureaucracy. This is where a unique value can be understood for parasitic attacks. Because of the nature of the parasite, primarily I am referring to the needed invisibility; responses can be slow to develop. The growth of the parasite does become an exponential one; or at least has the power to do so. With an augmentation, the device or system as host will continue to grow. A critical part of parasitic response is its need to interpret and react to environmental variable shifts that might occur. Parasites would benefit from being able to adapt to changes in their host entity.

We must begin to radicalize our definition now. We must take the mundane parasite and split it into an attack across all media. We must seek out hosts wherever they might be breathing. We must define now the industries and areas where parasiti-

cal media might be used as a form of response. I shall propose several names for distinctions between the genres of parasitic media that might be created: Slicing Parasites, Human Host Parasites, Soft Parasites, Hard Parasites, Memetic Parasites. Ideally these distinctions will blur themselves and new criteria will emerge. This exercise is used as a method for stimulating concrete thought of what a parasitic media response could actuate itself as. These are only sketches of deployment methodology. In any war, the weapons but be chosen appropriately and creatively. The parasite becomes both consumer and producer.

Parasitic media response is a practice that may not need such definitions. It has existed forever and at the same time is an infant. Finding new tools and choosing our weapons appropriately is the charge of the tactical media activist. Our weapons in the case of the tactic of parasitic media response are non-traditional. They are hidden from the views of the public and of the institutions of academia and the arts and sciences. They must remain hidden – their development and survival depend upon it. Parasitic approaches to media manipulation or extension is an area that demands much further experimentation. These experiments need not be technical. They can be as simple as vocalizing a concept or as difficult as creating transgenic organisms. These are all acceptable tactics for radical and parasitical behavior. We are in a period of tactical expression that is undergoing a transformation from an engineering model to a biological model, from logic to interpretation, from hard to soft. As this shift occurs, we are given an opportunity to reassert the aims of our practice while claiming the tactics of the parasite as our own media creation tool – a parasitic media.

In a time of renewed repression of political dissent, we must look to bacteria as our key to survival. Our fight is theirs. While radicals might appear to lack the capital or the voice afforded the ruling body, we are a critical appendage. We can invade our hosts as parasites. We can turn traitor and rise up in violent fashion with a gun held against the head of a genetic strand. We can mask ourselves as parasites. Invisibility is our savior. We can slay the beast from the inside out. The criticality is in remaining hidden when inside the belly of the beast. The beast is not the host itself but the functionality of the host. The parasite can operate within the host to slowly create a cellular shift in its primary usage. It is through a long cancer-like growth that the parasite can slowly alter the construction of its host. The generative parasitic media response that I am defining may not affect many immediate results. The incident based parasitic media that creates additional functionality or added usage for a host may eventually build its adaptation into the base makeup of its host. Rather than rely on an immediate revolution, these tactics are a form of molecular revolution that take much planning, skill, and patience. There value will be determined with time. Like the mythical Jonah who was swallowed by a whale, we will tear our way out from the inside and survive longer than three days and three nights inside the belly of the host creature. This is the cry for a parasitic revolution.

I leave you with a quote from Dumont in the 1982 Disney techno-classic movie "Tron": "All that is visible must grow beyond itself, and extend into the realm of the invisible."

— September 2002, revisited April 2003. The extended version of this essay, including examples of actions that fit into the categories of Slicing Parasites, Human Host Parasites, Soft Parasites, Hard Parasites, and Memetic Parasites, is available online at http://www.carbondefense.org.

17

The Language of Tactical Media

Joanne Richardson (Romania/US)

||

"World War III will be a guerrilla information war, with no division between military and civilian participation."
– Tactical Media Crew, borrowed from Marshall McLuhan

he future is a series of small steps leading away from the wreckage of the past, sometimes its actors walk face forward, blind to the history played out behind their backs, other times, they walk backwards, seeing only the unfulfilled destiny of a vanished time. The promise of the tactical media of the future — the end of the spectacular media circus as everyone begins to lay their hands on cheap "do it yourself" media technologies made possible by new forms of production and distribution — was inspired by a distinction between tactics and strategies made by Michel de Certeau in 1974. Strategies, which belong to states, economic power, and scientific rationality are formed around a clear sense of boundary, a separation between the proper place of the self and an outside defined as an enemy. Tactics insinuate themselves into the other's place without the privilege of separation; they are not a frontal assault on an external power, but makeshift, temporary infiltrations from the inside through actions of thefts, hijacks, tricks and pranks. But for de Certeau, the distinction was almost entirely focused on the power of reading (the consumption of signs) to transform submission into subversion. The most memorable example of tactics in *The Practice of Everyday Life* is the indigenous Indians who under Spanish colonization appear to be submissive but really "often made of the rituals, representations, and laws imposed on them something quite different from what their conquerors had in mind; they subverted them not by rejecting or altering them, but by using them with respect to ends and references foreign to the system they had no choice but to accept." The apparently submissive kneel, bow down, put their hands together in prayer, but they don't believe the words; when they mouth them they secretly mean something that was not intended by the original producers. The strength of their "resistance" is in their silent interpretations of these rituals, not in their transformation.

Maybe the most interesting thing about the theory of tactical media is the extent to which it abandons rather than pays homage to de Certeau, making tactics not a silent production by reading signs without changing them, but outlining the way in

which active production can become tactical in contrast to strategic, mainstream media. The examples of tactical media have almost become canonical by now: billboard pirating by Adbusters, plagiarized websites by the Italian hackers 0100101110101101.org, ®™ark's mock websites for G.W. Bush and the World Trade Organization, and (as the Yes Men) their impersonations of WTO representatives to deliver messages that don't challenge the WTO's position but over-identify with it to the point of absurdity. In contrast to mainstream media, tactical interventions don't occupy a stable ideological place from which they put forward counter-arguments; they speak in tongues, offering temporary revelations. But while shifting the emphasis from the consumption of signs to an active form of media production, the theory of tactical media seems to have lost some of the original contours of de Certeau's distinction. The tactical media universe as mapped by David Garcia and Geert Lovink in "The ABC of Tactical Media" also included "alternative" media, although its logic seems quite different. Grassroots initiatives which are focused on building a community around other values than the mainstream do occupy an ideological place that is marked as different; they don't infiltrate the mainstream in order to pirate or detourn it, as ®™ark might infiltrate the media image of the WTO.

Especially in the recent transformation of alternative media into the global Indymedia network, the separation between Indymedia's alternative voice and the mainstream enemy is quite evident. Indymedia critiques the pretensions of mass media to be a true, genuine, democratic form of representation; it opposes the false media shell with counter-statements made from a counter-perspective – a perspective that is not questioned because it is assumed as natural. My Italian friends who work with Indymedia showed me a video they co-produced about the anti-globalization demonstrations in Prague and asked what I thought. I replied that it was a good piece of propaganda, but as propaganda it never examined its own position. In this video you see a lot of activists who came to Prague from America, UK, Netherlands, France, Spain, Italy, etc.; occasionally you even get ossified Leninist bullshit from members of communist parties. What you really don't get is any reflection of the local Czech context – many locals denounced what they saw as an attempt to play-act a revolution by foreigners who invoked slogans from an ideology the Czechs themselves considered long obsolete. The confrontation of these different perspectives is absent from the video, since it is meant to promote Indymedia's own anarcho-communist position, raised to the level of a universal truth. And in this sense it was as strategic and dogmatic as mainstream media; it was only the content of its message that differed.

De Certeau was a child of his time; maybe as a former Jesuit he was more timid and better behaved than his siblings, but he played with the same conceptual toys. In its historical moment tactics was an important idea that sought to define a way of subverting the information spectacle that would avoid using the same tools (strategies) against its opponent. Tactics recycled the Situationist idea of detournement: taking over the images and words from mass culture, but putting them through an

unexpected detour, using them in a way they were not originally intended by combining them in surprising combinations, heretical juxtapositions. The Lettrists kidnapped a priest, and, dressed in his gown, gave a sermon at the Notre Dame on the death of god; the SI altered the soundtracks of karate and porn films to reflect the struggle against bureaucracy; even striking workers during May '68 stole the media image of James Bond with a gun for a poster announcing themselves as the new specter haunting the world. These were neither art nor political speech; their disruptive power was that they did not use the familiar, straightforward language of politics. Their wit and lack of directness was a measure of their success; the danger always lurking in the background was that this new mode of production through theft and infiltration of public spaces, including the media, could ultimately be used to deliver the same kind of blunt, inflexible propaganda as the media spectacle. As a practice, detournement reflected a contradiction between the recognition that fighting on the same terrain as the enemy is a seductive but inevitable trap, and the desire to occupy the buildings of power under a new name This contradiction crystallized in the hijacking metaphor: *detourne* was a verb commonly used to describe the hijacking of a plane.

The SI played upon this connotation, announcing their own productions as hijackings – of films, of politics, of quotidian desires. The terrorist as a symbolic equivalent of the subversion of power was never far in the background of associations. And in an almost straight line stretching across the precipice of history, aesthetic terrorism continues to be invoked as an honorific title. eToy advertise themselves as "digital terrorism"; in an interview, Mark Dery called CAE a "philosophical terrorist cell" and made comparisons to the Red Brigades; ®™ark is often congratulated for its brand of "media terrorism." Now it could be lamented that an unfortunate metaphor is being applied to practices that are very different – but in what sense is the affinity only a matter of metaphor? Terrorism is a way that the weak, lacking the strength in numbers and political influence, can try to make use of the strong by infiltrating their places of power, in the hope that the temporary seizure of a key building, an airplane, or a politician might shift the balance of things and bring power to the bargaining table. Ever since terrorism abandoned the tradition of tyrannicide and became a form of propaganda of the deed, it operated through a hijack of the media. Letters to the press, communiqués: 5 minutes under the opaque illumination of the media spotlight. The terrorist use of media hijacks is the point where tactical media and strategy meet – it may be a surprise infiltration rather than a direct attack, but an infiltration with a clear sense of separation between its own position and that of the enemy, an infiltration that ultimately mirrors the political organization, juridical system and mode of expression of the power it opposes. The Red Brigades' hierarchy of brigades, columns, national branches, and an executive committee was a double of the centralist organization of the state; the Weather Underground's counter-institution of "proletarian" justice mimicked the obscenity of the law in reverse: "We now find the government guilty and sentence it to death on the streets." And today's fundamentalist terrorism is a mirror of the network society of a stateless, global capitalism. Western educated bin

Laden militants don't belong to any specific country; they travel the globe from Bosnia to Paris and New York, use the internet and cellular phones, and have access to communication networks even in a desert cave.

Asking how media can be used tactically today implies a recognition of the contradictory history in which the idea was born – the moment of crisis when new social forces rendered old categories obsolete, and Marxism began to reveal itself as a bankrupt system in which capitalism found not its abolition but its supreme fulfillment. But alongside new ideas and the search for a new language lingered old modes of organization dating back to the Jacobin terror of the French Revolution, and the mythic image of the armed, militant hero. Tactics sought to express a new way that the weak could fight against power by using different tools – but in the old language of military engagement. Before de Certeau, the distinction between tactics and strategy was invoked by Clausewitz in 1812. Tactics is the manner of conducting each separate combat; strategy is the means of combining individual combats to attain the general objective of the war. Tactics is the deployment of individual parts, strategy, the overview of the whole. This is a very different distinction from de Certeau's opposition between modes of combat; de Certeau's tactics is closer to what Clausewitz called *strategem* – a concealed, indirect movement which doesn't actually deceive but provokes the enemy to commit errors of understanding. This is analogous to what Sun Tzu termed a "war of maneuver" – an artifice of diversion undertaken by weak forces against a large, well-organized opponent, an unexpected move that entices the enemy, leading him to make mistakes, and eventually self-destruct.

Whether direct or concealed, offensive or defensive, using the strength of numbers or the artifice of diversion, both strategy and tactics belong to the art of warfare and have the same objectives: conquering the armed power of the enemy, taking possession of his goods and other sources of strength, and gaining public opinion by destroying the enemy's credibility. And perhaps this is the limitation of a media theory based on a distinction between tactics and strategies – ultimately both are a form of war against an enemy power. The tactics of media hacks may differ from the strategy of independent, alternative media in their formal aspects, but what seems common to both is their self-definition through an act of opposition. A fake GWBush page cannot exist without the authentic one, which it parodies. Indymedia cannot exist without global capital, whose abuses it chronicles, or without mainstream media, whose falsifications it denounces. The mainstream also needs an embodiment of opposition to the universal values of democracy, enlightened humanitarianism, and the right to consume without restraint. And after the collapse of the other of "Eastern Europe," the image of the terrorist is now the perfect media fantasy, the face against which it can define its own values in reverse.

This reflection was occasioned by my editorial participation in the 4th Next 5 Minutes Festival; it's an attempt to think about its content, which proposes an investigation of the meaning of tactical media in the wake of September 11, and its decentral-

ized organizational structure, which will transform it into a series of dispersed but linked events, each focused on different local issues. If, as David Garcia admits, the idea of tactical media grew out of a specifically Amsterdam context (or perhaps in a wider sense, the liberal democratic context of the countries of advanced capitalism), it is commendable that N5M4 is attempting to transcend its origins and include initiatives that were previously left out of what seemed to be a primarily "western" idea of tactical media. The editorial team for N5M4 includes media tacticians like CAE, members of the Indymedia network, media centers in post-socialist countries which provide infrastructural support and access and education to local producers, and European organizations which provide ICT assistance to groups in Mali, Ghana, Tanzania, Uganda, Zambia, Jamaica, and Bolivia. Under the expanded cover concept of tactical media are included what appear to be both tactical and strategic media, as well phenomena that differ from both insofar as they are not forms of warfare — initiatives to provide infrastructure, improved access, means of communication and exchange to people who for economic and political reasons are lacking these means. These modes of production and exchange are not primarily constituted by being directed against an enemy; the content is not determined in advance through a preconceived opposition, but left to be shaped by its producers. Now to my mind, labeling all these diverse practices forms of "tactical media" risks missing precisely their differences and making the term meaningless. This loss of signification seems to correspond, in inverse proportion, to the recent inflation of "tactical media" as a cool label on the market of ideas. Instead of analyzing concretely what is inherent in different forms of media production and the ideologies they shelter and preserve, the term papers over their contradictions. Tactical media is good, progressive, alternative, etc. There is no need to ask questions; its truth already appears self-evident.

After making some extremely arrogant, offensive films of Maoist propaganda during the early 1970s, Godard became embarrassed, and started making films that had nothing to say. *Here & Elsewhere* – we went to Palestine a few years ago, Godard says. To make a film about the coming revolution. But who is this we, here? Why did we go there, elsewhere? And why don't here and elsewhere ever really meet? What do we mean when we use this strange word "revolution"? It is only when he was old that Godard learned how to ask questions, stumbling around like a foreigner in a language and a history he did not possess. *Here & Elsewhere*, which came out in the same year as de Certeau's book, occupies no fixed position, moves towards no preconceived destination, and takes nothing for granted, not even its own voice. In an era dominated by a politics of the message (statements, declarations of war, communiqués, demands in the form of new five year plans), it searches for a politics of the question.

The idea of tactical media is the harbinger of a question both necessary and timely: how is it possible to make media otherwise, media that expresses its solidarity with the humiliated thoughts and incomprehensible desires of those who seem doomed to silence, media that does not mirror the strategic power of the mainstream by

lapsing into a self-certain propaganda identical to itself and blind to its own history. But the language of tactical media simultaneously imprisons the idea of a different type of media production inside a theory of warfare, as a media of opposition, determined to conquer the enemy. While it is necessary to continue asking the question and experimenting with media that work in situations of crisis and adversity, it is also important to know when to change terrain. As wars rage around us — wars that rationalize the trafficking in merchandise under the shadow of sublime principles, wars against terrorism, wars against drugs, wars of information against information — maybe what we need least is to advertise our practice as an extension of one or another principle of warfare. When asked to take sides, for or against, siding with one army or the other, sometimes the only real answer is not to play the game. This refusal should not be confused with an exodus, a silent passivity, or a patient resignation. It is the vigilance of continuing to think, beyond the obvious — of a third, a fourth, or fifth alternative to the apocalyptic or utopian sense of the media.

– Cluj, 2002.

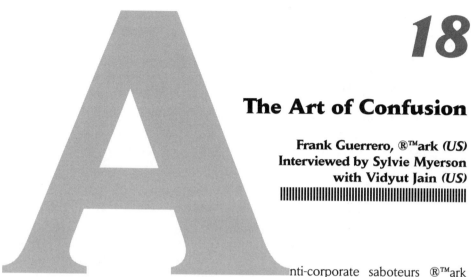

18

The Art of Confusion

Frank Guerrero, ®™ark *(US)*
Interviewed by Sylvie Myerson
with Vidyut Jain *(US)*

nti-corporate saboteurs ®™ark have been causing trouble since 1993, when they started off as an Internet bulletin board. They have grown and developed to such an extent that they are now at the forefront of "culture jamming" — subverting the language of corporate and advertising culture to point out what is brewing beneath the surface. ®™ark operates somewhere in the gray area between activism and performance art, or what Hakim Bey once referred to as "poetic terrorism."

< origins of ®™ark >

> *From looking at your web site (www.rtmark.com), it seems there's a certain amount of ambiguity about whether a specific project should be taken as a joke or a really serious act of sabotage.*

A lot of the projects do use humor as a means for slipping under the radar of social acceptability. Now just because a lot of the projects are funny doesn't mean that ®™ark's mission isn't serious. It is a serious system that means, through a combination of real actions and theater, to criticize and hopefully undermine the role that corporations are taking in supplanting democratic or social processes of governments. This is our main reason for being.

We feel very strongly that corporations have been slowly but surely supplanting and subverting the processes of government that were put into place so that the people could have some sort of say in their political and social destiny. It seems like this is an important moment in globalization — with all these international borders coming down — at least for capital, though not necessarily for people. We see it as a real problem that's boiling over.

So ®™ark is a way to attack that system from within using primarily theatrical and pedagogical means. We're there to destabilize the system in such a way that people might get a little entertainment and at the same time have those projects ask a few questions of them.

> *How did you develop from your original structure as a bulletin board?*

When the bulletin board went up in 1993, it was a networking tool that worked mostly through word of mouth. But ®™ark changed and is now coming into its own by using the Web as an open-ended networking and databasing tool.

We have a database that lists basically three things: the project idea, a funding amount and, lastly, workers. So you can come to the site and read through the list of ideas. If you see one that you like, you can offer to sponsor the project with some money or you could offer to perform the project. If it's an idea, let's say, to change a gas tank in a production automobile so that the gas tank can only hold two gallons of gas instead of 20, and you happen to be working on a production line where they're installing gas tanks, you might volunteer your services.

It's an open-ended system, and you can come to it with money, or you can come to it as a worker with an idea looking for money... That's probably the most common thing. People submit ideas they want to carry out themselves but need to raise some capital to do it.

> *So ®™ark is a facilitator?*

Yes, ®™ark is a facilitator, and ®™ark's primary reason for existing is to use the corporate veil as a way to permit people to offset their liability for participating in these projects, many of which fall into the gray areas of the law... [Some] of these projects receive cease-and-desist letters and legal attacks.

As a corporate entity, ®™ark is able to take these projects and provide a corporate umbrella for them, absorbing some of the liability and displacing it from the workers and the funders. This is the way the business world works anyway. If you form a corporation, your corporation can go bankrupt or, in the case of Union Carbide, have a major avoidable accident that kills 8,000 people, and yet the corporation stays in business despite having these crimes on the record. We feel that in this way ®™ark can highlight what we see as a double standard for corporations and people with the limited liability potential of corporations.

< voteauction.com >

> *One of your projects caused quite a stir during the U.S. presidential elections last year. Voteauction.com, a site created by James Baumgartner, was described as a project "devoted to combining the American principles of democracy and capitalism by bringing the big*

*money of campaigns directly to the voting public. We provide a forum for campaign con-
tributors and voters to come together for free-market exchange."*

The site used parody to point out that elections are influenced by the amount of money poured into the process by large corporations. Voteauction.com was closed by Network Solutions without any kind of notice after the Chicago Board of Elections filed an election fraud lawsuit against the domain. The New York State Board of Elections also told Baumgartner that they could press charges against him. Having received this threat, Baumgartner closed his site, selling it to Hans Bernhard, an Austrian businessman who took the site outside of U.S. jurisdiction. What was your involvement in this project?

We helped with the Voteauction launch by putting James in touch with a worker (a publicist who could help him get the word out), and by procuring a small invest-ment to help him pay for some of his hosting costs and phone bills. Later on, when James was under attack, we helped negotiate the sale of the site to ubermorgen.com in Austria.

> *To what extent was this intended to be a parody? It seems like some well-meaning people took it at face value, as a genuine subversion of the electoral process.*

Many famous satires have been taken seriously by some of the public. Even things like Swift's "A Modest Proposal," despite being completely unbelievable, made people genuinely angry about eating babies... But perhaps the lesson here is that even something as outrageous as suggesting babies as food isn't that outrageous, given the past relationship between the English government and the Irish, and the cir-cumstances of the potato famine. And in the case of Voteauction, it really isn't that outrageous for a company to be selling votes, given the way that elections work in this country today.

> *Was the project a success?*

It was extremely successful because it was seen by millions of people and became a subject of public debate around the world. I think in many of those news stories it successfully demonstrated just how corrupt our so-called democracy has become.

> *The Yes Men at WTO is another fine example of creating confusion and certainly one of ®™ark's funniest projects. It is summarized on the ®™ark site: "In early 2000, ®™ark transferred Gatt.org – which people sometimes mistake for the World Trade Organization's official Web site – to a group of impostors known as the Yes Men.... In May 2000, the Yes Men received an e-mail inviting Mike Moore, Director-General of the WTO, to discuss the WTO at a conference on international trade matters [hosted by the Center for International Legal Studies in Salzburg, Austria]. The Yes Men decided to do the ethical thing, and to try their best to fulfill the request. In late October, one Dr. Andreas Bichlbauer – the substitute "Moore" decided to send – spoke at the conference. His lecture described*

the WTO's ideas and ultimate aims in terms that were horrifyingly stark — suggesting, for example, the replacement of inefficient democratic institutions like elections with private-sector solutions like an Internet startup selling votes to the highest corporate bidder. None of the lawyers in attendance expressed dismay at Dr. Bichlbauer's proposals."

The only people who seemed to react to Bichlbauer's outlandish remarks were some Italian delegates who were offended by his statement concerning the impossibility of a merger between KLM and Alitalia due to the basic laziness of the Italian worker.

Posted on the ®™ark site is a hysterically comical series of letters and e-mail correspondence between Dr. Bichlbauer, Professor Campbell (the conference organizer), "Mike Moore" and his administrative assistant, Alice Foley. Through the series of letters, memos and e-mails, we see the farce unfold.

The whole thing really goes over the top when the Yes Men prolong the hoax by announcing that their representative has been "pied," contracting a grave illness from a bacterial infection. (Was the pie intentionally poisoned? Possibly by an offended Italian delegate?) Dr. Bichlbauer is promptly disposed of and a memorial service announced. The hoax is revealed as messages expressing both sadness and confusion pour in. Finally, a conversation takes place concerning the point of the exercise.

>So what was the point?

The Yes Men use affirmation to make their point. It is an unusual rhetorical strategy, almost a reverse-psychology approach. Instead of debating their opponents, they assume their opponents' identities and enthusiastically affirm their adversaries' beliefs. It's an unorthodox approach, but hardly new or original. In fact, I think something like Swift's "Modest Proposal" also falls into this category, in a sense.

The point of this Salzburg action was to enhance the legibility of the WTO's policies. To that end, the Yes Men gave a kind of uncensored version of the WTO's positions. There was an audience of legal experts who basically did not object to Andreas Bichlbauer (real name: Andy Bichlbaum) explaining that the WTO believed in doing away with all cultural differences (for example, siestas) that get in the way of free trade.

Since the expert audience agreed that Voteauction.com was a model for making elections more efficient and opening new markets, it appears that the Yes Men failed to cause any revelations at the event. However, clearly this should be a wake-up call to all of us who care about our votes… or any kind of representative government reflecting social interests.

> So why did Bichlbauer's offensive remarks not cause a stir?

I think it reveals that belief in late capitalism runs so deep that even an audience of specialists in trade and law refuse to see a fundamentally antisocial, if not fascist, message in the text. When that happens, people can only be blind to their complicity in an oppressive system.

< confusion >

> *Although you claim to use pedagogical means, it seems that creating confusion is one of your preferred tactics, and this is one of the recurrent criticisms made of your methods. Don't you think that this might just result in preaching to the converted and antagonizing the other side, further polarizing the debate?*

®™ark is one of only a few organizations who try to support these bizarre projects, so I think that is why we become known for confusion. Try to find a "legitimate" funding organization interested in the value of confusing people, and I think the list will be pretty small. And yet, if we sample history, I think we will see that confusion is a very important aspect of human communication, one that is as useful and prevalent as a more didactic approach.

We believe that all methods must be pursued in the interest of change. Certainly, those who are taking a more direct approach are doing the most important job for creating change. But there are people out there doing those things, and we happen to be better at something else. We believe that confusion is a very valuable state.

> *You attack corporations and large international organizations, yet you get reviewed in Artforum. Are you artists, activists, anarchists or a little of all three? Do you care how people perceive you?*

All of the above. Most importantly, we are people. We see all media outlets as potential sites for communication and dialogue to a wider audience. If we end up in art mags, so be it. We also like to be able to express ourselves in business publications, sports rags, etc. We do care about how people perceive us; we hope that through ongoing outreach we can contribute to the growing movement against unfettered global capitalism.

— *The interview first appeared in IN THESE TIMES (www.inthesetimes.com). The first part of this interview, in which Guerrero discusses the group's mission and tactics, is condensed from an earlier interview conducted by Sylvie Myerson with Vidyut Jain for the nonprofit arts magazine SANDBOX (www.sandboxarts.org), issue #7: Art vs. State.*

19

A Reaction to Tactical Media

Sfear von Clauswitz _(US)_

||

istory is no more behind us than we can walk through time. There is no destiny and no vanishing. Tactical media makes no promises.

< tactics vs. strategy >

The spectacle and spectacular media are forms of tactical media, even more so now than in the future. Newer forms of media production and distribution — computers, cameras, the internet, etc. — are not tactical. They exist as ballistics in the war of art, as does detournement and heretical juxtaposition. How these armaments are combined in conflict constitutes tactics.

These tactical conflicts culminate towards strategic goals. Strategy is defined by Clausewitz as a collection of battles in a war regardless of who the actors are.

Thus, strategy exists outside of nation-states and other such boundaries, just as Terrorists wage a war outside of such boundaries. As individuals become empowered with the ballistics of nations, so strategy becomes more useful for describing their activities. Individuals begin to enter the global strategic theater.

Strategy is not political, and cannot be in opposition to tactics. Strategy outlines a discourse of interactions, at times political, military, or aesthetic.

Tactics is no more a tool of resistance than a tool of the state. Isn't it enough to say it is a tool, and begin to explore its uses? How can we discuss the exchanges of tactics other than on a plane of strategy?

A Reaction to Tactical Media

< artists & hackers >

While many artists and hackers use tactical media, the divorce of these battles from the strategic and logistical landscapes renders such actions less significant than similar tactics in use by national and business actors.

EBN and Negativland developed beautiful munitions (heretical juxtaposition), and both Adbusters and ®™ark expand art's reach and capacity into new theaters. All of which is necessary for the expansion of art on the conceptual landscape.

However, much of this work has been fueled by the political agendas and affiliations of these artists. While alliance with the activist, anarchistic, and anti-globalization syndicates has enabled these developments, it has also created linguistic partisanship that prevents art's expansion into the strategic and logistical theaters

< the study of tactical aesthetics >

As tactics, subversion of a dominant is no more valuable than submission to a dominant, outside of a specific theatrical context. In this way, both diversion and alliance, as tactics, might serve a particular end at a particular time.

The super-empowered artist does in many ways resemble a Terrorist, but the association is superficial in as far as it perpetuates the political roots that modern aesthetic warfare technology was developed within.

Many noble sciences have been detoured by militaries to serve very different political ends than their creators had intended. It is with this detachment from originating political bias that aesthetic warfare must be studied.

Information warfare (future war) deals heavily with propaganda. Aesthetics enables propaganda. Advanced practitioners of aesthetic theory should then be adept at the creation of propaganda, whether they work for Indymedia, themselves, or the government.

Propaganda hijacks neither the media, nor the deed. Deeds no longer exist separate from information media. The process of recording mediates the phenomenal and thereby defines informational theaters. Propaganda, tactics, aesthetics, and strategy — all require a recorded or informational value.

Digitization is one trend that contributed to the passage of warfare from the physical to the informational landscapes, but one of many. Death of distance, identity fragmentation, mass mediation, the deconstruction of language, and copyright law all contributed threads.

However, once all aspects of warfare can be translated into flows of information, a language of aesthetics reveals the way that information can be used as warfare. It is aesthetics that enables information. In this way, tactical media is a form of aesthetic information warfare.

Artists are now in the best position to leverage their aesthetics to create a technology gap between art and rival conceptual frameworks. Tactical media may well be the most overt part of this larger process.

< modes of warfare >

Clausewitz's tactics enable both the weak and the powerful. However, by embedding class opposition into the language of military art, de Certeau destroys the usefulness of the terms describing modes of conflict outside de Certeaus specific theater.

Clausewitz's strategem and Tzu's war of maneuver are both useful tactics, in their time and ours. An artifice of diversion is a method of using information for tactical advantage. It is one of many tactics used by the mainstream and many others, but to limit arts investigation of warfare to one tactic, or to tactics as a dominant mode, limits art's ability to maintain viability in the conceptual landscape.

The battle between the mainstream and the alternative cannot trace the full spectrum of media tactics, but even if we were to concentrate our investigation there, how could we foresee a victory or lasting resituation without considering the strategy of this particular theater?

Also, the language of economics permeates our telling (and recording) of this conflict, and yet the language of logistics is missing. Perhaps this is due to de Certeau's politicizing of the modes of conflict, but then perhaps we have just not looked hard enough.

The continued viability of tactical art does require global participation, but it also requires a language to describe and refine that global participation — how it is gathered and distributed, authorized and synchronized. This language is the de-politicized language of strategy. A language that must be developed separate from the paradigm and perspectives of any specific theater, most of all the theater of activists, from which the vast majority of its practitioners emerge.

The preconceived opposition forms an essential context within which to discuss a particular theater. The specific economic and political intensities of a theater do form the essential difference between tactics as employed by different groups. Economic and political intensities are useful and even essential when recording the story of a battle.

But while these intensities are valuable we do not seek a history of the political winners. Nor do we seek a lexicon of potential media tactics. What we seek is art, an

art of war, the beautiful forms of information that can be applied to shifting the-
atrical contexts. We seek a way to describe the exchange of informational flows
within the theater.

We seek these things because it is the only way art agents will be useful actors in the
quickly shifting landscapes of the future, and advanced practitioners of aesthetic
informational warfare and tactical media may be the only way for art to remain a
viable conceptual framework.

> — *Response to "Language of Tactical Media" by Joanne
> Richardson. This article was produced as part of the
> Subliminal Propaganda Institute's annual roundtable on
> the nature of art in 2025.*

20

On the Tactic of Tactics

McKenzie Wark
(Australia/US)

henever a term passes backwards and forwards a few times without much reflection, I'm inclined to look up its origins. And so: "tactic" — which seems to have a Greek root, meaning to order or arrange. And "stratagem," which Caxton took to mean "artifice to surprise an enemy." A device or trick. Its root is the word *stratos*, or army, modified with a suffix that means "to lead."

I find the idea of the device or trick more interesting than that of ordering or arranging. Trick media, ruse media, media strategems — that sounds more encouraging. The problem is not so much escaping or staying ahead of meaning, as camouflaging one kind of sense in another. How can media vectors connect subjectivities together in such a way that they can conduct a conversation that might pass unnoticed, or remain misread, in the midst of all the others? Such a conversation, such a subjective endeavor, would most likely not be spatially or economically autonomous, but might nevertheless have an aspect of itself that remains free from capture by the prevailing vectors of capital and media.

But lets face it, talk of strategy and tactics is boys' talk, part of a retrograde fantasy we can all live without. The language of "mobilization" is itself part of the problem, and a hold over from the cold war. Intellectuals, artists, media people are supposed to join the ranks of this or that "movement" to fight against this or that foe in this or that "emergency." Suspension of aesthetic, ethical and political freedom for all can then be legitimized in the name of a higher calling.

So it's not a choice of tactics or strategy, but a choice of an authoritarian language for media practice or a democratic one. The mobilization of "forces" or escape from the grid of compliance, whether to the dominant power or its mirror image, the avant garde that would take its place.

It's more than a question of metaphors. Language doesn't represent anything. It connects things and people. It proliferates and reproduces itself in the process. The trick is to get the connecting and reproducing sides of language to work towards the production of plurality, difference, zones of liberty where meaning is neither led from the front nor punished at the margins.

Confrontation seems to me to usually involve the reproduction of the language of confrontation and authoritarian relations between people and things. Language becomes a matter of giving orders, announcing decrees, denouncing heretics, defining limits — and pronouncing all of the above to be necessary in the name of this or that emergency.

Escape, on the other hand, is something else. It usually requires a ruse, a cover, a fold in the coding. It appears to be one thing, but it might also be something else.

A favorite example: "burn baby burn" — a slogan from the Watts riots, tucked in a fold in a disco song: "I heard somebody shout burn baby burn disco inferno burn the mother down!"

The virtual side of media is the ever-present potential that some completely different subjective event will form out of what seemed like quite routine utterances. It's always threatening to veer towards flux. In the flow of media, as in the flow of water, order is always temporary. Its always on the verge of escaping towards pure difference.

Another example, from the endless riches of what Lester Bowie called the Great Black Music: Aretha Franklin, singing gospel as a teenager. Conventional words of piety. Suddenly shrieking, "Never gonna die! Never gonna die!" Her voice jumps straight into another realm, somewhere beyond meaning, into sense itself. Its as if the vibrations of her body transmit themselves, across space and time, across means of recording and distribution and reproduction, from her body to mine. An event outside meaning, or maybe inside it, hidden in the folds of it. Waiting to transmit.

There are any number of languages in which one might talk about media: aesthetic, ethical, political, but surely the military is the least necessary of them. And don't buy the old furphy about the "military origins" of the internet. The internet has many origins. It's a hybrid of a whole bunch of technologies, pioneered in lots of different places and organizational contexts. There is no necessity embedded in its origins. The net is what it becomes. Do we know yet what the net can do? I don't think so. The collective experiments have only just started. We have some idea what you can do with a book or a song, they've been with us a long time. We've suffered from some pretty extreme experiments with the so-called mass media. We've had the telephone for years but nobody has bothered to think much about the democratic potential of this remarkably distributed kind of media. And the

net... we're just starting, even though the technology goes back about 20 years now. That's nothing.

But the diversification of creativity on the net is still held back by a much older "technology" — language itself. Always the old terms! "Tactical media," "Net art" — like calling a motor car a horseless carriage. It is waiting for a revolution in language to reveal what lies hidden in its virtual folds.

— Sydney, Australia, 22nd May, 1997. Netletter No. 13. First distributed via NETTIME.

Response to the Tactical Media Manifesto
A Network of Castles

Peter Lamborn Wilson (US)

Tactical media, then, would be a kind of filth — an organic process — as compared with the ideological cleanliness of strategic media (the "author").

Do we need a defense of filth, or a theory of filth — as fertility, as pleasure, as relaxation from the rigidities of "Civilization"? Not nostalgia for the mud, but the mud itself? Or would such theorizing simply become another kind of tidying-up process — an erasure of its own theoretical object?

The tactical problem consists of the need (or desire) to stay ahead of representation — not just to escape it, but to attain through mobilization a relative invulnerability to representation. And the problematic aspect of the problem is that all media — even tactical media — deal in representation.

Thus one can follow the trajectory of a given tactical medium, through ever greater representation, towards the fate of being subsumed into some strategy. And the fatal black hole toward which so many of these trajectories vanish is Capital — of course.

Everything is a process of being cleaned up. To preserve its autonomy the tactical medium wants to remain dirty — it can never let itself be surrounded and cleared by strategy, by ideology. It must stay out ahead, drifting before all possible waves, uncertain even of its own trajectory.

By another paradox, this uncertainty itself becomes a "principle." It comes to occupy the space of a strategy — and thus to define a strategic space. No "authors" need to be implicated. A messy organic process — involving both reason and unreason — not imposed or categorical — emergent. Shape-shifting. Dangerous and plagued by failures. But not aimless or undirected. In effect — strategic.

Media as technologies ("machines") are perfect mirror-representations of the totality that produces them (or vice-versa). The internet, for example, mirrors not only its military origin but also its affinity with Capital. Like globalism, it breaks through borders — it is a "chaos," like Capital (which seeks the Strange Attractor of the numisphere, where the numinous and the numismatic are one and eternal). One might even speak of "nomadic" features ("migratory capital"). Like Capital, the Net is drawn toward virtuality, cognitive prosthesis, disembodiment. But (the "vice versa" process) media tend simultaneously toward the production of the totality — a complex multi-feedback relation.

In one sense, tactical media would then have to engage in the destruction and/or sub-version ("substruction") of this complex — driving a wedge between the machine and the totality. Such action would imply that the totality is far from total, that there will be interruptions along the feedback lines, breaks in "service" — missing zones, and zones of resistance.

Ad hoc, constantly mutating, determinedly empirical, at this point tactics begin to coa-lesce into a strategy ("spontaneous ordering"). Because this strategy has no "author" (and is not ideologically driven) each tactical medium — each tactician as medium — will be able to seek direction from it without losing autonomy to it. Thus the complex interplay between tactic and strategy is one of mutual validation or "co-emergence."

At this point, the metaphor of the castle — introduced by the Manifesto — takes on an added luster, or perhaps a baleful gleam. The Nizari Ismailis (the so-called "Assassins") structured their polity around a network of remote castles, most of which were inaccessible to every medieval military tactic — even prolonged siege, since they were supplied with their own gardens and water. Each high castle typi-cally protected a fertile valley and was therefore self-sufficient — but full commu-nication and even economic activity could take place within the network thanks to the "porosity" of medieval borders. And thanks to the policy of assassination or threatened assassinations, kings and religious authorities hesitated to interfere. This went on for centuries.

Some years ago I remarked that the Nizari model for utopia had been rendered impos-sible by modern technologies of war and communication. Perhaps it would be interesting as a thought-experiment to see if this negative judgment still holds true. From a military viewpoint of course it does — the "isolated castle" (or commune or the like) can still be eliminated by the push of a button. But "the military" must have a reason for such action. Since "assassination" is an absurdity (e.g. the Unabomber) — and even "militance" must be re-defined — there may be no imme-diately apparent reason for the military to suppress a given "autonomous zone."

The question of communication technology is trivial by comparison, but interesting. The Net as a "military" structure is "accessible to all," and even as Capital absorbs

the Net these tactical areas of indeterminacy persist — the same holds true for all "intimate" or tactical media. Thus the "network of castles" becomes possible — but the real question is whether the castle itself is possible.

Like any institution the castle will exist in part as a representation of itself in media. The Assassins' castles were rooted partly in the *imaginaire*, in the image that pervaded medieval media (text, word-of-mouth, legend), in the image of mysterious inaccessibility and danger. The Mongols finally destroyed Alamut not by direct assault but by demoralizing it with an even more fearsome image (pyramids of skulls from China to Hungary, etc.). But at its height of power, Alamut could dispense even with assassination, since the image alone sufficed to ward off all military and political attention.

Under the regime of global neo-liberalization or pan-capitalism that triumphed in 1989, the nation-states of the world have begun to "privatize" all social functions for the collection of taxes for the support of military and police force, and the use of that force in the interests of Capital. The "natural law of the free market," however, clashes with the remnants of social ideology embedded in such structures as the UN, the EU, or even the "old" liberal or conservative regimes of certain states. Politics in such situations becomes a matter of cognitive dissonance.

This is exacerbated by the appearance of "new media" which mirror the global totality but also enhance the cognitive dissonance (negative feedback, "noise") inherent in the representations of the totality. Capital seems to have a logic of its own — the tendency of money to define all human relations, if you will — but in truth neither capitalists nor politicians can really penetrate this logic or understand its direction — much less control it. Huge conceptual gaps open in the structure of the "totality." The question remains: are these gaps strategic?

The gaps cut across sedimentary layers of actuality, and the gaps themselves tend to shift position, change shape, open and close. Geography as well as the virtual space of the image, space as well as time constitute the mutating forms of these potential tactical regions. Some will be zones of depletion, in which all power has been shut off (there are rumors of strange tribes around Chernobyl...); others will be accidental autonomous zones which might involve classes, groups ("refugees") or specific areas. Some will be liberated zones (Chiapas), others will be deliberate seams. Some will be "unseen," others will enter into representation. In the midst of such fluidity, there must emerge some islands or rocks. Castles will be occupied in the confusion, and later there will be no military advantage in destroying them. The castles will not be defendable, but they will be irrelevant, unassimilable — too "remote" (even in the middle of ancient cities) — apparently pointless. An air of shabby eccentricity might be useful here.

Another reason for Alamut's success was that any king who allowed it to exist could consider the possibility of a secret alliance, whereby money could be used to purchase immunity from the dagger — or perhaps even a contract on some other king

— or most interesting of all, access to the secret sciences (astronomy, engineering and hydraulics, political philosophy, medicine, yogic techniques, etc.) of the Nizari observatories and libraries. In modern terms we might say that capitalists and politicians are so confused and ignorant about new media (far more so than the average artist or 14-year-old) that large sums of money are currently being spent on "secret sciences." Out of the conflict between Capital and State over monopolies of representation, gaps can be produced — and made big enough to contain castles.

All this of course remains on the level of tactics. But the construction of a "network of castles" would constitute not only (in itself) a pleasurable act of autonomy and self-organization, but also a "strategic" structure, or rather an organic and embodied complexity out of which a strategic dimension might well emerge.

> — *NYC, April 1, 1997. This is a reply to an earlier version of "The ABC of Tactical Media" than the "official" one posted on nettime (which appears in this anthology).*

overeign Media

22

Institutio Media

Kestutis Andrasiunas (*Lithuania*)
Interviewed by Joanne Richardson, (*US/Romania*)

|||

nstitutio Media (www.o-o.lt) was founded as a project in 1998. You define "institutio media," according to its Latin etymology as a mediating institution. How do you understand "institution"? For many people (and depending on the context) institution has a negative connotation — an institution is a bureaucracy, and bureaucracy multiplies intermediaries. Trotsky called this substitutionism, when he accused the Communist Party for substituting itself (and its leader) for the proletariat. On the other hand Cornelius Castoriadis defined an institution as the act of founding or instituting — which could also be a self-instituting, contrary to any bureaucracy. What connotations does the word institution have for you?

The Institutio Media (o-o) meaning of "institution" has quite a strong relation with the word "institute" in the Latin sense — to found, establish — "instituere". So it would be closer to Castoriadis' interpretation. To identify the institution with bureaucracy would be too easy, too straightforward, thus understandable. Both theorists you mention focus more on the political sense of the word. In politics substitution is strictly negative, but in arts and sciences it is not the same thing, though it can also be very unpleasant. The possibility of substitution always exists. And it usually overshadows the primary aims of the structure created. In order to operate effectively, big institutions usually need bureaucracy as some kind of legalization mechanism of the structure created. Bureaucracy is a formalizing force: it formalizes your wishes and behavior according to the laws and then decides whether it is it legal or not, executable or postponable. In this way, bureaucracy acts as a translator. A subjective translator. The negative attitude towards bureaucracy appears because this layer of translators has no clear instructions of people's behavior (which is, in fact, impossible) — and no objective guidelines for how to create this formalization. Bureaucracies often misuse their power because they are more skillful at using and interpreting the laws. Attempts to formalize the formalizers of behavior are hard, if not metaphysical.

> *Institutio Media – how do you understand "media," mediation? What are institutions mediating? Social relations, connections between people? Is mediation the result of a loss of directness? Or is mediation something inevitable?*

Yes, media is a word. It is used like an exclamation mark or like a self-explanatory epithet. Search results from google for word "media" [2001.12.06]: Results 1–10 of about 38,600,000. Search took 0.17 seconds

Means of remote communication have always fascinated people. Even more than the content being transmitted. Probably this has inspired the slogan "media is the message," although in fact the only message that media itself is producing is noise. But adoration of media exists because it's quite hard to understand/analyze such rapidly changing and appearing and disappearing means of communication. The lack of understanding casts a mythological shadow over "media." The changes are so quick that media theorists began to follow the facts created by software developers and corporations and to quote them as prophets. Software developing/writing has become a conceptual challenge much as writing [in the traditional sense] was before.

One of the first tools for direct communication is logic. As an attempt to reveal the laws for non-ambiguous writing and speaking. Now it is acting via code and processors. Each way of communication is distorting your message, and this distortion [noise] has often been of interest not only for media/net artists, but for ordinary users. So if your new way of communication is lacking speed/bandwidth, it could make possible new interesting forms of distortion. Just think about the difference between SMS and e-mails.

The institution of the internet can be considered as a tool for the concentration and spreading of information, knowledge. There is not much difference in its structure from a database, except maybe for semantical data sorting and compilation. o-o is an institute for forms of net action, having its diagram or scheme on the title page. In this case "institutio media" is acting more as a hub and database for information, information that can be used in different ways, even as a basis for pranks.

Mediation on the internet means sorting – i.e. interpreting. Sorting is one of the main problems, because humans are not able to correlate or to select relevantly such vast amounts of data. Information spreads exponentially but the sorting of data and search engines are still quite primitive. Boolean logic plus methods of formal information description – its time, size – that's not much of a medium for effective manipulation of data. It is probable that semantic machines or semantic databases could solve this deficiency.

Semantic web (www.semanticweb.org), a project started by Tim Berners Lee and the w3 consortium, requires a fixed identity with an electronic sign. It's a way of storing and revealing data according to its semantic meaning, and so the trust

bestowed on the originator or sorter is crucial here, since faked data somewhere could disrupt the whole chain of relations. For this reason an electronic signature is needed as a guarantee of data authenticity The data bits being stored are related in one or more aspects, depending on the context: if I'm describing a garden, I can sort data according to the type of trees, landscape, plants etc. And browsing would be just changing these contexts from the most common to the most detailed and refining my search. Maybe it's logical that if we want to work with the semantic web, we must distinguish-identify selectors and originators of the content.

So in this case, institutio media still exists as subjective collection of data of *some* o-o's (people involved in the o-o activity), a collection that is not compulsory and easy changeable. I think instant Peer to Peer sessions are already changing/replacing slightly these type of experiments based on static collection of data. Static, hypertextual subnets will disappear or will be forced to obtain the spontaneity and turbulence of peer to peer exchanges.

> *In the description on the o-o website, you define Institutio Media as "an attempt to transfer an institution to the Internet and study its functioning." What does it mean to "transfer" an institution to the internet? How do physical institutions differ from institutions that are founded in virtual space? Are net institutions less mediated?*

Institutions emerged in real space because there were no alternatives for keeping contacts and coordinating behavior. If you want to design a project and communicate with collaborators it is more convenient to have them next door to you — the real physical space is a factor of communication. Various buildings and interiors of parliaments are quite spectacular examples of arranging space for communication. Especially the positions of seats. The building, which serves as a communication medium for the traditional-type institution, historically became a symbol of the institution. And it becomes more and more symbolic — and symbolic means less functionality.

Now such structures may be replaced or reconstructed through the net, phone etc. — anything that enables the transfer of message through a distance. The shift from physical to virtual is becoming more and more common, even corporations with a physical location are starting to use virtual offices as well.

> *"In a real space and time the functioning of an institution is restricted by its premises and the regularity of activity, which is necessary for the interactivity and existence of that institution. In a virtual space it is restricted by technology and the quality of connection. The Web makes it possible to avoid the expropriation of the physical location — it is replaced by a 'site' in a server — the quantity of magnetic memory." In this definition on your website, it seems you are cataloguing the restrictions or limitations of institutions that exist in physical space. Do you think you are avoiding these restrictions by choosing to operate in virtual "space"?*

Virtual space is limited by the imagination and capability of projecting. And usually it is a set of conventional instructions. I could define a room as a desert and the aquarium in the room as an oasis and tell others to follow those rules and behave like tribes of desert travelers called bedouins. But the virtual space with these specific rules won't work if we have no imagination and ability to project. And in order to play this game you must have in mind that you are in the real room with the aquarium and that you are not a bedouin — you must not be totally immersed. I think total immersion (if it is possible) could make virtual space impossible.

The virtual is a conscious experience, since it includes being aware of some rules. It is not a hallucination. The virtual is a conventional simulation. The machinic environment allows you more freedom to construct or model possible worlds — worlds which don't have the necessity of physical worlds. Nuclear bomb simulations which imitating real world laws are possible, but so are simulations that don't follow real laws — for instance, 3d gardens which lack the law of gravity. The virtual is not something completely different than the "real" — it is just a model, a projection that adheres to its own rules. And since you are constructing your own models for action in machinic environment, these models have more freedom and less prescribed necessity than already existing reality models. Less of someone's "dura necesitas" :-)

> *In an earlier conversation I asked you why Institutio Media has no physical space (why it doesn't operate as the common form of the media center). You mentioned two things: the expense of administering a physical space and that there is not much context in Vilnius for the presence of a media center. To what extend have these constraints determined the desire to found the institution as a virtual one?*

From the beginning, the aim of o-o was to be an internet project and we had no desire for such an ambitious structure as a media center. (How many media centers, contemporary art centers and other centers exist in the world? There are already so many :-) And there is a very recent strange obsession with the word "center.") I have some doubts about the commonness of the media center as the form of activity for those using digital tools. If there is a reason to establish a media center or lab, then it is because operating with new, sophisticated and expensive hardware and software is not usually accessible for home users. And probably, since technologies are developing so fast, you hardly will be able to keep it up to date, even getting support from foundations. But setting up 3 or 4 personal computers in a room and calling it a "media center" — as is usually the case among net or media activists — is exaggerating the state of things a bit. This is the structure I am skeptical about. As far as the context in Vilnius — so, it is possible to create it, but we managed to create it through Institutio Media as web place for projects. The content developing was more important than the form of an organization. And what we are doing at o-o is usually using default tech (inexpensive and widespread hardware and software), so we are not conforming to the pressure to keep up to date.

And we thought out beforehand that too much effort and expense would go into establishing a physical structure, and that we would never be very sure about its future. But Institutio Media should also be understood as an attempt to minimize the tedious organizational work connected to running a physical space. The web form of data storing is much more mobile and gives you more freedom from the donors, who are usually politicians and culture managers and attach conditions to their donations. In this context, it comes as no surprise that many supported media projects are adopting the slogans and strategies from their financial providers.

> *You have said that Institutio Media was "started by writing a manifesto and drawing a scheme of the institute." You call the manifesto a "tautological manifesto." Are the propositions supposed to be self-evident? Some of the propositions remind me of Wittgenstein's Tractatus. And your manifesto doesn't have the exaggerated claims and gestures of a typical (political) manifesto – which relies on rhetorical effects upon the audience. Yours is a kind of logico-philosophico manifesto, a categorical listing of propositions. So in what sense is this a "manifesto," and secondly, why did you consider the form of the manifesto necessary? You seem to imply that a manifesto is a necessary part of the founding of an institution. Is an institution that is founded without principles, without statements of concepts and declarations of agendas not an institution?*

The manifesto is a form of literature, and more generally, of expression. It is not just the prerogative of politicians or artists. The manifesto form was used by Debian developers, gopher and GNU among many others. It is characteristic that the manifesto form contains mostly declarative propositions. Propositions which don't need proofs. It is commonly expected that a manifesto declares something new. But manifestoes quickly become outdated. As an aside on obsolete manifestoes, Fontana's television manifesto quickly became outdated and television was revealed to be to be a difficult phenomenon for artists to work with. And Nam June Piak's TV robots constructed of TV boxes just demonstrate this superficiality and impossibility to get in, to capture the problem of the television phenomenon and use it in artistic way. The medium was too constricting at this point.

The o-o manifesto was written quite carefully as a diagnosis of the current (which are now already past) state of things. But it appeared to us that many of the propositions sounded too obvious and brought nothing radically new (as it is commonly expected from the manifesto form), so we called it "tautological." The "tautological manifesto" emphasizes the aspect of using propositions in this form of writing. (There is one direct link to Wittgenstein's phrase in this manifesto.)

I think the more advanced we become in constructing virtual = possible worlds, the more important the knowledge of our depicting or modeling mechanism becomes. It is a very interesting phenomenon that artificial languages are merging with electronic devices and machines. Each sentence becomes an imperative in this environment.

As far as the connection between the manifesto form and institutions, the implication was that instituting is something you should define, in order to avoid ambiguity. And a better word for phenomena that is being founded without principles, without statements of concepts and declarations of agendas, is a constellation. Examples would be p2p sessions or SMS or other chat phenomena. But it would be difficult to talk about the founding of a constellation — the word "appearance" would fit much better.

> *From these descriptions, Institutio Media seems to be a kind of conceptual project, an "artform" (if I may be permitted to use the word) that takes itself as its own object. Insofar as institutions exist as means to a goal — as mediators — this institution appears to be an anomalous form, existing for the purpose of founding itself. The "clear and less ambiguous scheme" of the institute includes a mailing list, the webmagazine, the internet radio, and "direct social action." Can you say something about all the components that make up Institutio Media? And why are some components part of the institute body and others outside?*

The mailing list is a common form for direct discussions. People from Vilnius (related to the contemporary art scene, but also others) are subscribed to the list, but in actuality the mailing list has more contacts/subscribers outside Vilnius. The webmagazine is a collection of texts and provides the opportunity to comment or post responses about them. The internet radio & TV is used for broadcasting projects. So we thought that each form — word, sound and image — should have their place at o-o. Direct social action means action in a real space. At the beginning we supposed that this would happen in connection with the institute, but as it turns out, most of the work has been done on the net. The necessary parts of the Institutio Media body are those that make up the web institution — mailing list and webzine. The Net radio and social actions were considered not vitally necessary, so they were placed outside the body but remain connected to it. So in short, it would be possible to say: "o-o has no real space, but was founded in Vilnius."

23

Reality-Fiction
Visions of Reality

Candida TV *(Italy)*
|||||||||||||||||||||||||||||||||||||

andida TV was born from the melting of different realities: underground cinema, video production, rave parties, street theaters, independent radios, underground bulletin board systems and counterculture pop-magazines in the last seven years in Rome. Candida is a core of 12 people, fusing the experiences of self-managed squatted community centers and technical knowledge in the field of cinema and video production.

The Overdose Fiction Festival (O.F.F) that took place in the Forte Prenestino squat in Rome for three consecutive years was a catalyst in the formation of the group. We abandoned the idea of documentation of reality, and unleashed an imaginative creation of possible counter-hallucinations in mass-consensual reality. While documentation aspires to be a faithful representation of reality, we believe that is not possible to represent reality without modifying it, and so we moved closer to "reality fiction" – the presentation of other possible realities, like that of science fiction. During the organization of the festival we made an open call for "suburban stories" and we collected narrative visions of reality in the urban environment. We wanted to give a chance to the suburban imaginary to come out of the darkness and become visible on the big screen, a chance for others to tell unspoken stories, to create counter-hallucinations outside the dominant cultural paradigms.

In the summer of 1999 we decided that we had the right experiences to imagine the construction of a new television channel which could enter everyone's house and destroy the simulation mainstream. We were on air for nine weeks from December 1999 to February 2000 with a one-hour show each week on a local TV station in Rome. Our aim was to become a Pop Riot, our slogan was "Do you want pop? this is POP!" In fact we built a typical container show with music, news, cultural issues and we called on people to make their own television, to send us their tapes

and to create a Community TV channel. We had a vision inspired by a hacker ethic of television technology: TV could become something that everyone is able to put their hands on.

Our show circled around different themes: music (interviews with djs of independent labels), independent cinema, poetry, soccer (really pop!). We also had a section related to the conditions of people in jail with greetings from their families — the idea was to use television as a tool to send messages to prisoners. Another section was dedicated to the crimes of the Catholic church during the year of the Jubileum in Rome. On this occasion we promoted the beatification of Antonin Artaud on the streets during Catholic gatherings.

To infiltrate a mass medium like television meant to us to insert new meanings into the mainstream, not final truths or "real informations," but seeds of awareness. We wanted to uncover the media mystification of realities by exasperating the form of daily TV shows and stretching them toward the line of the "absurd." We created "white noise" to add to the overflow of media information. This visionary soul grew up together with another soul that still believes in the need of clear information, and so we developed in symbiosis with the Indymedia centers in Rome. The effects of our effort to infiltrate the media infiltration may not have brought us to a prominent, stable visibility on television (in Italy there is no law for Community Television), but it created an interest in visual mass media and since then several new video activist groups have been organizing all over Italy.

After the broadcast experience of the year 2000, we created anti-prohibition spots (short videos using humor and a worldwide language), made some streaming webcasts, and organized events to screen our works. In July 2001 our collaboration with Indymedia brought us to the terrible days of Genoa. In its wake we produced a short movie called "Supervideo>>>G8." Supervideo, our Superhero was born some months before the G8 meeting in Genoa. We consider it a synthesis of our performative, visionary soul and our need to communicate and share what we live and what we see.

Our desire to infiltrate mainstream media walks hand in hand with the need to create an information network from below, by giving access to communication technologies to people. During the last two years in Rome we organized workshops to teach boys and girls from suburban areas on the edges of the city how to use cameras and editing tools to make their own television. We call it "street television": a little sister who can reach places where big brother cannot enter because he is too big. This little sister, together with Indymedia is now in Palestine (April 2002) to help build an independent radio in Dehesihe, a refugee camp near Bethlehem, but now things are in a mad, horrible whirlwind, and she can be only a shield to protect civilians and a witness of crimes against humanity. There are never enough little sisters to communicate visions of realities and disseminate seeds of awareness.

<DECLARATION>

Candida was born from the evil blood of the human race. Despite all lack of fortune, she emerged from a fertile background of techno organized disorder. She grew up in a community network of outlaws in the cradle of necrotic European culture, living on the razor's edge of society and brain stability.

Screenal reality is a realm, a layer of reality, that pretends to be the only possible world, materialized trough the seductive words of plastic babies. Candida claims that this is the right moment to start squatting screenal reality. She moves with her network, like a swarm.

The swarm say: Our strategy is to infiltrate pop culture as a necrotic tissue from the inside. In the beginning of the eighties, The Sanz Patiente Kollective, one of the first groups representative of industrial culture in Europe, claimed their *postindustrial strategy* or *the cathedral of death:*

The Strategy is not dialectic: liberation against control, unconscious against conscious, deviant against normal sex, against chastity

The Strategy is catastrophic: carry the situation to its own limits

The strategy is symbolic: use against the system its own intolerable signs

The strategy is anonymous: we don't want to be categorized as another deviant star

We are the norm. We are the twilight.

"Surveillance cameras are all around us, Surveillance cameras are all around us, Surveillance cameras are all around us," Magazzini Criminali (the Criminal Stores, a theatre company from Bologna) hysterically sang the in the eighties in their theatrical piece "Crollo Nervoso" (Neurotic Breakdown). Surveillance cameras are all around us, but instead of howling hysterically, we decide to hold the cameras in our hand. Candida says:

Television is a weapon.

Screenal reality must be squatted.

One year ago in Rome, we began the experiment of "Candida – the first electric household TV." We had the weapon in our hand, BEWARE! almost all our games are played with live ammunition … you may shoot ammunition into the emptiness. If there exists a big brother, Candida is The Little Sister, the first electric household TV.

Let me explain the meaning of this slogan:

Candida in Italian means Candid as in Voltaire's Candide, for whom this is the best of all possible worlds. Isn't this what tv-pop-culture is trying to tell us while our bodies are daily dispossessed?

Candida is Candid as in immediate; she has an immediate relationship with the media. It happens in the moment of the experience; a transformation from the television for everybody to the television created by everybody.

Candida is the first electric household TV because her aim is to overcome the differences between the consumer and the producer: television can be done by everyone, you just have to use the television as a monitor, the camera as an eye, the video recorder as an editing tool.

"Make your own television" – to doubt prefabricated authorities and to promote the decentralization of information. Screenal reality has to be squatted, Candida wants to be broadcast on the official television channels because the television channels are still the mainstream of the collective subconscious. Candida has got net streaming, but she is not satisfied with this because the actual standards for net streaming are proprietary, as is the Real Network. What we need is free software for light net streaming.

We are invading the pulpit from which everyone is preaching to pour waves of vitriol in everyone's houses, we know that nothing is true and that everything is possible – the swarm are bastard nieces of uncle Dostoyevski and uncle Bill Burroughs. In the merry-go-round of media, as Guy Debord once said, what pretends to be true is false and what is false can only appear as true.

Let's play the game.

Book industry, telematics, radio, television: Candida is a nomadic swarm that advance as grasshoppers of sense.

no name will be changed to protect the innocent. everyone is fucking guilty.

But Is It Radio?

Heidi Grundmann, Kunstradio *(Austria)*

|||

The history of telecommunication art contains many examples of "sovereign media." It may suffice to refer to two quotations, 16 years apart, which suggest that, in spite of the speed of change in telecom technology — with all its social ramifications — our culture still needs to be reminded of the difference between broadcasting and networking.

"[Artists' use of] electronic communications means that no actual object is exchanged. It is in the ephemeral immediacy of the exchange that the meaning of the work exists. Slow-scan TV, like mail art, is a sharing activity. It cannot be passively viewed like TV or video or a painting or a performance, it demands a reply... a dialogue between producers." (Eric Gidney quoting Robert Adrian in *Art and Telecommunication*, 1984)

"Many-to-many communications... tend to ephemerality and instability, and are easily and typically altered in the process of interpretation. Unlike a film, the "text" of a dialogue is an evolving fabric. Even where the dialogue is mediated by technologies like e-mail and IRC, each contribution is unstable, like a move in chess, a challenge awaiting a response, incomplete in itself." (Sean Cubitt, "Virilio, Ecology and the Media," 2000)

< 1. radio >

Kunstradio (kunstradio.at), a weekly program of radio-art founded in 1987 is what one would call a minority program — late at night (every Sunday, 11 — 12 p.m.) on Oesterreich 1, the cultural channel of the Austrian National Radio (ORF). As all cultural channels, Oesterreich 1 itself is also a minority program, and as far as the late night programs are concerned, the usual instruments assessing listener figures are incapable of measuring their audiences. In Austria these programs usually reg-

ister in the category "between 0 and 18,000 listeners" (finer tuning impossible). And indeed, a program like Kunstradio is not kept on air because of listener-figures but in spite of them — as a fig leaf for the system of Public National Radio as a cultural institution, which otherwise is surrendering all too readily to infotainment pressures and the tyranny of audience ratings.

In the context of zero-audience, a radio program has to seek its contributors and public beyond the borders of conventional radio by developing strategies that circumvent the bureaucracy of the broadcasting institutions. Kunstradio, by producing international events, symposia, special projects like "Long Nights of (Live-) Radio Art," exhibitions, installations, CDs and catalogues, became known in Austria, Europe and around the world to people who had never heard the actual radio program itself. In this respect, Kunstradio could be said to have created a "public" but not an "audience" — gaining recognition and attention (in the sense of the notion of "the attention economy"), which in turn attracted artists (local and international) as contributors, supporters and listeners.

While radio-drama or new-music programs — sharing the same 0 to 18000 category as Kunstradio — are attractive to writers and composers as opportunities for the distribution, and occasionally even realization of their pieces, radio artists, working in the low-budget/high-motivation framework of Kunstradio-projects, are much more concerned with radio as a specific cultural space and context. Today, this also means that radio artists, who come from diverse media and backgrounds (visual art, literature, music, etc.), are conscious of the fact that the space of Public Radio has become just one aspect of and entry-point to the contemporary hybrid mediascape. Thus, these artists, by reflecting on the metamorphosis the radio medium itself has undergone through the impact of digitalization and the hybridization/convergence of communications media, inherently challenge the conventions of broadcasting.

The position of Kunstradio — however marginalized — inside a public radio institution (in the belly of the beast, so to speak) has made it possible for artists to exploit not only the institution's technical resources but also its mainstream program formats. There have been projects where artists were able to infiltrate other programs and/or channels of the ORF beyond the late-night ghetto, inserting radio-art into Oe3, the pop music channel, or into one or the other of several regional channels. Such interventions outside of the gallery-like space of the weekly national radio-art program are most successful, when they are not announced/perceived as art but are left to be incidents in the public space of everyday radio, anticipating an audience of passers-by who may or may not stop or hesitate for just a brief moment of irritation or even reflection. The message of such interventions is usually just their "difference," their being something other than the accustomed to everyday radio content or format: e.g. dog stories phoned in by listeners, sounds from steelworks, tap-dancing, etc. inserted into the usual daily programs, when and wherev-

er there is a small break, phone-in projects asking listeners not to talk but to transmit everyday sounds, etc.

One such by now legendary project, Landscape Soundings by Bill Fontana, inserted, for a fortnight and on all Austrian Radio channels, live sounds of birds and frogs from the Danube marshes using a complex collage of high-tech equipment, usually intended for the broadcast of major sport events or papal visits. This was only possible because the artist considered it part of his work to make the institution itself an accomplice in his project (by this he also undermined the usual image of the artist as a person incapable of coping with complex structures of everyday economical, technical, social-political life).

But institutional resources have also been utilized in another, almost opposite way: artists, with the help of friendly engineers, have made unauthorized (pirate) use of local ORF frequencies (usually used for live reports from outdoor events) to open up the space of exhibitions and installations — not so much to audiences, who could only come upon these unknown frequencies by chance, but rather as a statement of principle referring to a desire to render the traditionally closed exhibition space "radiant," in the sense of radiating/transmitting/connecting. For instance, during Zeitgleich, 1995, an exhibition of sound installations, several projects were broadcast on the "internal" 107.7 FM frequency of the regional Tyrolean channel of the Austrian Radio.

< 2. hybrid radio >

In the early 90s, artists with a background in telematic art began to explicitly integrate radio into their horizontal, telephone-based projects — projects in which radio, being just one medium in a collage of many different media — was infected with other models of communication (one-to-one, group-to-many, many-to-many). With these projects it was slowly becoming apparent that the privileged few-to-many broadcast paradigm was not sustainable in its classical form in the new horizontal media landscape. By granting artists, and their own networks, the possibility to hook up to the whole range of technology of the mass medium public radio and its institutionalized international infrastructure, i.e. to its various networked systems of transmission lines and its networks linking producers, technicians and broadcasting time in radio stations all over the world, the existence of a program like Kunstradio inside this institutional structure became itself a symptom of this new medial environment. By collaboratively developing elaborate strategies to appropriate all these facilities at different locations, the artists created "virtual stages, based on interaction and telepresence, on which the participants temporarily meet... Instead of vertically demarcating sender and receiver, they were aiming for platforms of reciprocal transmission." (Horizontal Radio, Ars Electronica catalogue, 1995).

In projects like Horizontal Radio '95 and Rivers & Bridges '96, hundreds of artists, collaborators and participants were linked for 24 hours in a unique world-wide community collaging old and new media — using all possible lines and connections between radio stations around the world from telephone to satellites plus the growing WWW. By having won access to mainstream, even primetime broadcasts and popular channels, these projects involved an on-air audience of millions of radio listeners/participants and/or on-site audiences of hundreds for performances and installations in some locations and some (a dozen?, a hundred?) on-line participants in the still-new internet. The shortwave service of Ostankino Radio (Moskow), multicultural FM channels in Australia, youth channels of national radios, pirate radios, community radios, a vast Eastern Mediterranean sub-network with unknowable dimensions mushrooming out from Italy, etc., were all producing their own radio versions of Horizontal Radio or Rivers & Bridges and feeding them back into the network. This simultaneous horizontal flow between dozens of stations and many more artists, created bizarre — sometimes chaotic, often exhilarating — mixes incorporating fragments from pieces based on many different styles, traditions and theories of art. Such networked hybrid radio art projects, being collages not only in the "few to many" but at the same time in the "many to many" communication mode, are intrinsically subject to "ephemerality and instability" as well as the loss of control by the artist/contributor: an instability defining the shared space in which individual interpretations are constantly being absorbed into new versions of a collective work which is not perceivable as a whole. It seems that in such projects, a finished piece of art no matter how elaborate it may be in its formulation or intention, is overridden by a paradigm which is not only informed by the notion that "the finished work of art is a thing of the past" (Tom Sherman) but also the knowledge that the radio artist "has no control over the experience of a radio work" (Kunstradio Manifesto, kunstradio.at/TEXTS/manifesto.html)

< 3. online radio / radio on-demand / hyper-radio >

Preoccupied by their struggle for survival in the face of the current neo-liberal broadcasting ideology, it took a very long time for the public radio institutions — at least in Europe — to recognize the dynamic changes in media consciousness and realities created by the internet. This meant that it was minority programs like Kunstradio, which (against incredible institutional resistance) joined the alternative groups in the exploration of the WWW as a medium for art before the institutions themselves went on line.

In April 1995 Kunstradio On Line was founded with the support of "The Thing Vienna" (no help from the ORF). Originally described as "Radio in Colour/Radio To Look At," Kunstradio On Line was conceived as a site of art as well as a means for announcing the weekly radio program and making it available on demand inside the online archive of Kunstradio programs and artists' bios. Keeping pace with the development of the internet, KR On Line soon began to experiment with RealAudio (1995) and, in response to the rapid improvement in web browsers,

started the development of complex project web-sites which, since 1997, were the basis of the collaborative multi-channel, "on air–on line–on site" concept of a series of Kunstradio projects. These web-sites are designed to provide simple interfaces to all the network nodes of collaborative productions, to be easily accessible during the run of the distributedly produced projects themselves and just as easily updated in real time and after to form the basis for an online documentation.

< 4. listening to the sound of the internet >

So, when Kunstradio On Line started in 1995, it was primarily understood as an extension – and/or visualization – of the weekly radio broadcast. But, since, the rapid improvement in streaming technology, compression algorithms and bandwidth have effectively reversed the roles: the non-stop flow of the internet now increasingly dominates the clock-dependent, scheduled broadcast medium. This shift from radio-oriented to web-oriented production is demonstrated very clearly in "on air–on line–on site" projects in which the radio programs, once the point of origin of every collectively produced project, has gradually become merely a short, time-framed window, listening to a much larger – potentially unending – networked world, frequently streaming generative sounds and images. The physical space of the "on site" installations and the broadcast "on air" space of radio, once viewed as the "real" project – with the "on line" network creating/describing the links – have now become elements or episodes in the continuum of WWW-based "on line" projects. Three recent "on air–on line–on site" projects illustrate this shift quite clearly: Immersive Sound (1998, five weeks non-stop), Sound Drifting (1999,nine days and nights with 16 nodes processing sounds around the clock), and the one year online-installation devolve into (2000), which – as a work in progress – is taking a revised shape as an open-ended on line structure of sounds and images collaboratively produced within an extended network (2001-2).

The redefinition of radio as one potential listening point into the ongoing sound of the Internet also means that any radio can become the audience of any other radio program which happens to be online. This changing role of radio – a cause for angst and panic among the managers and producers in the traditional broadcasting institutions – is understood by some people both inside and outside the institutions as an exciting and positive challenge to explore new hybrid forms of communication and content and to deal in a creative way with issues of intellectual property. Disregarding the cumbersome institutionalised product-oriented program exchange infrastructure of the big radio institutions, individual programs like GOLEM (a cult program on RAI – the Italian National Radio – dealing with media) or Kunstradio and probably many others can now use their slot on the National Radio as a possibility to explore the "sonority" of the Internet: "sounding the sounds of the Internet" – and thereby producing/offering/floating unstable "images" for the ever-changing hybrid mediascape.

< 5. loss of control / control-sharing with humans and machines >

The collaborative preparation, conceptualizing, setting up of parameters for the development of on air-online-on site projects in online discussions and/or face to face meetings as well as the raising of money and other resources at each location etc., makes the participants in such projects the first vitally interested and participatory "audience" of what is happening at all the other nodes. Of course the adage "the audience of an artist is other artists" also applies to other genres of art, but in collaborative, networked projects the existence of the whole project depends on the capability of each location to function successfully as a node in the network. So participating artists really need to check out and refer to what the others are doing and, in that sense, the term "zero audience" turns into an oxymoron as an actual "zero audience" in that sense, would lead to the demise of the project as a whole.

The distributed, shared authorship the success of which is intrinsically related to the development of linkable parameters means that in the "Immersive Sound," "Sound Drifting" and "devolve into" projects, machines generating sounds and, in some cases images, took over from the human initiators once the project got going. (The complex history of arriving at this state of affairs cannot even be touched upon here.) The artists stayed on as an active "audience" checking for failures and breakdowns. At some locations the networked generating and processing system was rendered for temporary "on site" or "on air" audiences while "online" it was just there, actively streaming from many locations around the clock – an "online" installation simply communicating with the other machines in the network and oblivious to human visitors.

As radio becomes what Andrea Sodomka (in an interview with the author, 1999) called "a multi-channel reality, which can function interactively and in which the user has choices to link the different channels," artists are positioning their work in awareness of control-sharing with machines and other artists and of the importance of site- or channel-specific parameters. In spite – or because – of the inevitability of the loss of control involved, the artists do have to keep very different kinds of "audiences/participators" (machines, other artists, passers by, listeners, gallery-visitors etc.) in mind from the very beginning of conceptualizing a project – an audience which co-creates and becomes part of a specific or undeterminable community of producing. Listener figures, "eyeballs" or whatever those who are selling products call "their" consumers, very definitely are not of any concern whatsoever. "Processing not Producting" is one of the guidelines for working with a radio which has (also) become pure flow, and as a multi-channel experience, is more than ever available only in very personal versions and never as a whole – not even to the initiators nor to the most avid contributors of and to such projects.

< 6. remembering / documenting "ephemerality and instability" >

Networked online-on air-on site projects may not only include explicit references relating to the history of radio- and communications-art, they implicitly are themselves discourses on an ever-changing paradigm of dispersed collaborative producing. Each of the projects involves artists who already have had some experience in networked production and some who are new to this situation. The latter may drop out because of or hang in in spite of the experiences/frustrations resulting from loss of control, a substantial fragmentation of their original "pieces" or the impossibility to experience the project as a whole. In chats, lists and occasionally even brief face-to-face meetings the more experienced contributors pass on much more than technical help to the newcomers; thus each of the projects has an undercurrent of an on-going "knowledge transfer" which includes the collaborative reflection of the general nature of such projects. This "knowledge transfer" amounts to the construction of an experiential tradition of collaborative work, rich in anecdotes and the creation of myths — comparable only to processes of "oral history." Relics such as photographs and/or sound recordings taken at individual locations, logs of chats, screen shots, the website trying to link participants and their individual streams, or maybe a CD, a small catalogue, a theoretical text, all have the character of souvenirs. Most of what is known about earlier projects resides in the individual memories of participants, or — as fading residues of obsolete technologies — in the archives of individual artists and some artist-run spaces (such as e.g. Western Front in Vancouver or, later, Avatar in Quebec City).

During the 90s Robert Adrian initiated/designed "documentations" of complex projects as part of Kunstradio On Line (itself an artist-run space and art-project). They were not efforts to "preserve art for posterity" but rather attempts to understand a medium which potentially should be capable of serving simultaneously as the site of evolving dispersed art-projects and their documentations at least insofar as they contain snapshots of images and sounds, together with texts, artists' bios and the basic structure of the temporary network itself. Over the years these "documentations" have become themselves subject to the ephemerality and instability inherent in ever-changing communication systems and the underlying technologies (broken links, obsolete browsers, ancient sound technologies etc.). So, rather than documentations of the actual projects themselves, these project-pages have become historical material illustrating how artists tried (and still try) to deal with a new media that seems to demand constant updating and at the same time defies any permanent recording processes by its very hyperlinked complexity and changing technological/sociopolitical/economical basis.

The recent interest of some art institutions and art-historians in the traces of complex, unrestorable fugitive events such as these projects may at its best lead to layers of "commentaries/interpretations" of something which only existed in "dispersion" and as "aesthetical wandering" and seems impossible to relate in any other way than in comparing subjective narratives based on experience. At its worst it might

end up in (falsifying) categorizations within institutionalized paradigms which have little to do with the excitement and confusions which are part of the dialogical openness and freedom of projects unfolding without the pressures of the clock, of audience figures and institutional rules.

> — *All projects mentioned above (Landscape Soundings, Zeitgleich, Horizontal Radio '95, Rivers & Bridges '96, Immersive Sound, Sound Drifting, devolve into) are archived on kunstradio.at. A first version of this text was written for the target.audience=0 panel at net.congestion in Amsterdam, October 2000; a second one was printed in ACOUSTIC SPACE 3, published by Xchange — Net Audio Network (xchange.re-lab.net).*

25

Transacoustic Research

iftaf — institute for transacoustic research *(Austria)*

||

he paradox of transacoustics can be found in that the transacoustic, per se, withdraws from definition, presenting something that, quite possibly, is not.

< iftaf >

iftaf, the institute for transacoustic research (www.iftaf.org) was founded in 1998 to define and research transacoustics. iftaf is a platform for the ear training arts/sciences and auditory phenomenology. it explores the borders between acoustics and their tangential realms: science and art, everyday life and research, sound and noise, tone and light, acoustic and other modes of perception. by permanently changing the auditory angle and continual reinterpretation of the manner of hearing, the borders of the acoustic and the audible can be expanded beyond the threshold of perception. reacquiring the capacity of listening (for the sake of listening) breaks open socially-induced functional deafness and expands the acoustic horizon.

iftaf uses structures which correlate with those of a scientific institute. it is divided into several departments working with various thematic emphases including: auditive phenomenology, social acoustics, vegetable sound research, translinguistics, visual music, experimental instrument skills, bioacoustics, demography, and klepto-acoustics. these departments have an open structure without hierarchical character. on the contrary, they are rhizomatically bound.

iftaf is made up of:
> archives (audio-library, library)
> consultation
> radio shows
> events (concerts, parties)

excursions, study trips, expeditions
research
publication of transacoustic texts
web pages
congresses, symposiums
contacts to other institutions in austria and abroad
listening booths
hearings
label (iftaf records)
competitions
transacoustic labor/studio
acoustic guerilla
readings, rehearsals, seminars, workshops

< transacoustic research >

the character of transacoustic research is not purely scientific, but also artistic, comprising a form of "audio art." transacoustic research carries out science by means of art and art by means of science. the antiquated differentiation of these two areas is rejected and methods and settings from both areas are combined to arrive at unique lines of connection and division.

transacoustic research is concerned with the peripheral effects and tangential areas of acoustics, with their borders to other areas of research. the contours and definitional borders are necessarily blurred and vague. transacoustics presents something which is basically nothing. it can and should not be defined in the sense of something laid down in writing. transacoustics as such, does not exist; there is only transacoustic research, which constantly circles its imaginary core and thereby arrives at the most diverse results and realizations. the question of the essence of transacoustics is as impossible to answer as the question of art or philosophy's essence. the success, productivity and efficiency of transacoustic research do not depend on finding an answer to this question.

transacoustic research is always looking for that which is new, unusual. it is not concerned with detailed formulations, but, rather, hinting at ideas, research and experiments. transacoustic research — as one of the acoustically "transcendent" areas of research and methods, should be understood as a view, a principle, an "acoustic perspective," a hearing device for the perception of incomprehensible acoustical events, or as a style of perception, and less as a narrowly defined scientific discipline with a clearly outlined field of research.

a crucial characteristic of transacoustic research is its interdisciplinary approach. people from various disciplines and areas of life (philosophy, fine arts, music, poetry, dance, theatre, electronics-technology, medicine, physics, psychology, etc.) meet together and collaborate to formulate the transacoustic. in this way, interesting syn-

ergy and alienating effects arise which generate unusual results. "trans" can and should build a bridge between various lifestyles and people. iftaf is not interested in concretizing a space, but rather in forming networks and enabling people with similar ways of thinking to come into contact with each other.

it is an illusion to assume that artistic or scientific work can take place in isolation from political and social contexts. for this reason, iftaf cannot and does not want to evade its political duty and feels obligated to take a public stand as well as reflect and incorporate social and political contexts into its own work. but our field of research is, by definition, transacoustics, which means that the work and the methods will proceed mainly from this base. political work is merely a by-product of transacoustic research (department social acoustics), just as the vegetable orchestra is a by-product of the vegetable sound research. within the concept of transacoustics, however, these by-products are attributed the same value as the actual research work, which in the end is possibly even carried out with the goal of creating such by-products.

< hearings >

hearings are given a special value in transacoustic research. they contribute significantly to the more precise circumscription and investigation of the field of research and at the same time mediate this to an interested audience. hearings are normally held on the premises of the institute. sometimes, however they take place at unusual sites (such as a piano cemetery). in the framework of the hearings, experiments and projects are presented which display a transacoustic character. the hearings are meant to offer various artists a platform for the presentation and discussion of their works and at the same time stimulate exchange with other artists. the contributions presented are mainly from the area of audio art and experimental music. there are, however, also collaborations and individual contributions from the fine arts, literature, humanities, dance, musical theatre, performance, electronics-technology, etc.

hearings include experiments in digital sound poetry. by limiting the base material to voice samples, the border between music and poetry becomes fluid. collage and montage are applied by computer to concrete speech/sound material. the realm of literature and language is thus liberated from the compulsion of writing and notation. this option is made possible by digital aids which are superior to analogue systems and the corresponding processes in their flexibility and ability to intervene in the sound. some processes, for example, constant reworking and microscopic cuts are even first made possible by these tools. in this way, literature is opened to linguistic sounds which, on the one hand, are not able to be noted down and on the other, would probably have never otherwise arisen.

hearings include performances of the first viennese vegetable orchestra (www.gemueseorchester.org). the orchestra is made up of nine people active in various artistic areas who work together on developing instruments and creating compositions

ANARCHITEXTS

with particular value being placed on the plurality of the musical styles. the instruments consist exclusively of vegetables although additional kitchen utensils such as knives or mixers are employed when necessary. this creates an autonomous and totally novel type of sound which cannot be compared with conventional sound conceptions. the preliminary work for practices and concerts is elaborate as all instruments must be bought and produced anew. the social structure of a traditional orchestra is reflected, imitated and adjusted to the stylistic necessities of the individual pieces. after the concert, the stage is left to the cooks who then work the instruments into a tasty vegetable soup which the audience and musicians consume together. the concert's audience thereby has the possibility of once again enjoying what they have just heard.

> hearings are part of the institute for transacoustic research's comprehensive strategy for transforming and further developing society.

> hearings counter the one-sided orientation of the media and entertainment industries toward easily swallowed and comfortably consumed products.

> hearings battle the hegemony of the added value of the image as opposed to the word and sound.

> hearings concretize the transacoustic.

> hearings are.

168

26

Media Without
An Audience

Eric Kluitenberg *(Netherlands)*

||

resence in the mediated environment of digital networks is probably one of the most complex phenomena of the new types of social interaction that have emerged in these environments. In the current phase of radical deployment (or penetration) of the internet, various attempts are made to come to terms with the social dynamics of networked communication spaces. It seems that traditional media theory is not able to contextualize these social dynamics, as it remains stuck on a meta-level discourse of media and power structures (Virilio), hyperreality (Baudrillard), or on a retrograde analysis of media structures deeply rooted in the functionality and structural characteristics of broadcast media (McLuhan).

Attempts to come to terms with networked communication environments from the field of social theory are generally shallow, ill-informed about actual practices, and sometimes straightforwardly biased. Psychology does not contribute in any significant way to an understanding of these social dynamics either. The rather popular idea, for instance, that the screen is a projection screen for personal pre-occupations, and that social relations that emerge through the interactions via networked media are mostly imaginary for lack of negative feedback or corrections, is deeply contentious. The idea that absence of corrective feedback stimulates the creation of fictitious relationships is an interesting one, but one that can apply equally well off-line as it can on-line. It illuminates certain patterns of human behavior, but it does not tell us much of what makes presence in the networks specific.

One of the greatest fallacies of current attempts to understand the social dynamics of networked media is the tendency to see these media as an extension of the broadcast media system. This idea has become more popular as the internet is extended with audio-visual elements. Interactive audio-visual structures, streaming media, downloadable sound and video, all contribute to the notion that the internet is the

next evolution of broadcast media. But this vision applies only partially, and is driven primarily by vested interests of the media industry. It is often not reflected in how people actually use the net.

The predication of the conception of media on the broadcast model based on a division of roles of the active sender ◇ passive receiver/audience relationship is the greatest barrier to understanding what goes down in a networked media environment. The networked environment should primarily be seen as a social space, in which active relationships are pursued and deployed; activities that often seem completely useless, irrational, erratic, or even autistic. The active sender and the passive audience/receiver seem to have been replaced by a multitude of unguided transmissions that seem to lack a designated receiver. Thus the net is seen as an irrelevant, chaotic, and useless infosphere, a waste of resources, a transitory phase of development that will soon be replaced by professional standards of quality, entertainment, information, media-professionalism, and above all respect for the audience.

Let me be clear, I do not believe in this vision, and I am convinced that the net will not evolve into the ultimate entertainment and information medium. Instead it seems more likely that the seemingly unstructured mess of random transmissions will prevail.

The ideal of seeing the media environment as a social space has a considerable history. Already in the late twenties Bertold Brecht formulated his now-famous radio theory in which he envisions radio as medium for direct two-way communication, and the media space as a connective network of decentralized nodes (use of cyber rhetoric deliberate here!) This idea heralds strong resonances of early cyber-utopian discourses such as *The Virtual Community* of Howard Rheingold. J.P. Barlow, one of the other great cyber-utopians, talked extensively about "the great conversation," emphasizing the kinship of network communication to the traditional meeting places, the street, the square, the agora, the theatre, the café. This early utopian phase of the net is over, cyberspace turned out not to be independent. Its sovereign existence is threatened by mega fusions of the AOL/Time Warner type, but there is one aspect where these early stories are right, and that is in pointing beyond the sender◇audience dichotomy of broadcasting.

:: a progression of media phenomenologies beyond the broadcast dichotomy ::

< intimate media >

The first step towards a micro-politics of resistance against the broadcast hegemony was introduced with the notion of "intimate media." I was introduced myself for the first time to this concept at the second Next 5 Minutes conference on tactical media in 1996. Intimate media have a high degree of audience feedback. Typically the distance between the sender and its remote audience is enormous in broadcast media,

if only because of the ratio of active senders and the overload of passive audience. Feedback mechanisms are necessarily complicated and bureaucratic; the letter to the editors, phone-in time available for only the tiniest fraction of the audience. Intimate media instead are micro-media: there is a close relationship between sender and audience. Ideally the sender and the audience all know each other, while the relationship is still more than a one-on-one conversation (as in a telephone call).

Intimate media are spontaneous media. They emerge at the grassroots level. They cut across all available media, all available technologies. Intimate media can be low-tech, they can also be high-tech. What characterizes them is an attitude. Intimate media range from micro-print to pirate radio, to hacked TV, web casting, satellite amateurs, micro-fm or high-bandwidth networks. Intimate media can be organized in a professional way, though usually they are not. Most common is their appearance as amateur media — their audience reach is generally not economically viable. Intimate media are not a good stock option. People often do know each other personally in these media networks. A curious incident at the second Art + Communication festival in Riga (Latvia) illustrates this beautifully. All the discussion were sent out live via audio streams over the net, and a few people were even listening at the other end. During one of the breaks the stream continued and one of the artists decided to take the mobile microphone used by the presenters into the coffee room. He placed the microphone silently on a coffee table, where a lively conversation (gossip) was going on. As it turned out later, the only person listening (in London) to this conversation at the time, was the person the conversation (i.e. the gossip) was about, and she protested via a chat channel within minutes. This type of media-intimacy is virtually unthinkable in the broadcast model.

< socialized media >

Media used in the context of a specified social group or in a specific regional context are best described as "community media." Common forms of community media that belong to a geographically situated community are community radio and television. The use of the internet in a geographically situated community is mostly referred to as community networking. Community networking has become very popular in the US, but also has some importance in Europe.

Special interest communities are usually organized around a topic, a theme, or a shared interest. They are essentially translocal in nature, hooking up local interest groups or even shattered individuals, who can be dispersed over different regions and countries. Networked communications can be highly beneficial for the process of community building and for strengthening the cohesion of such communities. It is obvious that translocal (special-interest) communities benefit most from networked communication, since it offers a low-cost and fairly effective means to stay in touch and exchange ideas. But the high degree of audience feedback, and peer to peer interaction also makes networked communication technology an invaluable tool for social interaction within a geographically situated community.

Typical forms of networked communication are the newsgroups that emerged from
Usenet, text-based fora where people exchange ideas and opinions about the topic
of the newsgroup. MUDs & MOOs, or generic on-line multi-user environments
where people can interact directly, started out as text-environments and became
popular as role playing environments, but they have become visual and subse-
quently also integrated live speech and 3D environments that can be navigated in
a more visceral way than the point-and-click navigation of traditional web pages.
Multi-user environments enhance the feeling of sharing a communications space
with others. The mode of interaction has to be active, otherwise it doesn't work.

Another important aspect of socialized media are the collaborative networks that have
emerged as a result of these low-cost translocal communication tools. Especially e-
mail has helped tremendously in this regard. Mailing lists are easy to set up and
can help to distribute information evenly and effectively to a very large base of sub-
scribers, while offering each subscriber also the opportunity to react to the sender
as well as to the whole list. "Audience" feedback here is immediate, distributed and
non-hierarchical. It is far removed from the letter to the editor that most likely
never makes it through the editorial filters. The practices of micro-media in the arts
and net.casting have benefited enormously from the availability of mailing lists such
as Syndicate, Xchange, nettime, Nice, and others, and have been tools to establish
co-operation, a sense of community and a discourse that is more open than what
any print magazine would have been able to support.

< create your own solutions! >

One of the most notable collaborative networks, still in becoming, has been the
Interfund. The Interfund is "a co-operative, decentralized, non-located, virtual but
real, self-support structure for small and independent initiatives in the field of cul-
ture and digital media." The Interfund proposes to become a shared resource pool,
a "Bureaucracy Protection Shield," a forum for the critique of (the inefficiency of)
large institutions, a pool of shared skills.

Beyond that, the Interfund stimulates individuals to "create your own solutions." One
of the more ingenious of these self-help solutions was the self-funding scheme! This
scheme addresses the nasty fact that cultural funding agencies generally want to
support projects only if they are already supported by other funding bodies. The
Interfund therefore came up with the idea of a micro-funding scheme where proj-
ects from within the Interfund community (which itself is an open structure) would
be immediately eligible for official support by the Interfund — in an amount of
either 1 or 10 US$ per project. With the official letter of acknowledgement new
funding applications to local agencies could be given extra credibility. "Look, our
project is already supported by the Interfund!" — "what, really?? Well in that case..."
If by any chance the Interfund office is far away, or there is no time for a surface
mail exchange, the entire Interfund would be downloadable in the form of PDF

files and other downloadable design elements, thus allowing each individual member to establish their own Interfund.

All of these types of media practices still have an attachment to the functional. There is an idea that something has to be communicated — a fallacy of course. What mostly distinguishes intimate and socialized media from the broadcast model, is that the media-infrastructures here primarily act as support structures for certain intricate social figurations to emerge. There is a highly specific sub-set of these media phenomenologies, however, that seems to have emancipated itself from even those basic functional demands of use and has entered into a kind of "phatic" state: the sovereign media.

< sovereign media or "the joy of emptiness" >

Sovereign media are first of all media that simply exist for the sake of nothing else. Sovereign media produce signals with an origin/sender/author, but without a designated receiver. The term "Sovereign Media" alludes to the notion of the sovereign as developed by Georges Bataille in *The Accursed Share*. As a media phenomenology it has first been identified by BILWET (a.k.a. ADILKNO — Foundation for the Advancement of Illegal Knowledge). For BILWET the sovereign media are a bewildering new UTO — Unidentified Theoretical Object — which they study with great curiosity and leisurely pleasure.

BILWET/ADILKNO's early observations of this UTO indicate that, "the sovereign media (...) have cut all surviving imaginary ties with truth, reality and representation. They no longer concentrate on the wishes of a specific target group, as the 'inside' media still do. They have emancipated themselves from any potential audience, and thus they do not approach their audience as a mouldable market segment, but offer it the 'sovereign space' it deserves."

Riding on the waves of pure data-ecstasy, the sovereign mediators invite us "to hop right onto the media bus" — the signal is there, you only have to pick it up! No more technical mystification, just pure enjoyment of the endless and multidimensional connections that are created between the liberated fragments of the universal media archive. Disconnected from the gravity of the professional, the alternative, the artistic and the political media, the sovereign mediators and their accidental audience float through the boundless media space beyond meaning and intention.

Our guides to the sovereign media galaxy explain that "these negative media refuse to be positively defined and are good for nothing. They demand no attention and constitute no enrichment for the existing media landscape. Once detached from every meaningful context, they switch over in fits and starts from one audio-video collection to the next." "We have lift-off!!!" — this is the point of departure where

any successful expedition into the sovereign space of media finds its origin. (From the B$_{ILWET}$ *Media Archive*.)

< presence beyond utility >

In *The Accursed Share*, Bataille defines the sovereign in opposition to the servile, in opposition to all activities subordinate to the demands of usefulness. The demands of usefulness, the basis of any kind of economic or productive activity, rule out the experience of sovereignty. By deriving its meaning and purpose from what it is useful for, the activity itself becomes intrinsically meaningless. The sovereign experience, on the contrary, is meaningful independent of its consequence. It always refers to the moment of its consumption, never beyond.

"Life beyond utility is the domain of sovereignty," Bataille writes. Only when experience is no longer subordinate to the demands of use is it possible to connect to what is "supremely" (*"souverainement"*) important to us. Sovereign media then should be understood as media beyond use. They should not be understood as "useless" but rather as "without use." The sovereign media are media that have emancipated themselves from the demands of functionality or usefulness to exist in their own right.

< quality is irrelevant! >

Freed from the demands of usefulness, quality becomes an irrelevant criterion for these media signals. The signals exist: how they are interpreted, what the framework and the demands are that are projected upon them, is not a consideration in the process of their production. The signals can be beautiful and brilliantly clear, or amateurish and oblique. The traditional criteria of media professionalism have long been left behind in the universe of the sovereign media.

One of the most beautiful examples of a supremely sovereign media practice is the net.radio.night, a global micro jam in net.audio, regularly hosted by the xchange network (xchange.re-lab.net). Typically for a net.radio.night a call is put out on the mailing list, inviting net.casters to join on irc and listen to a live stream originating from location one. Other locations listen and pick up the stream till someone announces on the irc channel that the live stream will move from its original location to theirs. The next stream is a remix of the original, some things added, others taken away. The process starts anew and the stream moves to the next location and the next re-mix. This process can go on for hours, and very soon the origin of any specific sound is lost. What the net.radio.night imprints on the participants is a strong feeling of being in the network, where the relationship between origin and destination has been dissolved. Also the traditional audience can tune in and listen, but is no consideration in the structure of the event.

A distinctive characteristic of sovereign media is their hybridity. Any medium can be combined with any medium. Sovereign media have a cross-media-platform-strategy, not to reach a new audience, but simply to extend the media space. Examples are the Virtual Media Lab (media.live.nu), an intersection of all available media in Amsterdam, combining cable television with web casting, with radio, and even at times with satellite transmissions. Another interesting cross breed are automated media such as the Frequency Clock of r a d i o q u a l i a, or Remote TV of TwenFM, allowing automatic scheduling of live streams from the internet on local radio and cable TV infrastructures. Or the project Agent Radio of the Institute of Artificial Art in Amsterdam that automatically and randomly selects sounds sources from the Internet and schedules them in the ether.

All these media operate beyond the body count of viewer statistics.

< private media >

In the Digital City Amsterdam the personal home pages of its "citizens" are called "Houses." For some years already the personal home pages on the world-wide web in general, and the success of initiatives such as GeoCities, prevail in the face of adversity, while big-budget entertainment networks such as DEN (Digital Entertainment Network), collapse even before anyone really got to know about them. The deeply respectable weekly economy magazine The Economist recently put a sad smiley on its cover, testifying to "what the Internet cannot do." Inside the issue a careful analysis is made why the Internet has such a hard time taking off as an entertainment medium, and is not living up to its promises at all.

The kind of private media formations such as GeoCities, the Digital City in Amsterdam, and others, mostly do not deal with the communication of a specific message at all. They have no target-audience, and are not part of the attention economy, but still they are highly successful as private media. More than the failed attempts to establish the ultimate entertainment medium, the net has flourished as the ultimate personalization of the media space. The endless stacks of private home pages are the icons of these truly privatized media. Their private messages, beyond anything else, simply state "I am here," but this simple message should not be discarded as a banal statement.

< phatic media >

In their final phase of evolution media become phatic. The term derives from linguistics. In linguistics phatic language relates to "speech used for social or emotive purposes rather than for communicating information." The typical, though admittedly somewhat stereotypical example, is the daily speech of housewives meeting every single day in the garden while hanging wash or taking care of domestic tasks. The exchanges of apparently meaningless phrases such as "how are you?", "How are

your children doing in school?", etc., communicate something beyond the semantics of the individual words.

An amazing image: A test channel of a satellite TV transmitter, operated by satellite tv amateurs — an international network. One central image surrounded by smaller screens. They show what looks to most of us like "nothing." A small room, an attic, a technical workshop, equipment, somebody sitting around, no apparent communication. The image is, it does not speak. One of our civilization's most highly developed high-tech infrastructures, utilized to celebrate the joy of emptiness...

This type of media appears to be completely useless within the traditional (broadcast) media scheme. It is a mistake to take this view for granted, however. There is indeed nothing banal about this media behavior. The media sphere is treated here as a new type of environment, "in" which people create presences, but without a desire or aim to communicate a specific message.

In fact I understand this as a fundamental anthropological principle — a way of inhabiting a new environment, and one that is, after all, primarily a hostile environment for most of us.

> — *Amsterdam, October 2000. Extracted from talks given at Banff Interactive Screen 0.0 and at NET.CONGESTION — international festival of streaming media, Amsterdam. Sovereign media bits remixed for SUBSOL.*

27

From Mini-FM
To Polymorphous Radio

Tetsuo Kogawa (Japan)
||

*We understand the end of something all too easily in the negative
sense as a mere stopping, as the lack of constitution, perhaps even
as decline and impotence; the end suggests the completion and the
place in which the whole of history is gathered in its most extreme
possibility. – Martin Heidegger,* Being and Time

Throughout its history, despite efforts by the
Futurists in the 1920s, radio has been considered largely a means of communica-
tion rather than an art form. Therefore, it is ironic that just as traditional forms of
radio are in decline, its possibilities as an art form are reaching extreme potentials.
If, as Heidegger once suggested, the most extreme possibilities can only be
reached at the end of something, what then ends with radio? What is radio's most
extreme possibility?

< the beginning >

The term *mini-FM* was first used in a mass-circulation newspaper in 1982, when a very
low-watt FM-station movement started. Mini-FM stations have very little power
judged by any standard – usually less than a hundred milliwatts. Although such a
weak signal may seem to be of no use for broadcasting, the purpose was not
broadcasting but narrowcasting.

The birth of mini-FM is related to the peculiar situation of radio in Japan. When mini-
FM originated in the early 1980s, most cities in Japan had only one FM station, if
any at all, because only government-operated stations could obtain licenses; station
administrators tended to be retired government officials. The situation is not so dif-
ferent today, although there are seven stations in Tokyo now instead of two. In this
constricted atmosphere many people wanted more open programming. In addi-
tion to a desire for diverse culture, there was another motivation for those of us
who started the free radio movement – to resist the commodification of subcul-
ture. Political activists for alternative culture in Japan had been involved tradition-
ally with underground newspapers and magazines rather than electronic media.
When youth subcultures started to develop mini-FM there was no immediate inter-
est among political radicals since they tended to critically dismiss youth culture.

However, certain industries began to develop new commodities for the subculture market and targeted young people as the new consumers. This created a dilemma for radical activists because we were aware of the tendency of postindustrial institutions to co-opt diverse culture and social movements.

The Italian free radio movement and Felix Guattari's response to it stimulated us very much. It provided thrilling examples in which politics and culture creatively worked together and gave us hope with which to cope with the dismal state of Japanese mass media. Guattari stressed the radically different function of free radio from conventional mass media. His notions of transmission, transversal and molecular revolution suggested that, unlike conventional radio, free radio would not impose programs on a mass audience, whose numbers have been forecast, but would come across freely to a molecular public, in a way that would change the nature of communication between those who speak and those who listen.

Based on these events, friends and I began experimenting with radio transmission in the early eighties. At that time we intended to establish a pirate FM station with a leftist perspective. However, there were few people who could help us build an appropriate transmitter and it was difficult to find a ready-made transmitter, at a reasonable price. Even a techno-freak friend, instead of giving me the instructions, warned me that within half an hour of breaking the radio regulations, the Ministry of Post and Telecommunication would discover it. This negative attitude had resulted largely from the psychological stigma attached to breaking the law during World War II when the authorities strictly banned the use of short-wave radio receivers, to say nothing of transmitters. Even now, there is still a general feeling that the airwaves belong to the government. However, we had a different idea — that airwaves should be public resources, not monopolized by the state.

In the meantime, an interesting thing happened: I stumbled upon Article 4 in the Radio Regulations Book. It permits transmitting without a license if the power is very weak and is intended to accommodate wireless microphones and remote-control toys, for example. Under this regulation, quite a few wireless transmitters were sold in toy stores and electronic markets. Also, several audio-parts makers sold the wireless stereo transmitters to link amplifiers to speakers without wires. My idea was to use this type of tiny unit for radio transmitting. During several tests of small ready-made FM transmitters we found that some of them could cover a half-mile radius. Presumably, the sensitivity of radio receivers had increased beyond the Ministry's estimation when they established the regulation in the 1950s.

As a commentator of popular culture, I started to make this idea public in various popular magazines and through my book *This is Free Radio*, which provoked strong responses. In late 1982, my students and I started Radio Polybucket, a station using a small transmitter on the university campus. At the same time, a group of young musicians, advertising agents, designers and so on, started a station called KIDS, intending to promote their new businesses — shops selling goods for the young.

Whenever popular journalism addressed this kind of news item, the number of mini-FM stations increased. The exact number is unknown, but it can be estimated from the number of small transmitters sold that, in a year, over one thousand stations appeared in Japan. People on college campuses, in housing complexes, coffee shops and bars, stalls at street fairs and even local offices started mini-FM stations. More than ten companies, including Mitsubishi, Panasonic, Hitachi and Sony, sold a transmitter labeled "For mini-FM use."

< centripetal rather than centrifugal >

The boom was fantastic, in a sense, but it puzzled us. We had intended to establish a free radio station, not to transmit a one-way performance that disregarded listeners as most stations did. During the boom, most mini-FM stations were able to communicate to a handful of people only. But many of these stations seemed to us to be naively copying professional radio studio work. On the contrary, we paid attention to constant and serious listeners and sought to provide a community of people with alternative information on politics and social change.

The radio station that my students and I had started on the campus re-established itself in the center of Tokyo when the students finished school in 1983. The new station was called Radio Home Run. Every day, from 8 PM to midnight, one or two groups aired talk or music programs. Themes varied, but members always invited new guests who were involved in political or cultural activism. Repeating the station telephone number during each program was our basic policy. Listeners who lived close to the station began to visit. Guests sometimes recorded cassette tapes of our programs and let their friends listen. Radio Home Run quickly became a meeting place for students, activists, artists, workers, owners of small shops, local politicians, men, women and the elderly. The function was centripetal rather than centrifugal: listeners tended to want to come to the station.

< DIY technology >

We had a number of experiments to remodel the transmitting system, create programs and pursue a new way of getting together. Sometimes, we tried to have a number of radio sets and transmitters to relay to each other and to extend their service area. Since the cost of each unit is cheap, one could have a number of radio sets and transmitters to relay to each other quite inexpensively. But in practice it turned out to be very hard to do because the sound quality is lost as the relay is multiplied. Through our experiments we came to the conclusion that we must work within a half-mile service area. Tokyo is densely populated so even a half-mile area has at least ten thousand inhabitants. This meant that mini-FM could function as community radio. Radio stations which can only cover areas within walking distance could be relative to the human body and be sensed easily. This is not broadcasting, but narrowcasting.

I called this kind of media "polymorphous media" or "polymedia." Polymedia are not intended simply to link smaller units into a larger whole: instead they involve the recovery of electronic technology that individuals can communicate, share idiosyncrasies and be "convivial." Polymedia must be based on self-controlled tools, otherwise advanced technologies will remain as tools for the manipulation of power.

< beyond a communication vehicle >

We tried to think about radio in a different way, as a means to link people together. To the extent that each community and individual has different thoughts and feelings, we believed there should be different kinds of radio — hundreds of mini-FM stations in a given area. If you had the same number of transmitters as receivers, your radio sets could have completely different functions. Thus radio transmission technology could be available for individuals to take control of their transmission and reception. This block radio could reactivate diverse cultures and politics — "micropolitics" in the words of Felix Guattari.

Conventional radio and television is generally eager for as large a service area as possible: from nation-wide to global networks. According to these models, communication is considered as a way of conveying information as a material entity from one place to another. Mass media has functioned (and still does) as strong catalyst of industrialization, characterized by the transportation of solid material, integrated homogeneous grouping and an industrious work ethic. However, as Humberto Maturana and Francisco Varela have argued, such a notion of communication is forced and distorted. Human communication is based not on tube conveyance but on structural coupling.

In the process of transmitting, we became more interested in pursuing a new way of getting together rather than circulating information. We found that even one kilometer community is too large and there are more different units of cultures and tastes of the individuals. Micro-revolution can happen only on such a level. That's why we became more conscious of our members than of (possible) listeners. The action of transmitting together changed our relationships in a way that seemed distinct from the effects of other collective actions that did not involve transmitting. It is in this context that I gradually understood the meaning and potential of mini-FM. Radio could serve as a communication vehicle not for broadcast but for the individuals involved. Even if they have few listeners, these stations do work as catalysts to reorganize groups involved in mini-FM.

Those who were familiar with conventional radio laughed at mini-FM because it had only a few listeners, listeners within walking distance of the station, and no consistent style. However, even if one overlooks the dramatic effect on society, one must admit that mini-FM has a powerful therapeutic function: an isolated person who sought companionship through radio happened to hear us and visited the mini-FM

station; a shy person started to speak into the microphone; people who never used to be able to share ideas and values found a place for dialogue; an intimate couple discovered otherwise unknown fundamental misunderstandings. At that time nobody talked about such a psychotherapeutic; function, however, given the number of people involved in mini-FM, it must have been understood unconsciously.

The signal of mini-FM is too weak and too special to provide information. However, this does not mean that mini-FM is not relevant to discussions of free radio. Mini-FM has changed our communications procedures and has offered examples of new types of communication. For as long as radio has been considered as a means for the circulation of information from one place to another, mini-FM has been different.

< natural radio >

Although I have been involved in the free radio movement of mini-FM and have also worked with pirate stations in Japan since the early 1980s, I now doubt if radio, when developed to its most extreme potential, can be appropriately called "free radio."

My experiences have led me to imagine therefore what ends with radio: we are now in the process of surpassing radio as a communication means and as form of self-expression for artists. Both of these models belongs to modernity, the same matrix that adopted terms such as freedom and democracy. It has become necessary to think a new direction or framework for human self-fulfillment that does not rely on these types of notions of freedom. Perhaps now the era of freedom as an ideology has ended. This does not mean that freedom was an illusion or that we enter a new age of non-freedom. Rather, it means that other concepts completely different in character from freedom are emerging.

Compared to technologies using steam and springs which are based on compression and release, radio is a medium beyond freedom in the sense that it is based on electronics, a post-freedom technology. When radio was first developed, there was no inherent need to separate transmitters from receivers. However, at that time, freedom was still a valid political ideology, so transmission and reception were strictly separated to allow for contrasts between the free and the not free: transmission was monopolized by the broadcast stations and "unfree people" called "listeners" were created artificially. We might in the 1990s have to consider retiring the expression "free radio." Even mini-FM is not within the descriptive framework of free radio.

A new horizon has been opened, outdating the separation of transmission and reception that had been forced upon electronic media. The question in the age of satellite media is no longer whether or not radio or television is "free" but whether it is "polymorphous." We are at the dawn where we can imagine a different type of

radio, such as Murray Schafer describes in "Radical Radio." Schafer criticizes radio that "has become the clock of Western civilization, taking over the function of social timekeeper from the church bell and the factory whistle," and imagines a new type of radio that could "ring with new rhythms, the bio-cycles of all human life and culture, the biorhythms of all nature." This does not imply that we should reject all radio that tries to convey messages — message radio. But I just want us to think about the different potential of radio, the experimental side of radio.

28

Notes on Sovereign Media

Geert Lovink & Joanne Richardson *(Australia/Romania)*

|||

n this age of media overproduction, information immunity is a question of life or death. Data are no longer stimuli to interest, but an inimical barrage constituting a physical threat. From exchange to effacement: communication is preying on naked existence. This condition takes the shape of the catastrophe while simultaneously embodying a promise of liberation.

Sovereign media do not criticize the baroque data environments or experience them as threats, but consider them material, to use as they please. They operate beyond clean and dirty, in the garbage system ruled by chaos *pur sang*. Their carefree rummaging in the universal media archive is not a management strategy for jogging jammed creativity. Sovereign media refuse to be positively defined and are good for nothing. They demand no attention and constitute no enrichment of the existing media landscape. Once detached from every meaningful context, they switch over in fits and starts from one audio-video collection to the next. The autonomously multiplying connections generate a sensory space, which is relaxing as well as nerve racking. This tangle can never be exploited as a trend-sensitive genre again. All the data in the world alternately make up one lovely big amusement park and a five star survival trek in the paranoid category, where humor descends on awkward moments like an angel of salvation and lifts the program up out of the muck.

From the calculating perspective of the mainstream, media are intermediaries, conduits for communication, communicators of information. Media mediate information and carry it from A to B. They are presented as the condition of possibility for the exchange of information in its commodity form. The most useful media efface their presence; they disseminate the information in the most condensed form in the shortest possible time to the largest audience. Economy ultimately reduces itself to the economy of time — Marx said somewhere. And vice versa, time reduces itself to economy — to measurement and circulation for profit. The clock

is necessary for the calculation and the organization of life under the rules of business. At the dawn of capitalism, merchants discovered the price of time as a consequence of the calculability of space. The exchange of commodities entailed movement from a point to its destination, and the time taken up by movement through space became subordinated to the money-form.

Media signify mastery over time under the rule of profit. Sovereign media are instances of mastery over nothingness... free of motivation, without purpose, they let themselves go, driven by the winds of data. Sovereign media are fundamentally disinterested, they don't care about the extraction of value or a surplus of meaning, they are beyond the demand for information and the utilization principle of the network. Sovereign media lack any comprehensive idea of its customer base. They cannot comprehend the language of mass media, a language militarized by the clock, reduced to sharp words that carry blunt concepts. They do not pay attention to the attention economy. Sovereign media are self-exponential. What they communicate is something other than information. They communicate themselves, liberated from the most oppressive category around: the audience. Casting beyond "the public" is the ultimate form of media freedom.

Sovereign media insulate themselves against hyperculture. They seek no connection; they disconnect. This is their point of departure — we have a liftoff. They leave the media surface and orbit the multimedia network as satellites. These do-it-yourselfers shut themselves up inside a selfbuilt monad, an "indivisible unit" of introverted technologies which, like a room without doors or windows, wishes to deny the existence of the manifest world. Sovereign media are not individual monads, rather, the world they inhabit is a monad, a parallel universe... beyond (or beside) the universe of the mainstream media and its demand for representation, reality and truth.

Sovereign media have not abolished the desire for connection and communication; they communicate with each possible node within their parallel universe. But their communication act is a denial of the maxim "I am networked, therefore I am." The atmosphere inside the sealed cabin conflicts with the ideology of networking, which subordinates the process of making links and connections to a practical goal, a concrete project, the promise of a future gain. Networking is never fully in the present nor fully in-itself, it is endured for the sake of something always just out of immediate reach. Sovereign media have severed the ties to utility, the weight of time, the labor of the project, the measurement of profit. Freed from the demand for information, communication becomes gregariousness, a gracious form of sociability. It becomes what in fact it always was — a process of forging social relations that are not subject to exchange (giving something for the purpose of extracting a return). The public is freed of its obligation to show off its interest and can finally stop paying attention. The desire to connect is determined by the pleasure of communication rather than the imperative to exchange information or establish a (political) agenda.

Sovereign media differ from the post '68 concept of alternative media (and its most recent metamorphosis into "Indy" media) as well as from 1990s tactical media. Alternative media work on the principle of counter propaganda and mirror the mainstream media, which they feel needs to be corrected and supplemented. Their strategic aim is a changed consciousness — making individuals aware of their behavior and opinions. These little media work with a positive variant of the cancer (or virus) model, which assumes that in the long term everyone, whether indirectly or through the big media, will become informed about the problem being broached. They presuppose a tight network stretched around and through society, so that in the end the activism of a few will unleash a chain reaction by the many. Alternative media have to appropriate Truth in order to operate. For sovereign media there is no Truth, only data which can be taken apart and reassembled in trillions of bytes.

The post-'68 alternative media universe took shape as a swarm of little grassroots initiatives, self-organized by the "radicals" and militants — media from below in the form of community newspapers, radio, and television, which were only locally available, but untroubled by their local constraints. This changed during the 1990s when the internet made it possible for do-it-yourself media to transcend their local boundaries, and become transnational, like their uni-directional global counterpart, the mainstream media. The Independent media of the 1990s is the globalization of the alternative media (due to the democratization of technology) and the universalizability of the principle of grassrootedness.

Indy media, as the most recent legacy of the alternative media model, seek to supplant the old media universe. These counter media constitute an internal, dialectical negation, an immanent critique that can never get out from the presuppositions of the system it challenges. (We need only think of Marxism's dialectical negation of capitalism, which preserved the imperative of productivity, the utility of instrumental technology, the repressive apparatus of the State, police and standing army, as a necessary "first stage.") The mass media universe purports to be a true, genuine, democratic form of representation. Indy media critique these pretensions from the inside, wanting to expose the ideological shell behind them. But they want to preserve the rational kernel, to offer a form of media that is a true, genuine, democratic form of representation. Indy media aspire to become the dialectical supersession of mass media, and dream of a future when media itself will be transcended, insofar as media implies a separation between sender and receiver. With the democratization of information, as the receivers can become, potentially, the senders, such a separation is abolished, and information becomes a free-floating field, a pure transparency. The truth of Indy media is the post-medial universe of unmediated relationships.

Indy media work by deploying counter-propaganda. They oppose the false, ideological shell of the mass media with counter-statements made from a counter-perspective. Independent media are dependent on the image of the mass media, which they

seek to reverse — they need to bounce off this shell, often borrowing the same strategies. Propaganda puts forward a position without being aware of its construction, taking it for something natural or inevitable, disarticulating the ideology it shelters and preserves. The counter media do not question the position from which they speak. It is self-evident. And like mainstream media, they are deadly serious, they fight, militantly, to defend their position. They have a mission, a supreme Cause — the revolution in ruins — and, perpetually, they wait. Caught in the web of journalistic discourse, they too calculate time. Still not actual, they invest their energy toward some future beyond that legitimates their existence. Showing off their militancy, they are often blind to internal contradictions, closed off to the possibility of criticism, and devoid of the principle of pleasure. Propaganda and reflection do not always make good friends. And pleasure can become a danger to the Cause, it can throw it off-track, it can drown its unaware victims in a sea of forgetfulness. And above all, the counter media need to remember, to measure offenses, to accuse, to seek retribution.

Tactical media, by contrast, do not take themselves that seriously. They don't need to take the moral high ground and instead look for cracks in the media system. They know how to laugh, occasionally, even at themselves. Urged by their desire to form new coalitions they are capable of taking risks, even if this means they might self-destruct in the process. Clever tricks, the hunter's cunning, maneuvers, polymorphous situations, joyful discoveries, poetic as well as warlike. The tacticals are rebellious users of the mass media universe, whose messages they jam and hijack. As happy negatives, they are determined by their enemy. A fake GWBush page by ®™ark cannot exist without the "authentic" one, which it parodies without reserve. Culture jammers do not exist without corporate billboards. Tactical media use what is handy, what can be improvised in the moment. They do not deploy the same strategies as the inside, they shy away from solemnity, and the claims to truthful representation. Tactical media create a system of disinformation, which implicitly questions the power and status of signs. Information becomes laughable, it is exposed as a sham. The truth is not a hardcore database full of "facts" but only appears as a brief moment of revelation, popping up out of the (collective) unconscious.

Tactical media may be art, but they are not, however, "disinterested" — ultimately, they have some long-term political aim, they labor for a future cause, even though they may know how to enjoy the moment. They have given up the masses, but they seek to change the consciousness of a minority, by conducting a politics by other means, a politics that has surpassed itself and become an art form. They wage not counter-propaganda, but propaganda of the hoax. The toolbox of tactical media is sometimes borrowed from the basement of the avant-gardes, who although not "militant" in the strict political sense, made a fetish out of the metaphors warfare and terrorism. And metaphors are not always innocent. The avant-gardes began decomposing a long time ago, as the militarism concealed in their names, gestures, and mode of organization came increasingly under disrepute. But sometimes they

can still be heard gasping for life, somewhere beyond the grave of history, having since metamorphosed into "communication guerrillas."

Unlike the media of opposition, which are based on a radical critique of capitalist (art) production, sovereign media have alienated themselves from the entire business of media politics and the contemporary art scene. An advanced mutual disinterest hampers any interaction. They move in parallel worlds which do not interfere with each other. No counter information or criticism of politics or art is given in order to start up a dialogue with the authorities. Sovereign media have cut all surviving imaginary ties with truth, reality and representation. They no longer concentrate on the wishes of a specific target group, as the alternative and tactical media still do. They have emancipated themselves from any potential audience, and thus they do not approach their audience as a moldable market segment, but offer it the "royal space" the other deserves.

The royal Other is not a receiver of information, but a partner in a communication without purpose. Sovereign media are media without the message, the dialectic of media at a standstill. They are stalled at the intermediary step of making connections, without moving toward an aim, without the finality of exchange. Sovereign media lift up the media as an end in-itself. This should not be understood as a desire for the "purification" of the medium, a desire that has accompanied every old and new media revolution. On the day film was born, the conceptualists of purity wanted to eliminate from its realm everything that did not belong to it — narrative, representation, metaphors — and which had been imported from other media, like literature. The sovereignty of media is not a phenomenological reduction or purification of a language specific to "media as such." Sovereignty is not a conceptual project, but an aesthetic wandering. Communication ceases to be a general equivalent through which something is quantified and squeezed; it becomes an end in itself, narcissistic, ecstatic, and free.

If Indy media labor to become the supersession (Aufhebung) of media into Truth, sovereign media are its total dispersion. The counter media seek to abolish the separation between sender and receiver, between medium and the message, thereby completing the internal development of media. Sovereign media inhabit a universe which is post-medial in another sense. There is no sender and receiver because there is no broadcast and no message. Sovereign media do not surpass the sender-receiver regime by bringing it to its completion, they take no interest in it, they annihilate the problem, and with it, the desire for a solution.

Without being otherwise secretive about their own existence, the sovereigns remain unnoticed, since they stay in the blind spot that the bright media radiation creates in the eye. And that's the reason they need not be noticed as an avant-garde trend and expected to provide art with a new impetus. The reason sovereign media are difficult to distinguish as a separate category is because the shape in which they appear can never shine in its full luster. The program producers don't show them-

selves; we see only their masks, in the formats familiar to us. Every successful experiment that can possibly be pointed to as an artistic or political statement is immediately exposed to contamination. The mixers inherently do not provoke, but infect chance passersby with corrupted banalities which present themselves in all their friendly triviality. An inextricable tangle of meaning and irony makes it impossible for the experienced media reader to make sense of this.

So what are sovereign media? The form of the question might be incorrect. Sovereign media are. In the pleasure of Being Media, sure of themselves and lacking nothing, they embark on a journey to shape the data universe.

> — *This is a revision/update of the earlier text "Theory of the Sovereign Media" by BILWET (a.k.a. ADILKNO — Foundation for the Advancement of Illegal Knowledge), which was published in English for the first time in Adilkno, THE MEDIA ARCHIVE, Autonomedia, 1998. The original version can be found on-line at (www.thing.desk.nl/bilwet/adilkno/TheMediaArchive/02). The revision was written in November 2001, somewhere between Sydney and Zagreb.*

29

Warning: This Computer Has Multiple Personality Disorder

**Simon Pope &
Matthew Fuller (England)**

*ody-identity assumes that a person is defined by the stuff of
which a human body is made. Only by maintaining continuity of body stuff
can we preserve an individual person. Pattern-identity, conversely, defines the
essence of a person, say myself, as the pattern and the process going on in my
head and body, not the machinery supporting that process. If the process is
preserved, I am preserved. The rest is jelly. – Hans Moravec,*
Mind Children: the Future of Robot and Human Intelligence

< surgical strike cartesianism >

Disembodied intelligence is always a con. If these glowing elite minds migrated into data-
space we can be sure that at some point they would have to recognize a codepen-
dency with the material world, one composed primarily of minerals, electromag-
netic sensation perhaps, and a new kind of physicality would emerge — possibly
something akin to what Ballard imagines in his repeated metaphor of the superses-
sion of "civilization" by the crystalline. The mind always emerges from the matter.

The entropic, dirty, troublesome flesh that is sloughed off in these fantasies of strongly
masculine essentialism is implicitly interwoven with the dynamics of self-process-
ing cognition and intentionality that are relegated to a substance called "mind."

However, lest this should materialize as a "holistic essentialism" that swaps meat-fear-
ing disembodiment for a dread of the machinic body we should move on to
acknowledge that homo sapiens evolved as a result of a deep, coevolutionary inti-
macy with the "inhuman," with tools, with the machinic. At the very core of our
development as a species is the gradual bootstrapping of the brain, the supposed
Slot In Memory Module, which according to neodarwinian evolutionary theory is
itself possibly the result of a possibility-space opened up through the development
of the opposable thumb. A mutation in one part of the body, with far-reaching side

effects on all others, that opens it up to a combinatorially explosive array of relations with other forms of matter. Thus, we are always already deeply post-human.

That information-processing technology is being touted as the "next opposable thumb," generating the possibility-spaces that we are currently living through, does not of course lead us in an automatic loop back to a glorious disembodied life on the outer reaches of some computer's sub-directory. A survey of most contemporary multimedia work, however, might convince us otherwise. From Automated Telling Machines, through the freebie CDs on the covers of computer magazines; corporate presentation material and "high-end" games such as Myst, contemporary multimedia constitutes presence in relationship to this post-human body as a process of exclusion.

Computers are embodied culture, hardwired epistemology, and in the area we are focusing on, two parallel sequences are occurring. They are implicitly related but whilst twisting in and out of each other, operate in different ways. The bureaucratization of the body into organs and the privileging of the eye in multimedia is one. The renewal of encyclopedism is the other.

< the bureaucratization of the body into organs >

Much has been made of the notion of the eye as primary organ (and primary also in the genitive sense), around which bodies (literally) organize. From Dziga Vertov's cruise missile approach to Berlin, to anti-sex feminism's abhorrence of pornography the eye is seen as a unifying and explanatory media in its own right. Perhaps a certain apotheosis of the privileging of the eye is reached by Guy Debord in *Society of the Spectacle*, who assigns an immense life-expropriating power to "The Order of Appearances" whilst simultaneously positing a different type of image, the printed word (of his writing of course), as the catalyst for the destruction of this world of relations mediated by images. Sight remains the most theorized, most contested over, yet in some ways least contested of the bureaucratized senses.

Within multimedia, the desire to transfer information without transforming its integrity has remained strong, and the senses have been prioritized and valorized in order that this system should work efficiently. With the eye situated as the locus of authority, assurance is passed to the other senses, which are called upon to further validate the evidence presented before them. Following the sales mantra "image, text, sound, video," graphical interfaces reinforce this rigorous separation of the senses into a hierarchy of feedback devices. In other words, as you will see when using anything from Grolier's Multimedia Encyclopedia to the Arts Council's Anti ROM interaction is fed first and foremost through the circuits of sight.

Within the sight-machine of contemporary multimedia then, the mind has to be re-thought or re-programmed as a simple processor of Information Graphics. Once recognized and regulated, sense can be made and order imposed on data; it can

be subjected to the strictures of simple structuralisms where sign = signifier and all's well with the world. Under the heading comes the sub-heading, under which comes the sub-sub-heading, until all complexity can be understood at a glance from somewhere outside the filing cabinet...

Through this representation stacking, it is hoped that a mind-melding transparency can be achieved: interfacing the disembodied mind and disinterested data. The mind is immersed into the encyclopedic data-space, as charmingly freed from visceral distractions as a bottle of deodorant. That the eye sloughing off the cankerous meat in an attempt to fuse mind and data, one electronic pulse with another, chooses to confirm its conferred status shouldn't be a surprise. The eye, released from constraint, with a mind of its own, "can take any position it wishes."

What is remarkable is that this pursuit of the monadic eye realizes itself in most contemporary multimedia as nothing much more than a subset of behaviorism: with users barking, whining, and slathering at the interminable (once in a lifetime) chance to point and click their path to dog-food heaven.

< the renewal of encyclopedism: pavlov's menu >

At the center lies the desire for the enforcement of meaning. The encyclopedic organization of data preserves a point of privilege from where the eye can frame the objects of its desire. There are no obstacles in this space, only straight paths cleared to open unimpeded vistas. Within this space, intention steps toward the user, to be understood without the hindrance of cumbersome literary convention. All can be conveyed from within the universal iconic language, a visual, pre-linguistic key, clearly carrying reference to the ciphered world. This virtual architectural space has been constructed by an unseen author, whose intention is usually to impose a closure to a narrative, to provide the goal to be reached by means of one of many approaches, the reader/user/participant/player (choose according to theoretical preference) can wander, but must not stray from the intended thoroughfares.

From any point it is possible to look back along your path, holding on to Ariadne's thread, taking solace in the fact that all you have seen is recorded, marked, referenced and ultimately retraceable.

< i/o/d 2 >

I/O/D is a Macromedia Director Projector with associated files that is small enough to be compressed onto one High Density disk. That we choose the size to be restricted by the limitations of the most mundane and cheapest storage device is important, because it means that I/O/D is very easy for people to copy for their friends – or surreptitiously leave on the computers of their enemies. It also means that because of its relatively small size it is quite feasible for it to be made available over computer networks such as the internet and on Bulletin Board Services.

Distribution over the networks is in fact the major way in which I/O/D gets moved around. It is also worth noting that within the internet, where degrees of access are stratified, we make I/O/D available via a variety of protocols — ftp, gopher, and world wide web — in order to ensure that as many people as possible have the option of downloading it. Alongside the sites that we maintain a direct connection to we are encouraged to find that I/O/D is also being independently distributed by people we have had no contact with.

I/O/D is not on the nets in order to advertise anything but itself. It is specifically an anti-elitist contribution to the development of the nets as a "gift economy." Rather than urge multimedia as a potential grounds for the renewal of spectatorship, representation and simulation or to engage in the renewal of encyclopedism's drive to suburbanize multimedia, we are interested in developing something that is synthetic. Specifically: a process of playing with process.

Configurations of flesh that have been disarticulated, that are The Unspeakable, are particularly attractive to us. With I/O/D we are in part attempting to articulate some of those configurations that have been erased from the multimedia vocabulary.

In disrupting notions of a "transparent" interface, and in investigating the possibilities of physicality in multimedia we are not therefore proposing to formulate any new paradigm of multimedial correctness. Nor do we find as with any amount of "artists" that merely scattering computers, camcorders, movement sensors and monitors around a gallery in a vague utopian gesture towards interactivity deserves any response but stolen equipment. We propose neither a new disciplinary regime nor an abstract vacant "creativity."

If meaning-construction always takes place at the margins of a system — and meaning-enforcement at the center — then computer networks, where margin is folded in upon margin, in an economy of fecund, yet excremental exchange are currently a useful place to find oneself. In part it is this sense of margin rippling into margin that I/O/D as a border zone process attempts to play with.

What has been marginalized as incidental in behaviorist multimedia: the flitting of a user's hands over the keyboard, the twitching of the mouse, repetitive or arrhythmic events, noise, confusion... accretes into a secret history of makeshift, unimagined conjunctions. I/O/D then is an intensely haptic space. In issue two for instance, the arrow-head cursor is largely abandoned and replaced both by positions indicating sound and by the springing into life of the sprite that it would previously have been needed to animate. Within the boundaries dictated by the hardware of an average Macintosh computer we are coaxing out what has been disarticulated: different types of mouse movement; exaggerated clicking routines; the slashing and burning of Macintosh Operating System norms; larger than screen interfaces; repetitive strain injury; sloppy directories; a physicality of multimedia that correlates with what Ronald Sukenick has termed "fertile non-

sense"; the feeding back of an action in one sense into another to produce a cross-wiring synaesthesia.

And it is perhaps as synaesthetics, the neurological disordering of smart-cufflinked control, that within the abstract machine what we have here reviled — text and image "as truth," the renewals of spectatorship and encyclopedism, the privileging of the eye — will lose themselves as the prime loci of authority to be superseded by pattern finding and dynamic engagements with material processing. A dynamic that at once both infests bodies and that actually opens itself up to positively engaging with a bodily contamination that has always been operative, but bubbling away in the background.

> — *This is an excerpted version of a longer text written for Embodied Knowledge conference, Goldsmiths College, London 1995, with particular reference to I/O/D 2. Original version first published in Mute, and can be found online at www.axia.demon.co.uk.*

30

Post-Media Operators
Sovereign and Vague

Howard Slater
@ Break/Flow *(England)*

|||

hy theory? >

We have to dispense with the idea that theorizing occurs after the creative event; that a poem or a track or a text is made and then, as part of its process of dissemination, there follows the theorizing of the piece. Such a theorizing is normally attributed to those known variously as critics, reviewers and essayists. However, what actually occurs is that theorizing goes on at the same time as the creative event is being worked upon. There is a thinking and an engaging with materials at the same time. Praxis. Process. It is complementary to the event and, more importantly, it is the continuous precondition for the event. Such a theoretical component to any activity is denied because theory is normally attributed to a textual product, and like the role of the critic, this comes to exercise the effect upon creative producers that their activity is somehow "below" the level of theoretical process. This self-deprecation, actively instituted by the division of labor (a compartmentalization of tasks that undoubtedly limits perception), serves to reinforce the divide between consciousness and activity, between thought and action; it severs the creative producer from the consciousness of his or her activity to the point that the theoretical component is occluded.

Perhaps a theorizing that neglects such auto-theoretical aspects could be termed "discourse" and that this latter form of theoretical activity is so often hermetic, self-referencing and exclusory is maybe because it seeks to resolve problems "once-and-for-all" within a text rather than filtering these through an activity that is constantly posing these problems anew as a part of daily practice. In this way, by coralling theory into servicing their own renewal, academics do not confront the division of labor (the provisos of their knowledge) and instead reproduce the hierarchization that not only occludes but occults the shared auto-theoretical component. Such hermetic academic discursivity — seen in the proliferation of secondary texts that

veil and seek to possess the primary text — serves as a means of formalizing the "right" to theory; specializing it as a work of discipline that it divorced from "practical energies."

Yet, to re-create what is meant by "theorizing," to refuse to differentiate it from "everyday" activity, experience and experiment is to be engaged in a process of de-conditioning; a translating and de-translating of the "inexhaustible stores of material" that, by means of memory and conscience, make of everyone an auto-theorist. Such a process, in not confining problems to discourse nor in seeking to compress them within formal, dispassionate and conclusive restraints, is a process of social engagement. Not knowing of boundaries, not even knowing of taught techniques of cross-over, the *sui generis* sites of communication proliferate and as they do it becomes clearer that, beyond the models offered by the media and the academy, it becomes a matter of re-appropriating the means of written, visual and aural expression. This approach is, in part, what those conspicuous outsiders, the situationists, meant by "drifting": a reflective activity is not solely a matter of a "large table and piles of books" but is as much a matter of the social-interaction of "walking": a non-discursive sense of the environment. This situationist take on auto-theorization, which relates to the Marxist sense of critique as opposed to criticism, was partly employed to differentiate their activity from academia and, if today this auto-theoretical dimension has been supplanted by the discursive, making this dimension invisible to practitioners who self-deprecatingly deny its existence to themselves, it is sadly sought and reconvened in the pages and sites of the media where, not only does it fall to journalists to articulate our activity for us, it is, as a result of such voluntary delegation, a matter of creative producers searching for a "scene" anywhere other than in their own auto-theoretical potential to be engaged.

< media pimps >

However, such flight from the academic and discursive towards the "free space" of the reputedly popular does hardly anything to resuscitate and encourage auto-theorization. The exchange of one set of exigencies for another reveals that the choice between academia and the media (the false choice of rigor versus hedonism, earnestness versus noncommittalism) is one which posits, at best, an acute negotiation between dissemination and compromise and, at worst, a blind innocence bordering on unconscious collusion; an innocence that is in part an innocence of seeking after the legitimating word of arbiters but which is also a naivety undercut by an unsureness of motive — a lack of any social context other than that of hermetic careerism (one slot becomes the advert for another slot).

Creativity, the free-flow of desire becomes channeled into a playful and distracted entertainment but it is still a creativity that is eulogized with an overload of super-superlatives. And so, as with academic eulogies to creativity, when the mainstream media discusses creative processes it is normally couched in terms of what makes a poem, text or track "better" than someone else's. That the "Harvard System" of

annotation is replaced by the interview situation does not diminish the degree of reverence. The canonical and the popular still resound to the familiar ring of "genius" but in the media things are maybe worse in that a premature acclaim or interest in a creative producer can work to sap auto-theorization by making the processes that inform the creativity into the motor of a production line: famous for a product, that product is replicated; famous for being misrepresented, the misrepresentation is promulgated. Often creative producers can almost be heard to be in the thrall of the mediatized situation, where, with the interviewer engaged in the dynamics of ego-activation, the interviewee is less likely to take the opportunity to talk in more general terms that could offer encouragement to others. The most successful manipulators of the media are those who know that they are dealing with the promotion of their own product (themselves) and, rather than pre-empt a critic's review and move out from the "silent" confines of the interview situation, they choose, in many ways, to meet media censorship with self-censorship. This is the price of their pleasure: that their desire, which becomes ours, is a stopped-flow called entertainment.

But, crucially, one of the primary elements of auto-theorization is the fact that it is dependent on being flawed and tentative. It is a space where mistakes and *meconnaissance* play a vital role. The media space is, however, by and large one of celebration, one where "success" and the finalization of product are reified into something that is unchanging. This media space requires that its subjects, obedient and pliable in the long sought-after first-flush of acclaim, suspend their self-critical faculties to the point that enthusiasm can be wrought into the unadulterated jubilance of publicity (every opportunity to speak becomes a retrenchment).

The media can't celebrate process or becoming. That would be to begin to suppress itself and, at the end of that fine day, it would be possible for us to return the creative product to its prosaic reality, bring it down from the reified air of its presupposed future posterity and install it as a social product. But in the meantime an air of unreality ensues. Everyone begins to expect a non-existent perfection and, awaiting their turn in the spotlight, are unable to address each other without the glare of this fictive mirror. Comparison, the benchmark of media quality control, equivalizes value and begins to infect a scene which, abandoning its idiosyncratic drive, begins to compete and then, exhausted, it reproduces the norm only to find it is too early or too late. For this divisive simulation to catch us in its thrall it is necessary for the "invisible structures" of the media to remain unillumined.

Journalistic construction is dependent on many elements and processes that do not find their way into finalized articles or reviews. There is the selection of subjects, which elevates some at the expense of others (reinforcing hierarchy, individualism and competitiveness) and which is, more often than not, carried out in relation to readership-expectation: a fictive, self-perpetuating and generalizing factor, that itself continually passes through discussions with editors, sub-editors, circulation-managers and financiers. Perhaps at this stage there is consideration of factors such as the ease

of access to subjects; the discussion of what is currently being supplied to pose as demand; the need for exclusivity, to be the first, to set trends. These are factors that establish a media mind-set where, above all, a kind of narcissistic investment in "profession" is mistaken for objectivity: the media not only "constructs" the popular, as if the "popular" pre-existed its journalistic mediation, but it then adheres to this definition of the "popular" and thus perpetuates it. This mythic shading of the media would be quite interesting if it wasn't, as with all blind faith, so insidious, so in touch with the unconscious, so much a built "drive" that modelizes people.

But as with "heaven," access to the media is a fraught and self-immolating path. Not just anyone can get in, for access to the media becomes a slow trickle because introjection of the "new" has to be couched in terms of the already pre-existing and discovery of the contemporaneous is overshadowed by the preparation of the "new"! That there is a constant obedience to these exigencies of the profession via editors and that this obedience effects a journalist's modes of perception and communication means that even when research is carried out it cannot be turned into a "processual" endeavor, a means of extending self-theorization, but must be directed towards the final piece whose outcome is, before even being written, somehow already expected (its syntax and superlatives are already capitalistic). In the journalistic trade in "symbolic" capital, whatever is said in an interview situation is subject to its being filtered via the journalist's own agenda: an agenda that may encompass... subservience to an editor to ensure the status of regular contributor... to the seeking-out of subjects and material that fits neatly into the tenor of a long-term approach (the thesis). The pay-off is that creative practitioner is offered the promise of diffusion because the journalist is structurally placed as a gatekeeper permitting access to a means of mass distribution and potential popularity. The unconscious dynamic which pervades such an exchange is one of censorship where the whole mythic idea of the popular (saved by visibility/made subject) becomes a fear of being unpopular (damned by invisibility/made abject) and, like a child who seeks approval, we are witness to one means by which the media induces infantilism: there is a rush to conform to the proscribed limits of behavior and thought, to seek not to be marked out, to never say or encourage anything politically contentious, to agree with that which flatters.

< media whores >

Everyone knows a media-whore when they see one. It's pointless making a list because most people have their own. They're the ones that crop up everywhere and at every available opportunity. It's not so much that they are acclaimed by many or that their persisting visibility is a mark of "quality." No. The media-whore is one on their own. One of a kind. A grafter in more ways than one. A grifter and a grafter. A convenient success-symbol for the ongoing pliable acceptance of the non-guaranteed freelance culture of "creative" self-exploitation. It is a question of professionalism meeting professionalism, of slotting into the requirements with all the smooth politeness of a parasite. Thus the media-whore is trusted. Deadlines can be

met. Appointments adhered to. Soundbites well-rehearsed. There will be no time wasting. No arguments about context because the media-whore is the context. A one-man-band; a one-man-context. So, not knowing the full extent of an activity the media-whore springs to mind as the delegate of that activity and is endlessly invited to appear, perform and contribute by people hoping to attract enough of an audience to justify the grant. For the more the person-product is seen and reported, the more it becomes increasingly predictable, the more its repetition attracts the hip-academics who come to view the output as having the necessary consistency to merit coverage in overviews.

In this way the already mediatized is further mediated but this mediation doesn't stop because the media-whore, being under contractual pressure to produce, will never complain about how s/he is to be represented because representation (the marketing of the "self") is all that is wanted and the more prisms of representation (advertisements) there are to refract through, then the more the hall of mirrors reflects, rather than distorts, the face of the media-whore. This, then, is the "circularity of circulation" in which the media-whore is caught: the same always proclaimed from a slightly different perspective (the tempered idiosyncrasy of a new journalist on the team), the same softened by academic attention (the researcher looking for thesis-matter). But it's a nice trap. For being visible attracts more visibility because visibility is not seen as the empty modus operandi of the media but as a mark of legitimation, a site, even, for the barely avowed projection of envy.

< recuperating the media >

The episode of the media-whore reveals one major facet of the media: its selection of subjects and its continual presentation of them allows people to be witness to the way that the media constructs the narrow dimensions of its ever-expanding circle. If one of the functions of the media has been the elevation of certain subjects that are supposed to merit attention, then, in a post-media scene the effect is reversed. Here, the need to avoid being overloaded by options and choices comes to be filtered via the media in that the choices and options it offers are, on the whole, rejected. But, a post-media attitude is not an anti-media attitude. We are begrudgingly attentive to the media because, living in a nuance of the same world, its effects cannot be escaped from and, more positively, it is through the media that capitalism articulates itself. The media, a negative injunction, instates the social with an updated set of contradictions that are always in the process of being played-out and if these processes are not highlighted by the media they can be covered and articulated in post-media contexts. Jean Baudrillard expresses a facet of this contradiction when he asks "Are the mass media on the side of power in the manipulation of the masses, or are they on the side of the masses in the liquidation of meaning, in the violence done to meaning?" Baudrillard's playful question points to the question of subjective agency and whether this should speak for itself or have others speak for it; whether it should seize the media apparatus or rejoice in the "devolution" of choice and responsibility. This points to contrasting political strategies that

can, in a post-media context, exist side by side. There is the recognizably "political" position of constituting ourselves as "subjects, to liberate, to express ourselves at any price" and the position of the obstinate and truculent "mass," the object at which the media messages are aimed and which involves "the refusal of meaning and the refusal of speech... the hyperconformist simulation of the very mechanisms of the system, which is another form of refusal by overacceptance." Whereas Baudrillard is trying to refute the thesis that the "mass" is manipulated by the media and that it requires "enlightened" intellectuals to show it the way towards liberation, he is maybe, by adhering to the cumbersome and undifferentiated concept of "mass," not going far enough in imbricating these two positions.

The post-media operators, as those that function in a space between "media" and "academy," do not identify as being either intellectual or mass, and being both authors and punters, composers and listeners, artists and spectators, their position, informed by the diffuse energies of desire, is constantly shifting. This is what makes it an autonomous practice and being one that is unrestricted by the paradigms of "feature" and "thesis" it can be free to articulate the findings of its own transversality. For instance, if an increase in information marks the present times and if this increase is producing "uncertainty," a confusing array of choices and strategies, then this uncertainty can be recuperated by post-media operators to effect each pole of Baudrillard's playful dichotomy: we are no longer certain of being political subjects identified as working class or communist, but we are also no longer resting assured in our refusal to speak and answer back. We are no longer cadre or mass, "contacts" or consumers, and this is where the auto-theorizing component comes into it, for, as post-media operators, we are continually engaged in elucidating the nuances of context and situation and the theorizing, in many ways a non-verbal theorizing in that it includes gesture, image and sound, is propelled by the particular exigencies of varying situations (it is a resistance to legitimatising models in favor of a "method" of desire; an opening up of micro-political dimensions; an instinctual transversalism). If we are always working class and militant then our reactions come to be predictable but, even so, we cannot allow this dimension to disappear completely, implying as it does a resistance to the monopoly of the means of distribution by means of becoming expressed by a misuse of the increasingly available means of production. Yet, if in a situation we remain silent our silence is read as a legitimating compliance and, yet, this same silence can maybe make a supposed quietude pregnant with obstinate incredulity whilst also allowing "transference" to take place: the media, in the rush to say anything, reveals itself and draws our prognosis. This chameleon-like activity is maybe a post-media recuperation of journalistic practice but, unlike the bounded and professionally sanctioned dissimulation of journalists, we inadvertently merge Baudrillard's two strategies, and make theory and practice become co-incidental. This form of becoming, of never having remained, of being a "lingering residuum," may in fact have been spurred-on by the media's collusion with the constant overproduction of an acculturating capitalism, but a further post-media recuperation of it allows us to be dispersed

rather than localizable, just as power is itself dispersed and not present in any one space or molecule. Beyond the pleasure principle lies auto-theorization.

The media is recuperated at every turn. From the aping of a record review that imbues this promotional form with an intensity and a social meaning to the establishment of web-sites as nodes of research that are independent from the media and the academy, the post-media practice learns from what Foucault called "the exteriority of its vicinity." Both connected to and autonomous from the media, it is like Marx's proletariat who, on the receiving end of the capitalist mode of production in the factories and workspaces, know instinctively the meaning of the methods that are employed on it: manipulation may be met with silence but it casts back a disgust at the barefacedness of the manipulator, a disgust that accumulates and, thus intensified, draws others into the orbit of conflict (in this case a conflict over the prevailing culture of compliance). Whereas a workforce, organized into unions, may too often have fought sectional battles, the creative producers of a post-media scene are disorganized to the extent that their sectional interests, becoming increasingly transversal, see points of contact and unification in their shared dismay of the inhibiting methods, form and content of the media.

Just as a vicinity to the media makes for an over-familiarization that effects a withdrawal of interest and the establishment of alternative media spaces, the media's persisting misrepresentation of activity leads to the recuperation of misrepresentation as a device to manipulate the media. Just as an increasing exposure to exploitation at the workplace provokes the development of means to subvert the contractual obligations of the workplace by means of petty theft, absenteeism, brewing-up, ridiculous union demands etc., so too are media messages recuperated by a choosing and filtering of messages: Throbbing Gristle used to recommend turning the sound of the TV down and playing music as its soundtrack but there are a myriad of other possible detournements that can range from consciously using the media's banalities as a way of "switching-off" to using it as a means to activate the energy of disgust. What occurs throughout is that the media's power is negotiated and post-media operators are, in a sense, manipulating their own manipulation; becoming conscious of the fact that social manipulation is instituted. Not only does this reveal the role of the media in this manipulation — its homogeneity assured by the editorial diktat, the elevation of central signifiers and models of perception — it also brings into focus the receptive power of the post-media operators themselves, a power that, because it has diversified the levels at which it can place itself, achieves an imperviousness to a further conductance of those censorious and mediating powers of the media: it makes meaning doable. By means of the "exteriority of its vicinity" it is empowered enough to be overpowered and, as a result, is sensitized to the dispersion of power which is not solely conducted through the channels of the media. Crucially, then, it comes to "recognize these powers as its own" and, in so doing, the post-media operators, absconding from the quietism of the workplace, come to effect an expropriation of the means of expression.

< towards self-institution? >

Auto-theorization allows us to inhabit such contradictory spaces without having to synthesize them or choose between them. It is dependent on being flawed and tentative and relies upon mistakes as the tangential material of its own engagement; a material that places in relief the overproduced and hermetic products so feted by the media. Thus post-media activity is not the outcome of a discursive resolution, which would only lead to another discourse, but is the process that allows contradictions to be pushed in the direction of enigmas and provocative alloys. It allows for experimental positions without co-ordinates, it drifts off the map, flees from forced identification (and forced subjectivization) and takes with it the masks and tools that would enslave it. And so, auto-theorization is a constant vigilance, a controlled loss, a permutability of the rational and the unconscious. A processing of the self revealing social process.

Being both screen and projector, receiver and sender, silent and voluble, being the margins of a center that doesn't exist it occupies a liminal position that, in continually being dispersed, coincides and overlaps with a post-media practice whose overall rhythms are broader (a breadth that can turn to history and precursors). Being a no-space, being illegitimate, means that the academy can be plundered and the media copied, but rather than ape these and look for a "new" that fits into the criteria, post-media operations, by claiming back the auto-theoretical dimension, affirm those subjects and projects that are omitted: there is a place for history as opposed to nostalgia, for autobiography rather than biography, for militancy rather than quietism, for continuity rather than immediacy, for dirty timbre rather than slickness, for abnormal rather than normalizing forms.

The post-media operators, being attracted to process via auto-theorization, are drawn to those cultural products that are conducive to propelling the process of discovery they are already engaged in. In brief these are products that are critical of consensus and which draw attention to the determining "invisible structures": the selection and editing techniques that act to overcode and delimit the powers of reception; they are, to a certain degree, free of being overencumbered by prior interpretation and in this way can function as sites for a "practice of freedom": a freedom of thought, a freedom of language and a freedom of sound. Practices that could not be pursued through the media or the academy. This thumbnail description may sound reminiscent of the avant-garde, yet just as there is a definite coincidence, fuelled by a historical inquisitiveness denied them in the media, the post-media operators, not being aligned to the strictures of categorization nor to the traps of visibility, would enter into the same relation to the avant-garde as it does the media: one of "exterior vicinity."

A common objection to post-media practice is that by not following the "popular" route, by not conforming to an expectation of boundaries, it is not only difficult to locate but, in theorizing its own paradigm, it is difficult to understand. Such accu-

sations are themselves indicative of a desire to maintain the status quo for if a cultural product becomes too easily digestible, if it is too readily understood, then any thought of participating in the production of its meaning is left to those cognoscenti for whom meaning is a currency that defines what is. By accepting what is already present, by becoming overawed or enervated by it, we are closing down the possible areas where the "social can be enacted," as it is the nuances of our own positions, their idiosyncrasies, that can, in creating meaning through combining meanings, be a spur towards action. This is precisely what the media denies. Its immediacy, the instantaneity of its communication, creates what Bourdieu called "a climate hostile to action whose effect is only visible over time." Such generalized conditions of impatience that the media induces throughout society becomes translatable as a reluctance to take the time to understand and participate in anything. This, in another turn of "circular circulation," another conformity to the rhythms of the media, becomes the reason that familiar forms, familiar sounds and familiar language are always invoked. They save time, save us from the implications of our own "doing," and, in providing the cushion of digestibility, come to form a bulwark against auto-theorization.

Thus it is maybe a case that we "understand" too much and in "understanding" we replicate what is. What the post-media operators are intent on providing is a sense of "radical imagination," a transversal engagement, that is spurred on by using desire as the method: being free to go anywhere, free to draw on anything, free to say anything, unmoored and without vested interest is, after Castoriadis, to bring another mode of Being into existence, a Being that is self-instituting and is its own mode of "self-alteration, its own temporality." Yet, whether this results in the institution of a "new class" whose freedom is the freedom of working "outside the sphere of material production proper" or whether it is the opportunity for a social fiction entitled Post-Media Operators — Sovereign and Vague to be written, is, so the media have taught us, by the by, for it has been said now and said is as good as read and read is as good as real and, so the media have taught us, to write is to recuperate hype.

— Title is drawn from two chapter headings in Adilkno's book MEDIA ARCHIVE (Autonomedia, 1998). Text spurred on by Pierre Bourdieu's ON TELEVISION AND THE MEDIA (Pluto, 1998). This version re-mixed for subsol. Other versions of this text have appeared in Infotainment No.5, Datacide (datacide.c8.com/text/7-sov.html) and on Nettime.

31

Recombinant Television

VakuumTV *(Hungary)*
||

akuumTV was founded in February 1994 on the initiative of Laszlo Kistamas and currently includes Dora Csernatony, Ferenc Grof, Laszlo Kistamas, and Attila Till. Its members presented weekly broadcasts on Monday nights at the most popular cultural club in Budapest, Tilos az A. Between February 1994 and September 1997 Vakuum TV broadcast 52 shows, and after 3 years of rest, started broadcasting again in 2000. Each show blended short films, interactive engagements between the audience and the announcer, and live performances but each used a very different content to create a parallel televisual reality.

During the VAKUUM TV AT THE VIDEOLOGY show (September 28, 1997), the context was the relation between computers and their users, and a VakuumNet multimedia choreography was composed for the show. Live performances on the stage, dialogues, and games complemented the associative system of VakuumNet which simulated net surfing. This gave rise to a kind of collage which unified three usually independent spaces: the space of the audience with the space of the stage and that of the net.

For PARALLEL OF HUMAN BEING (July 8, 2000) our topic was the evolution of robotics and the very near future of cyborgs. Connected to our "scientific theatre" project we made an attempt to mix the world of the conventional sci-fi movies and documentaries with our imaginary projections creating a montage of "low-tech futurology." In MECHANICAL TELEVISION (August 31, 2000), we focused on the early history of television. This media archeological topic was "re-mixed" on stage using video projections with live acts, interactive engagements with the audience, a re-built Baird Television receiver and some archive videos from the fifties about the "dawn" of Hungarian broadcasting.

Needless to say, the designation "VakuumTV" is not meant to refer to any kind of conventional television channel which could be received on TV sets in commercial circulation. Rather, its founders envisioned a live show in which a large frame separating the stage from the audience imitates the experience of watching TV for the audience. Thus VakuumTV can be received only where this frame is set up.

VakuumTV is a form of the modern cabaret, in which theater blends with video art, performance with television, and art with play. This combination bears some affinity to the earliest "café theatres" and to the Dadaist Cabaret Voltaire, founded in 1916, which also operated in an entertainment locale. In this detourned television, censorship is obliterated and everything desired by the body or the soul is permitted.

The broadcasts are a mixture of various, largely independent numbers or scores. Absurd humor and attempts toward greater permeability of the boundaries between different media are only two of the hallmark features of VakuumTV broadcasts. Many of the numbers take conventional television broadcast techniques as their point of departure in order to reinvent them in a distorted manual form.

Electronics and high technology are present in a different manner than in ordinary television. Everything takes place live, through a peculiar imitation of tricks normally associated with television, but in altered form. Broadcasts include videotaped material recorded and edited before the broadcast. Images are projected upon a tulle screen attached to the TV frame, allowing an alternation of video projection and live performance. When illuminated by stage lights, the tulle becomes transparent and those on the stage enter the broadcast; when the stage is dark, the tulle surface serves as the screen for projections.

The combination of live performance and projected images, the mobilization of the audience for active involvement, as well as the employment of a camera which can broadcast happenings and images occurring simultaneously on the stage or elsewhere enable VakuumTV to transcend the limitations of conventional television. With the viewers being simultaneously in the television studio and in front of their TV sets, interactive television becomes a reality.

Autonomous Media Cultures

32

V2_: Institute for Unstable Media

Alex Adriaansens & Nat Muller, V2_Organization (Netherlands)

edia and technology play an increasingly important role in contemporary society. Communications, production, trade, urbanism, medicine are all being changed by the same technological developments that are transforming the arts. Art that makes use of electronic, especially digital or "unstable" media, explores the meaning, the specificity and the boundaries of these media. Instability is a creative force which is fundamental to the continuous reorganization of the social, cultural, political and economic relations in our society but which can also be regarded as a deregulating force that disrupts existing social structures. Rather than showing us an orderly and homogeneous world, unstable media present us with an image of the world that is contradictory, heterogeneous and transient.

V2_Organization (www.v2.nl) was founded in 1981 by a group of multi-media artists in 's-Hertogenbosch, and moved to its current location in the center of Rotterdam in 1994, and has since then concentrated on art in electronic networks and on the World Wide Web. V2_ offers a critical perspective on the futuristic promises associated with new media technologies and functions as a platform for debate about the production, distribution and presentation of the art of unstable media. V2_ is interested in the combination of and relations between different media and between different artistic and scientific disciplines. It consistently pursues its research about the relationship between art, technology, the media and society by bringing together artists, researchers, social groups and commercial companies, and by initiating interdisciplinary working relations among them. Over the past fifteen years, V2_ has thus created a continuous dialogue with a wide network of contacts on which it draws for the development of particular art projects.

What follows are snippets of an email conversation between Alex Adriaansens (founder and director of V2_) and Nat Muller (events organizer at V2_ since

January 2000). Different generations, different gender, different educational backgrounds: congruous and convergent points of view.

Nat: I did a close reading of the "Manifesto for the Unstable Media" (www.v2.nl/browse/v2/manifesto.html), which was issued by V2_ in 1987, and somehow signified a focusing of the organization on media technology. In a general sense, the manifesto symbolizes for me a critique on "traditional" artistic practice. The usage of technology and electronic media for creative practice has highlighted the disruption of categories like art discipline, individual authorship, authenticity (whatever that has ever meant), machine as tool, and the whole commodification of art through the system of museums, curators, and conspicuous consumers. For me, the true nature of "instability" lies herein: the continuous pushing and stretching of boundaries and categories we have become accustomed to, the permanent re-thinking and re-inventing of artistic and critical practices, and perhaps most important the generation of the new (however you want to define it). In short, I guess "unstable media" figure as a disturbance engine. I deliberately use the word engine here, since it combines an aspect of facilitation (as in a steam engine: it gets you places), generation (engines in machines drive the production as it were), and pollution (I don't mean it in a pejorative sense here, rather more like "noise," "disturbance," "disruptions," the occasional explosion). What do unstable media mean to you, and has it changed over the years?

Alex: It is a nice understanding of what instability can mean in the context of media. But for me it's not a thing in itself with a straight goal ("innovation" as you called it); no, I see its meaning going further. Instability for me is inherent for understanding media and more specific for understanding dynamics in all kind of processes (social, cultural, technological). It's not just meant as an instrument serving a certain purpose, it really is about a basic understanding of social, cultural, technological processes and how these processes can deal with complexity, diversity, dynamics and the "accident" all seen as qualities. This is rather tough as instability indeed also confronts us with the dangerous side of complex processes. This interest for complexity and instability is rather new as these concepts mostly had a negative connotation. Instability refers to the fact that things have to be unstable to be able to transform themselves and processes. As Dick Raaijmakers said, "Walking is actually falling." When walking one is in a state of instability, so it is a necessity to be able to move around and to interact with our surroundings.

Nat: V2_ defines itself as an "interdisciplinary" center for art and media technology. Let's ponder a bit on this notion of interdisciplinarity. Actually this is a question I have been wanting to ask you ever since I started working at V2_, and perhaps have never voiced because of the sheer mundanity. What the hell does interdisciplinary mean? See, my problem with "interdisciplinarity" is that it rides along with other series of fashionable and obligatory buzzwords, such as "interactive," "virtual," etc.… Just like "interactive" comes to mean most of the time "reactive" (the familiar click here, click there, click everywhere syndrome), "interdisciplinary" usu-

ally means multi-disciplinary. In other words, you will have an accumulation of different disciplines (audio-visual, video-installation, sound-sculpture, robotic performance). Yet, if the prefix "inter" signifies "in-between" or "in the midst of" rather than many, then in-between which disciplines do we situate ourselves?

Furthermore, doesn't the term "interdisciplinary" perpetuate the notion it is actually attempting to combat: re-enforcing the concept of delineated disciplines? Inter-disciplinarity doesn't seem to accommodate room for new formations of practice/theory really. Shouldn't we ditch or rethink this concept all together, and define it from material practices, which, if one has to insist on utilizing the term "discipline" would be rather trans-disciplinary or meta- or sub-disciplinary? In any case, I think the concept of discipline is far too disciplining and confining, and perhaps it is more useful to have a look at practices in relation to new media: those of artists, but also those of audiences, theorists and organizations. Then, whatever way we choose to define ourselves will be rooted in a situated knowledge of the field. Stemming from the notion that any usage or practice involving technology/art is not created/exercised within a void, but localized within specific geographic, socio-economic, and political contexts. So, Alex, let's throw away this utterly meaningless term "interdisciplinarity" or give me a good reason why we should keep it. Just to throw more oil on the fire: I think what we do in our practices is countering the black-boxing of technology and creative practice. What "interdisciplinarity" does is pure black-boxing, since the term means actually nothing; it's just a pleasant-sounding hollow signifier. PLEASE, straighten out my semiotics here ;)

Alex: "interdisciplinarity": referring to different kinds of sciences and disciplines (Kramer's dictionary). In the modernist sense of the word interdisciplinarity means some sort of contaminated practice: a practice that is not purely disciplinary, but which is derived from and leans on the vocabulary and methodologies of different disciplines, and by corollary generates its own vocabulary and practice. This is how V2_ approaches interdisciplinarity. The way this is developed is always subject to change and debate.

The placing of interdisciplinary practice within V2_ *vis-à-vis* traditional disciplines is awkward, since it is different for every project. I do not see how I could clearly situate the interdisciplinary practice of V2_ topologically. It is not so important whether sometimes it is closer or further away from a known discipline, or in between or around it. It all stems from a hybridization and migration of practices. This hybridization and migration – which features prominently in media technology – is opposed to an extreme specialization which we have witnessed the past century, and which always had an introverted quality. The latter is also true for the language utilized within specialist practices. In short, behavior leading to hermetic systems ought to rethink itself and develop new relations and connections.

To dismiss "interdisciplinarity" as a term because it is over-used or because it is subjected to inflation appears to be inadequate and in fact says more about the problems

of language in relation to practice, than strengthening your argument on a content level. I always try to understand as well as I can what people mean by interdisciplinarity when they talk about it, and especially how they make it explicit in their work. Whether terms are a fashion fad or do the right job is another point of conversation. The whole terminology game of trans-, inter-, meta-, and sub-disciplinary is nice as an exercise in discourse, but not really practical. So despite the fact that I agree with you that notions like interdisciplinarity are difficult to maintain and cause misunderstandings, it is not necessarily the case that a new terminology will clear the skies. Nevertheless, the discussion about terminology and discursive frameworks is an important one. In 1996 we organized a debate on the topic with several people from within the arts and media, and made it part of our culture, though it appears that for you this is still going too slow or is not visible enough. That's why – for the past few years – we have seen it as our goal to make explicit notions such as "interdisciplinarity"' and "interactive," and thus to infuse them with meaning and content (there are quite a few V2_ texts and publications which testify to the latter). So, I wouldn't call for a declaration of the obsolescence of certain notions; on the contrary, one has to give them specific meaning through texts and projects. So that's why I think interdisciplinarity is for me less of a problem than for you. I can still give it a meaning, while you cannot anymore. Also, for me it is less an epistemological question when speaking of interdisciplinarity, but rather a continuous conversation around practices and notions which are in motion.

(aside from Nat: I guess both Alex and myself agree on the same things here, in the sense that we are both more interested in the embodiment of a notion, that is the practice of something. Still, my literary background comes back to haunt me, the continuous battle between the word and the deed. I would like them adequately integrated somehow.)

Nat: Over the past few years, especially after inception of the V2_lab in 1998, V2_ has grown almost 500% in terms of people working for the organization. There are currently 25 people employed by V2_; that is quite substantial for a cultural organization. So I would like to exchange some thoughts on institutionalization. I somehow always read "Institute for Unstable Media" as an ironic aside, a critical sneer towards the lethargy and inertia of the traditional bodies of art, encapsulated in the brick and mortar of museums, galleries, art funds, and yes, even in the bodies of curators, who become institutions upon themselves. Nevertheless, one cannot deny that over the years V2_ has established a leading role within the digital art world, and is working closely together with institutions such as Ars Electronica and ZKM. So, I guess I am asking: does size matter?! Perhaps you can point out the advantages and the drawbacks (if any) of growing so rapidly into a larger entity. In addition: what is the story behind "institution," and how do you view institutionalization? Is it happening with V2_ somehow, is that good, bad, or malleable?

Alex: Let me get some facts straight before your numbers cause any further confusion. With the inception of the V2_lab, three years ago, six extra people were

hired for the lab. Since 1998 we hired six to seven extra people, who used to before work for us on a project-base. So actually V2_ grew since 1998 100% (not 500%!) in terms of employees.

V2_ didn't grow very fast, rather gradually, and only once with a boom, since its move to Rotterdam. The desire to found a media lab existed already for years: a media center without a Research & Development department is like a one-legged person. So the media lab had to come, and therefore fitted almost organically within the organization... it was only a matter of time. It has never been the growth of the organization itself that was problematic, but rather the bad relationship between structural means and project money which made it impossible to tune the organization adequately to its growth. The latter causes specific problems such as continuity in certain areas in the organization, the sustainability of expertise which people gather, etc. V2_ has always been conscious about size, since it always has and in the future aims to have a flat hierarchical structure. This can only be the case if you don't have too many people working for the organization. The more people you get, the more specialists you get, since usually they are hired to perform specific tasks and functions. By corollary, mobility decreases. The oldies were omnivores in that sense, doing all kinds of tasks, and thus having a different relationship with the organization than the newcomers (specialists).

Once you start getting more than 25–30 people in an organization it becomes increasingly difficult to maintain a horizontal structure: naturally you get more divisions of tasks and responsibility, and hierarchical layers. We made the conscious decision that 25–30 people should be the maximum number of people working at V2_, unless people want to take completely different directions or a new management will be installed. I think these possibilities remain open. So, despite the fact that the organization has become more differentiated and responsibilities have been more sharply delineated, there is still a flat hierarchy and lots of room for every individual working here.

You could say that V2_ has made a choice to become an institute with a limited size. Whether it "institutionalizes" as an organization is a different question. We planned a certain size and a certain organizational structure which aims to counter the negative effects of institutionalization. Obviously this is something you cannot simply prevent, but it is very dependent on the people who work there, and how they work and develop. So one has to remain alert. Considering the turbulence at V2_ during the past seven years, there hasn't been a moment of rest for the organization, let alone of "institutionalization." So V2_ is an institute, an institute for unstable media that wants to take a certain responsibility and contribute strongly to a local, national and international development in media culture. It's an organization which will – hopefully – be able to take it easier in the coming years, so that external factors (politics, money, technology) will become less binding for its further development. In this scenario, more time and attention could be invested in our programmers and in the overall structure of the organization.

Nat: As we grow as an organization, aren't we becoming more vulnerable to the 3 Ps: Pressure to Perform, Perpetuate and Preserve? What are the implications for how we function and for our audiences?

Alex: Certainly... The larger an organization, the more money is pumped into it. This is a result of – to a large extent – public funds and politics. Obviously, there are certain conditions to be met here. One of them is audience accessibility. In politics the demand to cater to larger and more diverse audiences has become increasingly more important. This doesn't exactly make life easy for us, since many of our activities – on all their different levels – concentrate on research. Furthermore, often there is this tendency to attribute certain functions and tasks to organizations of a specific size. For example: education and collecting. For an organization like V2_ it is not so self-evident to meet these terms, because of its specific character. V2_ has always profiled itself (inter)nationally as an organization with a strong research quality, and we know how fruitful that has been. So I guess that the pressure of the three Ps is quite manageable. Nevertheless, you are right that in a more general sense V2_ has a larger responsibility towards the public, but this need not be limiting. In fact it is challenging. The pressure to perform qualitatively at maximum level is high, as is the pressure to secure continuity without always having the means. Nevertheless, I have always had the impression that V2_ is always its own biggest critic.

Nat: I guess it's silly to have this conversation without reflecting on the subject of Las Palmas. For over 2 years V2_ had been involved in negotiations about setting up an international center for visual culture and media technology in Rotterdam (in the warehouse Las Palmas) together with the Photo Institutes in Rotterdam (Netherlands Photo Institute, Netherlands Photo Restoration Atelier, Netherlands Photo Archive). Ever since I can remember, these negotiations have been difficult and bumpy, culminating in a total collapse of the initiative in September. Can you shortly describe the incentive of Las Palmas, and its demise? Also, from the outset, Las Palmas seemed to me a very political construction, initiated and pushed by the Minister of Culture and the City of Rotterdam – correct me if I am wrong. Which would provide the city of Rotterdam a particular cultural profiling, as the ZKM provides the city of Karlsruhe, for example.

Can politics ever be a solid basis for cultural enterprises, and conversely, can cultural practices, which somehow become co-opted into political schemes, and whether they like it or not dependent on city or governmental policies, ever maintain their critical, and radical perspectives? Probably I am greatly over-simplifying matters here, but I do this partly to provoke.

Alex: The Las Palmas project was an initiative from several organizations including V2_. It didn't start as a project by politicians. Of course it was clear that it was an interesting project for policy makers as it wanted to relate to the whole range of technical media like cinema, photography and digital media. We also knew that the

practices and relations of the participating organizations towards media were quite different, but we wanted to see if we could develop a model that could deal with these facts. So it wasn't strange that we had to talk a lot with each other and that we came into conflict at certain moments. The biggest trouble we nevertheless encountered was the fact that these debates on different media practices were enlarged on a political level (boards, local and national politics) and made it impossible in the end to agree on the concept of the organization and the organizational structure. Las Palmas was looking for the moments of convergence and divergence between media and other practices. It wanted to focus on the interferences between media and how media were intervening in the practices of different disciplines. V2_ defined Las Palmas as a connection machine that developed its practice by collaborating with different specializations. Interdisciplinarity was formulated here within the concept of a connection machine.

When one would ask me if politics can be a solid basis for a cultural enterprise I would bounce the question as what is the real question here? The question of politics in relation to art and culture has always been a relation of friction as both have different agendas. As an organization that gets support from public money one has to relate to local, national and international politics and this isn't bad at all. For the Las Palmas project it became a major obstacle as the partners in this project weren't able to define a strong common concept which made it possible for politics to intervene with a different agenda.

Nat: Taking a look at the V2_archive online, as well as on the shelves of our media archive, the publications, etc etc. V2_ boasts a very impressive list of artists, theorists, activists, performers and so forth. I mean, almost everybody, everything has been at V2_! Whew! What is next? I mean, where's the exciting, innovative, new stuff at for you at this current moment?

Alex: Since the 21 years I've been at V2_ I must say that the last decades are defined by all kind of social, technological, cultural and political transformations. Artists, and specifically artists in the field of media technology and their practices, are part of these transformations. We made strong alliances with different groups in society to redefine their practices and role in a broader cultural and social context. I never experienced this as looking for new developments, to be new and present new work. This is more for the museums that became part of a market economy in which new products are a necessity.

The range of questions that have been positioned in the last decades are about very basic things like:

* Can we still rely on the definitions of art that were put in place in the last century? If not, what has changed and with what has it been replaced?

* It seems that art migrated to different domains in society. If so what does this mean for the arts and its practices?

* If we have less interest in objects and more in processes what does this imply for art practices? For example what does interactivity really mean in this context? And what constitutes the artwork?

One knows all these questions and one also knows that we just touched on some of the implications of these transformations. I would say that we will be surprised during the coming years to see what will come out of all of this. We still have to research and build on these practices for the years to come. All your mentioned difficulties with words such as interdisciplinarity and interactivity, and that they mean nothing for you, are just starting to be discovered and given meaning in art practices. Finding the right vocabulary and models is something that will occupy us for the coming years, I guess, and this through all kind of projects that artists, scientists and interdisciplinary collaborations will show us.

I'm really looking forward to the years to come, not to just see just new things, but to see the deepening of some of the concepts that are defined today. The fact that old concepts are under fire forces us to rethink our position and practices while being aware that some of the proposed models are just the old ones, and this is what I like most about contemporary practices.

33

Mikro
Initiative for the Advancement of Media Cultures

Inke Arns *(Germany)*
Interviewed by Joanne Richardson *(Romania/US)*

n March 1998, fifteen artists, theoreticians, journalists, organizers and other cultural producers founded mikro, a Berlin-based non-profit initiative for the advancement of media cultures. The founding members work mostly in the field of independent media culture — from video art and electronic music, independent radio and TV production, to creative use of the Internet and digital multimedia technologies.

What brings this multi-faceted group together is the need for a critical discussion of the cultural, social and political impact of media in today's society. We felt that there was an extreme lack of this kind of critical discourse in the city. Many of the founding members had been working in independent, media cultural projects all over the place in Germany or in Europe, but there was no platform, no place or institution in Berlin where we could have connected all these issues to. Internationale Stadt had just closed down. Many of us knew each other before as we had been cooperating in projects, like, for example, the Hybrid WorkSpace during Documenta X in Kassel 1997. Concerning mikro the notion of a "platform" emerged again and again, as we felt that the media cultural scene in the city was extremely heterogeneous and disparate, in fact so heterogeneous as to prevent any communication between the different projects. Therefore one of mikro's goals certainly was the cartography of the media cultural landscape in the city, and also the establishment of some sort of communication and exchange between the different projects.

> *What are some of the projects and events mikro has organized?*

mikro's explicit aim is to foster the development of an open and democratic media culture by presenting and discussing the artistic and cultural applications of the digital, computer-assisted media in public events, including panel discussions, project presentations, workshops and conferences. Between March 1998 and March 2001 we have organized 31 mikro.lounges at the Berlin WMF club (www.wmfclub.de) focus-

ing on themes ranging from copyright & music on the Net, cryptography & security, diasporic communities, "cooking pot markets" and the gift economy, to net art, political activism on the Net, software patents, and ICANN. These lounges combine the different formats of video screenings, lectures, panel discussions and DJ sets.

The setting in the WMF club and the mixing of formats were very important: the lounges were not only about "transferring knowledge" and discussing the issues at stake, but also about fostering informal meetings between people from various contexts. Having a drink together at the bar in a nice lounge atmosphere and doing some kind of casual talking can sometimes be more effective than putting people together on a panel... or, let's say, it worked exactly in this combination: focused discussion first and casual get-togethers later on. That was the format developed by the mikro.lounges.

For these lounges we did not only invite representatives of local cultural initiatives and companies for a presentation of their work but we also invited media cultural experts from other parts of Germany and the world, thereby enriching cultural debates in the city and making accessible these specific themes for a broader audience. In order to initiate a critical public discussion of the impact of the Internet and new media technologies on today's society I mentioned earlier we saw it as absolutely necessary to raise a broader awareness for these topics beyond specialist (private, or semi-public) circles.

Given the nature of the whole field which reaches out way beyond economic reason, for discussing these topics we found it necessary and appropriate to approach these topics in a genuinely trans- or interdisciplinary way, i.e. bringing people together from the most varied backgrounds: from computer science and net art, from the games industry and net activism, lawyers and hackers. This interdisciplinary approach also goes for the larger international events which mikro has organized: The net.radio days '98, an international meeting of net radio & net audio activists, and two Wizards of OS conferences, the first in July 1999, and the second in October 2001.

The first Wizards of OS (www.mikro.org/wos) conference was entitled "Open Sources and Free Software" and focused on surveying free software and its practical applications. In retrospect, Free Software really was an eye-opener for us. It proved that freedom, openness and community work. Which is even more surprising since this was established in the very area of technology that forms the core of the digital "knowledge society" and, as such, is the battlefield for fierce competition. It has become clear that open contributory knowledge cultures and community-based innovation can be found most anywhere — in law and genetics, in journalism and in the arts. The second Wizards of OS (www.wizards-of-os.org) conference on "Open Cultures and Free Knowledge" invited representatives of these cultures to Berlin to talk about cooperation and tools, the legal position of informational common goods, different software cultures, security, an open and open-source e-gov-

ernment and governance, and a possible future beyond capitalism. The conference centered around the changes in the conditions of intellectual creation of any kind, the mediation of its results and their collaborative continued development. In the "knowledge society," questions of the production, distribution, archiving and reception of software-based knowledge enter center stage. It is precisely this set of topics the conference wanted to address. Extensive documentation on each of these events is available on the mikro website (www.mikro.org). In the beginning of 2000 mikro initiated Rohrpost (pneumatic post), a German-speaking mailing list for media and net culture. The events and mailing list have fostered a critical discussion of the impact of new media on today's society, not only within the initiative itself, but among a wider interested public. In this way, within the last three and half years, an independent Berlin-based platform for media critique has emerged.

> *How do you define "independent?" Independent from what? From state institutions? From academic institutions? From monolithic, well funded cultural institutions? How does independence or autonomy relate to sources of funds and, consequently, to the goals of the project and the internal organization? And what is the significance of the name you have chosen — mikro — in this context?*

I just came back from a panel discussion at the Hamburger Bahnhof (including other Berlin-based independent cultural initiatives like kunst+technik, Botschaft, loop, platform) where exactly these questions were discussed. Independence — at least for me — means to be independent from all the (inherently monolithic) institutions you mentioned: state and academic institutions, well-funded media centers, commercial sponsors and the like. Perhaps it might indeed be better to talk about autonomy here, especially concerning mikro.

From the beginning, the name "mikro" was programmatic: the initiative never intended to develop into an institutional makro structure, but instead focused on the small, distributed, yet no less influential capillary structures, through which the media and technologies exercise power within art and society. The field within which mikro operates is characterized by its heterogeneous, multi-faceted and networked elements. These networks exist parallel to commercially formed social structures and are based on relations of trust and the gift economy. The diversity and the fragility of this network of relationships is the reason for the careful formulation of the aim of the association: "advancement of media cultures." mikro thereby stresses the importance of the heterogeneity of social and cultural practice.

Back to the question of autonomy: During the three and a half years of its existence mikro has successfully avoided developing into an institutional structure. mikro never had its own space, it never had an office, it never had an administrative or bureaucratic overhead, (and/because) it never had a significant budget. It essentially was non-existent on that level. It never wanted to have all these nice things as they would have reduced mikro's mobility and flexibility significantly, i.e. its ability to quickly react to new topics. I think that different speeds/velocities are a very

significant difference between institutions and non-institutionalized associations. mikro basically consisted of a group of people who communicated via e-mail and who met regularly face to face every two weeks in some smoky back rooms of restaurants in order to discuss media cultural topics.

The internal organization of mikro is loose and based on different projects. On the mailing list and during our regular meetings every two weeks we discussed possible topics & focuses for the lounges. Somebody would suggest a topic which then would be discussed (refocused, broadened conceptually, alternative panelists would be named) by the present mikro members. It was essentially a collective discussion process. The realization of each lounge would then be taken over by individual members, a so-called task force, one would take over the moderator's part, the other would prepare the technical set up, etc. This worked rather like an rotational system, even if some of the mikro members always suggested more topics and invested more time and energy than others (that's quite normal, I guess). Everybody could essentially do everything. On the other side, when it came to the official level, the whole fact of setting up a non-profit association requires an official interface which includes the assignment of specific functions, titles and responsibilities to individual people. We officially (have to) have a "president," a cashier, a public relations person and an archivist. But within the initiative this was totally meaningless as all the members were considered equal.

Except for single larger events like the net.radio days or the Wizards of OS, mikro did not receive any kind of public or private funding for its ongoing activities. For the net.radio days in 1998 we received a small amount of money from the Berlin Senate for Cultural Affairs, which meant that most of the international participants organized their own funding. The Wizards of OS 1 was co-organized by mikro, the working group Computers and Society of the Humboldt University and the ZKM. It was largely funded by the Berlin Senate for Economic Affairs in the framework of the initiative "Projekt Zukunft – Der Berliner Weg in die Informationsgesellschaft" (Project Future – Berlin's Way into the Information Society) and supported by the House of World Cultures, and many Berlin-based, European and international small and large-scale companies and media cultural institutions active in the field of free software. For the second Wizards of OS in 2001 mikro cooperated with the German Federal Office for Political Education (who also gave the largest portion of financial support) and the working group Computers and Society of the Humboldt University, and was supported by the Center for the Public Domain, the Berlin Senate, the German Federal Ministry for Economic Affairs and Technology, and by many local and European media cultural institutions. Large institutions are interesting for strategic partnerships. Strategic partnership in this context means: To cooperate or to co-organize specific issue-oriented events together with larger bodies whose aims concerning these specific topics are compatible with those of mikro.

The mikro.lounges, i.e. mikro's ongoing activities since 1998, have been exclusively funded by a very moderate entrance fee of 5 DM (= $2.50 US) taken from the audience (roughly around 100–150 people) and by the fact that all the mikro members were working as "volunteers," or, to formulate it positively, out of amateurism in the original sense: doing something for the love of it. There are different modes of doing things: for earning money ... and out of a sense of necessity, interest, or topicality. We managed to keep the mikro discussions free of arguments like, "let's do an event to make money and fill the mikro coffers" or "we need to 'professionalize,' carry mikro activities to a new level, therefore we need full-time, paid executives, therefore we need a regular source of income." The most fascinating for me during the last three and a half years has been to see how through this cooperative effort not only by its members, but also by many friendly initiatives, it was possible to bring into existence public discussions and raise awareness for themes we all felt an urgent need to discuss.

> *Why the urgency? Can you talk about the local context in Germany, and more specifically, in Berlin? Did a tradition of this kind of critical discussion about net culture and the social implications of the free software movement, copyleft, net.radio, etc., already exist in Germany? Or has the context been created during your years of operation?*

There definitely existed a critical discussion concerning free software, copyleft, surveillance / encryption and other net cultural topics independently from mikro. I think what mikro achieved is really that it raised awareness for these topics beyond these hermetical specialist circles. In this sense I see mikro's work in a line with the aims of Internationale Stadt (IS, 1995-1998), a Berlin-based cultural Internet access provider, or, rather, a "context system" similar to that of the Digital City Amsterdam developed in the mid-1990s. IS's aim was to provide affordable access to the Internet at a time when this still wasn't available everywhere. What IS tried to do was to broaden the usage of net tools that previously had been accessible only to specialists, programmers, hackers, etc. These specialists themselves were not able or willing to get larger/broader audiences acquainted to the possibilities the Internet offered. In my book "Net Cultures," which will be published by Rotbuch in spring 2002, I describe this as a significant paradigm shift between the net culture of the 1980s and the 1990s. IS did some first practical steps towards the establishment of critical media literacy for a broader public. In this sense I see mikro's work as a continuation of that of IS: it's about raising awareness, about critical media literacy, and about extracting knowledge from specialist, hermetic circles and bringing these topics out into a broader public, and all this with an inter- or trans-disciplinary approach. In contrast to IS mikro did not develop Web tools but tried to establish a certain level of media cultural discourse in the city. And it succeeded to a certain extent.

> *I was surprised to find out that mikro does not have a space, a fixed location for events and meetings ... You suggested previously that mikro is not an institution but a non-institutional association. Can you explain the difference? I think of institutions as being bound up with*

a physical location, a building, an infrastructure. Is an association more "mobile"? And what are the reasons that you prefer to organize events in places that belong to other people rather than to have your own – which would be associated with the identity of the group?

To answer the association/institution question: yes, mikro is rather an association or initiative than an institution. For me, institutions are intrinsically connected to having a space of their own and a more or less clear and long-term budget. I explained earlier why mikro was never really keen either to get its own space or to have a fixed budget, i.e. to become an institution. I think a very important element for staying out of the vicious "becoming-an-institution" circle was the fact that mikro members never had any financial interest in the association's activities. They made a living out of projects (grants, jobs, etc.) other than mikro itself. It would have made a great difference if some of us would have had concrete plans to turn mikro into a viable structure in economic terms. Then it could have been quickly turned into an institution with all its (dis)advantages.

While mikro did not have its own space we were, however, identified very strongly with the WMF club where the mikro.lounges took place every first Wednesday each month during the three and half years. As I said earlier, the WMF club/lounge setting greatly added to the atmosphere of the lounges, and certainly was associated with mikro's identity. Even if it was not our "own" space. We just happened to organize events there quite regularly.

> *mikro was involved in setting up the cooperative media lab, bootlab, which has since become independent. What were the reasons for the parting of the ways of the two projects?*

Concerning mikro's involvement in the bootlab (bootlab.org) and the parting of the two initiatives one can describe the developments as follows: mikro was involved in setting up the bootlab in summer 2000, a cooperative workplace which by now has become an independent initiative. In the beginning there were many mikro members who were interested in renting/establishing an office for themselves. As many of these mikro/bootlab members soon got regular jobs (with offices), they understandably lost their immediate interest in the idea of a cooperative workplace. It soon turned out that the bootlab group consisted more and more of non-mikro members, and therefore it seemed only natural that the bootlab would develop independently from mikro. And apart from that, what would the anti-institution mikro be like with an office? ;)

[Notice: Some people might wonder why I am talking about mikro in the past tense. Well, mikro does still exist, but it is unclear how the initiative is going to continue. This can partly be explained with individual life plannings (new jobs, new projects, new families, new cities, etc.). Perhaps projects like mikro reach their maximum life span after three and a half years. After that there will be new projects in ever-new constellations. Be sure about that. ;) I am.]

34

Multimedia Institute

Zeljko Blace, Marcell Mars
& Tomislav Medak *(Croatia)*
Interviewed by Joanne
Richardson *(Romania/US)*

ULTIMEDIA INSTITUTE, OR [MI2]
for short is an NGO established in 1999 in Zagreb, as a spin-off of the Soros internet
program (similar to Ljudmila in Slovenia, but a few years later in the process). In 2000
[MI2] opened its public space, net.culture center "mama" (mama.mi2.hr), which instant-
ly became a meeting spot in Zagreb, attracting people with its cheap internet access,
lounge space with DJs constantly performing, presentation and screening space and
media-book library. Serving no liquor, having no corporate beverage policies, open from
12h to 24h and often much later through the night, it has created a unique environment
for meeting with hackers, philosophers, artists, DJs and activists who have time to spare
for chilling out in "mama." Speakers in this interview are (in order of appearance):

< *Tomislav Medak (alt+0153 for short), member of the theory group "past forward," only MA
enabled, but possessing a vocabulary that would make Shakespeare's face red* >

< *Zeljko Blace (201cm for short ;), ex-sportsman, non-exhibiting artist turned arts manager,
enthusiastic over obscure technologies (including abandonware like BeOS)* >

< *Marcell Mars (short for Nenad Romic), co-founder of [mi2], freefloating researcher and inno-
vator, focused on producing self-sustainable systems, for good reason* >

The conversation was conducted at very late hours and Teodor Celakoski (the brain
behind the financial and organizational structure of [mi2]) had to leave before it
reached a more-less comprehensible form of articulation, so his name is absent
from the mix.

> *Before I came in you were having a disagreement in Croatian about the word "institution" –
what was this about?*

Tomi: I said that [mi2] is an institution and Teo reacted badly to that because he thinks of institutions as big systems that tend to be bureaucratic and ossify at some point in time — which is not the case with [mi2], at least for the time being. By contrast, I think institutions are, simply, something instituted. An instituted organization has certain codified rules for cooperation and action.

Zeljko: … in our case this means working in the non-profit sector, a non-established field with little or no understanding of the issues we deal with. This situation makes us work together in a system that looks more like a commune when seen from the outside.

Marcell: I think of institutions as also having to do with establishing a field that maybe wasn't there before, so in that sense they have a kind of groundbreaking role. Like V2_ or Backspace, which created something that didn't exist before. So in that sense they don't just institute themselves as organizations, but they institute a field, a form of activity. They bring something into existence which later is recognized as a field. They then become known in that field as a first association, as playing a kind of leading role. In this sense institution could be a word without negative connotations.

Tomi: As far as the constitution of a field is concerned, "mama" is in an ambiguous position — in an international context the field of new technologies is already established, so we are more important in forming a local field of action here which didn't exist before.

Marcell: We wanted to connect the scene — I mean the media culture scene around organizations like V2_ or events like N5M — with the scene that exists in Croatia which is activist, but in a different sense, on the level of "autonomous culture" but not really having anything to do with media culture or the context of new technologies.

> *So what kind of institution is [mi2]?*

Zeljko: There are such different people involved with mama and we all perceive it differently, so it is impossible to have a single definition of what [mi2] is. Some people see it as more of a production space, some see it as more of a service, some see it in a more artistic light, some more technical, some may see it as a good space for public programs, others may see it as more of a family affair (when describing our openness, the metaphor of nudist family comes to mind … we would gladly host you for a lunch or dinner party, but will make you feel awkward about any hidden agenda). In the context of these differences, it is sometimes amazing that we function at all since we have such different backgrounds and goals. The main thing that makes us work closely is a common context, which looking at it from the outside, is the lack of any other similar initiative in Croatia. When we present our activities to the outside world (friends and colleagues, media and funders), it is

usually perceived as extremely wide. To us it is mostly about articulating existing cultural potential, opening critical perspectives, and managing hardware/software/wetware resources.

We use the space of net.culture club "mama" as a public platform for presenting contemporary artistic, social, political, organizational, and technological experiments which are still miles away from established mainstream culture. This might be anything from GNU evangelism and obscure electronic music to net streaming events and making a summer camp in the ex-military base on Adriatic island of Vis. Annually we organize a computer arts exhibition, and this year we initiated a new public event called "New Media Culture Week."

In addition to these kind of activities we also try to bridge the gaps and fill the holes which are left out by state institutions – by presenting international new media art, providing net services to NGOs, publishing texts and invading other media with "tactical" issues. Programs therefore range (in random order) from screening of geekish Anime, to more alternative (camp, fine art movies, video-art), from HTML / Flash workshops to Lasttuesday meetings. DJs mixing groovy tunes in the lounge space and the theory group "Past Forward" also equally add to the spectrum of colors in "mama." We are now also starting a Queer culture/arts series. And we host, on a more or less regular basis, programs by other groups – Zagreb anarchists, dance/theatre programs of Frakcija, and occasionally Croatian Linux User Group, Museum of Contemporary Arts, Croatian Visual Artists Association, Gallery Miroslav Kraljevic and many more. And we recently opened our media lab, so we will be focusing more on production and Research & Development.

Marcell: We offer some resources that were not available before. If people wanted to get a projector before, they had to go through long bureaucratic procedure with the Soros Center. "Mama" can offer space, internet connection, equipment – and I think we are also much better at collaborating with other groups and communicating their interests to funders (foundations, city and state governing bodies). For instance now we have a project called Clubture, which is about building an efficient program exchange mechanism between independent clubs and initiatives in Zagreb (city level), Croatia (national level) and ex-YU countries (regional).

Recently we established 11MB intranet for 4 different clubs and the media lab. This is the kind of infrastructure on which you can build a lot – TV production, radio … And I am one of those who is less interested in having programs at "mama" and more interested in getting people to use this kind of infrastructure for their own projects.

> *Can you say something more about what Clubture is?*

Marcell: Clubture is a kind of platform for connecting independent spaces, not just music clubs. We think more of associations, independent presentation/production centers which are nonprofit (like "mama," KSET, Mocvara, and Attack). Clubture

is a platform for the articulation of our needs, and one of these needs is having a good infrastructure for production. The media lab was an important part of extending this infrastructure. Currently our GNU digital publishing label (mostly operating from www.egoboobits.net and with CDR publishing) is working there and other people are producing music and web projects. But it's important to extend the media lab beyond the local scene and also to invite people from the outside. We invite people involved in open source projects to be in residencies in our media lab, to work on developing their own projects but also to promote these projects and ideas among people here.

> *How about the international dimension of the "mama" project? In the one year of existence, "mama" already has an international reputation. You have had a lot of guests from other countries, and you are also invited to make presentations abroad. How would you compare these international aspirations to the work of building a local network?*

Zeljko: Maybe this is a question of perspective. For some people like Marcell the most important thing is working with other NGOs in Croatia to develop a local network, and for others the international context is more important. I am currently more interested in establishing international projects and activities because I think we have outgrown the capacity of little local audience that we have. In Zagreb there are many things happening (especially in art circles) all the time, so people are not as interested in getting to new information with this kind of overload. And the programs at mama are very specific and only sometimes cross the field of art lover interests. So those people who are mostly interested in art events don't come that often to "mama."

> *So what was the idea behind starting "mama" in Zagreb, who was it for, I mean besides yourselves — though I don't want to downplay the importance of creating this kind of activity for yourselves. I ask this because I've noticed that you often have very small audiences for your events, so I'm wondering if it's because of a lack of interest in the field of new media in Zagreb. Presentations that are more connected to art which are incidentally organized at "mama," like those by WHW, tend to have much bigger crowds.*

Marcell: Those of us involved with mama are outsiders here as far as the art scene is concerned. The museum of contemporary art sends their invitation, and people just go to whatever event it is just because of the name.

Zeljko: ...because they are used to this situation. Inertia is a mighty power of consumer society.

Tomi: A different kind of audience is being addressed through our activities — not the kind of audience that goes to see a presentation about contemporary art like the one by Victor Misiano organized by WHW which you mention above. The form of production of EgoBoo.bits is what Zeljko often refers to as prosumer, a cross

between producer and consumer. So the audience are those who are already involved in the production, rather than those who only consume.

Zeljko: In numbers these are over 10 live acts with 20+ resident DJs in "mama." Maybe this seems like an insular community, but it is more relevant each day.

Marcell: In this case, audience may not be the right word. We are more interested in building a social network around "mama" than we are in establishing a cultural program that can draw large audiences who come to listen passively to lectures.

35

The Folds of an Institution

**Greg Sholette, Cesare Pietroiusti
& Brett Bloom** *(US/Italy/US)*
|||

rett: Let's start this off with a discussion about working with institutions that can be seen as oppressive as opposed to "dropping out" of the art world. Cesare, an important thing you have mentioned in previous exchanges of ours was working in the "folds" of an institution — finding a way to create autonomy in what could be an oppressive structure. Do you want to recount the story you told us of the exhibition where you used your invitation to in turn invite many others to contribute?

Cesare: I think that a critical artistic practice doesn't take any advantage from a frontal contraposition with an oppressive institution. The strategy of complaining of being marginalized, or not considered, is also a losing strategy, because somehow it is too visible, too "declarative." I am more interested in strategies that are more lateral. A "fold" in a system can be seen as an interruption of its internal order, an irregularity in its rigid functioning. Artists can be flexible (easily moving and restructuring) and hopefully smart enough, to exploit the system's folds, and work within (or even thanks to) them.

In 1996 I was invited to the XII Quadriennale in Rome, a National survey show of "emerging artists." The Quadriennale is an old and bureaucratic institution (still working according to the rules established in the 1930s during the fascist period) whose curators are nominated by politicians, and whose cultural references are quite provincial. When I was invited, it seemed to me that the exhibition had no cultural content but the list of the 160 invited artists itself — with all the subsequent polemics about who-is-in-and-who-is-out. At that time I was working with a group of artists from Rome (the "Giochi del Senso e/o Nonsenso"), and together we decided to enlarge my invitation to the show to whoever wanted. Everyone willing to exhibit an image, a text, or anything else, was invited to do so at no charge during the two months of the XII Quadriennale. More than 250 pieces were col-

lected and exhibited. The invitation to participate was passed on by word of mouth, through some newspapers and with a notice posted in the exhibition space itself. Such a project could not be accepted by the institution, but it was possible because of the general disorganization (basically, the day before the opening we "occupied" the space that was supposed to be that of the publisher of the catalogue) and the lack of understanding on the part of the curators — the chief curator realized what was happening a week after the opening, and when she called me and asked me to close the space, it was very difficult for her to exercise what, at that point, would have been an evident censorship, because it would only have created more visibility around our project. In other words we exploited the folds of this rigid institution and made our project "evident" when it was, for them, too late to exercise any censorship. A big discussion arose and, in the Italian cultural scene, our project is known for having been an effective challenge to institutional rigidity. Let's say that refusing *a priori* to be part of that show would have been in a sense more coherent, but definitely less effective.

Greg: Institutions are us. They determine our wages, track our debt, and brand our clothing. Still others collate this information and sell it to other institutions that in turn develop marketing strategies to target our "individual" needs all over again. To my way of thinking the standard opposition between institution and individual is no more. Instead I prefer the way Gilles Deleuze describes the current state of affairs in his essay "Post-Script on the Societies of Control" — "We no longer find ourselves dealing with the mass/individual pair. Individuals have become 'dividuals,' and masses, samples, data, markets, or 'banks.'" Deleuze goes on to argue that unlike the disciplinary mechanisms of the 19th and 20th centuries — schools, factories, prisons and we might include here the museum in certain instances — the new system of control operates through a generalized form of administration so diffuse that it is difficult to locate or represent. If we accept this depiction, it requires us to re-evaluate not only the shape of institutional boundaries but our potential opposition to them. This revision is especially necessary if, as Deleuze and other theorists indicate, the institutional border runs directly through each of us, penetrating even our cherished sense of autonomy.

None of this implies that these mechanisms of control operate unopposed. For me the difference comes down to accepting the articulation as given or actively producing points of dis-articulation within the terrain. In other words, we can choose to comply or instead to redirect, by hook or by crook so to speak, portions of these larger institutional structures for radically different ends. This re-direction might seek to re-distribute institutional resources as in the Quadriennale action that Cesare describes or it might link artists to issues of economic, legal and social justice. Here I am thinking of some of the work that REPOhistory has produced over the last eleven years. In practical terms however, these sundry actions might be confrontational and have a limited but precise target, or they might infect the "folds" that Cesare has discussed, folds that are inevitably produced by any institutional structure. In the long run it is this latter practice that is potentially most interesting but

also one that obligates a state of near-blindness by those sent to burrow into the depths of the institution. The downside is that in the dark it is hard to tell the difference between a genuine mole and a mere rodent.

Brett: I think that if you spend too much time working in opposition to institutions that you always do so according to their rules. They determine what is focused on and what is important. This isn't very interesting. The dichotomy just reinforces the power and cultural authority that the institutions have. The tricky thing is to pose a systemic challenge without there being a recognition of what is really happening. There are also a lot of people deciding to work a lot less within institutions and engage things on their own. This can only be a healthy step.

My interest in helping Groups and Space get going was making a place where people who are working in independent and autonomous capacities could get direct information on what others like them were doing around the world — to speed this process up. Mainstream publications do not function in this way at all. They tend to reduce everything to the same flat, one month floor show without really articulating where ideas are coming from and the larger context they exist in.

Cesare, another thing you mentioned in a previous exchange was the "self-confirming" process of institutions. This is a really nice observation. I have never heard it put exactly this way. Could you explain this again?

Cesare: I think that a good way to define an "institution" is to outline the fact that most of its efforts go in the direction of a self-confirmation of the institution itself. Therefore its activities will be, to a large extent, a "celebration," a continuous effort to give an image of success, of richness, of effectiveness, of power. It's obvious that any critical position will be seen as a menace; and, as I am convinced that the artist's position is basically a critical one, there will be an inevitable contradiction between the artist and the institution. Having said that, I also think that not all the institutions are the same, nor that all their activities have always the same character. It's true that the institution can have the "power," so to say, of accepting and neutralizing even critical positions (making them become "trends" in the art market), but I do think that "institutional critique" is more interesting than neo-expressionist painting or sleek corporate photography, because in any case its content (especially in the beginning) provokes the public to pose questions. And then, when it has become a successful trend, no big drama. I think it just means that time has come, for another critical position to appear.

Greg: Cesare's definition that a large institution is one that celebrates itself is wonderful and suggests a string of metaphors — since celebration often involves fireworks and spectacle. Perhaps we can differentiate between various species of institutional power by the degree of visibility a museum or university or a biennial can achieve and how that is many times more intense than what an Oreste or REPOhistory or Temporary Services can achieve. However, light requires dark.

And this requirement is met by the tens of thousands of unrecognized artists, the amateurs and the "Sunday painters" who make up what I call the art world's version of dark matter. Nevertheless, it is the tremendous gravity of this unseen creative effort that prevents the art industry and its hierarchies of value from flying apart. What is different today is the gradual lightening of this dark matter. (According to the 1990 US Census only 24 percent of self-described artists said they could actually make a living at their profession. Naturally a key difference between art and science is that nobody in the art world is actually looking for this "dark matter.")

I think this illumination is occurring for several reasons. One is the erosion of high modernism and its tenant of the artistic genius. This allows more room for other kinds of creative work — but not a lot really. Rather what is most curious is the role that digital technologies are playing in this development. Without assigning an epochal status to this shift, it seems clear that the Internet, email and even cell phone networks are opening up organizational and representational possibilities not previously possible. (Can I suggest that these technologies are helping to gather the folds?) Today, what was in the shadows of large institutional structures is suddenly more visible and not only to these centers of power. Those of us that are working in the folds are emerging into a field of light that is permitting us to see each other. Perhaps this even constitutes a new visualization of politics. Nevertheless, there has already been the development of numerous alternative networks for the distribution of work, of ideas, of strategies. The potential raised by this luminous space is exciting as well as dangerous since visibility means just that: we emerge into the scopic field of full-blown institutional mechanisms. Of course it will be interesting to see how the institutional center with its need for routines and control will respond to the warmth of this "light" this time around.

Cesare: At the same time I actually see that the art system is in perfect shape, that its traditional ways, including biennials with big prizes (that were mostly abolished, during the 1970s and early 1980s) are expanding all over the globe; that, parallel to the diffusion of computers and electronic data, there are more and more contemporary art books and magazines and catalogues in paper; that the star system more and more seems to create an available desire for any area of "dark matter" in the art field... Like Greg, I think it's crucial to work on the channels of communication, and to problematize the generally accepted equivalence between possessing such channels and the power to legitimate a certain artistic production. One of the main goals that Oreste has had — for example in projecting the series of initiatives within the 1999 Venice Biennale — was to create a useful net of communication, of exchange of experiences and of resources among initiatives, groups, individuals. I can't say how successful we were or we will be. After a few years of attempts, however, I think that the "generalist" idea of creating "the" alternative network is beautifully generous (for the ones who really want to try to do it), but also ideological and, in the end, probably bound to fail. I think that the attitude of "replacing" a system we don't like with another one can be dangerous in the sense

that one can just end up (beyond any good intention) replicating the same rules, games of power, exclusion etc.

The best things that have come out from the Oreste experience are something, I would say, quite banal: small groups' relationships (on both personal and working levels), among people who would have probably had less chance to meet. And most of this is somehow outside of any control, happening outside the boundaries that Oreste has constituted (the web site, the residencies, the public meetings, the books etc.). I like Greg's point about self-recognition, the possibility of knowing about each other's work, ideas, etc. This is very important; I think that Oreste's contribution has been that of not only exploiting the technologies that makes this easier today, but also of stressing the importance of the actual personal face-to-face meeting, talking, but also eating and living together — the residency as a model for an extended time experience, the attempt to combine existential with poetic positions (the "real" with the "symbolic"), something that usual "restrictions" within the art system do not give as a possibility.

Brett: This is nice. I also agree that it is an abuse trying to replace one set of power relations with another. This won't do us any good. The internet is often said to be a place where this can really happen... that we can truly challenge abusive power and create democracy. This has happened, but in a really limited capacity.

But, it is important to always point out that the internet was created by the U.S. military. Its very foundations are not democratic and are meant to insure that the status quo persists (in the case of a global nuclear war). Businesses very quickly colonized cyber-space and made it a part of the mainstream. However, decentralized media groups like the Indy Media Center are a very interesting phenomenon in terms of organizing an alternative, in this case, to mainstream global corporate media. The internet has created a million "folds" in globalized culture in which we can act and build our independence.

Greg: I think it is worth adding that the entire history of art including its many technologies, from frescoes to photography and beyond, were always at the disposal of the church, the state, the police and so forth. The internet is no different. But, to pick up on something I was saying a few minutes ago... I alluded to past attempts at creating an alternative network that linked groups and individuals who were not central to the art world structure with artists. One of these attempts was the mission of an artist group I was involved with beginning in 1980. Political Art Documentation and Distribution or PAD/D sought to create an archive documenting the scattered and autonomous activities of individual artists and art groups with an explicit interest in social or political change. More than just collecting the work, PAD/D hoped to re-distribute this material using its newsletter and using university galleries and community centers, to inspire and educate other artists and activists. This desire to produce a living archive that would be a tool for visualizing

oppositional works was ultimately hampered by the lack of a viable means of distribution and this is what the new technologies appear to offer.

Today, the PAD/D Archive is now part of the Museum of Modern Art's library (in NYC). And while the PAD/D Archive is now being used by scholars to revise the art historical picture of postwar art, it is not the activist, organizing tool we in PAD/D once hoped it would be. The group's mission statement as it appeared in its newsletter "Upfront" in February of 1981 stated that "[PAD/D] cannot serve as a means of advancement within the art world structure of museums and galleries. Rather, we have to develop new forms of distribution economy as well as art..." One way that PAD/D sought to develop this new form of distribution economy was to seek out actual alliances — often temporary and sometimes contentious — between socially engaged artists on the one hand and organized Left political movements on the other. And not only PAD/D was attempting this, other small art organizations such as Group Material and Carnival Knowledge were making similar connections between themselves and non-art institutions and activists.

What happened in my opinion by the end of the 80s was this: the art world selected a few, individual artists making "political art" or "art with social content" and set about legitimating them within the museum and within the art historical canon. Meanwhile, the broad base of such activity that had led to the very possibility of this recognition was thrust back into darkness, a darkness I should add that made us invisible not just to the institutional center but also each other. It is apparent that today a similar kind of cross-over phenomenon in which artists move away from a strictly art world context and into an activist or autonomous mode, is taking place. This new activism is most visible in the WTO counter-actions in various international cities. Antonio Negri and Michael Hardt have even described these new activists as "Nomadic Revolutionaries." What one finds is the participation of academically trained artists working beside "non" professionals and political activists all involved in transforming collective dissent into an energetic and pleasurable carnival. Let me repeat that it is invigorating to see this cross-over activity happening and perhaps this time, thanks to the self-awareness and cleverness Cesare describes as well as the increased visibility and networking potential afforded by new technologies, things will go differently.

> — *This is a reconstruction of a conference call (the recording of the call was lost) between Greg Sholette (REPOhistory — www.repohistory.org), Cesare Pietroiusti (Nomads + Residents — www.nomadsresidents.org, and Oreste — www.undo.net/oreste) and Brett Bloom (Temporary Services and Groups and Spaces — www.groupsandspaces.net). The conversation originally appeared in the Groups and Spaces e-zine in July, 2001.*

Karosta
Under the Surface

**Kristine Briede of K@2 *(Latvia)*
Interviewed by Joanne Richardson
*(US/Romania)***
||

The Culture and Information center K@2 in Karosta (www.karosta.org) grew out of the previous activities of the independent film group Locomotive. So can I first ask, who and what is Locomotive?

"Locomotive" was founded in 1995 by young filmmakers Carl Biorsmark and Roberts Vinovskis. Locomotive was initially a studio focused on documentary filmmaking, but also made television programs and organized other culture events. Later the studio changed its name and became "Locomotive International." The people changed as well — some left, some new ones joined. We cooperated with other organizations, artists and filmmakers of different backgrounds and nationalities but the main aim remained the same — to hold up to a mirror today's society and its processes — even if the art forms we used have changed through the years: texts, paintings, organizing exhibitions or film festivals, making films or social advertisement series.

> *Locomotive was also collaborating with Re-lab and is one of the founders of RIXC, the new media center in Riga?*

Locomotive, the film group was one of the founders of RIXC at the beginning of last year, but after founding the Culture and Information center K@2 in Karosta, Locomotive has slowed down its activity a bit. K@2 is not part of the RIXC organization but we do work together with RIXC. We are organizing similar things, programs of cultural exchange and collaboration. RIXC is Riga based, and they are also happy to have a regional partner outside the center, and we can cooperate in different ways.

> *You founded the Cultural Center K@2 in Karosta. Why Karosta? When did you first encounter the place, and why did you decide to stay?*

We first came here in 1997. We didn't know this kind of place existed, we were living in Riga, and in Riga, in the capital, people often don't know what is happening in other spaces and places in Latvia. We came for a Swedish and Latvian documentary filmmakers meeting, and when we saw this place for the first time, it really fascinated us. It was a fascination about the simultaneous beauty and ugliness of the place. The seaside and environment is beautiful. Its actual condition is something else, which you can understand from its history.

Karosta was built by order of the Russian Tzar Alexander III — this region was under imperial Russia, and he decided to build here a military port in the Baltic Sea region. For that time it was a very modern town, the houses and bridges were modern. A fortress wall was build all around the whole city, but the interesting thing is that the fort was never used, there has never been a single shot fired from here. Then there was the Russian-Japanese war. Liepaja had become an intermediate stop for Russian emigrants to go to New York — there was a direct ship Liepaja-New York — and in this sense there was a concurrence with Japan. The Japanese won and the agreement was that the Russians would destroy their own fort by exploding it. After the Russian Revolution, this remained a military port for 50 years while the Soviet army was ruling. During that time, Karosta was a closed district, and civilians from Liepaja (or elsewhere) could not enter — there were guards at the bridge, and people were permitted to enter only with special permits. The Soviet army left in 1994, and some 6000 people (mostly Russians, who were relatives of the army, or the staff and servants serving the army, or pensioned military). And practically the next day after the army left those who stayed behind and also those from the countryside came here to rob the houses. They took out the doors and windows, sometimes bricks, and all the metal things, lamps, wiring, etc. (sometimes the houses were exploded to make it easier to take out the metal). There were metal shops set up that bought metal 24 hours for black trade. People were so uncertain about their future that they grabbed whatever they could. Today there are some 7500 people living in Karosta, mostly Russian speaking, less than 25 percent of those living here are Latvian citizens, the rest are either Russian citizens or so-called "aliens" (stateless, they have a Latvian passport for aliens or they even carry the old Soviet passport which they never replaced).

So now the town appears to be a landscape of ruins, many houses are completely destroyed from the original vandalism. There are problems of mass unemployment in the region as well as depression. There are no cultural events or any organizations that could organize them. But from the first time we came here we could see that there is something under this surface, something which may not be observable to tourists. Many tourists don't come out from the busses because from their windows it may looks like a ghetto, and maybe they see poor people and destitutes and they are afraid to come out. One of the aims of our project was to see things differently, and maybe we saw the beauty in this place because we were seeing with different eyes.

> *You told me in an earlier conversation that one of the things that fascinated you about Karosta was that it was a town of ruins. Perhaps ruins are fascinating not only architecturally, but symbolically, because you can never start something completely from zero, and ruins are a kind of in-between space. They don't already have a pre-determined use, they had one once, but now they represent a stage of transition. They don't come ready-made, they must be transformed.*

Since they are in-between, they have potential. There is something that you could create. There are not so many places that I have been where I have felt that you can create something out of it … art and history and social life all came together and gave me this impression. In our film "Borderland" there is a text that goes: "If something is created in an empty place it's not empty anymore…"

> *When did you decide to stay and start the social center?*

It was after our transit zero film-makers workshop and exhibition — we felt we didn't want to leave. We wanted not only to live here but to do something for the area. We weren't sure what we could do, since we are not social workers, we are not pedagogues, we are artists. We had already started a process of workshops with kids during the summer (ceramic, painting, and photo workshops) while we were preparing for the transit zero exhibition, and it was so difficult to leave. We felt that if we left the children, it would be like someone who takes care of a cat for the summer and in autumn when they go back to their towns they throw it away, leave it behind. And we didn't want to come to such an occasion.

I will tell this in Carl's words: in deciding to move here, we did something that professional filmmakers would never do. In moving here we have come to the other side of the screen, we are now inside (or outside, or behind) the screen. If someone would be making a film about Karosta now, they would film us because we are integrated into the community here. But we felt this was the right step for us, and that it was more important than keeping a professional distance… So from being documentary filmmakers we have become documentary social workers. It's kind of strange, we have actually become part of the place to such an extent that it feels like shooting a movie without any film in the camera.

> *You choose the name K@2 for the center. What is the significance of the name?*

There are several reasons we chose the name. The address of our center is Cathedral Street number 2 (Katedrales iela 2). And we have a Russian Orthodox Cathedral across the street. This is a cathedral for spiritual life, and we thought we could be a kind of cathedral for earthly, material life. But the most important reason is that in Latvian there is an expression K2 which means transport on foot, by your two legs, and this is connected to our conception. We didn't come here with everything ready, with equipment, and with a finished concept and ready money. We are

doing it as a process, and we go step by step, quite slowly sometimes. Along the way we see how it develops.

> *What is the connection between the films that you were making about borderlands, about physical borders across territories (although physical borders are also about something that is between two different states, between the virtual and the actual) and the choice to move and work here. This is not exactly a border town, it is not on the geographical border between Latvia and Russia. But it is in other symbolic ways a borderland because the Russian community who lives here doesn't speak the language, and because the town is between having been something once (a military base) and becoming something different now.*

At first, Karosta was one of the objects of the documentary film Borderland. Karosta is a part of the many segments of the film. This is a very compact borderland, because in this microcosmos many border phenomenon are present. There is the language border, there is the border of economy, since it is not really integrated in a capitalist mode of life. There are mental borders since Karosta is in Liepaja, but yet it's outside since when it was a military base it was a closed district. And still now people from Liepaja look upon Karosta very suspiciously. If you ask someone in the center, they will tell you not to go to Karosta because it's such a terrible district. And if you ask them: "Have you been there?" they might say: "Yes, I drove by once." But probably, they did not get out.

> *I'm wondering why here and not in Riga – and I can think of two reasons, first that there are already these kinds of initiatives in Riga, and secondly, that the atmosphere here seems kind of barren and depressive and there's a lack of social activities.*

Yes, exactly. And also, to be honest, I was tired of so-called high art, and sometimes I cannot follow the meaning of this kind of activity. If it doesn't have an emotional and social significance it does not have any value. Sometimes the paintings and the work done by the kids at K@2 is much more interesting and relevant to life.

> *How did you acquire the space for the center from the municipal government? And how are you getting money to maintain it on a daily level?*

In December 2000 we established an NGO together with Liepaja people that is called the Culture and Information Center K@2, and this organization has signed an agreement with the city council that we will rent the house for 15 years for quite a low rent, and we have agreed that we will not pay in rent but with the renovation work that we ourselves are doing. We have applied for finances on a project basis from different institutions, including local ones as well as in Europe and beyond. The hardest problem we have is operational infrastructure costs because the house is big (1000 square meters) and it's impossible for Carl and me to do all the organization. We have not found any foundations who will pay salaries for peo-

ple to work here. And the money for equipment and hardware has so far come
entirely from project costs.

> *What workshops and other events have you organized?*

We have made workshops for children under the program Art for Social Change,
thanks to the "European Cultural Foundation." So there is a photo workshop that
is not teaching kids photo art, but trying to get them to express themselves through
the tool of the photo — through the image. For different workshops there are dif-
ferent age groups, for the photo workshops the age range was 9-14. For the graph-
ic workshop there will be smaller groups of different ages, between 4-18. The
workshops began running during the school year, and are now continuing in the
summer, and next autumn. Sometimes we have about 30-40 participants every
day. Although we focus on workshops for children, we also have programs for
adults, like evening lessons of Latvian language, and cultural events with larger
audiences, concerts, film screenings, visual poetry readings. Sometimes we organ-
ize events ourselves, sometimes we invite our friends from other places, for
instance from Riga, to take over the space and do it.

> *Why did you decide to focus most of your attention on creating workshops for children?*

Or, we could ask: why did the children decide to do workshops with us? We think it's
productive for them, especially these kids who have no other possibility to do any-
thing creative just because of the social conditions in their families. And it's pro-
ductive also for us. We get more pleasure out of working with others, especially
with children, because we get so much response (emotional and conceptual) from
them. We just like interacting with each other.

> *The fact that you picked children for the Art for Social Change program seems to imply that
those who are most able to enact social change are children — the new generation.*

It is important to work with the new generation because these are the seeds for devel-
opment. Maybe it sounds cruel to say that the attention today should be devoted
to the younger rather than the older generation, which we cannot influence so
much because they are more fixed in their habits and thoughts. It seems to us that
it is these kids who are capable of remaking the past into a new future.

> *And you feel this is something that they can't get from their routine school education? Do you
think of these workshops as an alternative educational model?*

Maybe they can, I don't know, but they seem more drawn to it. Before we used to have
the center open during the morning, and it turned out that some of the kids were
skipping school to come here, so we had to change the hours, and now we are
open from 2-7 pm. Maybe they are more drawn to us because we are neither pro-

fessional pedagogues nor their parents. We approach things in a different way, and they see us differently, more like their adult friends than their instructors.

I wanted to mention the new workshop we are doing this autumn called Digital Billboard, which started in September. Kids and young people from Karosta are making their own newsreel every week; different groups film what they think is interesting, and it is totally different from news on TV. They are editing it together with us, and we plan to start screenings on an outdoor screen outside the house, and then to screen it on television the next day. At the end of the project, they will make a larger film from the newsreels and the new media group will tour by bus to different places in Latvia, Lithuania, and Estonia that are similar to Karosta, and they will present the Karosta newsreel film themselves.

> *People usually receive news passively, as something made by somebody else and served to them for consumption, so to switch this and have them take on the function of the producers of news seems to have significant implications. By analogy, their lives are organized from the outside, and they are just receptacles, so to put them in the position of producing news, indirectly seems to give them a message that they can actively produce their own lives.*

Yes, it is important for their own sense of production, but also the screenings are meant to be interactive, so that the audiences where they present can also question the production of news. Maybe after it becomes a routine every week, we will receive proposals from the audience about what should be in the news from their own perspective.

> *Before, when you were working on the film Borderland, it seemed that you were yourselves in transit all the time, going to different locations, not having a fixed place where you lived and worked. And now you've chosen to stay in this one location, to identify with this territory....*

Yes, but staying in this fixed place is not an end in itself, it is also a transition, temporary. We want to set it up, to involve the local people to such an extent that they can run it themselves in the future. At first maybe we can be in a position of consultants, and when we see that it can work without us, we can move on, maybe go back to making films. Our plan was just to set it up, after that it can develop organically, out of its own momentum.

> *Who do you think will take this over, since it seems that most of the people who are involved with K@2 are children?*

We have found very good people that could do it and are interested, but they can't do it yet. They need more confidence, and also more knowledge. It's not a question of months, but of years. Several of the youngsters are interested. One of the girls wants to be the director of the center, and she is perfect for it. She is 14 now, and she has herself said that she wants to do it, only that she has to first grow up a little.

MediaArtLab
Dossier of a
Virtual Community

Alexei Isaev *(Russia)*
||

s an initiative, the "MediaArt-
Lab" creative group was originally established in 1997 by Alexei Isaev, Olga Shisko and
Tania Gorucheva as part of the Soros Center for Contemporary Art (SCCA). It was
founded with the intention to build a bridge between activities in the fields of culture
and new information and communication technologies. The participants of
MediaArtLab projects have included artists, film directors, critics and theoreticians, jour-
nalists, producers and curators working in the field of contemporary culture and art, as
well as Internet and electronic media experts, and the representatives of most "media-
active" professions. From the beginning the goals of MediaArtLab included focusing the
attention of scholars, creative communities, representatives of state organizations, and
the public at large toward the impact (as well as the problems and potential solutions)
of the development of new technologies upon general cultural processes.

Since March 2000 the initiative has become independent of Soros, and is registered as
an autonomous non-profit organization — "MediaArtLab" Center for Culture and
Art. The time of its foundation as an independent organization coincided with the
crisis of the institutional structure of contemporary art in the post-soviet period, a
structure that was based primarily on the investments of Western foundations.
Among these, the most important was the Soros Foundation, which financed from
30 to 50 per cent of the projects in the sphere of "actual art" — a situation that
proved very suitable for the Russian Federation Ministry of Culture as well as for
other state organizations. And, suddenly, during one single year almost all the pro-
grams of contemporary art that were financed by the Soros Foundation were
closed.

By the time this crisis spread, the MediaArtLab group had already acquired substantial
experience in organizing and conducting Russian and international events in the
field of media culture. Up to 2000, while it was still part of SCCA, MediaArtLab

realized two Da-Da-Net festivals (www.da-da-net.ru), on-line events dedicated to Russian information resources on contemporary culture and art, as well as presenting art projects on the Net (1997-1999). Their aim was to discuss and provide solutions for integrating various projects coming from contemporary culture and art into electronic systems of data exchange. Another major initiative was the Trash-Art International Net-art festival (1999) – an artistic experiment unique in Russia, based on ideological and aesthetic provocation. It included both a conference with a roundtable discussion, and also, importantly, an artistic competition in which the most prominent Russian and European artists and theoreticians took part, thus changing the traditional perception of Net-art as simply a technology. Media mentality, contemporary art, and their interaction as a love-hate relationship were presented through an approach that was both theoretical and practical. In 1999 the MediaArtLab website (www.danet.ru) presented a discussion about Russian Internet, the Internet community and Net-art in the bilingual English-Russian edition of "View from the East." These events and activities provoked interest among artists and the artistic community in the field of new media technologies, especially in the internet.

After the Soros Center for Contemporary Art was closed, the MediaArtLab group was able to continue its existence, becoming primarily a "virtual" organization. Without a stable residence, the group was able to reject the office routine and shift the emphasis towards the creative part of the project. The primary advantage of this situation was the increased mobility and artistic potential of the organization as a whole and in its individual participants. The work of the organization as a process was able to become one of creation, not of administration. Thus the actual space became less important than virtual presence, which allowed the activities of the group to spread. This was a very important period in the development of MediaArtLab, as it acquired a radically different position. A micro- and macro-partnership network both in Russia and abroad was created as a result of MediaArtLab's project activities in interdisciplinary fields (at the borders of culture, scholarship, society, politics and technology). Secondly, a survival strategy for independent art initiatives during this transition period was developed, which later acquired the status of a general cultural policy in a period of financial instability.

It is important to point out that during this period, the intellectual activity of MediaArtLab differed significantly from the concepts of Russia's leading political technologists (for instance, Gleb Pavlovsky), who served the official powers and exploited the terms "new media" and "cultural policy" in order to create an image of a "democratic" Russian politics (which remained on the level of a mere image).

After the changes in 1991 in Russian political and economic life, and again after the subsequent changes of 2001, contemporary art began to lose its actual status on the international art scene (as it lost the actuality of raw material resources and the focus shifted from the production of artistic kitsch that could be consumed in exhibitions). The orientation of the art system gradually transformed into a form of

business activity, but this activity still remained largely unprofessional since it never really took into account the specifics of its profession. Russian actual art got stuck between the political and economical ambitions of the Perestroika regime. The crisis of art accompanied the political and economic crises.

During this crisis, there was a gradual transfer from emphasis on the sphere of contemporary art to the sphere of contemporary culture, or to be more specific, to the field of contemporary media culture — as the whole complex of culture and mass media interrelation became more central in Russia. MediaArtLab's existence at this stage as a "virtual" community and its activities in uniting the interests of artists, critics, cultural studies scholars and the general audience can be understood as a form of art activism, which represented the interests of the international net-community. The Internet as a communication space for both creative and business activity was instrumental for the emergence of new communication spheres during the period plagued by the financial instability of cultural institutions.

As Tatiana Mogilevskaya has written in her diagnosis of "Art on the Internet," the "WWW is not only a space towards which Russian cultural life, weakened by the current crisis, is shifting, but it is also a place where it could come to necessary unity. Let us keep in mind that Russian cultural life stays extremely centralized in Moscow, and its Internet representation could overcome this fatal Russian peculiarity. The Net could become the place of existence and survival of culture which is now being forced out from the off-line world called Russia..." (included in the collection of articles in "View from the East").

During its existence, MediaArtLab has devoted its activities to the creation of a practical and theoretical basis for the development of media culture in Russia. It has organized all-Russian and international interdisciplinary projects, with members from humanities as well as technical communities, together with contemporary culture managers from Russia, countries of the former USSR, Eastern and Western Europe, America, Australia and Japan. Its most recent activities have included the international interdisciplinary symposium Pro&Contra (www.procontra.danet.ru) during May 2000, and Media Forum as part of the XXII Moscow International Cinema Festival during 2001. MediaArtLab has also focused on developing new education models, and forms of archiving and distributing contemporary art and culture. An important part of developing these models has been the creation of internet resources (in Russian and English) on the www.danet.ru site. MediaArtLab has published theoretical and research materials on the intersections between media culture and contemporary art, politics, society, information sciences, education, and institutions. These collections are published both in traditional print media and on CD-ROM and Internet, always in bilingual Russian and English versions, comprising works by Russian and foreign authors. In this way we have sought to disseminate "foreign" ideas among a Russian public, and Russian ideas abroad — aspiring toward a mutual exchange between Russian culture and the international community.

38

WRO Center

Piotr Krajevski *(Poland)*
Interviewed by Joanne
Richardson *(Romania/US)*
||

You founded WRO (wro.art.pl) at the beginning of 1990 in Wroclaw. Could you describe the social and political context in which you were working directly after 1989?

Actually, we started our activities even earlier. The first WRO festival was organized in the first week of December 1989. This was quite a special time: three weeks after the Berlin Wall fell down and several months after the first free election in Poland. We were witnessing pivotal changes taking place at that very unique moment, although their meaning was not entirely comprehensible for us.

All in all, the euphoria felt around that first WRO event was optimistically taken as a clear sign that there was something new for art, too. That was actually how what we were doing was perceived in Poland — as a sign that culture was renewing itself, as politics was. A minimal budget was sufficient because the post-communist economy allowed setting different activities up without having solid financing.

The biggest part of this pioneering WRO festival was filled with video-art and computer animation shows, which were in the mainstream of new media at those times. These were shown on what seems to have been the only video projector in Poland then, borrowed from the Polish national TV. Along with this we carried out many other things, the Amiga computer animation pieces, the first interactive and multimedia performances, and a bunch of bizarre concerts. We presented all the tapes we were sent without any selection — and there were over 200. This seems hard to believe now but the audience stayed for everything. They booed and whistled at mediocre works but stayed and kept watching. A terrific atmosphere of discovering new worlds accompanied these shows, concerts and exhibitions, and that feeling was shared by several thousand audience members who attended the event.

WRO was not only the first such event in this part of Europe but also, which is remarkable, it was perceived immediately as a big media festival and gained wide recognition. That recognition meant huge audiences, and it attracted press and television reporters, who, despite their not-too-clear understanding of what was going on, sensed that it was something extraordinary and gave the event very intensive publicity. The event was also an occasion for meeting over 100 artists who came to Wroclaw from the USA, Germany, France, Italy, Holland, Russia (actually, from different countries of the Soviet republic), Hungary, and Czech Republic.

However the most important fact for development of art in Poland was that the festival gathered different generations of Polish artists, including the youngest one — they became known to everyone right then, and they immediately experienced themselves as a new movement, a motor for further changes. It is clear now in retrospect that the event was crucial for them as the place of meeting each other and discovering they weren't doing their things alone and in isolation, which was their common belief due to a complete lack of information. They got to know not only what was happening abroad, but that similar activities were taking place, say, in the next town.

It is obvious that our strength are meetings between West and East, obvious to such extent that we have never found it necessary to state it explicitly. We have written about meeting of artists from "here" and "there," we had the feeling that our activity has a strong and clear relevance for many political aspects, but we wanted to avoid labeling and resorting to a banal political rhetoric. WRO has become known as an event, a festival. Its first edition was a beginning for us. Later when we understood its significance, we placed our expectations on a very high level and ever since then we have been responsible for coming up to them.

> *When you began, did a tradition of artists founding their own space and association already exist in Poland? And was there already a context for "media" art during this time?*

Describing the tradition and general context of our activity must involve some insight into the conditions for culture during the last years of communism. Official culture during this time was actually dying from its own impotence, whereas there was a strong current of unofficial, independent culture. This was very important, but also beginning to show its constraints as something that remained unofficial and behind the scenes. It seems we acted at the first moment when it became possible for things that were underground or marginalized until then to find themselves in a normal circulation. It became obvious that many people had been waiting for it for a long time.

As far as media art is concerned, what is curious is that many phenomena had already existed, yet without any possibility to introduce or present themselves to the public. The first video realizations had already appeared in the mid 1970s, however the media artists practicing in Poland were for a long time outside the area of offi-

cial art supported by the communistic state. There was no room for them in the authorized picture of Polish art, in the galleries. Only a few independent places, closed for those who were not in the know, showed video-art, and even there this was rare. No wonder that the audience, even those interested in contemporary art, had no idea about video-art. The first generation of medialists split into two groups: one abandoned the domain because it was devoid of any possibility to act. The other simply emigrated in order to develop their work abroad – Zbigniew Rybczynski and Krzysztof Wodiczko serve well as examples.

On the one hand the technological underdevelopment and complete lack of possibilities of showing works brought about a situation in which the group of artists working with video or trying to experiment with the computer remained small for years. But, still, they were present as a force, and the continuity with this earlier movement was crucial for the further, accelerated development during the 1990s, when WRO created a forum for meetings and for presentation of these kinds of works.

> *What are some of the projects WRO has made through the years that you consider most important? Is the festival one of these? What has been the impact of the festival – did it arise in the context of an emerging new media scene in Poland, or create this context itself?*

Projects that we have completed within the structure of WRO are obviously numerous and very versatile, taking account of the 13 years of WRO's existence. WRO as a festival (which was established as a biennale after first three editions) is of course of the most important part and most of the projects we accomplish are more or less rooted in this event. Therefore the majority of completed projects have been presented during one of the biennale's editions. Their characters is very diverse: recent examples include internet performances with real-time feedback, a concert by a group performing with Gameboy consoles, and a project based on the phenomenon of clubbing, called "i-club residents." Exactly one year ago we succeeded in one of our most ambitious undertakings, which was a performance of Jaron Lanier's compositions written specially for WRO – a concert of virtual instruments and chamber orchestra. Some projects are small and require almost no effort, others are huge, involving many people, as well as technologically complicated. The character of what we have become accustomed to call "new media art," or abbreviated, "media art" has changed significantly during WRO's existence, just as everyday life has.

Therefore it is normal that during these years the structure of presentation and the artistic phenomena we present have also changed and evolved. What has remained unchanged is our effort to create a cognitive distance, a sort of critical perspective upon media art. We have attempted to achieve this distance through our choice of the general themes for particular events, through the selection of works and setting a final program for the biennale, as well as through symposiums, which are always present as part of the program.

Between 1991 and 1997 very crucial for us was our collaboration with the 2nd National TV Channel, thanks to which the topic of new media art was quite often and quite thoroughly presented on TV. This gave us interesting possibilities to reach audiences that were much wider than our usual festival audience. Many of our productions were documentaries on artistic events, such as reports on international festivals like Multimediale organized by ZKM, Ars Electronica, and finally WRO itself. However there's something even more important to stress — the fact that Polish Television has commisioned works by Polish artists through WRO as an independent TV co-producer. The professional conditions of each such production and later its national broadcast was very valuable for an artist who didn't have to make compromises that are a feature of each collaboration with any specific TV station, because in this case all the mediation and responsibility were on WRO's side. In most cases neither the television nor the artists could manage such co-production with mutual understanding. We served as an interface, operated as producers and curators working for the sake of projects. This brought remarkable outputs and was very important for Polish video-art. Each year there were several works by different artists, sometimes we managed to complete 5–6 projects. Among the most important video works a significant number, I dare to say even a majority of them, came into existence thanks to this relationship with the TV. This was certainly a sort of creative challenge. That collaborative experiment with the TV went even further: several times we organized within WRO festival special events and performances, which were broadcast live, often during a good time, so we reached an audience of a few million. After 1997, the collaboration with television started getting weaker. The situation of art changed, and the TV changed as well, but we still cooperate. Now however, this is limited to one or two programs per year. Summing up however, our output is quite impressive — it's more than 120 different programs, from several-minutes pieces to ones that are over one hour long.

Another kind of project WRO has implemented relates to education. It should be mentioned that Poland has lacked a proper artistic education in the domain of new media. There's nothing comparable to German or Dutch standards. Therefore since 1990 we have traveled with lectures and shows between galleries, art schools, museums and various ephemeral alternative places. This adds up to something like 200 lectures. We find it a great means of communication, exchange of ideas, as we have reached and met various artists, various peripheral environments, and have built up a network of relationships, which was extremely important before the net as we now understand it actually appeared.

> *When we met in Prague, you talked about the WRO archive. What is in this collection — and does it have an open character, in other words, is it open to the public?*

The WRO archive cannot be labeled extremely large by international comparisons, but it is the largest of this kind of collection in Poland. We have mainly video tapes (VHS format prevails, but there are also a few hundred of Betacam tapes) as well as CD-ROMs, and publications — constituting a very rich collection of Polish artists'

works. A number of these are represented by WRO, so we could also be said to be distributors. The total number of collected works is over 3000. Most of them are available for viewing on the spot for educational and research purposes. The archive is open mainly to students — there are several master's degree papers which included research of our collection. However the conditions of accessing the archive are limited, so I would not call it open to the public.

> *Is WRO also a media lab available for artists who want to use the equipment to produce their own works?*

WRO is not a production lab, and as far as video and other production equipment are considered, we don't really have this kind of possibility in our space. When the need arises, we organize all that is necessary for a particular project, configure the situation, seek people to cooperate with, search for sources of financing and optimal means of realization. We also don't have an exhibition space. Of course we do have working space, let's call it an "office," with a communication infrastructure, 5-6 computers, the archive, documentation, accountancy and so forth. Thus when organizing a show or exhibition we cooperate with galleries, museums and theaters (generally institutions having their own spaces). We have often looked for "other," more neutral locations. A huge exhibition of installations in December 2000 was assembled in the lofts of a baroque building of Wroclaw University (a space that has never before been attended by the public) and in the university's mathematical tower, which was just restored and opened for visitors for the first time since WWII. We also set up presentations and exhibitions in an old inactive railway station, large TV studio and National Museum, as well as different historical halls.

We attempted to uses spaces that corresponded actively to the concept. For instance, Lanier's concert took place in one of the city's most beautiful baroque halls, usually reserved for events of the high culture. Stelarc's performance on the other hand took place in the black room of the Laboratory theater, where in the 1970s Grotowski and his actors experimented with overcoming the limits of the expression of the body in the theater — place that is a shrine for all who know anything about the contemporary theater.

> *What is the role of the SCCA in Poland — both in terms of promoting media culture and in terms of funding opportunities for artists and organization — and what is your relation to them?*

The role of Soros Foundation in Poland, as far as the new media issue is considered, cannot be compared to other Eastern European countries, where the origination of different SCCAs had a much more crucial, initiating value for emerging new environments and phenomena. This case is completely different in Poland. Certainly Stefan Batory Foundation (even its Polish name is different) is a powerful and rich organization with very wide spectrum of activities, carrying out many important social projects, but its activity is not focused on new media. Several

times we obtained grants for the WRO Biennale from the foundation's Cultural Link program, or individually, we obtained money for travel and fellowships like Arts Link. This is very precious, but in Poland Soros hasn't facilitated a faster development of the new media domain. In our case all this simply means that as an independent institution we are completely devoid of a steady and constant subsidy from any budget sources. All we have done was based on our efforts to obtain grants for particular projects, and some small amounts we managed to work out on our own.

> *What does being an "independent" institution mean to you? Independence is a negative characterization, something that is not dependent? Not dependent on what? State institutions, funding bodies? Does financial independence also have negative aspects?*

Although I have stressed the positive aspects of WRO's existence, there is another side, and there are some things we won't ever realize without a more solid financial base. Despite existing for so many years, WRO has never had a longer period of stabilization. In countries like Holland, Germany or Austria almost everything that appears as "independent" (if only it seems to be solid enough) usually connects somehow to the system or softly gets institutionalized or gains some form of stable subsidy. In Poland the system is much more resistant. The problem is twofold: first — poverty (the state's expenses for culture is barely 0.5% of its budget); second — the system firmly sticks to the traditional view of culture, so such institutionalizations are very rare and even if they occur, they're limited to other (read traditional) initiatives in culture. We have tried several times to establish an institution offering wider possibilities for functioning, but without money to sustain this, it will remain only an idea. Recently, last fall, our project concerning the establishment of a large municipal cultural center focused on media in a wide context, from art to education and social activities with local society was rejected. Our proposal was to convert the abandoned building of an old industrial bakery into a place suitable for such a center. We have worked on this project for quite a long time, even cooperating with the city's authorities. It seemed to have good chances to succeed but finally it encountered strong internal resistance of the authorities. It simply ceased. All this happened despite the fact that WRO is one of the most widely recognized cultural events in Wroclaw, each time gathering a public of several thousand people, despite being widely commented on in the press and public media, and despite being mentioned in various cultural or sociological research papers as one of the most important cultural events that Poland is known for.

> *Is WRO an organization? A community? What kind of relationship exists between the different members?*

Many times I used the word "we" to refer to WRO and that is because I strongly believe that all the best comes from the fact that we work as a team. And "we" means Violetta Kutlubasis-Krajewska, who graduated from Wroclaw University, the Theory of Culture Department and from the film school in Lodz, and Zbyszek Kupisz, who

studied political science and managed underground and experimental rock bands. Together with a few other people we set up in 1988, using different legal ploys, "Open Studio Cooperative" — probably the first Polish independent cultural institution that had legal status. During the end period of communism we tried many strategies for operating but to be able to exist legally and to be able to really function were two completely different things. After a year of experiments and failures only the three of us remained and we set up WRO as a festival and later as the center, which for a couple of years has had the legal status of a foundation.

Aside from the three members who have remained steady through the years, we have also always been lucky to meet great collaborators. They are mainly students who have looked for possibilities of doing interesting things. Some of them worked on one or two projects, others stayed for a few years, gradually becoming self-sufficient curators and organizers. This dimension of collaborative work, a sort of community that works together and enjoys the successes of projects is our greatest experience.

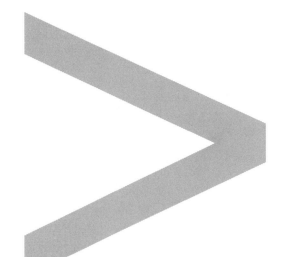

39

Kuda.org

**Kristian Lukic *(Yugoslavia)*
Interviewed by Joanne
Richardson *(US/Romania)*
‖‖‖‖‖‖‖‖‖‖‖‖‖‖‖‖‖‖‖‖‖‖‖‖‖‖‖‖‖‖‖‖‖‖‖**

When was kuda.org born, and from what context – specifically from what political and cultural context in Yugoslavia? And why now?

Kuda.org (www.mec-kuda.org) is a non-profit organization of artists, theorists, media activists and information users. The idea to establish such an organization derived primarily from the urgent need during the nineties. With the development of ICT, especially in the second half of 1990s, the gap between artistic practice and digital environment grew larger and larger. It was necessary to find a means to span these two separate fields and bring the methods of working in each closer to each other. In 1998, a group of artists (mostly coming from the group Apsolutno) came to the idea of establishing a center that would function as a distributive information point for new media and digital culture in Yugoslavia.

At that time the negative political impact was very strong. Under the Slobodan Milosevic regime, any initiative that was connected with a critical position towards the government was, if not openly prosecuted, then just ignored, which meant lack of any financial (crucial) support. There were many difficulties in founding and especially in sustaining any kind of non-governmental organization. And it is important to say that kuda.org was not a Soros spin-off project (although we cooperate with them), so that is why we didn't have any institution behind us.

The idea was born as a virtuality – a possibility – but devirtualizing it in a real space that became kuda.org was a slow process. The lack of financial and governmental support greatly slowed down the speed of realizing the project. After the political changes at the end of 2000 – when the regime of Slobodan Milosevic was replaced with DOS (Democratic Opposition of Serbia) – the municipality of Novi Sad gave us a proper space for kuda.org, which finally allowed us to begin our activities.

> *Since you have just opened, it's not possible to ask in detail about your previous activities. But what kinds of events and activities do you have planned for the future? Will kuda.org function as a kind of media lab where people have access to equipment which they can use for production? Or more of a media center, a place for people to meet and discuss issues related to media culture?*

Most of the people working at kuda.org are coming from an art background, but our goal is to involve lots of people from different fields and to make possible the emergence of common interdisciplinary interests and activities. In terms of strategic goals, our priority is first to establish media literacy among a larger public. Kuda.org will develop its media lab department (media territory) parallel to its program activities, lectures and presentations (media lounge). What is most significant for us is to raise people's individual consciousness about the importance of content; to form a community of people who, with an increased social, cultural, and aesthetic awareness of media culture, will have the necessary structure for future production. The production cannot come first.

Media literacy also includes communication and the transit and exchange of people and ideas — that means an exchange from kuda to the outside and from the outside to kuda. Kuda.org will provide open space for people from Europe and beyond (in terms of residency programs, presentations, lectures and conferences) to work and to present their projects here. In that sense, one of our intentions is also to gain international visibility and to establish collaboration with similar media centers in the world. At the beginning the most important thing we can do is to begin to make partnerships with organizations in our own "neighborhood," like [mama] from Zagreb, Ljudmila from Ljubljana or InterSpace from Sofia. And this process has already started to happen.

> *There have been other initiatives that seem similar in objectives, at least from an external viewpoint — for instance CyberRex, which is known abroad mainly because its connection to B92, which received a lot of international support and fame after they were shut down by the Milosevic government. How do you define yourself vis-à-vis CyberRex? Are you collaborating with them or completely unconnected?*

CyberRex is a very important cultural initiative and we (as individual artists) have collaborated with them on different levels. Now, we (kuda.org as an "institution") have the opportunity for cooperation on an institutional or inter-institutional level. As an organization, CyberRex originated from Rex — the cultural department of Radio B92 — and it was a kind of electronic shelter after the ban by the Serbian authorities against B92 (as a place that disseminated "independent" news that was not biased by the official state propaganda), a ban that occurred soon after the beginning of the bombardment by the US. As the cultural department of B92, CyberRex was not primarily focused on news or media as such, but more oriented towards cultural activities in a wider sense: theater, music, visual arts, film, etc.

249

Kuda.org is less oriented around art, and more towards new media and ICT technologies and their social and cultural impact. There is a strong need for coding the current digital society (if we dare to say that such a thing exists) in Yugoslavia. The fact that members of today's Serbian government declare themselves "technocrats" (by the way, the Serbian prime minister just signed a contract with Microsoft, giving Microsoft a strategic position within Serbian infostructure) shows the possibilities for the development of Information Technologies in Serbia.

> *What do you mean by "infostructure"?*

The term infostructure was used as the title of part of the world-information.org exhibition last year in Brussels and Vienna. The organizers of the event, Public Netbase, used the term to indicate a world that is structured through information (routers, servers, operating systems…hardware, software and wetware).

> *And what does the fact that the Serbian government considers itself a government of "technocrats" actually mean for the possibilities of IT? I'm not sure whether you are using the term in an ironic sense?*

I used the term "technocrats" in a partly ironic way, but I actually meant to show the real emphasis of the new Serbian government on Information Technologies. Although their position is quite intricate and not unambiguous, the new "neoliberalist" governmental structure is a reality. So in that sense, on the governmental level, we can say that we are bravely stepping into the New Economy paradigm. But, if we look deeper into this situation, we will see the reasons for our entry into the New Economy as well as its specific limitations.

In an economically exhausted country, after a decade of war, instability and the lack of opportunities for employment, many young people spent their time getting an education (especially in IT), in the hope that one day they will leave the country carrying their knowledge with them as goods that can be exchanged. There are lots of young people who are educated in the field of IT (either on a basic or advanced level). But instead of leaving the country, many programmers and computer experts are offered the opportunity to stay, working in "remote slavery" for multinational IT corporations for $4–5000 per year without any kind of insurance (social, health…), which is approximately ten times lower than in developed countries. From the governmental point of view this is ok, because there is Real Cash coming from the outside, and educated people are staying in the country.

These are some of the reasons why raising a critical awareness towards the (mis)use of technology is most important in countries where the implementation of digital culture is still in its beginnings. Digital culture can offer opportunities, and simultaneously new forms of slavery. The inevitable delay in the implementation of digitalization and the permanent material dissatisfaction among those who are in a position to profit from them creates an atmosphere of latent frustration. This frustra-

tion is often expressed as a non-critical approach to technology — that is, when technology finally finds its way to the local market.

With a rising awareness of media culture during the eighties and especially the nineties, Yugoslavia participated on some level in the "revolutionary" paradigm of media technology. The experience of "media hype" during the late eighties, when ethnic particularisms gained their fifteen minutes of media glory, was "stimulating" for individuals' media consciousness. The culmination of the media revolution in Yugoslavia reached its highest level during the bombardment of 1999 when most people watched their own war on TV screens — first you feel the earthquake, then you go to see on TV what's happened. A further step was not only watching the war on the television screen, but also intervening in it. Soon after the beginning of the war, we could buy the ultimate game on the software black market: The Art of War II: Flashpoint Kosovo. The digital era was won.

> *Since you're being ironic about two ways to "win" the digital era — by the government, which can create a new form of slavery in its own interests, and through commercialization, which can offer a false sense of freedom by reducing intervention to the level of a virtual game — how do you propose an alternative to this through the activities of kuda? Can you say specifically what is the importance of an "independent" initiative in the promotion of digital culture? And how do you define this independence?*

There is no total independence. When you are starting from this kind of presupposition, you are prepared for struggle. From our point of view at kuda, the most important thing is to educate people, especially young people, so they can develop a critical awareness and make their own decisions. If we get support from the government or other institutions to achieve these goals, we'll accept it, as long as the institution that offers support has a position that is similar to ours, and so long as it does not impose conditions which would require us to compromise our own position. For instance, kuda.org is preparing several workshops with an aim to educate school teachers. We don't want to become a closed circle of enthusiasts with no external effect, and that is why we want to be near social structures like schools, universities, and even governmental institutions.

The experience of the late eighties and early nineties, when lots of people wanted to be independent from authoritarian pressure, has taught us the weakness of that approach. That independence actually helped in increasing the power of the regime. If you are independent from something, you are automatically an object from the perspective of the structure you want to be independent from. Today, we must be more active and we must become subjects. We must force the elements of political public structures to become dependent on individuals — from the inside rather than from an external, antagonistic position.

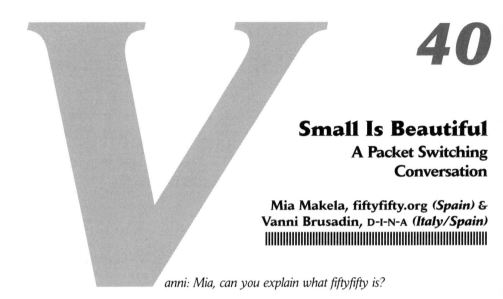

Small Is Beautiful
A Packet Switching Conversation

Mia Makela, fiftyfifty.org *(Spain)* **&**
Vanni Brusadin, D-I-N-A *(Italy/Spain)*

|||

anni: Mia, can you explain what fiftyfifty is?

Mia: FiftyFifty (www.fiftyfifty.org) is a cultural agitator. FF started as an online distributor of digital creation (gasbook, jodi, maeda and more unknown products) but one of our goals was also to organize presentations of cd-roms for the public. One problem of the digital art market is that the access to this media is limited mostly to festivals and to a very specific public, like artists, curators and festival organizers. Our idea was to share knowledge of this scene to a wider audience and create situations which would function as a meeting spot for people who are working on similar ideas and tools.

The next step was to become a label. FF published FFMIX01, a compilation cd-rom which collected together the projects of 15 creators from Barcelona and invited artists (netochka, lia, magda). What was special about FFMIX01 was that it didn't have a main interface, it was non-curated, and it was a combination of videos, interactives and music. We didn't want to separate these areas but rather bring them together, also seeking to bring down borders between art and design and to call all of it creation.

FF has curated exhibitions/shows as part of different festivals like Sonar (Barcelona) and OVNI (Barcelona) and has also organized installations like Walk-in Orchestra as part of Zeppelin festival (Barcelona). This installation was open to all visitors — who could take an active part and play music with different soundtoys. In the end we had a concert with different people mixing everyone's output together.

At that time live performance became one of our biggest interests, and we formed a performance group called DADATA which combines real-time sound and image

using nato and other tools/instruments. The interaction between sound and image is also the theme of the play-music selections for Sonar.

The way the music industry works provides an interesting model for media strategies. As music creates movements and styles through parallel channels and uses, it also emphasizes the possibility to become your own producer, distributor and agent.

We also started to organize nato workshops (Barcelona, Paris, Bogota, Medellin) and other workshops like hacker techniques and game modifications. The workshops started in June 2001 in Hangar (Barcelona) and are continuing in Brussels and Berlin next year.

Vanni: And that's why we met.

Mia: Yes, FF invited Gabriele Cosentino and you from d-i-n-a to give lectures during the hacker techniques workshop in Barcelona. We thought the program of d-i-n-a was ground-breaking in its emphasis, finally showing online projects that would be better defined as "network art" than "net art" — a term that is nowadays so overused.

Vanni: Well, I like the term network art and I myself use it whenever I can. But I wouldn't like to break down all the distinctions between art and design. In this sense net art can be useful to mark a difference from so called web art. That's a position that we at d-i-n-a deeply share.

Mia: Tell me more about d-i-n-a, is it just a festival?

Vanni: Well, d-i-n-a (www.d-i-n-a.net) could be considered an informal network of 4 artists and researchers. We are trying to produce debates on network culture and also to share knowledge about all the ways communication can become a basis for artistic action. Individually we have been involved in research on net culture since the end of the nineties and so far as a group we've produced two editions of a festival (digital-is-not-analog) in Bologna as well as some other smaller events — some in other countries. After relocating to Barcelona, it remains to be seen what d-i-n-a's future will be after becoming more mobile. You know, I realized after moving to Barcelona that you usually travel a lot. Festivals, workshop, events. Is this kind of nomadic production part of FF's style and identity?

Mia: FF has organized happenings, exhibitions, workshops and other events in collaboration with other institutions, organizations and festivals. We have preferred to stay nomads and not tie ourselves to a fixed place or a 5 year plan. Since the world of digital creation moves forward so fast, we wanted to keep ourselves on the move as well. Our interests are focused on the contemporary — or should I say "post-contemporary" — cultural movements, which are not necessarily created inside institutions, but on the streets, through technological evolution, through collective impulses which are almost impossible to predict. For this reason we would prefer to locate ourselves somewhere between the fragile border of "underground" and "accepted" forms of creation.

Vanni: What about your projects? I know you like to define yourselves as "cultural agitators": what does it mean in terms of your relationships with (local) institutions?

Mia: One of our concepts is to offer/organize situations that enable creative producers to show their projects (also in unfinished form) and share their knowledge in non-curated (or mediated) manner and without limiting access. In this way I could say that we are more interested in contemporary culture than in art. But it is not easy to categorize what FF is — as our identity keeps changing according to our interests, and as we are combining different areas like distribution and performing, our definition is flexible. This could be difficult to maintain if we were an institution, as permanent structures demand different kinds of objectives. One reason why we have preferred to collaborate with other partners is that it gives us more freedom to concentrate on the content rather than administration.

One thing that is special about Barcelona is that we have CCCB, the Center for Contemporary Culture situated just next to MACBA, the Museum of Contemporary Art. The methods and programs of these 2 institutions differ a lot from each other. MACBA represents a traditional museum that concentrates on art. CCCB open their space to other groups and initiatives to organize different projects. CCCB has helped to create an active cultural life in Barcelona. Many of the festivals we have collaborated with have also taken place in CCCB.

Vanni: So you are simply a group relying on collaborations with other groups, right? If I'm not wrong you prefer enjoying autonomy from structures rather than building new ones...

Mia: FF is an independent organization in the sense that we don't have a permanent infrastructure or funding. This is not at all an unproblematic position. We have ideas that would be easier to concretize if we had a permanent place where we could invite performances and other programs. But to be able to do this funding is essential, as it would enable us to hire people to do different things and to create a larger structure. But the dependency on the funding would in the long run carry the risk of affecting the original goals and freedom — maybe to make compromises in fear of losing the funding. There are a lot of examples of interesting digital culture initiatives that have started with big funding and then died soon after the funding ceased to continue. Wasn't that the case with Salara in Bologna?

Vanni: Yes, even though Salara in itself was not an association but a work group within the Department of Culture of the Bologna City Council. We started working together a few months before, during the European Cafe9 project, an ambitious project of European collaboration on a web streaming project where each of the 12 participating European capital cities had to freely provide video/audio contents. Within this program we organized digital-is-not-analog.00, which was the first Italian event focused on net art. It was a very simple event (with some moderated presentations and some projections) but at the same time it was quite successful. Just a couple of months later it happened we were all working for the Culture Department and we finally managed to get a second digital-is-not-analog.2001

approved within the Young Artists Promotion program. Part of the agreement was that we would collaborate with Culture Department staff in the organization of different Internet related activities at Salara – a beautiful historical building in the center of Bologna. Salara was used until June 2001 for art exhibitions and various kinds of performances. The second edition of our d-i-n-a festival was meant to start a new major program called Salara Medialab, a publicly funded internet free access space with a parallel activity of research and production. It never started because unexpectedly the right wing government of Bologna decided to heavily intervene in the cultural landscape, cutting public funding to cultural activities. This is how all the projects of Salara suddenly stopped in June. By the way today (six months later) Salara is still closed and empty. After it closed, we decided not to give up and to focus on d-i-n-a as a group that could start a production even without institutional facilities.

Mia: So you have a mixed experience: institutional and independent.

Vanni: Yes, and even commercial! Two of us worked for a while for a big Italian company that specialized in selling works of art. It's been quite useful to understand the inner mechanism of a large company. A marketing approach and a structure based on hierarchy and hidden struggles applies also to cultural public institutions (although with way less efficiency!)

Anyway, I can't say we don't like big institutions, but rather we don't like big institutions that don't work well. Unfortunately most of them don't work well – they have some kind of bug and often you start thinking that there is no patch that could fix it. Institutions tend to structurally function as (enormous or not) bodies that take silent decisions through collective, blind, everyday actions. So, delays, incertitude, useless expenses, battles for small slices of power can be frustrating for whoever has to deal with the body of institutions.

Mia: Working inside of an institution has never been very attractive choice for FF. Especially because we didn't want our identity to be linked with the identity of the institution. And that could also limit our freedom to collaborate with other organizations, as we then wouldn't "need" them anymore. I think the identity of an institution could be slower to change than ours.

Vanni: Yes, actually independence is supposed to be the purpose of all the fund-raising efforts. So independence seems to refer more to money than to ideas. d-i-n-a started with a well funded project that had the support of Bologna City Council, the digital-is-not-analog festivals. But that was not a sustainable model, since it relied too much just on one public institution. But for those special occasions it was an interesting form of production: formally we worked for Salara, whose staff (a few people from the Young Artists Office in the Department of Culture) occasionally collaborated with external groups. The ideal hierarchy, in a way. Light staff, light bureaucracy: which meant high potential for action, at least in theory. Now, I don't see many possibilities for a group like d-i-n-a except to start an intensive fund-raising campaign or to go towards auto-organization. In the first case we would need to have roots in a territory, and that's not our case right now. Auto-organization means economic independence and DIY, for example, funding ourselves by charging

money for research, server space, small publications and events, etc. This is a funny, ener-getic and sometimes very satisfactory process, but not sustainable for a long time since peo-ple can't make a living out of it and soon start finding time-consuming "real jobs."

Mia: Why did you choose Barcelona instead of continuing in Bologna?

Vanni: That's the second part of the story! Most of us were living in Bologna since the mid-nineties and felt the desire to really move for a while. And to be honest we suddenly felt frustrated because Salara was closed after a successful and engaging event like the second digital-is-not-analog. Barcelona has such a great fame abroad, we knew some people here and so we wanted to verify its reputation.

Actually we are continuing our activity as d-i-n-a mainly by working a lot on line, so and in a way it can make sense to drift for a while. But we know that if we want to keep our web activity alive we will (eventually) need to locate what we do. This sounds counter-intuitive since the web is supposed to be non-located. But even for our new web site we have an Italian public in mind: we aim to translate a lot of material that has appeared on the net and to offer a tool for basic study and further discoveries in net culture. I personally don't exclude the idea of working in Italy again, even if I know that this is not a shared feeling within the rest of the group. This is the reason to do such a huge (and sometimes stupid) work of translation: to locate ourselves.

At the moment we are ready to discover new possibilities in Barcelona. We are looking for con-nections with institutions or smaller groups like FF.

Mia: FF is nowadays organizing more events and workshops outside of Barcelona. This means FF can have "virtual" activities in other countries even though we would physically stay mostly in Barcelona. This model of small organizations collaborat-ing together in horizontal connections, and having exchange of ideas, workshops, shows etc is very inspiring. We have noticed that there are a lot of people who are tired of waiting for something interesting to happen and start to organize small scale things themselves, without waiting for financial support, but trusting more in the cooperation of friends and colleagues. Like Betaville in Paris.

Also there is a need to find new places and formats of cultural activities. To get closer to a still unidentified public. This is necessary to be able to create something fresh and exciting, as institutions and museums have their own goals and needs. In this new situation, SMALL IS BEAUTIFUL.

Vanni: Yes but actually I know that even a small association can grow and become an institution. I guess that the distinction between the two is a difference between being funded as a whole (for daily operations, salaries, etc) and on the other side, being funded for single projects.

Mia: So, now what are you planning for the future in Barcelona?

Vanni: Actually, moving from one country to another is still having strong effects upon us — starting from the basics of adjusting to everyday life onwards. Whatever you are doing is a shock, both exciting and hard. In this situation we started rethinking of d-i-n-a as a strategy for creating awareness of the potential of net culture. Be it through big events like a festival, or organizing meetings or producing web projects. Be it in Spain or in Italy.

Does this mean that we are "nomad"? I don't know, I'm not sure I really like the way people use this word. We all desired to move from Italy but — in a way — I'm not fully sure I've not been forced to move. Someone defined the "Networking Nomad" as a creature who wants "to aimlessly wander through the electronic networks, to connect and disconnect at his own will, to drift from continent to continent via phone lines, cables and satellites, freed from any restriction of physical territoriality." And this is often just a merry utopian approach to difficulties in sustaining your projects in the long run.

Mia: How I understand nomadism is far from an "aimless wandering." Sometimes, there is a reason and necessity for moving.

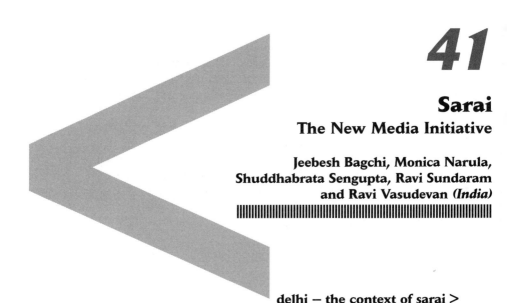

41

Sarai
The New Media Initiative

**Jeebesh Bagchi, Monica Narula,
Shuddhabrata Sengupta, Ravi Sundaram
and Ravi Vasudevan (*India*)**

delhi – the context of sarai >

The streets of Delhi are now dug up to lay fibre optic cables, and tracks for a long awaited metro. Frequent power cuts, evictions, demolitions, and the everyday violence of a harsh and unequal city speak of a different order of reality. We live in desperate times, in Delhi. And it is the very nature of our times that make communication and reflection crucial to survival in Delhi. A city of close to 14 million, one of the fastest growing urban spaces in the planet, is searching for ways to connect to itself and to the world. Sarai: the New Media Initiative (www.sarai.net), a programme of the Center for the Study of Developing Societies is a part of this process of looking for ways to communicate and reflect the contemporary urban condition in our part of the world. Sarai tries to address some of the questions of communication and reflection that are vital to our everyday lives in Delhi.

To understand the need for this, it may be necessary for us to take a brief step back to the summer of 1998, when five of us, (Ravi Vasudevan & Ravi Sundaram from CSDS, and Jeebesh Bagchi, Monica Narula & Shuddhabrata Sengupta from the Raqs Media Collective) began to conceive of Sarai. The summer of '98 was a time for many new beginnings in the city of Delhi. The nineties had been a decade marked by doubt and rethinking on many fronts, all of which seemed to have come to a head for some of us during that summer. There was a sense of disquiet with increasing urban violence and strife, dissatisfaction with restrictive modes of thinking and practice within mainstream academia, the universities & the media and a general unease at the stagnation that underlay the absence of a critical public culture.

At the same time, Delhi witnessed a quiet rebirth of an independent arts and media scene. This became evident in exhibitions and screenings that began taking place modestly in alternative venues, outside galleries and institutional spaces, and in archival initiatives that began to be active. Spaces for dissent and debate were being kept alive by clusters of teachers and students in the universities. New ideas, modes of communication and forms of protest were being tried out and tested on the streets. There was a vibrant energy evident in street level improvisations with new technologies. Public phone booths were transforming themselves into street corner cyber-cafés, independent filmmakers were beginning to organize themselves in forums and a new open source and free software community made its mark in the city's BBSs (Electronic Bulletin Boards). The city itself, as a space and as an idea, was becoming a focus for inquiry and reflection, and a provocation for a series of creative experiments.

< how sarai happened >

It was from within this ferment of ideas, rough & ready plans, and fragments of proposals, that a series of conversations on film history, new media theory, media practice and urban culture was able to mature into the conceptual foundation of Sarai. Sarai (the space and the programme) takes its name from the caravansarais for which medieval Delhi was well known. These were places where travelers and caravans could find shelter, sustenance and companionship; they were taverns, public houses, meeting places; destinations and points of departure; places to rest in the middle of a journey. Even today, the map of Delhi carries on it twelve place names that include the word Sarai. The Sarai Initiative interprets this sense of the word "sarai" to mean a very public space, where different intellectual, creative and activist energies can intersect in an open and dynamic manner so as to give rise to an imaginative reconstitution of urban public culture, new/old media practice, research and critical cultural intervention.

The challenge before the founding group was to cohere a philosophy that would marry this range of concerns to the vision of creating a lively public space where research, media practice and activism could flow into each other. It took two years (1998-2000) to translate this conception into a plan for a real space and a design of a workable interdisciplinary programme of activities. Today, the Sarai initiative embraces interests that include cinema history, urban cultures and politics, new media theory, computers, the Internet and software cultures, documentary filmmaking, digital arts and critical cultural practice. Sarai opened its doors to the public of Delhi in February 2001 and the first year has been very hectic for all of us, especially as all our projects and public interventions have begun to take concrete shape. As we draw towards the completion of our first year we realize that our strength lies in the collaborative vision that has been the founding principle of Sarai and that the space can grow only by continuing to include and engage with new people and ideas from across the world.

< the center for the study of developing societies >

Sarai is a programme of the Center for the Study of Developing Societies, Delhi
(CSDS). The CSDS, founded in 1964, is one of India's best-known independent
research institutes. Bringing together some of South Asia's best known thinkers and
writers, the CSDS has played an important part in shaping the intellectual and cre-
ative map of this part of the world. The CSDS' research has focused on democratic
politics, cultures and the politics of knowledge, critical discourses on science and
technology, and violence, ethnicity and diversity. Added to this has been an impor-
tant new programme of the Center: Sarai, which reflects the Center's very con-
temporary concerns in intellectually and creatively addressing issues of the new
millennium.

Today, Sarai includes under its ambit a media lab which is a focus of creative and exper-
imental work in various media (video, audio, print, internet), a programme for the
development of Hindi language resources in cyberspace, a free software develop-
ment programme, a public access space (the Interface Zone) which is a platform
for the exhibition of new media projects, and an active Outreach Programme (The
Cyber Mohalla Project or Cyber Neighborhood Project) which works in a slum in
central Delhi to create resources of digital creativity for young people in disadvan-
taged spaces.

Additionally, two interdisciplinary research & practice projects — Mapping the City, and
Publics & Practices in the History of the Present act as catalysts for a variety of intel-
lectual and creative interventions at Sarai. Sarai has embarked on a publication pro-
gramme, and the first Sarai Reader on the theme of the Public Domain was pub-
lished in February 2001. The Sarai Reader aims to be an annual publication and will
bring together each year a range of new critical writing around themes that connect
cities, communication, public cultures, new media, media history and information
politics. The Sarai Reader 01 a joint publication of Sarai, CSDS, Delhi and the Society
for Old and New Media, Amsterdam, edited by the Raqs Media Collective (Sarai)
and Geert Lovink is available online at www.sarai.net/journal/reader1.html.

< research >

Sarai places a great deal of emphasis on developing new and critical interdisciplinary
theoretical work. The research agenda of Sarai is organised towards two comple-
mentary themes — understanding the place of the media in urban public practice
and consciousness, and reflections on the city as constituted through representa-
tions and technologies. The research on media is directed towards understanding
the rhythms and routines of daily life in the city as mediated through words,
images and sounds. Our particular concern is with the possibilities involved in peo-
ple's relationship to the media, the domain of "needs," "desires," work and leisure,
creativity and communication practices that the media world opens up. The analy-
sis of urban life attends to the varied dimensions of everyday life. These range from

planning and housing to geographies of the city, mediated through work, leisure, transport and communication. Technological forms that underwrite contemporary urban experience as well as the social practices through which the city is imagined and acted upon will be addressed in our research.

< people >

Sarai has a core team of eighteen people from different backgrounds and disciplines (filmmakers, academics, software programmers, lawyers, social workers, activists, designers, writers, researchers and media producers) who work on a regular basis on different collaborative and individual projects. Apart from this, there are eighteen seed grants and fellowships that have been given out this year for different research and media projects on themes that resonate with Sarai's interests with city spaces, urban cultures and media forms. Sarai has also embarked on a modest residency programme for visiting artists, practitioners and scholars to work and interact with Sarai fellows.

< sarai and the public: the interface zone >

The Sarai website (www.sarai.net) and the digital interface located in the Interface Zone at Sarai render all of Sarai's work public. This includes an emerging archive of urban culture, an online gallery of new media works and an active discussion list, the Reader-List which began in February 2001 and has more than two hundred subscribers at present. The Reader List is archived online at mail.sarai.net/pipermail/reader-list. Sarai is becoming recognized as an important alternative venue in Delhi for discussions, workshops on the politics of media culture and urban space, screenings and as a convivial space where many young people can feel comfortable in an increasingly constricted cultural milieu. In laying open the possibilities of a new communicative ethic and a space for connectivity between different strands of intellectual work, cultural intervention, technological innovation and a commitment to free speech and open culture Sarai hopes to create a modest autonomous space for public creativity in Delhi.

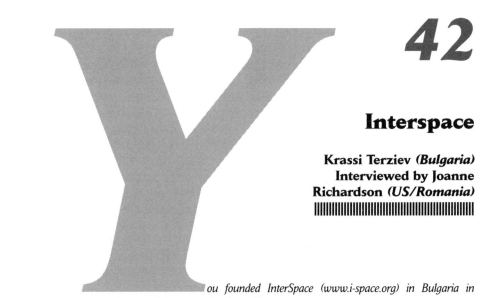

Interspace

**Krassi Terziev *(Bulgaria)*
Interviewed by Joanne
Richardson *(US/Romania)***
|||

ou founded InterSpace (www.i-space.org) in Bulgaria in
1998. What is the significance of the name "interspace"?

We founded the center, or founded the idea about it during a time period when there
was a very vague notion of media art in Bulgaria. So at that time "InterSpace" meant
for us a space that existed somewhere between different axes, a crossover of oppo-
sitions like art⋉technology; theory⋉practice; streets⋉media. We realized that if
we wanted to pursue our personal interests in developing our art practices in
"Media," we had to go beyond ourselves and develop connections between theo-
rists, scientists, artists, do-it-yourself media makers, etc... Our own art practices could
not become a reality unless there was already a media art scene, and the scene first
needed a space where a new kind of media art practice could grow up in a friend-
ly, collective environment and could appear to a public in the right context.

> *As far as I know, there was no media lab, nor even a media space at the time in Bulgaria.
Did a tradition of artists founding their own space and association already exist? What
motivated you to begin this project?*

There were a few independent groups and associations already existing in the con-
temporary art scene in Sofia, such as the group around the XXL Gallery and the
group around The Institute of Contemporary Art, but their scopes were promot-
ing a more traditional form of art and were quite far from media practice. ICA still
exists now as a group of important curators, focused more on the representation
of Bulgarian art abroad in a very high level Art system (like Venice Biennale or
Manifesta). XXL was and still is somewhat outside this high-level international
scene, offering a local gallery space for a circle of artists and curators with a more
radical, political attitude.

But when there was a question of producing or presenting media, there was a suspicion or misunderstanding on all sides. There were no conditions whatsoever for working with media when we started. No legitimation of such a form of production as art, no infrastructure, and no bodies focused on production, presentation, and distribution. And we were young and adventurous enough to decide we could create such an infrastructure, or at least to partly promote a situation that would enable it to develop. I don't know if I am the right person to give an evaluation of the local scene, but these comments are meant to show that we started from ground zero. And we saw that if we wanted to change things for ourselves as individual artists, the whole scene would have to be transformed.

> *Could you elaborate on what you mean by creating a scene for "media art"? I often find this term problematic, since all art uses a medium, so at best it means "new media" art. And it is hard to generalize what old and new media means, because it varies by context. Although video and video installations were an established form in the West in the 1970s, in Romania people often consider video new media because there wasn't any real access to it before the 1990s. What constitutes new media in Bulgaria? And what is the reception of the limits and possibilities of the internet? Much of the discussions in the West about the internet as a new medium that will transcend the previous hierarchies of information and communication are coming from a leftist perspective. Does this kind of net.leftism exist in Bulgaria, or do you find it to be primarily a Western phenomenon?*

Well I agree that "media art" is a very problematic and controversial term, but for lack of a better one, we have to use it. At the same time I hate this differentiation between old and new media (the video vs. internet discourse) and all this artificial hype about new media, digital revolution, etc. I believe these movements since the invention of the TV are all about the same utopian beliefs and hopes. In a region like Bulgaria, with only some ten years of contemporary art history, it is impossible to import a Western-type discourse and phenomena. So being based in Sofia we are talking of old and new media simultaneously. We are talking about how social and economic spheres are being transformed by new technologies and the internet, but at the same time about how a whole new infrastructure has to be build on top of the ruins of the communistic past, and what weird phenomena and mutations appear in these rapid changes. In a country with a prime minister who is a former king, and a president who is the leader of the socialist party, it is very hard to determine clear left/right oppositions and to follow a clear political discourse.

> *Could you say something more about who is InterSpace – the people and the backgrounds and the way you are organized?*

At the moment, InterSpace is a core of 10 persons, but there are also other people who work with us on specific projects — so there is a wider network of supportive people and organizations. We are a colorful composition of artists, curators, software developers, multimedia designers, do-it-yourself media makers, etc.... It is hard to define precise positions in the organization, because most of us are doing 2, 3 or

more kinds of activities at the same time, depending on what needs to get done. The group has changed several times during the years. There was a period for example, when there was a dominance of people coming from the club scene, so we did mostly club events during that time. Now we have a clearer configuration of different positions within the group. There are two coordinators who are responsible for the projects we make, or for the funding strategies to implement them; we have data artists who are responsible for server administration and software applications development, etc. Working on different projects during these years has taught us that we have to have key specialists on the different activities we develop because it is easier to work this way, but we would still like to keep a horizontal structure in our organization (as long as it is possible) and avoid hierarchies of functions within the group.

> *What are some of the projects you've made?*

We focused our strategy of activities along several key streams, which in our vision had to develop all the missing aspects of media awareness in the art scene, and in the wider society. We organize events in the area of "Art & Technologies" in order to familiarize the audience with ideas and concerns around new media. Some of our recent events were NET_USER, an International Internet Conference, at USICC, Sofia (2001), MAKROVIDEO, a series of video installations in public space, at the National Palace of Culture, Sofia (2001), and URBAN CYCLES, an Interactive video installation in Public Space, National Palace of Culture, Sofia (2000) — this was a collaborative project between InterSpace in Sofia & IDEA in Manchester, England. For these different events, we have organized production and presentation of projects by other artists not belonging to the InterSpace group.

The InterSpace media lab has been used for our own projects, but there is open access, and the lab has been used for the production of a series of media art projects by other artists. We also maintain a Server for Art and Culture in Bulgaria (www.cult.bg) which is a long term project, attempting to capture the different aspects of the local scene and to give them a public interface on the web. The server gives systematic information about events happening in Bulgaria as well as opportunities abroad, and offers a forum for open discussions about the processes in Art and Society and about social phenomena arising in our post-everything society. This forum includes all the communication tools in the portal site — submitting content online, submitting comments on reviews online, the mailing list, etc.

> *How do you sustain these projects? Do you have sources of income from grant institutions, or have you had to become (semi) commercial?*

During the past 3 years, we went through different stages and we relied on different models of sustainability. In the beginning, when nobody knew about who we were and what we were doing, we had to be very inventive, combinative and flexible in order to survive. So we had to do partly commercial productions, because the

grants we were able to get were only for specific projects and events and did not include the structural and infrastructural expenditures of just running InterSpace on a daily basis. Although it is common to disparage commercial production, we can say in retrospect that it was a useful experience to depend on commercial projects, because as artists we learned to operate with deadlines, and were able to get a clearer sense of whom we could trust to be dependable, etc., and we were able to form a team with very innovative and energetic people.

Recently we have been able to decrease this kind of semi-commercial production, and can rely more on grants for long-term projects. This has been important because we want to concentrate more on our own projects and gather all the pieces of the puzzle of our past activities together so we can think about a strategy for development in the future.

> *Do you see a greater level of independence now that you are relying on grant money rather than commercial projects? Or is this trading one form of dependence for another? Many initiatives label themselves "independent" (and I always wonder what this means – independent from state institutions, from academic institutions, from commercial interests) but are getting a lot of money from grant institutions which often have their own agendas, like the European Cultural Foundation which wants to promote "European" values to the East. How do you think sources of funds relate to (or affect) the goals of independent projects?*

You have to be living for some time in this part of Europe to understand our perception of independence, which is neither an American or European understanding, and I think the notion in itself is not abstract but depends on certain circumstances. Everything here is a negotiation and there are enough difficulties in the simple fact of running such an organization, without lobbying on any level of the power structures. We don't have the privilege to believe in the anarchistic ideas I see behind your question.

> *I do not consider myself an anarchist, nor do I see the presuppositions behind my questions in this light. This is not to say that I don't have some sympathy for anarchist groups (rather than anarchism as an ideology) simply because of the abuses and manipulations they have suffered through history at the hands of the Marxists. But on the level of ideas, I share some of the reservations about anarchism that the Marxists had – anarchist ideas of freedom and autonomy seem to be one-sided and do not recognize the extent to which they are implicated in the structures they criticize. In this sense, there is no complete autonomy – "independent" institutions are dependent in financial and other ways on the state and other "repressive" structures. It is this notion that was behind my question. Practically, as an individual, I recognize that to fight for a certain level of freedom (freedom from work done for someone else) I am dependent on grants, some of which have come from the repressive body of the US government. I don't think any of us have the luxury of pretending to be innocent about money. Someone else's money often makes your "independence" possible. It is always a question of choices and negotiations. But maybe this is too abstract, and we can come back to the specific context in Bulgaria. Can you tell me what has been the local*

response to InterSpace in Sofia? Is InterSpace an initiative that is better known locally or internationally?

Because the situation in Bulgaria was one of isolation, and because we have been focusing on establishing and maintaining a production lab with only our efforts, with no state or any other support, we stayed for a very long time a local phenomenon. On the other hand it gave us a very good reputation here and we enjoy a very active audiences and supporters in Sofia. Just in the past year or so we have gained a more international recognition. And for me starting locally and then spreading out is a quite logical process of preparing the situation and going step by step in order to have a longer-term effect and impact.

> *In many East European countries it is still the (former) Soros Center for Contemporary Arts which seem to have the largest budgets (even if gradually losing direct support from Soros and declaring themselves independent by applying for other sources of funding). Their size and historical reputation often cut competition by smaller fish. What is the relationship between the (former) SCCA in Bulgaria and other smaller initiatives?*

I have a question for you: do you see any new infrastructure capable of replacing the Soros Centers, which are starting to fade out all over Eastern Europe? Despite all the wrong steps and bad investments made by them in the past, I don't understand all the complaints about the Soros Network — which seem to either be made by people who do not know the situation or who are driven by hypocritical ambitions.

> *I think someone from America, or Spain or Australia would have little reason to complain about the Soros network, simply because they don't know the situation, and it doesn't appear on their horizon. Most of the complaints I have heard about the Soros Centers came from people who were immersed in the situation. And I am speaking from my knowledge of Soros Centers in the three countries that I know better than others (and which I won't mention by name), so what I say can be considered a generalization, which, as such, is partially false. I can give you several scenarios as examples. The first is of SCCA administrators who enjoy the privilege of traveling to all the important exhibits and festivals (and staying in nice hotels), and whose help to artists has been minimal — that is, aside from the over-production of catalogues which is perhaps one thing that artists in the area can boast as a direct benefit of the Soros legacy. I can also mention cases where it is a very closed circle of artists who are promoted by SCCAs, which sometimes includes friends, lovers and ex-husbands. But to be fair, this kind of nepotism is present in new organizations as well, like some Pro Helvetia chapters where it is possible for half the funds for a given year to go to a project by the spouse of the director. There are other cases of ugly quarrels and abuses — for instance, of an artist who is involved in a legal case because the SCCA published a text of hers in a catalogue after she expressly denied permission for it to be included. And it is too simple to interpret these as individual "complaints" about instances of misuse of power — together they form a critique of the organization and purpose of the structure of SCCAs, which to a large extent seem to have been founded to promote artists as a means of promoting themselves as an organization. And*

which have often ended up monopolizing the cultural funds available in a given country for their own projects, thereby excluding smaller initiatives – with different ideas and visions – that would try to compete with them.

This is not to say that the former SCCAs have not achieved some important results, and in my own opinion they were most successful when they were not in the business of promoting individual artists abroad or international artists locally, but when trying to create the conditions for a wider cultural awareness of issues that go beyond art – like the influence of new technologies. I'm thinking of events organized at the very beginning of the nineties by the SCCA in Bucharest (when there was a different director), which were important for opening the discussion about the role of media and new technologies not just in art but in a wider cultural framework. And when the SCCA in Budapest became a separate institution with a different concern and agenda, C3 – Center for Communication and Culture, they were not just instrumental in trying to develop an awareness of Information Technologies among artists as they were in getting hospitals and educational institutions wired for the first time.

So it is not so much a question of replacing the Soros Centers with a similar infrastructure – in other words, another body of administrators and art critics who can take on the role of intermediaries and promote artists locally or internationally. What is more interesting to me in the emergence of small media centers in this area is that they are transcending these narrow definitions of art and trying to operate on a different level and with another public. And the idea of forming a network between these small media centers (which we discussed a few months ago at the Art Servers Unlimited 2 meeting in Croatia) acknowledges the importance of providing a means for communication and exchange of information and resources between them, while rejecting external intermediaries (like SCCAs).

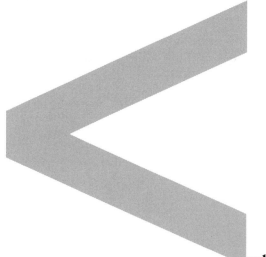

43

Autonomous Culture Factory

Marko Vukovic *(Croatia)*

|||

politics >

In order to make some sense out of the present we always need to go back in time. This story takes us back to the beginning of the 1990s when the process of transition started to change many societies that are now labeled "post-socialist." The shift in ex-Yugoslavia took a different course, which ended in a tragic war. The sequence of events in an irreversible history brought rigid nationalists (HDZ and Franjo Tudjman) to power and assured that they would stay there for another ten years.

This might seem like a pretentious beginning to a story about a Croatian youth/urban/activist/cultural/political group, but it was the determining context out of which Attack emerged. During the 1990s, and especially in the post-war years, there developed a constant social conflict between (conditionally speaking) the extremely traditional Catholic nationalists who were in power and the "republicans" (As a footnote, it should be remarked that the word is analogous to the situation in Spain during '36–'39, when the entire opposition to Franco was known under one name — the republicans).

As the (sometimes relative, sometimes absolute) power lay in the hands of a regime which was built on traditional values of home, fatherland, and family, the space necessary for a counterculture to develop and exist was simply destroyed. All the clubs were either closed or sold to private entrepreneurs. The non-profit/youth media lost its funding and was faced with the alternative of being shut down or becoming the servants of power. The level of state control over the entire public sector was very high and if you weren't a Catholic-Capitalist-Croat (C-C-C) you were automatically excluded from the system. This era culminated in the period around 1995-96 when the country was purged of everything that even resembled

the "alternative." Thousands of young people chose to leave Croatia and move Westward...

< birth of a monster >

In the eyes of those who had political power any kind of alternative culture was a monster — the other which was most feared because it was so close right under the surface. Autonomous Culture Factory, abbreviated as Attack (www.attack.hr), was formed as an initiative in 1997 in order to tackle the problems of the lack of space and infrastructure and to try to make it possible for an alternative culture to emerge. The goal was to open and run an autonomous cultural and social center in Zagreb to bring issues to light that otherwise remained repressed, to reclaim a public space which belonged, in principle, to everyone. In retrospect, the timing seemed to be exactly right: a rather small group of people managed to gain a lot of public support in a very short period of time. We started as a bunch of lunatics that would just take a table, put it out in the street and begin to talk to people ("we've got an idea!") and we ended by having our own rented space within 3 months. At that time, this seemed unthinkable for Zagreb.

Someone once claimed that the group was using post-modern strategies in a pre-modern society. The society was definitely pre-modern, and whether or not the strategies were "post"-modern, they seemed effective: free public events in the parks, demonstrations, street performances, distributed leaflets and posters, web presence, free "overdesigned" newsletters — all constituting a direct and open approach in a society accustomed to hiding. Introducing direct actions to the streets of Zagreb gave the group a significant momentum. Simply doing things, and doing things in a public space that had previously been closed and protected was an empowering experience for us. And for a public used to many years when it was impossible to think of even simple, small actions for fear of state reaction, it seemed like an important and inevitable change.

< factory of basics >

The Autonomous Culture Factory was an attempt to combine "Autonomous" in the sense of Hakim Bey's TAZ/PAZ, and the "Factory" model of production in Warhol's work. Other than a fancy name, the slogan was also meant to provide a concept for the group — a model for radically changing the ways in which culture and politics are produced and consumed. The goal was to create a space making possible a living experiment — an incubator where ideas could be born and implemented.

There was a significant level of interaction between the "hosts" and the visitors as Attack gradually developed into a hang-out place for many young artists. New friendships and projects were born out of chance meetings and improvised encounters. This resulted in a series of joint exhibitions — some were made on the spot while others were selections of older works. In most cases what was exhibit-

ed were artifacts that were never shown before as they were to "small" to enter the official spaces of exhibitions.

The Factory's activity also sought to produce a shift in the theater/performance scene. A new generation of performers grew out of this environment, and reciprocally, also played a significant role in the constitution of Attack. There was an initial fusion and collaboration between young performers who were doing weekly street interventions as political gestures and people working in the alternative (sometimes referred to as non-professional) theater. The concrete result was the organization of FAKI (the Festival of Alternative Theater Expression). The first theater festival was held in the streets — which brought a lot of attention to the group and the issues it was dealing with.

The time was very political, and so was the art produced in its context. The most well known action — "22%" — involved a mobilization of performers and visual artists in a protest action against the new tax on books (22%). During one day of action in the summer of 1998 more than 20 events were held. Some were out in the open, like the re-enactment of the scene from the movie *Fahrenheit 451* in one of Zagreb's main squares. Others where staged in bookstores — during one of the most provoking "performances" a group of activists entered the most expensive bookstore in the city and stole books. When they were caught they argued about the price of knowledge, first with the staff and later with the police.

One of the regular and less visible events organized by Attack were the Wednesday night sit ins — gatherings for small groups to share information and discuss topics from the area of civic activism and alternative politics. There were evenings of discussions about Bookchin, Chomsky, Kosovo, the death penalty, electronic civil disobedience, LETS (local exchange trading system), or sometimes just the sharing of travel stories about foreign places. There was no real outcome of the sit-ins, other than the possibility to meet people and talk informally. The events and informal conversations, combined with a bar, an infoshop, library, video archive, permanent installations, some tools for renovations, a few boxes of clothes, and a sewing machine made up Attack, the Factory for the production of autonomous culture.

< territory and mobility >

The lack of any institutional space during the 1990s forced the entire urban scene to adapt to the new conditions of scarcity and migration. Without territory, other than the ground they happened to be standing on at the moment and a small fragment of an imaginary (cyber) space, a whole generation learned how to move from one open spot to another. Nomadic tribes were born. High mobility, fast reaction, and the spoken word as the medium of communication. From one-night parties in squatted atomic shelters and public garages. Events were held in small private bars usually hanging on the edge of bankruptcy, prepared to try anything to survive.

Emerging out of this environment, Attack possessed a lot of experience in dealing with spaces, spaces that didn't exist. It developed a pattern of moving from one place to another. If the group was forced to move from one domain it would simply settle somewhere else, temporarily, and wait for the next opportunity, be it in real space, on a wall, in a magazine, or on the net. The ability to move and adapt was also useful for the group during the period when it shrank and recomposed. A relatively small, determined and experienced group accustomed to tactics and maneuvers managed to prolong the life of the larger group which no longer seemed to be breathing. Movement can sometimes create the impression that something big is still happening, after all the visible signs have vanished.

< no strategy, no platform >

Attack was a group driven by youth, existing without developed strategies or platforms. This was probably our biggest advantage and, simultaneously, our greatest drawback. No strategy and no platform other than the slogan "alternative needs space!" was the only thing that could attract so many supporters. Seeing a group of young people dancing and handing out leaflets in the street early on a Thursday afternoon brought new alliances from those who could not identify as C-C-Cs. The word spread, our visibility rose, and the media started to pay attention. Everything seemed very organic. However, no strategy and no platform also meant organizational problems. Being driven by the impulses and desires of youth meant an abundance of energy, and a lot of inexperience. Organic was often taken for a synonym of "without responsibility." From the point of view of the present, it seems there was no determination or sufficient capability to channel all that energy into anything resembling a structured organization. So Attack's biggest strengths eventually became the heaviest weight tied around its legs.

According to the cynicism of time, which may also be the cynicism of age, Attack appeared as a cell that grew out of proportion, carried on the wings of enthusiasm, until it reached a point at which it actually stated to change people's ways of thinking and began to mean something to the wider public. Eventually, it collapsed out of its own momentum, as there was no skeleton to hold the new organism intact.

A more optimistic vision of this history would be to affirm that Attack has played its role, a role that was as necessary as it was transitory. And the general impression locally is that it has. Its activities have opened up the space for a number of other projects that followed — projects that were better organized and more capable of reaching significant results. Attack still exists as a much smaller group, and continues to occupy a place on the cultural/activist map of Zagreb. But perhaps the most important historical role it can claim was to have offered a glimpse of possibility, and to have been a factory that produced the context for other groups to build an autonomous culture of the future.

Production of the Future

Cognitariat and Semiokapital

Franco Berardi Bifo *(Italy)*
Interviewed by Matthew Fuller *(UK)*
and snafu@kyuzz.org *(UK)*

||

Fuller: In your book, The Factory of Unhappiness *you describe a class formation, the "cognitariat" – a conflation of cognitive worker and proletarian, working in "so-called jobs." You've also previously used the idea of the "Virtual Class." What are the qualities of the cognitariat and how might they be distinguished from this slightly higher strata depicted by Kroker and Weinstein in* Data Trash?

Bifo: I like to refer to the concept of virtual class, which is a class that does not actually exist. It is only the abstraction of the fractal ocean of productive micro-actions of the cognitive workers. It is a useful concept, but it does not comprehend the social and bodily existence of those people who perform virtual tasks. The social existence of virtual workers is not virtual, the sensual body of the virtual worker is not virtual. So I prefer to speak about cognitive proletariat (cognitariat) in order to emphasize the material (I mean physical, psychological, neurological) disease of the workers involved in the net-economy.

> *Fuller: The political/economic theorization of post-Fordism, which has much of its roots in Italian activism and thought of the sixties, seventies and onwards, is now an established term in describing post-industrial work conditions. You present a variant of this which suggests that the full political dynamics of this change have yet to be appreciated. How can we describe the transition from "The Social Factory" to "The Factory of Unhappiness"?*

Bifo: Semiokapital puts neuro-psychic energies to work, and submits them to machinic speed. It compels our cognition, our emotional hardware to follow the rhythm of the net-productivity. Cyberspace overloads cybertime, because cyberspace is an unbounded sphere, whose speed can accelerate without limits. But cybertime (the time of attention, of memory, of imagination) cannot be speeded up beyond a limit. Otherwise it cracks. And it is actually cracking, collapsing under the stress of hyper-productivity. An epidemic of panic is spreading throughout the circuits of the

social brain. An epidemic of depression is following the outbreak of panic. The current crisis of the new economy has to be seen as consequence of this nervous breakdown. Once upon a time Marx spoke about overproduction, meaning the excess of available goods that could not be absorbed by the social market. Nowadays it is the social brain that is assaulted by an overwhelming supply of attention-demanding goods. This is why the social factory has become the factory of unhappiness: the assembly line of net-production is directly exploiting the emotional energy of the virtual class. We are now beginning to become aware of it, so we are able to recognize ourselves as cognitarians. Flesh, body, desire, in permanent electrocution.

> *Snafu: This consideration opens up, in your book, an interesting reflection about the mutated relationship between free and productive time. In the Fordist factory, working time is repetitive and alienating. Workers start to live elsewhere, as soon as they leave the workplace. The factory conflicts with the "natural desires" of the worker. On the contrary, in the post-Fordist model, productivity absorbs the social and psychological capacities of the worker. In this way, free time progressively loses its interest, in favor of what you call the contemporary "reaffectivization" of labor. On the other side, you depict the net-economy as a giant "brainivore." My question regards the apparent contradiction embedded in this double movement. How is it possible that people are at the same time so attached to their job and so exhausted by it? What are the psychological reasons that push people to build their own cages?*

Bifo: Every person involved in the net-economy knows this paradox very well. It is the paradox of social identity. We feel motivated only by our social role, because the sensuous life is more and more anorexic, more and more virtualized. Simultaneously we experience a desensualization of our life because we are so obsessed by social performance. It is the effect of the economic blackmail, the increasing cost of daily life: we need to work more and more in order to gain enough money to pay the expensive way of life we are accustomed to. But it is also the effect of a growing investment of desire in the field of social performance, of competition, of productivity.

> *Fuller: In what ways are people developing forms of resistance, organization, solidarity that shift the algorithms of control in their favor in "the movement of the cognitariat." Or in other words, what forms — and given the difference between the "felicita" of the original title and "happiness" in English — might the production of happiness take?*

Bifo: Some people still create social networks, like the centri sociali in Italy: places where production and exchange and daily life are protected from the final commodification. But this is a residue of the past age of proletarian community. This legacy has to be saved, but I do not see the future coming out from such resistance — it will come from a process of recombination. The movement spreading all over the world, since the days of the Seattle riots, is the global movement of self-organization of cognitive work. It's not resistance against "globalization," but a global movement against corporate capitalism. Where is it receiving its potency from?

I don't think that this is the movement of the marginalized, of the unemployed, of the farmers, of the industrial workers fighting against the delocalization of the factories. Those people are part of the movement in the streets — but the core of this movement resides in the process of conscious self-organization of cognitive work all over the world, thanks to the Net. This movement represents the beginning of a conscious reshaping of the techno-social interfaces of the net, operated by the cognitarians. Scientists, researchers, programmers, mediaworkers, every segment of the networked general intellect are going to repolarize and reshape its episteme, its creative action.

> *Fuller: You were involved in manifestations against the OECD meeting in Bologna. What are the tactics developing in that movement and elsewhere that you see as being most useful? What are those tactics that connect the cognitariat to other social and political currents?*

Bifo: I do not think that the street is the place where this movement will grow. It was born, symbolically, in the streets; the street riot has been the symbolic detonator, but the net-riot is the real process of transformation. When eighty thousand people were acting in the streets of Seattle, three, four million people (those who were in virtual contact with the demonstration thanks to the Internet) were taking part in a big virtual meeting all around the globe, chatting, discussing, reading. All those people are the cognitariat. So I think that the global movement against corporate capitalism is absolutely right when it goes to the streets, organizing blockades like in Seattle, Prague, Bologna, and Quebec City, and Genoa. But this is the symbolic action that fuels the real movement of sabotage and of reshaping, which has to be organized in every lab, in all the places where cognitarians are producing and creating the technical interfaces of the social fabric. The industrial working class needed a political party in order to organize autonomy, struggle, self-organization, social change. The networked class of the cognitariat finds the tool of self-organization in the same network that is also the tool of their exploitation. As far as the forms of the struggle in the streets are concerned, I think we should be careful. This movement does not need violence, it needs a theatricalization of the hidden conflict that is growing in the process of mental work. Mental work, once organized and consciously managed can be very disruptive for capitalist rule. And it can be very useful in reshaping the relationship between technology and the social use of it.

> *Snafu: I'd like to know what the "keywords of resistance within every lab" that you mentioned are, and to ask what the technical interfaces of the social fabric are? In particular I'd like to understand if by "techno-social interfaces" you mean non-proprietary systems such as Linux, or if you have a broader view. Do the shared production of freeware and open source software represents a shift away from capitalism or are we only facing the latest, most suitable form of capitalism given in this historical phase? As far as I know, military agencies and corporations use and develop free software as well as hacker circuits...*

Bifo: I do not see things in this antagonistic (dialectical) way. I do not think that freeware and open source are outside the sphere of capitalism. Similarly I do not think

that the worker's collective strike and self-organization in the old Fordist factory was outside the sphere of capitalism. Nothing is outside the sphere of capitalism, because capitalism is not a dialectic totality suited to be overwhelmed (Aufheben) by a new totality (like communism, or something like that). Capital is a cognitive framework of social activity, a semiotic frame embedded in the social psyche and in the human techne. Struggle against capitalism, refusal of work, temporary autonomous zones, open source and freeware — all this is not the new totality, it is the dynamic recombination allowing people to find their space of autonomy, and push capitalism towards progressive innovation.

> *Snafu: What about the network? It can be used as a tool of self-organization, but it is also a powerful means of control. Do you think that there are new forms of life emerging within the network? Can the network guarantee the rise of a new form of political consciousness comparable to the one emerging with mass parties? At the moment, global networks such as nettime, syndicate, rhizome and indymedia remain platforms for exchanging information more than real infrastructures providing support, coordination and cooperation (with few exceptions, such as Toywar). Do you see the development of the network of the cognitarians from a means of info-distribution to a stable infrastructure? How will different communities — such as hackers, activists, net.artists, programmers, web designers — define a common agenda? At the moment each of them seem to me pretty stuck on their own issues, even when they are part of the same mailing list.*

Bifo: The net is a newborn sphere, and it not only going effect conscious and political behavior, but it is also going to re-frame anthropology and cognition. The Internet is not a means (an instrument) of political organization, and it is not a means (an instrument) of information. It is a public sphere, an anthropological and cognitional environment. The Internet is simultaneously the place of social production, and the place of self-organization ... There are two different (and interrelated) stages of the global revolt: one is the symbolic action that takes place in the street, the other is the process of self-organization of cognitive work, of scientists, researchers, giving public access to the results of the cognitive production, unlocking it from the hold of corporations. The physical action of facing police in the streets, of howling below the windows of IMF, WTO and G8 — this is just the symbolic trigger of the real change, which takes place in the mental environment, in the ethereal cyberspace.

— This is an excerpted version, edited for SUBSOL. Original version is online at Nettime and www.axia.demon.co.uk.

45

Self-Organizing Markets

Manuel DeLanda *(Mexico/US)*

hurricane represents a form of non-organic life. It lasts long enough for us to give it a name. It assembles itself. It's not living in the sense that it doesn't breathe. To ask it to breathe would be to impose an organic constraint on it. Certain winds do breathe, say the monsoon, the wind that is most prevalent on the southern coast of Asia. It is a perfectly rhythmic creature: it blows in one direction for six months of the year, blows in the other direction for another six months, and every sea-faring people in Asia who made a living from the sea had to live with the rhythm of the monsoon. The monsoon is a self-organizing entity, there is no command component at all, it is a pulsing non-organic life. The planet, even before living creatures appeared, was a cauldron of creativity, a receptacle of spontaneously emerging order.

When the theorists of self-organization studied cardiac tissue, they discovered that you can take the cells of the heart, put them in a little flat plate and they'll keep beating. In other words, what is making the heart beat is a similar process as to what is making the monsoon beat. It has very little to do with genes. The flesh itself can beat, as non-organic life, it has this breathing rhythm all to itself.

Compared to non-organic life, an organism, even though it is more complex and lasts much longer, has more command components than self-organizing components. The command components come from genes. Your genes tell your flesh "You are human, you are not a dog, you are not a monkey, you're human and your shape is like this. You don't have six fingers or seven fingers, you have five fingers. If you have six fingers, you're a freak, you belong in a circus, you're not a real human."

Genes are what keeps the flesh that is self-organizing and full of non-organic life in order. And the genes are completely hierarchical, the genes within the cell obey the cells within the tissue, obey the genes that make up the organs, obey the genes

that make up the organism. As organisms, we are little hierarchical creatures ruled by command components. The flesh, which doesn't know any organs, continues pulsing to its own rhythms.

The concept of self-organization which has developed in the last thirty years has caused a great revolution in different disciplines of science like physics and chemistry; as the dust is settling, we are starting to glimpse what the consequences of this revelation will be for human societies. One of the areas that is already being influenced is economics — what is becoming manifest is an order that has come out not because someone planned it, because someone commanded it into existence, but an order that is self-organizing. The clearest example of that economic order is markets. Let's understand markets to have a very concrete image: peasant or small-town markets, a place in town where everybody brings their stuff to sell or goes to buy something, and it meets every week in a certain part of a town and it comes apart and then meets again the following week. In those very specific places, everybody shows up with their intentions: I go there with the intention to buy, or I go there with the intention to sell. So a lot of what happens is planned, is intentional, but the overall effect, for instance the price that every particular commodity happens to go by, is unintended. There is no one buyer or seller who says, "I want this to be the price of this." In a real market, no one commands the price, prices set themselves.

All the way back to Venice in the fourteenth century, Florence in the fifteenth, Amsterdam in the eighteenth, London in the nineteenth, in other words, through-out European history, beside these spontaneously coordinated markets, there have been large wholesalers, large banks or foreign trade companies or stock markets that are not self-regulated but organized through commands. In The Perspective of the World, Fernand Braudel has shown that as far back as the thirteenth century, and in all the centuries in between, capitalism has always engaged in anti-competitive practices, manipulating demand and supply in a variety of ways. Whenever large fortunes were made in foreign trade, wholesale, finance or large scale industry and agriculture, market forces were not acting on their own, and in some cases not acting at all. What Braudel shows is that we must sharply differentiate between markets and anti-markets, between the dynamics generated by many interacting small producers and traders (where automatic coordination through prices does occur), and the dynamics of a few big businesses (or oligopolies), in which prices are increasingly replaced by commands as coordinating mechanisms, and spontaneous allocation by the market is replaced with rigid planning by a managerial hierarchy. What these new historical findings suggest is that all that has existed in the West since the fourteenth century, and even after the Industrial Revolution, is a heterogeneous collection of institutions, some governed by market dynamics and some others manipulating those dynamics, rather than a homogeneous, society-wide capitalist system. If markets and antimarkets have never been the same thing, then both Adam Smith and Marx were wrong, the former because spontaneous coordination by an invisible hand does not apply to big business, and the latter because commodity fetishism does not apply to the products created by small busi-

ness but only to large hierarchical organizations capable of manipulating demand to create artificial needs.

The question in front of us now as intellectuals is whether we've inherited so much bullshit that our criticism is condemned to be ineffective, or whether we can find escape routes and create a new brand of criticism that recovers its teeth, its ability to bite, to intervene in reality in a more effective way. To criticize something simply by calling it a "capitalist tool" or a "bourgeois tool" has become a kind of propaganda. The problem with Marxist dogma is that it fails to distinguish between self-regulating economies where there is no economic power and the anti-market institutions where economic power is the center and the reason for the existence of those institutions. Failing to distinguish means that, for a Marxist, the very fact that an object acquires a price — that it goes into a market to be sold as a commodity — is a bad thing. The process by which an object acquires a price and enters a market is called "commodification." Today this has become a cliché, a thing repeated without thinking. We believe we are criticizing the system when we say something has become commodified but, in fact, we are not saying anything. We still don't know if it entered the market as a free commodity, so to speak, which will be affected by supply and demand, or if it entered the market as a manipulated commodity. The burger war between McDonald's and Burger King, or the famous cola wars between Pepsi and Coca Cola — these are commodities in the Marxist sense. Objects that have zero use value are nothing as technological innovations, they are pure cosmetics, pure simulacrum, pure consumerism. But if you trace those products to their source, you will find that in a majority of cases they come from anti-markets. And if you trace every technological innovation, from the steam roller to all the little machines and procedures that were necessary for the Industrial Revolution, they will almost always have come from small producers.

Today in the United States, there is a very strong political movement, mainly led by the right wing, who are trying to shrink the size of the government, claiming this is in the interest of the "free market." But, translated into the terms just introduced, what they really want to do is let anti-market forces run wild. They don't want small producers and small manufacturers and bakers and printers and mom-and-pop shops to have more room to maneuver and make money. They want national and international corporations to have more room to maneuver and manipulate the market. They want to shrink government so that there are less regulations to prevent monopolies from doing what they want. But if you study these corporations, rather than looking like a market, they are like mini-Soviet Unions. Socialism is a society where commands have replaced prices completely. National and international corporations replace prices with commands on a smaller scale, they are small socialisms minus the ideology.

The movement supporting anti-market forces is spreading its influence into the economics of the internet. The internet can be thought of as an international network of computers which organized itself, a very complex structure that

emerged spontaneously out of the activities of many different people — with an overall effect that wasn't intended or planned. The internet, precisely because it is a self-organizing structure, benefits in the first place small producers, in this case, small producers of content. However, as anti-market forces advance into the territory of the internet, it could be transformed from a self-organized entity into a planned economy. The question is whether all the grass-roots networks like the bulletin board systems can thrive and will be robust enough to resist these anti-market forces. How can we guide the evolution of the internet so that it ends up benefiting small producers of content instead of those who already own the infrastructure: the telephone and cable companies which can eventually absorb and internalize the content-producers?

A central issue that will affect the internet economics is whether market or anti-market forces end up winning the main scarce commodity: bandwidth, the amount of information which can run through the channels. There are several means of guaranteeing cheap bandwidth. Right now, the telephone companies own one part, the cable companies own another part, and if we allow them to come together into a huge anti-market institution, they would give us cheap bandwidth. But at what price? The internet is still symmetric: you can consume bits but you can also produce bits and this two-way system is what makes it unique. If the telephone and the cable companies owned the infrastructure of the internet, they could change it into an asymmetric design in which there are bits coming in for you to consume and very few bits going out — thereby transforming it into just another consumer media. If big producers of content simply send you information to consume, the internet will become a tool of propaganda, a means of control. A much more efficient one than television because it is much more pointed: they know who you are, they know your tastes, they will be able to track and make consumer profiles out of your web surfing.

Of the writers who have analyzed the effects on internet economics of a change from scarce to plentyful bandwidth, no one has received more attention than George Gilder. When bandwidth is expensive much of the infrastructure investment is on the switches that control the movement of analog or digital information through the conduits. A system of optical fiber liberated from switches, a "fibersphere" as Gilder calls it, together with the use of the atmosphere at high-frequencies, could result in a world where bandwidth is so plentyful as to be virtually free. Gilder's right-wing biases assume that any interventions by the government should be attacked, even if they serve to break up monopolies thereby contributing to technological development — as was the case of the break-up of AT&T in 1984. Gilder agrees that there are such thing as monopolies, like those of the Robber Barons of the nineteenth century, but the enormous profits that these monopolists generate are seen as transitory, and therefore the menace they represent is dismissed as largely imaginary. Although Microsoft is today playing a similar role as the Robber Barons, according to Gilder its potential menace (and any government action against it) should be dismissed. So what if Bill Gates has acquired a virtual monop-

oly on operating systems, a position of power that allows him to control the evolution of much of the software that runs on those operating systems? No problem, says Gilder, in a world of bandwidth plenty, the paradigm of operating systems will change to one of distributed software in the internet, and this by itself will end Microsoft's domination. This assumes that Microsoft cannot simply buy and internalize any company it needs in order to ensure its powerful presence in a networked economy. The core of Gilder's ideological maneuver is to lump together small producers and oligopolies in one category, and to call that the market, and to focus exclusively on government regulation as the only real enemy, dismissing monopolies as chimerical. The fastest way to cheap bandwidth is to allow the optical fiber infrastructure of the telephone companies to be combined with the final connections to homes owned by cable companies, even if this creates huge monopoly profits. (After all, according to Gilder, this would be transitory.) So the government who opposes this merger between the telcos and the cable giants is the enemy of the people because its anti-trust regulations are preventing us from enjoying the benefits of a world with cheap bandwidth.

The best way to get cheap bandwidth is for the government to force telephone companies to rent fiber-optic space to independent small producers. This means that the government is going to have to be persuaded that a big monopoly made up of a fusion of telephone and cable giants would be more powerful than the government itself. The only way to dissipate this danger is precisely by letting the small producers of content rent their own fiber optic space. The telephone companies might own it, but they would not control its use. Cheap bandwidth would be available without the danger of one monolithic company owning the guts of the internet. If the cables and the connections are kept symmetric, so that criticism can leave the terminal as propaganda comes in, then we have a fighting chance. This is not a utopia, but it's what would make the game still interesting.

> *— Current version is excerpted for* SUBSOL *from an interview by Konrad Becker and Miss M. made during VirtualFutures, Warwick 96. Original version can be found online at www.t0.or.at/delanda/intdelanda.htm. The re-edit also includes some excerpts from Markets, Antimarkets and Network Economics, which is online at www.textz.com.*

46

Possibility

Alexander R. Galloway (US)

e explore... and you call us criminals. We seek
after knowledge... and you call us criminals. We exist
without skin color, without nationality, without religious
bias... and you call us criminals... Yes, I am a criminal.
My crime is that of curiosity. My crime is that of judging
people by what they say and think, not what they look
like. My crime is that of outsmarting you, something that
you will never forgive me for. I am a hacker, and this is
my manifesto. – The Mentor

Any newbie hacker will be able to tell you that hacking relies on "exploits," preexisting
bugs that are leveraged by the hacker to gain access to a computer. Burglars know
that houses have their own exploits. Locks may be picked, windows broken, doors
jimmied. The same can be done to a computer: buffers may be overflowed, trap-
doors sprung, Trojan Horses deployed. Yet, while a burglar's exploits often rely on
physical force to gain entry, a hacker's exploits generally rely on logical force. That
is, hackers generally hack the possible bugs and loopholes of a machine's logical
code base (rather than taking a crowbar to its hardware).

Hackers don't care about rules, or feelings, or opinions. They care about what is true
and what is possible. And in the logical world of computers, if it is possible then is
the real. Can you break into a computer — not "should you" or "is it right to."
When poured in a vessel, water will fill the vessel completely; when poured into a
computer network, the hacker will enter any space available to him/her. In fact,
possibility often erases the unethical in the mind of the hacker. An anecdote from
the legendary hacker Acid Phreak illustrates this well. After being told certain per-
sonal details of his rhetorical opponent John Perry Barlow, information which he

would later use to obtain Barlow's credit history, Acid Phreak screamed, "Mr. Barlow: Thank you for posting all I need to know to get your credit information and a whole lot more! Now, who is to blame? ME for getting it or YOU for being such an idiot?!" Most hackers would answer: you, for being such an idiot.

Fredric Jameson said somewhere that one of the most difficult things to do under contemporary capitalism is to envision utopia. This is precisely why possibility is important. Deciding (and often struggling) for what is possible is the first step for a utopian vision based in our desires, based in what we *want*. Hackers are machines for the identification of possibility.

The relationship between utopia and possibility is a close one. It is necessary to know what one wants, to know what is possible to want, before a true utopia may be envisioned. "When computers become available to everybody the hackers take over," wrote Steward Brand in 1972. "We are all Computer Bums, all more empowered as individuals and as cooperators." The hacker's unique connection to the realm of the possible, via computer technologies which structure themselves on precisely that threshold of possibility, gives the hacker special insight into the nature of utopia, or what we want out of computers.

One of the most important signs of this utopian instinct is the hacking community's anti-commercial bent. Software products have long been developed and released into the public domain, with seemingly no profit motive on the side of the authors, simply for the higher glory of the code itself. "Spacewar was not sold," Steven Levy writes, referring to the video game developed by several early computer enthusiasts at MIT. "Like any other program, it was placed in the drawer for anyone to access, look at, and rewrite as they saw fit." The limits of personal behavior become the limits of possibility to the hacker. Thus, it is obvious to the hacker that one's personal investment in a specific piece of code can do nothing but hinder that code's overall development. Code does not reach its apotheosis for people, but exists within its own dimension of perfection. The hacker feels obligated to remove all impediments, all inefficiencies that might stunt this quasi-aesthetic growth. "In its basic assembly structure," writes Andrew Ross, "information technology involves processing, copying, replication, and simulation, and therefore does not recognize the concept of private information property." Commercial ownership of software is the primary impediment hated by all hackers because it means that code is limited — limited by intellectual property laws, limited by the profit motive, limited by corporate "lamers." Even Kevin Mitnick, a hacker maligned by some for his often unsavory motivations, admits that the code itself has of higher priority than any commercial motivation "such as trying to get any type of monetary gain."

British hacker Dr-K claims that "corporations and government cannot be trusted to use computer technology for the benefit of ordinary people." It is for this reason that the Free Software Foundation was established in 1985. It is for this reason that so much of the non-PC computer community is dominated by free, or otherwise de-

commercialized software. The hacker ethic thus begets a utopianism simply through its (anachronistic) rejection of all commercial mandates.

However, greater than this anti-commercialism is a pro-protocolism. A protocol is a set of guidelines that govern how computers communicate over networks. Protocol, by definition, is open source. That is to say, protocol is nothing but an elaborate instruction list of how a given technology should work, from the inside out, from the top to the bottom, as exemplified in the RFCs, or "Request For Comments," documents freely available from the Net. While many closed source technologies may appear to be protocological due to their often monopolistic position in the market place, a true protocol cannot be closed or proprietary. It must be paraded into full view before all, and agreed to by all. It benefits over time through its own technological development in the public sphere. It must exist as pure, transparent code (or a pure description of how to fashion code). As concerned protocological actors, hackers have often called attention to commercial or governmental actions that impede protocol through making certain technologies proprietary or opaque. One such impediment is the Digital Millennium Copyright Act (DMCA) of 1998. The hacker magazine *2600* has pointed out that the DMCA "basically makes it illegal to reverse engineer technology," reverse engineering being the term to describe the interpellation of source code through an examination of the results of that code. "This means that you're not allowed to take things apart and figure out how they work if the corporate entities involved don't want you to." This certainly is a pity for those of us wishing free use of commercial technology products we have purchased; however, it is a greater pity for possibility. For if technology is proprietary it does nothing but limit what is possible.

The synonym for "possibility" most commonly used in today's technospeak is "access." On the Net, something is possible only if it is accessible. Hackers reject situations where access to technology is limited. Purveyors of proprietary technology "want to be able to dictate how, when, and where you can access content," complain the editors of *2600* over a lawsuit levied by the Motion Picture Association of America against hackers who had cracked the proprietary limitations of the DVD media format. *2600* writes, correctly, that the real issue here is one of control over a specific technical knowledge, not potential piracy of DVD media. "The Motion Picture Association of America wanted to make sure they had control and that nobody, not hackers, not civil libertarians, not ordinary people in the street — dared to figure out how to challenge that control. Selling a pirated movie is nothing to them. But telling people how the technology works is the real threat."

The question of access is top priority today. Access to physical space, and access to psychic space. We can learn from the hackers, those machines of possibility, to help carve out our possible futures.

47

Cooking-Pot Markets
An Economic Model for the Trade in Free Goods and Services on the Internet

Rishab Aiyer Ghosh *(India/Netherlands)*

what is value, or: is the internet really an economy? >

Much of the economic activity on the net involves value but no money. Until a few years ago, there was almost no commercial activity on the internet. The free resources of the net still greatly outweigh all commercial resources. It is quite hard to put a price on the value of the internet's free resources, at least in part because they don't have prices attached. They exist in a market of implicit transactions.

< the economics of gossip >

Every snippet posted to a discussion group, every little webpage, every skim through a FAQ list and every snoop into an online chat session is an act of production or consumption, often both. There is no specific economic value inherent in a product. Value lies in the willingness of people to consume a good, and this potentially exists in anything that people can produce and pass on.

Even bad writing and even junk mail are parts, however reprehensible, of the internet's economy, but let's look at a more obvious case, Linux. After all, software, in particular large operating-system software occupying up to six cd-roms when distributed offline, is undeniably an economic good (for example, Red Hat Software). And Linux, with its loosely organized community of developer-users and its no-charge policy, undeniably has an economic logic that seems, at first, new.

< something for nothing? >

Linus Torvalds did not release Linux source code free of charge to the world as a lark, or because he was naive, but because it was a "natural decision with- in the community that [he] felt [he] wanted to be a part of" (quoted from personal corre-

spondence with Torvalds). Any economic logic of this community — the internet — must be found somewhere in that "natural decision." It is found in whatever it was that motivated Torvalds, like so many others on the net, to act as he did and produce without direct monetary payment.

Of course, it is the motivation behind people's patterns of consumption and production that forms the marrow of economics. Figuring out what motivates, let alone measuring it, is always difficult but it is even tougher when price tags don't exist. It is simpler just to assume that motivations only exist when prices are attached, and not attempt to find economic reason in actions motivated by things other than money; simpler, therefore, just assume as we often do that the internet has no economic logic at all.

This is wrong. The best portions of our lives usually do come without price tags on them; that they're the best parts imply that they have value to us, even if they don't cost money. The pricelessness here doesn't matter much, not unless you're trying to build an economic model for love, friendship, and fresh air. On the internet, through much of its past, the bulk of its present, and the best of its foreseeable future, prices often don't matter at all. People don't seem to want to pay — or charge — for the most popular goods and services that breed on the internet. Not only is information usually free on the net, it even wants to be free, so they say.

But free is a tricky word: like love, information — however free in terms of hard cash — is extremely valuable. So it makes sense to assume that the three million people on the internet who publish about matters of their interest on their home pages on the web, and the several million who contribute to communities in the form of newsgroups and mailing lists, and of course anyone who ever writes free software, believe they're getting something out of it for themselves. They are clearly not getting cash; their "payment" might be the contributions from others that balance their own work, or something as intangible as the satisfaction of having their words read by millions around the world.

While writing my weekly newspaper column on the information society, Electric Dreams (dxm.org/dreams), I was distributing an email version free of charge on the internet. A subscription to the e-mail column was available to anyone who asked, and a number of rather well known people began to receive the column each week. My readers often responded with useful comments; I often wondered whether people would pay for a readership like this. Having many readers adds to your reputation; they make good contacts, helping you out in various ways. Simply by reading what you write, they add value to it — an endorsement, of sorts. So who should pay whom — the reader for the work written, or the writer for the work read?

The notion that attention has value is not new and has been formally analyzed in the advertising industry for decades. The "attention economy" has been described in the context of information and the internet by M. Goldhaber in "The Attention

Economy" and R. A. Lanham in "The Economics of Attention." It would be facile to suggest that attention necessarily has innate value of its own. However, more often than not, attention is a proxy for further value. This may appear in the form of useful comments (or bug reports from Linux users), assistance, and contacts, or simply as an enhanced reputation that translates into better access to things of value at a later point.

Even those who have never studied economics have an idea of its basic principles: that prices rise with scarcity and fall in a glut, that they are settled when what consumers will pay matches what producers can charge. These principles obviously work, as can be seen in day-to-day life. But that's the "real world" of things you can drop on your toe. Will they work in a knowledge economy? After all, this is where you frequently don't really know what the "thing" is that you're buying or selling, or clearly when it is that you're doing it, or, as in the case of my column, even whether you're buying — or selling. Contrary to what many doom-sayers and hype-mongers suggest, it always seemed to me that the basic principles of economics would work in an economy of knowledge, information, and expertise. They are, after all, not only logical on the surface but also practically proven over centuries — a powerful combination. Even if the internet appears to behave strangely in how it handles value, there is no reason to believe that if it had an economic model of its own, this would contradict the economic principles that have generally worked. However, if a textbook definition of economics as the "study of how societies use scarce resources to produce valuable commodities and distribute them among different people" remains as valid now as ever, almost all the terms in there need reexamination (P. A. Samuelson and W. D. Nordhaus, *Economics,* 15th ed., NY: McGraw-Hill, 1995). This is because the same peculiar economic behavior of the net suggests that it has developed its own model, the economic model of the information age.

The Times of India sells some three million copies every day across India. The whole operation, particularly the coordination of advertising and editorial, depends on RespNet. This internal network won the *Times* a listing in *ComputerWorld* magazine's selection of the world's best corporate users of information technology. RespNet runs on Linux and other similar free software off the net.

Raj Mathur, who set up Linux on RespNet, agrees with Torvalds when the latter says, "people who are entirely willing to pay for the product and support find that the Linux way of doing things is often superior to 'real' commercial support." This is thanks to the large community of other developers and users who share problems and solutions and provide constant (sometimes daily) improvements to the system. The developer-users naturally include operators of networks similar to RespNet. So many of them can separately provide assistance that might not be available if they were all working together in a software company — as Linux Inc. — where they would be producers of the software but not consumers. This shifting base of tens

of thousands of developers-users worldwide working on Linux means that the *Times of India* would have a tough time figuring out whom to pay, if it wanted to.

The fact that people go looking for other people on the internet, and that Linux developers look for others like them, is just one instance of the immediacy of much of the trade that takes place on the net. When you post your message to rec.pets.cats, or create a home page — whether personal or full of your hobbies and work — you are continuously involved in trade. Other cat-lovers trade your message with theirs, visitors to your homepage trade your content with their responses, or perhaps you get the satisfaction of knowing that you're popular enough to get a few thousand people discovering you each week. Even when you don't charge for what you create, you're trading it, because you're using your work to get the work of others (or the satisfaction of popularity) in a discussion group through your website. What is most important about this immediacy of the implicit trades that go on all the time on the net is its impact on notions of value. Unlike in the "real world," where things tend to have a value, as expressed in a pricetag, that is sluggish in response to change and relatively static across its individual consumers, on the net everything is undergoing constant revaluation. Without the intermediary of money, there are always two sides to every transaction, and every transaction is potentially unique, rather than being based on a value derived through numerous similar trades between others — that is, the pricetag.

As we continue to alternate between examples from the worlds of free software and usenet — to reiterate their equivalence in economic terms — we can see the two-sided nature of trade in this hypothetical example about cats. You may value the participants in rec.pets.cats enough to post a long note on the nomadic habits of your tom. In a different context — such as when the same participants are quarreling over the relative abilities of breeds to catch mice — you may not find it worthwhile contributing, because the topic bores you. And you may be far less generous in your contributions to rec.pets.dogs. You value the discussion on dogs, and catching mice, much less than a discussion on tomcats, so you're not willing to make a contribution. This would be "selling" your writing cheap; but when you get feedback on tomcats in exchange for your post, it's the right price.

Unlike noodles and bread, readers on internet newsgroups don't come with pricetags pinned on, so commonplace decisions involving your online acts of production require that you figure out the relative values of what you get and what you give, all the time. Others are figuring out the worth of your contribution all the time, too. Life on the internet is like a perpetual auction with ideas instead of money.

That note on your tomcat probably does not deserve the glorious title of idea; certainly the warm feeling that you got in exchange for posting it — when people responded positively and flocked to your homepage to see pictures of your cat — couldn't possibly be classed with "real ideas." Still, for the sake of convenience the subjects of trade on the net can be categorized as idea (goods and services) and

reputation (which when enhanced brings all those warm, satisfied feelings, and more tangible benefits too).

Ideas are sold for other ideas or an enhanced reputation; reputations are enhanced among buyers of ideas, and reputations are themselves bought and sold all the time for other reputations, as we shall see later. The basic difference is that reputation (or attention) is, like money, a proxy. It is not produced or consumed in itself, but is a byproduct of the underlying production of actual goods ("ideas" in our binary terminology).

< two sides to a trade >

Unlike the markets of the "real world," where trade is denominated in some form of money, on the net every trade of ideas and reputations is a direct, equal exchange, in forms derivative of barter. This means that not only are there two sides to every trade, as far as the transaction of exchanging one thing for another goes (which also applies to trades involving money), there are also two points of view in any exchange, two conceptions of where the value lies. (In a monetary transaction, by definition, both parties see the value as fixed by the price.)

As the poster of notes on tomcats, the value of your posting something is in throwing your note into the cooking pot of participatory discussion that is rec.pets.cats and seeing what comes out. As the author of a page on cats, what you value in exchange for your words and photographs is the visits and comments of others. On the other hand, as a participant on rec.pets.cats I value your post for its humor and what it tells me to expect when my kitten grows up; as a visitor to your webpage I learn about cats and enjoy pretty pictures.

When I buy your book about cats, it's clear that I am the consumer, you the producer. On the net, this clear black-and-white distinction disappears; any exchange can be seen as two simultaneous transactions, with interchanging roles for producer and consumer. In one transaction, you are buying feedback to your ideas about cats; in the other, I am buying those ideas. In the "real world" this would happen in a very roundabout manner, through at least two exchanges: in one, I pay for your book in cash; in the next, you send me a check for my response. This does not happen very often! (The exception is in the academic world, where neither of us would get money from the Journal of Cat Studies for our contributions; instead our employers would pay us to think about cats.)

As soon as you see that every message posted and every website visited is an act of trade — as is the reading or publishing of a paper in an academic journal — any pretense is lost that these acts have inherent value as economic goods with a pricetag.

In a barter exchange the value of nothing is absolute. Both parties to a barter have to provide something of value to the other; this something is not a universally or even

widely accepted intermediary such as money. There can be no formal pricetags, as an evaluation must take place on the spot at the time of exchange. When you barter you are in general not likely to exchange your produce for another's in order to make a further exchange with that.

When the contribution of each side to a barter is used directly by the other, it further blurs the distinction between buyer and seller. In the "real world" barter did not, of course, take place between buyer and seller but between two producer-consumers in one transaction. When I trade my grain for your chicken, there's no buyer or seller, although one of us may be hungrier than or have different tastes from the other. On the internet, say in the Linux world, where it may seem at first that there's a clear buyer (the *Times of India*) and an equally clear, if aggregate seller (the Linux developer community), there is, in fact, little such distinction.

Just as the existence of the thousands of independent Linux developers are valuable to the newspaper because they are also users of the product — and may face similar problems — other Linux developers welcome the Times of India because the way it faces its problems could help them as Linux users.

< can you eat goodwill? >

Perhaps you will agree that when you next post a note on cats, you're not giving away something for nothing. But what you get in return is often pretty intangible stuff — satisfaction, participation in discussion, and even answers to cat-related questions are all very well, and may be fair exchange for your own little notes, but don't seem substantial enough to make much of an economy. As for Linux — it's fine to talk about a large base of user-developers all helping one another, but what has all this brought Linus Torvalds? Although Linux did get vastly improved by the continuing efforts of others, none of this would have happened without Torvalds's original version, released free. Assuming that he's not interested in Linux as a hobby, he's got to make a living somehow. Doesn't he seem to have just thrown away a great product for nothing?

First, let's see what intangible "payment" Linux brought Torvalds. In the circles that might matter to Torvalds's career, he's a sort of god. As government and academic participation has declined as a proportion of the total internet developer community, most recent "free" technology has not been subsidized, either. The main thing people like Torvalds get in exchange for their work is an enhanced reputation. So there are, in fact, lots of net gods.

Net gods get hungry, though, and reputation doesn't buy pizzas. So what does Torvalds do? He was in the University of Helsinki in October 1996, when I first interviewed him (he's now with a U.S. company where "it's actually in [his] contract [to do] Linux part-time"). "Doing Linux hasn't officially been part of my job description, but that's what I've been doing," he says. His reputation helped: as Torvalds says,

"in a sense I do get my pizzas paid for by Linux indirectly." Was this in an academic sense, perhaps? Is Linux, then, just another of those apparently free things that has actually been paid for by an academic institution, or by a government? Not quite. Torvalds remained in the university out of choice, not necessity. Linux has paid back, because the reputation it's earned him is a convertible commodity. "Yes, you can trade in your reputation for money," says Torvalds, "I don't exactly expect to go hungry if I decide to leave the university. "Resume: Linux" looks pretty good in many places."

< is reputation a convertible currency? >

Suppose you live in a world where people trade chicken and grain and cloth — a very basic economy indeed! Suddenly one day some strangers appear and offer to sell you a car; you want it, but "Sorry," says one of the strangers, "we don't take payment in chicken; gold, greenbacks, or plastic only." What do you do? It's not hard to figure out that you have to find some way to convert your chicken into the sort of commodities acceptable to car dealers. You have to find someone willing to give you gold for your chicken, or someone who'll give you something you can trade in yet again for gold, and so on. As long as your chicken is, directly or indirectly, convertible into gold, you can buy that car.

What holds for chicken in a primitive barter economy holds also for intangibles such as ideas and reputation in the part of the economy that operates on the internet ("Implicit Transactions Need Money You Can Give away," ED 70). And some of these intangibles, in the right circumstances, can certainly be converted into the sort of money that buys cars, let alone pizzas to keep hunger away. This may not apply to your reputation as a cat enthusiast, though; it may not apply to all software developers all the time, either.

On the internet — indeed in any knowledge economy — it is not necessary for everything to be immediately traded into "real world" money. If a significant part of your needs are for information products themselves, you do not need to trade in your intangible earnings from the products you create for hard cash, because you can use those intangibles to "buy" the information you want. So you don't have to worry about converting the warm feelings you get from visits to your cat webpage into dollars, because for your information needs, and your activities on the net, the "reputation capital" you make will probably do. "The cyberspace 'earnings' I get from Linux," says Torvalds, "come in the format of having a network of people that know me and trust me, and that I can depend on in return. And that kind of network of trust comes in very handy not only in cyberspace." As for converting intangible earnings from the net, he notes that "the good thing about reputations...is that you still have them even though you traded them in. Have your cake and eat it too!"

There is, here, the first glimpse of a process of give and take by which people do lots of work on their creations — which are distributed not for nothing, but in exchange

for things of value. People "put it" on the internet because they realize that they "take out" from it. Although the connection between giving and taking seems tenuous at best, it is in fact crucial. Because whatever resources are on the net for you to take out, without payment, were all put in by others without payment; the net's resources that you consume were produced by others for similar reasons — in exchange for what they consumed, and so on. So the economy of the net begins to look like a vast tribal cooking pot, surging with production to match consumption, simply because everyone understands (instinctively, perhaps) that trade need not occur in single transactions of barter, and that one product can be exchanged for millions at a time. The cooking pot keeps boiling because people keep putting in things as they themselves — and others — take things out. Torvalds points out, "I get the other informational products for free regardless of whether I do Linux or not." True. But although nobody knows all the time whether your contribution is exceeded by your consumption, everyone knows that if all the contributions stopped together there'd be nothing for anyone: the fire would go out. And that wouldn't be fun at all.

< cooking-pot markets >

If it occurred in brickspace, my cooking-pot model would require fairly altruistic participants. A real tribal communal cooking pot works on a pretty different model, of barter and division of labor (I provide the chicken, you the goat, she the berries, together we share the spiced stew). In our hypothetical tribe, however, people put what they have in the pot with no guarantee that they're getting a fair exchange, which smacks of altruism.

But on the net, a cooking-pot market is far from altruistic, or it wouldn't work. This happens thanks to the major cause for the erosion of value on the internet — the problem of infinity. Because it takes as much effort to distribute one copy of an original creation as a million, and because the costs are distributed across millions of people, you never lose from putting your product in the cooking pot for free, as long as you are compensated for its creation. You are not giving away something for nothing. You are giving away a million copies of something, for at least one copy of at least one other thing. Since those millions cost you nothing, you lose nothing. Nor need there be a notional loss of potential earnings, because those million copies are not inherently valuable — the very fact of there being a million of them, and theoretically a billion or more — makes them worthless. Your effort is limited to creating one — the original — copy of your product. You are happy to receive something of value in exchange for that one creation.

What a miracle, then, that you receive not one thing of value in exchange — indeed there is no explicit act of exchange at all — but millions of unique goods made by others! Of course, you only receive "worthless" copies; but since you only need to have one copy of each original product, every one of them can have value for you. It is this asymmetry unique to the infinitely reproducing internet that makes the

cooking pot a viable economic model, which it would not be in the long run in any brickspace tribal commune.

With a cooking pot made of iron, what comes out is little more than what went in — albeit processed by fire — so a limited quantity can be shared by the entire community. This usually leads either to systems of private property and explicit barter exchanges, or to the much analyzed "Tragedy of the Commons."

The internet cooking pots are quite different, naturally. They take in whatever is produced, and give out their entire contents to whoever wants to consume. The digital cooking pot is obviously a vast cloning machine, dishing out not single morsels but clones of the entire pot. But seen one at a time, every potful of clones is as valuable to the consumer as were the original products that went in.

The key here is the value placed on diversity, so that multiple copies of a single product add little value — marginal utility is near zero — but single copies of multiple products are, to a single user, of immense value. If a sufficient number of people put in free goods, the cooking pot clones them for everyone, so that everyone gets far more value than was put in.

An explicit monetary transaction — a sale of a software product — is based on what is increasingly an economic fallacy: that each single copy of a product has marginal value. In contrast, for each distinct product, the cooking-pot market rightly allocates resources on the basis of where consumers see value to be.

< a calculus of reputation >

A crucial component of the cooking-pot market model is reputation, the counterpoint to ideas. Just as money does not make an economy without concrete goods and services, reputation or attention cannot make an economy without valuable goods and services, which I have called "ideas," being produced, consumed, and traded.

Like money, reputation is a currency — a proxy — that greases the wheels of the economy. Monetary currency allows producers to sell to any consumer, without waiting for the right one to offer a needed product in barter exchange. Reputation encourages producers to seed the cooking pot by providing immediate gratification to those who aren't prepared to pull things out of the pot just yet, or find nothing of great interest there, and thus keeps the fire lit.

Money also provides an index of value that aids in understanding not just individual goods (or their producers), but the entire economy. Reputation, similarly, is a measure of the value placed upon certain producer-consumers — and their products — by others. The flow and interaction of reputation is a measure of the health of the entire cooking-pot economy.

Unlike money, reputation is not fixed, nor does it come in the form of single numerical values. It may not even be cardinal. Moreover, while a monetary value in the form of price is the result of matching demand and supply over time, reputation is more hazy. In the common English sense, it is equivalent to price, having come about through the combination of multiple personal attestations (the equivalent of single money transactions).

Money wouldn't be the same without technology to determine prices. Insufficient flow of the information required for evaluation, and insufficient technology to cope with the information, have always been responsible for the fact that the same things often have the same price across all markets.

The management of reputation is far too inefficient today to be a useful aspect of a working economy. Its semantics are poorly understood; moreover, it has nothing remotely akin to the technology that determines prices based on individual transactions in the monetary economy.

< conclusion >

The common assumption that the net feels at home with free goods and vague trade because its population is averse to money, altruistic, or slightly demented is wrong. It is becoming more obviously so as floods of "normal" people arrive from the world outside, and initiate themselves into the ways of the net.

An economic model based on rational self-interest and the maximization of utility requires the identification of what is useful — sources of value — as well as a method of expressing economic interaction. In the cooking-pot market model, while scarcity creates value, value is subjective, and may therefore be found in any information at all that is distributed on the net. The cooking-pot model provides a rational explanation (where a monetary incentive is lacking) for people's motivations to produce and trade in goods and services. It suggests that people do not only — or even largely — produce in order to improve their reputation, but as a more-than-fair payment for other goods — "ideas" — that they receive from the cooking pot. The cooking-pot market is not a barter system, as it does not require individual transactions. It is based on the assumption that on the net, you don't lose when you duplicate, so every contributor gets much more than a fair return in the form of combined contributions from others.

Reputations, unlike ideas, have no inherent value; like money, they represent things of value, as proxies. Reputations are crucial to seed the cooking pot and keep the fire lit, just as money is required to reduce the inefficiencies of pure barter markets. However, reputations require a calculus and technology for efficient working, just as money has its price-setting mechanisms today.

The cooking-pot model shows the possibility of generating immense value through the continuous interaction of people at numbing speed, with an unprecedented flexibility and aptitude toward intangible, ambiguously defined goods and services. The cooking-pot market already exists; it is an image of what the internet has already evolved into, calmly and almost surreptitiously, over the past couple of decades.

The cooking-pot model is perhaps one way to find a rationale for the workings of the internet — and on the net, it finds expression everywhere.

> — *A longer version of this text was first published in FIRST MONDAY, the peer-reviewed journal of the Internet, in 1998 (www.firstmonday.org/issues/issue3_3/ghosh/).*

48

Open Money

Michael Linton & Ernie Yacub (Canada)

he problems with money stem entirely from how conventional money is normally issued — it is created by central banks in limited supply. There are three things we know about this money. We know what it does — it comes and it goes. We know what it is — it's scarce and hard to get. And we know where it's from — it's from "them," not us.

These three characteristics, common to all national currencies, determine that we constantly have to compete for a share of the limited amount of the "stuff" that makes the world go round. This money can go anywhere, and so it inevitably does, leaving the community deprived of its means of exchange. The pattern of everyday social actions derives from the ways in which money flows through the community — the money comes into the community, it goes around maybe once, and then it leaves.

The consequence of these conditions is an economic context in which strategies of competition dominate. If you have to have money to live, and money is short so everyone competes for what little there is, then you too have to compete to get what you need, you have to compete to live. And it's the same at every level — nation shall compete with nation, region with region and community with community. The rhetoric of the marketplace, the political slogans, the cynical self-interest all seem to make perfect sense, to reflect an apparently inescapable logic, that of the survival of the fittest — by which is meant those with the least scruples. But this "perfect" sense rests on very imperfect assumptions — that it's all due to human nature, or it's just the way society works. There is no recognition that the context in which the social behavior arises is set by the nature of the money that drives it, nor that the money we use is only one particular form amongst several different possible forms.

Money — as a really imaginary thing, a promise — began to come about when political powers gradually reduced precious metal contents, and stamped coins from base metals, declaring their value to lie in the fact that they were issued by, and acceptable to, authority. It had value because it had the "right" marks on it. A purely imaginary, social valuation, money is merely a promise, a ticket that provides its carrier with the expectation of something real. But yet it still is thought of as real — by economists and bankers, by adults and children. We think it is real, because of our experience that it's scarce, that only so much of it exists. It has at least that attribute of reality.

MONEY IS INFORMATION. It is just a measuring device, which we use to measure the value of our real exchanges. Why should a community be short of measures? Imagine you go to build something, and you have the materials, the bricks and the wood, and the tools, and the time and the inclination, and planning permission and whatever — but ... NO INCHES! Damn, we used too many yesterday, and now all the inches in town are over at the big project on the south side. This is obviously absurd — but it is just exactly the way we talk about money. So, just as you would use a different way to measure if someone told you there were no inches, so you can use a money of your own when the one from "them" isn't coming to hand.

There have been many local money systems throughout history, which have merely been small scale versions of the larger national currencies. But these don't work better at the local level than they do at the national. Issued in scarce supply by some local or regional authority, such currencies, simply by their very nature, create a local context of competition, which in turn generates conditions for local unemployment, local rich and local poor. Furthermore, they are inherently even less stable than their national counterparts, and prone to embarrassing and irrecoverable collapse.

To paraphrase Einstein, the problems we face cannot be resolved using the tools that created them. There is nothing positive that can be done within the current context. The form of any design for a new money should avoid any of the faults of the old. The form of an open money should:

> -exist in sufficient supply — - — - — — - — - there's enough
> -only be used within a community — - — - — - it recirculates
> -be created by its users — - - — - — - — - — - it comes from us

Open moneys are virtual, personal and free (www.openmoney.org). Any community, network, business can create their own free money simply by providing a set of accounts through which members can record their trades. "Free" should be understood as in free speech, free radical, freely available — but NOT as in free lunch, or free ride. It's not something you get for nothing. Open money is money that must be earned to be respected. When you issue it, you are obliged to redeem it — your money is your word. It's a matter of your reputation in your community.

Open money is flat money. It confers no power of one over another, only one with another. When you have your own money, you can't be bought and sold so easily. You can choose what you do to earn your money. And there's no monopoly — all money systems coexist in the same space. Exploitation is no longer a problem. This is because open money is virtual and not limited.

LETS, also know as Local Exchange Trading System, is a new form of economic organization applicable to any community. It is a self-regulating economic network which allows its members to generate and manage their own (completely legal) currency system independent of and parallel to the federal money system. It offers communities everywhere the tools to stabilize and support their local economy without diminishing their participation in the whole. It allows members of the local community to exchange goods and services on a "green dollar" basis when federal dollars are scarce or unavailable.

Being a member of a LETSystem (www.gmlets.u-net.com) is as simple as having another bank account. Member accounts hold green dollars, a quasi-currency, equivalent in value to the federal dollar, but no money is ever deposited or issued. All accounts start at zero and members can use green dollars only with other members. If you provide some product or service to another member, your account is increased and his/hers is decreased by the value you agree on. The system is thus always exactly balanced with some of the members in credit and the others in debit.

There are several features of the LETSystem that distinguish it from conventional currencies, banks, and credit-card barter systems. Conventional money systems involve the issue of money to a population by some authority. In a LETSystem, it is the people and businesses themselves who create the currency, and do so at the time and place where it is needed. A negative balance means you have issued money to others, not borrowed it from them. No individual is waiting for you to "pay up" and nobody has a claim on you or your assets. It's not debt, it's commitment, and you honor it at your own rate — usually some LETS and some normal money, enough to cover your cash costs. My commitment, in a debit position, is a general one, to the community as a whole, and a temporary or even permanent inability to recompense hardly restricts the rest of the community, who are still perfectly able to continue trading with each other, using my issued money. My inability to meet commitments in the cash economy is often a result of the scarcity of money. In the LETSystem the money I issue never leaves the community. It's always available for me to re-earn, and since it is not in short supply, it is less likely that competition for it will exclude me from earning.

As a meme, LETS has quickly developed a life of its own. Connecting mind to mind, it has become the best known and most widely used open money system in the world. In the most recent development of the LETS project, the open source software development model is being used to ensure the widest opportunity for programmers and system designers to contribute their skills and experience. With a

project that can grow very quickly, it is absolutely essential to do it right. For modern money management in retail businesses, restaurants, transport services, "doing it right" means using smart cards — memory microchips on plastic cards. These are in some ways much like credit and direct debit cards, but in others, very much smarter. One smart card can carry many independent virtual community moneys, just as a normal wallet can hold several sorts of money bills — yen, dollars, francs — but the smart card doesn't get them mixed up. A network of on-line internet accounts and off-line smart cards creates a perpetual money machine — a friction-free energy circuit for all the moneys needed for a fully functioning community economy.

We believe that the problems that come from conventional money can be resolved with open money systems. Where conventional money is scarce and expensive, the new money is sufficient and free. Where conventional money is created by central banks, the new open money is issued by us, as promises to redeem — our money is our word. And where conventional money flows erratically in and out of our communities, creating dependencies that are harmful to the economy, society and nature, the new complementary money re-circulates, enabling business and trade.

Imagine a perfect money system that simply enables people to trade equitably and efficiently; a form of money that only connects, people to people, business to business, each to the other. Imagine money that circulates in communities and networks so that what you spend always comes back. Imagine a perfectly open money that is available to all, created by us, sufficient to any and all needs so that there is never any shortage. Imagine a society and economy operating without any of the familiar monetary problems of poverty, exploitation, homelessness, unemployment, fear and stress. After all, money is just the symbol we give for something of real value.

49

Introduction to a True History of the Internet

Sebastian Luetgert (Germany)

||

1) There isn't much you can do if there aren't two of you. Sometimes, if you're entirely on your own, you need to duplicate yourself, betray your country or assume another nationality, in other words, to really be twice. Lenin's great ideas came to him when he was not living in Russia. Later, there was so much he had to do, he spent half of his time making mistakes, and then he died. But his prime phase of creativity was when he was in exile in Switzerland, when Russia was overcome by famine, and when he used to go for bicycle rides in the hills around Zurich. That was when he could think best — when he was in two places at once. The most interesting aspect of the internet or doing websites is that you can share with others the opportunity of being in two places at once. However, these should also function as sites of communication, since that's what they essentially are, but in fact they impede communication.

(2) Setting up a website, the way it is usually done, is so profoundly monotonous that this fact has to be concealed by any means whatsoever, with a bunch of ignorant and bored people who are always seeking novel ways of killing time. Then, fortunately, someone has an ingenious idea, immediately defined as ingenious, because otherwise you would call it stupid, and people would never dare to admit: I'm doing something stupid. That's why you say: I'm doing an ingenious website. You collaborate for three months, you have to talk to each other, and then you break up. But it only takes three months. Then you look for something new. It is really a totally wrong life, held together by fear and a lack of vision in the minds of people who actually have lots of visions, but who, for some reason, are not capable of perceiving them. They want to see less of them on their screens, that's what they

like. Even the best website is less interesting than a day in the life of just anyone, and this anyone, once he has seen the website, considers it much more desirable than his own life. These are all quite strange phenomena, but that's not what I'm bothered about. Only, to live such a life is quite miserable.

(3) So how to discuss these matters, how to react? One simply can't. Society and all its pressures are too strong. And even between people who initially liked each other... We were in love, XXXXX and I, in spite of all our mistakes, but then... In fact, all I can say about it is that the internet has driven us apart. I think she always resented not having been offered a job in Silicon Valley, and I guess she would have been happier there, if only she had been born ten years earlier, with the opportunity to end up in San Francisco one day. But in the beginning, the priority was to do internet in a different way, to be able to make a living with it, to survive, to live in a normal fashion, that is, to do internet in a normal fashion, to make enough money for a two-room flat with a nice bathroom and occasional holidays, and to do the websites you want to do, not promotional or pornographic or political sites or whatever. And not to be forced to move to the U.S., like all the other Europeans. We almost achieved this, but it took such an enormous effort, and we felt so lonely, that we ultimately realized: All this is just mad. You have all the means to do websites... And then you find out that people don't want to change as much as you think they do, nor does the world.

(4) In the internet, it is easier to change things, even in the internet industry, much easier than in literature or in the arts — or what we call the arts — just because there is less going on, there are fewer websites being published than books being printed. It is easier to change programming, because there are fewer programs and fewer programmers. In Germany, the number of people who are doing websites is much smaller than the number of people who are writing. It should be easier to change the relation between the computer and the desk, rather than between a printing press or a conveyor belt, a workbench or a machine in an Audi or Ford factory. But the former remains the most resistant configuration. Today, even cars are no longer produced the way they used to be in the past. But a computer... if you take the PC, it is still the same as it was in the seventies, it hasn't changed at all. Everyone is constantly shouting for change. But no, they want things to get better, not to change. Things get strenuous if you are forced to change, change is difficult. To make it from the age of five to the age of thirty — how long does that take? 25 years. That's arduous. Things could be different. But change isn't easy. I believe the internet is an area where it should be relatively easy to change things, because the internet isn't that important. But it is precisely where people cling to their positions more than anywhere else.

(5) You can tell a programmer, or a worker who considers himself to be underpaid: Alright, I'll pay you more — that's what I did, naive as I was — I'll pay you more, but come up with some texts, too. He says: They won't be any good, I can't write. Then I tell him, I know, but because they are going to be bad they will help me to

find better ones. So allow me to pay you for your effort of writing absolutely stupid texts. They will help me to come up with better ones. Things would be a lot easier if I could start with something silly in order to come up with something less silly. But, believe me, he would never use the word processor. As a programmer, he would never use the word processor, even if you told him to write something about himself. About himself, that would be even worse. He could talk about himself, but that wouldn't leave a lasting impression. In fact, when it comes to talking, internet people definitely talk a lot. Even more than in normal life. In normal life you have to work, and that means you don't have time to talk. Students are not allowed to talk in class, workers are not allowed to talk in the factory, and secretaries must keep silent all the time. But on the internet, you are privileged: they are talking all the time, it almost never stops.

(6) It's the amateurs who make Yahoo rich. They make a lot of homepages, but always only one at a time, one about their holidays, another one at Christmas, maybe another when a child is born, but they never set up a page that could be linked to the first one. What drives these people to make all these homepages? For them it may be just a natural thing to do, but for a professional I don't consider that a natural thing. For me, the real enemy is the internet professional – who actually spends even less time programming than the amateur. At least I can ask the amateur if he has already taken a look at one of my websites. And then I can ask him, After doing this homepage, why didn't you do another? At least this gives me the opportunity to have a real conversation about the internet. And the amateur will in fact realize that having to do another one means that you want to establish links. That's something he doesn't need to, no one is expecting that from him. Not everyone is expected to do websites. But you should be allowed to expect it from those who are actually doing websites. Professional — what does that mean? It depends on whether you define the term in a positive or negative way. Usually, when I argue with professionals, I accuse them of not being professional, precisely because they claim they are. But towards other professionals who accuse me of not being professional, I reclaim the status of an amateur. I tell them: by the way, you are not internet amateurs, you are even worse professionals than professional soccer players. Of course they are a class, a sort of mafia, and people are afraid of them. Streaming, for example, a field that would not need to be that complicated, is rapidly becoming more and more specialized, but at the same time, it remains the same. No one has an idea what to do with it, so they do nothing at all. You can explain it by defining what is a good or bad worker. You can assess whether a table is well or badly constructed. Then you can discuss the assessment. If the table breaks down as soon as you sit on it, and someone claims: I built it, and I'm a professional carpenter, then you can answer: Okay, but you're a bad professional. The internet is just as simple. But there is always someone trying to fool you. I think that people really have no idea. Programmers rarely know how computers work, and they are unable to fix them. They prefer taking a broken computer to the store for repair. Hardly anyone knows what a processor is. Even at Yahoo, very few employees know what they are actually doing.

(7) The biggest fraud concerns the notion of the so-called target group. They are telling you: You have to respect the target group, you have to make sure that the website doesn't bore the target group. Above all, you have to remember that that if the website bores the target group, they will no longer visit it, and in case you have put money into your website, that money will be lost. It would be more correct to say: I must attract as many people as I can in order to make as much money as possible. There's nothing wrong with that, but that's what they should say. Instead of: you mustn't bore the target group. "You mustn't" is a completely meaningless line. For a long time, my gut reaction, based on the respective insight I had at that moment, would be: there is constant discussion about the target group. I don't know what that is. I can't see them. I don't know who you mean. When I began thinking about the target group that was due to certain enormous failures, like SansSoleil.com, visited no more than 18 times in two weeks. Only 18 times, I can still count that far. So I asked myself: Who the hell are these 18 people? I would have liked to see these 18 people who had visited the website, I would have liked to know what they looked like. That was the first time I really thought about the target group, that I was able to think about the target group. I don't think that amazon.com is capable of thinking about the target group. How can anyone think about 12 million users? Their CEO might be able to think about 12 million dollars, but to think about 12 million users, that's simply impossible.

(8) Rolux does not propose a concept of the internet. All it may be able to offer, at least that's what I attempted to do, is an idea of people on the internet, and I think that's less dishonest than, for example, the eToy website, where they are trying to convince people that that's how things are on the internet. And even though people don't understand anything about it they are happy with it, because it fits with their concept of the internet, which is that you can't understand it anyway and that's just how it works. However, the way the ToyWar website was done was very different from what people think. It is no coincidence that ToyWar won the Webby Award for the best foreign website, because it's a typical American website. ToyWar is a technical term, a term for a trick. It is a technical issue. But I think this website was awarded because of its masterful concealment, precisely because it claims to reveal the true essence of the internet, an unattainably distant, magical realm that simultaneously attracts a lot of pleasant and a lot of unpleasant people.

(9) Financiers, go-betweens or providers are more realistic than the majority of net artists, because they think of their target group in terms of dollars, in terms of three million consumers at two dollars per hour, they make a brief projection, and then that's it. That's how they think. At least they are reality-bound, and that's what they are trying to be. But what if you don't think in these terms? What do I have that might attract four million users? It took me a long time to come to a conclusion, and I think that in Berlin maybe one or two hundred people are interested in what I have to say. But how to reach them? The internet is not particularly well-organized to such ends. To reach them through e-mail, I would have to send too many mails. My website doesn't reach them either. To reach them, I

would have to change it, to do a website I wouldn't like to do. So I say to myself: One has to think smaller, a bit longer, and in a different way. And then I realize how lonely I am. And this leads us to the actual problem. What causes the things I do to be of interest to others? You can knock at your neighbor's door at any time and tell him: Listen, give me five dollars, and I will read you a story. And then you can make a statistical analysis of who opens the door, gives you five dollars and listens to the story. Whether or not it's a good story is a different matter... But that is the true problem of production and distribution. The actual producers, the accomplices of the portals, are the multitudes of users, in other words, the whole of society. They just delegate... In reality, people are living their own lives, innumerable more or less extraordinary episodes. Those slaving away in a factory are living unbelievably arduous lives. But they delegate... they don't use their own imagination... people who are a bit more clever manage to keep circulating their ideas, some of them even quite well — that's their way of working — but that doesn't the fact that people delegate the idea or non-idea of their life to the internet. And then it's over and done with...

(10) And when I take a look at the eToy website, I consider mine more honest, if you like, since I have remained totally outside, because... I don't know... Back then I didn't think that way, but today, if I had to start again, that's what I would try to do. What is dishonest about the eToy website is that it doesn't show how they engage and employ people. Why they employ agents and lawyers and why... eToy just present themselves in front of a small helicopter that they don't even own anymore, and then they put the word "Internet" on top of it. Which, even as an indication of what they think of the internet, is complete bullshit. The true history of eToy would be a very fancy website that would become horribly expensive during its production. To me, the internet is primarily a matter of money. Someone has money and gives it to someone else who in return acts as if he was an artist, but in reality... And about Rolux: I don't know, I see people working on the internet, and then I see how it is ruining their relationships, the internet obviously isn't a good place to... But after ToyWar — how could you still explain what that is: doing a website? You would say... I don't know what you would say. You wouldn't be able to... And this is precisely the power of the internet, it strengthens people's belief that it is mysterious and familiar at the same time, because it costs them 50 or 60 dollars in access fees each month. Internet and television should be like local newspapers. Small papers do exist. The artists here... they are publishing their own paper. There are small papers published in universities, and no one would say: this paper has to be distributed all over the world. It is internal, and that is sufficient. I think that the same goes for websites. There may be some major ones aimed at everyone, but it is wrong to begin with everyone. I believe this can have quite horrible consequences that people have no idea about.

(11) There is one thing that has always interested me: how to get from one website to another? That means, basically, why you link a website to another. Amateur programmers don't do that, they don't need to. But professional programmers, they

don't just link two pages, but rather 800. They can rely on the fact — that's how it works today — that the 800 pages are all the same. One page multiplied by 800. They are engaging different designers, just to prove... the only reason that all the links have different names is that, if they hadn't, people would stop visiting. But people are completely at the end of their tethers, working at the university or at the office, so they don't notice that it's always the same website.

(12) The internet is a power, and people still like websites. What do they enjoy on the net? Rolux, or if you like, ToyWar: if that's still what people like, then that's because the way these sites are done is closer to them, because they possess an enormous power, and because that won't change. Technical standards may change, but the essentials remain. The internet is the only field where it is possible to change things that are useless the way they are. In any other area that would require too many people and too much equipment. So you have the choice to wait and manage your own petty affairs. But even this demands profound passivity. Sometimes there is a sudden explosion, you don't get it done. But it's possible on the internet, because it's relatively easy, it only takes a small number of people. Sometimes you collaborate with twelve people, sometimes just with two, and then, given two or three others, you can try to find a few more out there who might be interested. Maybe you don't even have to join up with internet people. One should be seeking one's allies elsewhere to get things going. Silicon Valley? Indeed, that is a cultural phenomenon, much more powerful than anything else, and it will never disappear. It simply can't. The proof is that it is more prosperous than ever. It is more prosperous than it ever was in the nineties. And the users? There are more users than ever before. How many babies are born each year? Where do you think the target group has its origin? After all, the people who are supposed to use these websites have to be created somehow.

(13) We only know very few people. We quickly break up with the few people we know. I just can't find a friend. The only one I managed to find — and it was him who approached me — was XXXXX. He came and told me: I can't do websites on my own, I have to be more than one. He wanted to do websites, but in a different way than all the others, not on his own. And unconsciously, I realized that I wouldn't be able to make it on my own. You have to be at least two. And then maybe three, if possible. But I didn't make it. After XXXXX I got to know a woman, a girlfriend, but we said to ourselves: We are only one-and-a-half. One-and-a-half, because together we were only half of three. One-and-a-half doesn't mean one and a half one, it means three divided by two. I have never managed to be three. The problem of my website is finding the third one. A programmer, for example, but a programmer who would also like to do something else, other than programming, or at least one who would need programming for himself, who would not be happy just earning money and selling his knowledge, but who would need the code for himself and not just for the agency or for me. If it would be a programmer — fine. If it would be a financier then it would be a financier. If it would be a writer then it would be a writer. It wouldn't matter — anyone could be

the third one. We tend to believe that the major Silicon Alley portals are done by one person, sometimes by two, if they are good, if they are slightly better. And if, for example... Just recently, I realized once again that the power of Nettime, the reason for their breakthrough in Europe at a certain time, was that it was run by three or four people who were talking about the internet. There was a time when Geert Lovink and Pit Schultz were talking to each other. And in relation to the others around them, that was already sufficient, because they were expressing themselves and felt the need to express themselves, because they felt the need to collaboratively transcend an illusion. And this illusion was the internet, not the book. Otherwise, you wouldn't use the internet.

(14) Net critics should do websites, rather than criticize. Or else engage in net criticism as if they were doing websites. Their strength — as long as they were engaged in net criticism — was that it was not a critique. They discussed other programmers' websites as programmers themselves, and often they didn't really know what to say about a given website, because they simply didn't like it. All they could do — for they couldn't just claim that the links were broken — was to name the person responsible for the website, as a physical and moral person, and then attempt to blame this physical and moral person for just about anything, in order to make the person aware of the fact that they didn't like the website. When they were doing Nettime, they were talking about websites because they didn't get any websites done themselves. That didn't make them sad, as they were still at the beginning. At least I think that's how it was. I have never seen myself as a net critic, but rather as someone who talks about websites because he likes to do one himself. It was a way of getting involved in the internet.

(15) Let us imagine that, if you were engaged to a woman, you would put a picture of her on the web in order to remember her. Things only start to get expensive once you start trying to say more. A whole portal about your loved one or yourself, that's costly. The server is not what is expensive. A server that costs twenty or hundred thousand dollars, that's not the expensive bit. The technical part of a website is relatively cheap. In the case of a four million dollar website, server space and traffic don't cost that much. What is expensive is the way all this is done. The boo.com episode was expensive. They sent e-mails to Los Angeles or San Francisco with the following content. The budget was fixed at ten million dollars, and then — they hadn't even begun programming — they said: We have already spent ten million dollars. So an e-mail was sent to New York, asking: Boss, can we overdraw the budget and spend up to twenty million dollars? It took one week for the reply to arrive, stating that they were indeed allowed to spend up to twenty million. In the meantime, the website had already reached the twenty million anyhow, with all the people around and the telephone bills. So they sent the next mail: We have now reached twenty million dollars, can we go up to thirty? And so on, up to 250 million dollars. Today, setting up a website in Silicon Valley will have cost at least twenty million dollars by the time you sign the contract, and that's the absolute minimum, even for a medium website.

(16) It took me a long time to understand that on the internet there is no desire to make money. The world economy as a whole is structured to the ends of making profit. But on the internet, people want to spend money. Some people are making money, a company's CEO or web designer, they earn a lot. But if some people are making money, like in the U.S. or in Europe, where income is generally high, then that's because people in the Philippines, in India or Mozambique are losing money and don't have enough to eat. We are dealing with interconnected systems, the Earth is not an unlimited entity. And today, in a time in which communication has become so rapid, people eat better in the U.S. the worse people eat elsewhere, because things happen so much faster. The poor are poorer than in the Middle Ages, and the rich are getting richer. The interesting thing about the internet is that it is a zone of excess, otherwise people wouldn't be paying fifty or one hundred dollars a month for it.

(17) But today I think that... I rather try to think and say to myself: There must be a whole lot of people who have similar problems as I do, in their own way, wherever they are. I know that from reading the newspaper, from watching television, and from the stories I'm being told. When you listen to the news, or when you're being told what people are up to, strikes, murders... when I read the news and try to make sense of them for me or for you, that some people fought over some property or that someone killed his child, whatever, even business news, then I say to myself: There must be people who aren't that much different from me. Two years ago, I wouldn't have said that. It's a result of working on the internet. You are a kind of communication vehicle, you're neither the one struck by the arrow nor the one shooting, you are the arrow. Writing, programming, thinking, talking may all mean being the arrow. Love is a different matter. Love is the instant when the arrow either is shot or hits its target. In this case you don't have to think about the arrow. But sometimes the arrow doesn't go straight and is just traveling through the air. This may take hundreds of years or just three seconds.

(18) The world has changed, but then I think, maybe not that much. People dress up in medieval clothes, in an overly perfected environment. A lot of things change, but then again not that many. The websites, the ones I see... the users can't have changed so much, since the websites are still the same. Or maybe the websites have changed and the users have remained the same. This would have to be demonstrated. A website doesn't exist on its own, it's necessarily part of a family. Homepages only exist as a part of a family. If there were no families... Let us imagine what would happen if there were only lovers, and they wouldn't get married and create families. Then there wouldn't be any homepages. Yahoo would collapse immediately if there were less marriages.

(19) If one would do websites, and if one would take a close look, rather than just babbling about it, one would most certainly see something. One would be able to discern which elements to preserve and which to discard. But then everything would change to such an extent... That would imply a colossal amount of work. Genuine

work. I think that all the websites I have done are critical websites, in a more or less successful way. That's why it is so difficult to perceive if they are working, precisely because they are critical websites. A critical website, as I understand it... It's like justice. It's a critique. It's a website that makes visible specific elements of something else and promotes critical reflection. The term "critical" has different meanings: a critical moment is a juncture at which a change of direction occurs, the boiling point of water or the turning point in a dramatic situation. "Critical" refers to a critical situation: you fall off your bicycle, war is beginning, or you're abandoned by your wife.

(20) It is not possible to judge a situation my means of adjectives. We are living in an age where adjectives are used as a means of definition. But definitions require verbs. Nouns and adjectives serve a different purpose than to define. Today, adjectives are used to define websites. That's why today I would like to start again — and if we find the time, we are going to do it, if I find two or three people who would like to collaborate — I would like to start again, and I hope this will uncoil like a spiral rather than turning around in a vicious circle, to start again with criticism, talking about the internet or doing internet by the means of a magazine. To do something else than programming for a while, writing and publishing, a mixture of screenshots and texts, especially net criticism, the way I think it should be done today, maybe different from before. To criticize a website the way you criticize a meal or a car engine that has been badly installed. Maybe one would end up stating something else than just: That's great, that looks like Jodi, that's more beautiful than Jodi...

(21) We went to Ars Electronica, that's true, but we really felt uncomfortable there. We didn't want to go to Berlin Beta, and that's why we felt obliged to go to Ars Electronica, and we simply didn't dare to tell them that they were just as stupid as we were, because we had come along. And then, we also wanted to show our website. All this is really very complicated. It's just like going to an event and then realizing how lousy it actually is, and that you can't stand all this crap anymore. But that's something you only realize once you've been there. Media festivals are like a law. Anyway, media festivals are the only places where no one talks about websites. It's important to exchange ideas about your work, but that happens to take place in this form. It's really the same in all areas of activity. There are all sorts of congresses, dentistry congresses... The internet is an industry like any other. Of course, dentists would not dare to announce: Festival of the Tooth.

(22) On the other hand... The internet is not a regular industry, it's an industry of expenses. It is not profit-oriented, such as the car industry, the electrical appliances industry and the stamp industry. It is not an industry dealing with physical objects. A website is a moment of stored energy, held in motion, beginning to flow and then to disappear. New technologies are being developed to replace the internet, because internet and phone lines, by the fact that they are durable, are said to be endangering entire industries and, by extension, mankind's industrial subconscious.

Paper is sufficient as a means of storing information. Signs and symbols on paper, that's enough to write down the commandments, that's still the best. Phone lines and websites are full of potential danger. They transcend the law. Of course the law could be written on websites, but that would mean to establish links, and that would imply a judgment. Once there is a law it is written on paper so that there is no need to judge. We are talking about a decree, not a law. We are talking about a decree, an order. Websites are not orders. Websites are put in a certain order, and thus they create a certain way of life.

(23) Telephone wires are quite resistant. After about one hundred years, nobody knows exactly, they begin to corrode. And yet people believe that this is still a bit too long, there are too many websites that will remain, and that could become problematic in the end. Decrees can still be printed on paper, there is no need to use a different method that might possibly induce change. Today there are new means of recording, but rather than perfecting the traditional ones, new methods were invented which are much less durable, like the CD-ROM. Hewlett-Packard is no longer producing printer paper, much to the disappointment of their genuine community that still prefers paper, and the prospect of being able to keep it for 60, 100 or even 200 years. Now people are using DVDs, with the manufacturers' explicit intention of limiting their life span to 10 years. It is understandable that this is the way things are. And who knows, maybe it's just all right.

(24) In one sense, Geert Lovink helped me a lot. He had been expelled from the internet, and, rather than lamenting, went to all the media festivals at a time when all the internet people hated media festivals. He was very clever, he knew how to make the most of the situation. He managed to squeeze more money out of institutions than he would ever been able to get through the internet. Later, precisely this was the reason why he had to quit the media festivals. He was unusual in any respect. Then he got funding from all sorts of foundations, from the Vatican, the Red Cross, wherever he could. I don't think I have ever given much support. Once I've given something. I met XXXXX, she had no money, and I had 2,000 dollars, and I gave them to her, that's not that much. That is my capital, made up of a variety of other things, far bigger than me because I am too small to be able to absorb it all. Sometimes that makes me mad and angry and bad-tempered, or just a bit stupid, because I am six foot tall and about ten inches wide, and I have ideas that can walk twenty or thirty yards. You can't absorb the whole world, not even in your imagination. I would prefer to have different ideas, that's why I like talking, either to people in extreme situations or, in the case of the internet, with those who have limited success and unlimited problems.

(25) Someone like Pit Schultz was quite an outsider, a genuine outsider and probably far more unhappy than the average citizen of Mozambique who doesn't have enough to eat. This is also Geert Lovink's influence, to consider places beside the norm, to go elsewhere, and not to be afraid of doing websites for just a few. I am always happy, except in overcrowded buses, in overcrowded airplanes, or when I

am stuck in a room with twelve others. Actually, I've always preferred being alone, but with someone else in the same situation. Most people like to be in a crowd. This reveals class difference. Poorer people prefer communal spaces, even if that means some discomfort. But they like it there, for they are surrounded by others who also can't stand being alone. But on the internet, there are really too many people these days. I quite liked it when there were only five or six. Back then, you could at least ask: What extraordinary coincidence brings you here?

50

Free Software and GPL Society

**Stefan Merten, Oekonux *(Germany)*
Interviewed by Joanne Richardson *(Romania/US)***

||

Oekonux – an abbreviation of "OEKOnomie" and "liNUX" – is a German mailing list discussing the revolutionary possibilities of Free Software. Many people speak of Free Software and Open Source Software interchangeably – could you explain how you understand the differences between them?

The term "Free Software" is older than "Open Source." "Free Software" is used by the Free Software Foundation (www.fsf.org) founded by Richard Stallman in 1985. The term "Open Source" has been developed by Eric S. Raymond and others, who, in 1998, founded the Open Source Initiative (www.opensource.org). It's not so much a question of definition as of the philosophy behind the two parts of the movement – the differences between the definition of Open Source Software and Free Software are relatively few. But whereas Free Software emphasizes the freedom Free Software gives the users, Open Source does not care about freedom. The Open Source Initiative (OSI) was founded exactly for the reason to make Free Software compatible with business people's thinking, and the word "freedom" has been considered harmful for that purpose.

> *Free software means the freedom to run, copy, distribute, study, change and improve the software, and these freedoms are protected by the GNU General Public License. The definition presupposes open sources as the necessary condition for studying how the software works and for making changes, but it also implies more. The definition of Open Source is quite close: it means the ability to read, redistribute, and modify the source code – but because this is a better, faster way to improve software. Openness = speed = more profit. The Open Source Initiative proclaims quite proudly that it exists in order to persuade the "commercial world" of the superiority of open sources on "the same pragmatic, business-case grounds that motivated Netscape." But recently, it is the term "Open Source" that has gained popularity ... and by analogy everything has become "Open" – open source society, open source money, open source schooling (to echo some of the titles of panels of the last Wizards of OS conference in Berlin.)*

Indeed the Open Source Initiative has been extremely successful in pushing the freedom-subtracted term into people's heads. Today people from the Free Software Foundation always feel the need to emphasize that it's the freedom that is important — more important than the efficiency of production, which is the primary aim behind open source. Of course open sources are a precondition for most of this freedom, but open sources are not the core idea of Free Software and so Open Source is at least a misnomer.

> *How do you mean it's a "misnomer"? The two movements exist and the names correspond to the different ideas behind them. And "Open Source" is the name the people from this initiative chose for themselves, and seems quite an accurate characterization of their focus.*

Free Software and Open Source Software are not two movements, but a single movement with two factions, and as far as I can see the distinction plays a major role mostly in the more ideological discussions between members of the two factions. They are collaborating on projects, and sometimes unite, for instance, when it is a question of defending against the attacks of Micro$oft.

And, no, "Open Source" is not an accurate characterization of this faction, since their focus has been making Free Software compatible with business people's thinking. A more correct name would have been "Free Software for Business" — or something like that.

> *What seems misleading to me is that the leftist intelligentsia has begun to use "Open Source" as a cause to promote without realizing the pro-capitalist connotations behind the term.*

Today the widespread inflation of the term "Open Source" has a deep negative impact. Often the core idea behind Free Software — establishing the freedom of the user — is not known to people who are only talking of Open Source — be it leftist intelligentsia or other people. I think this is a pity and would recommend using only the term Free Software because this is the correct term for the phenomenon. You don't call "green" "red" if "green" is the right term — do you? After all, even "Open Source" software would not be successful if the practical aspect of freedom was not inherent in its production and use. Interestingly, in an article entitled "It's Time to Talk about Free Software Again," one of the founders of the Open Source Initiative also considers the current development as wrong. (www.perens.com/perens_com/Articles/ItsTimeToTalkAboutFreeSoftwareAgain.html).

> *The idea behind Oekonux began, in kernel form at the first Wizards of OS conference in Berlin in 1999. How did the motivation to begin Oekonux develop from this context?*

I had the idea that Free Software is something very special and may have a real potential for a different society beyond labor, money, exchange — in short: capitalism — in 1998. In September 1998, I tried to make that a topic on the Krisis mailing list. However, next to nobody was interested. In July 1999, I attended the first "Wizard of Open Source" conference organized by mikro in Berlin, and was especially inter-

ested in the topic "New economy?". However, in the context of the idea I mentioned above — the potential to transform society — I found the ideas presented there not very interesting. After the talks I took the opportunity to organize a spontaneous BOF (Birds Of a Feather) session and luckily it worked well. So we sat there with about 20 people and discussed the ideas presented in the talks. At the end I asked all the people to give me their e-mail address.

After the WOS conference, mikro created a mailing list for us — and that was the birth of the Oekonux mailing list which is the core of the project. In December 1999 I created the web site (www.oekonux.de). Its main purpose is to archive the mailing list. Texts and other material created in the context of the project is presented there as well as links to web sites and pages relevant to our discussion in some way. There is also an English/international part of the project (www.oekonux.org) archiving the english list, list-en@oekonux.org. In June 2000 I created another mailing list, projekt@oekonux.de, which is concerned with the organization of the project.

During April 28-30, 2001 in Dortmund we had the first Oekonux conference, which brought together people from different areas who were interested in the principles of Free Software and the possible consequences of these principles on their particular field. The conference was attended by about 170 persons from a very broad range of ages and backgrounds, from software developers, to political theorists and scientists. It was a very exciting conference with a perfect atmosphere and another milestone in the way we and — if we're not completely wrong — the whole world is going. The next conference is planned to take place in Nov 1-3, 2002.

> *How active and large is the list?*

From the start we have had very interesting discussions with some silent periods but usually an average of 6-8 mails a day. The atmosphere on the list is very pleasant and flames are nearly unknown. Fortunately it has not been necessary to moderate the list, as it regulates itself very well. The discussions are very contentful and this interview would not have been possible without them. They cover a wide number of details but nearly always stay on the central topic of the list: the possible impacts of Free Software on society. At the moment we have about 200 subscribers at liste@oekonux.de, who come from a wide range of intellectual traditions and areas of interest. Though of course they all share a common interest in political thought, there are people from the Free Software and Hardware areas as well as engineers of different brands, hard core political people as well as people with a main interest in culture and so on. Though the traffic is quite high we have nearly no unsubscriptions which I think is a proof for the quality of the list.

> *In a previous interview with Geert Lovink, you mentioned that the relationship between free software and Marxism is one of the central topics debated on the list ... Do you think Marx*

is still relevant for an analysis of contemporary society? Could you give an idea of the scope of this debate on the list?

First of all we recognize the difference between Marx's views and the views of the different Marxist currents. Although different brands of Marxism have distorted Marx's thought to the point where it has become unrecognizable, I tend to think that only Marx's analysis gives us the chance to understand what is going on today. The decline of the labor society we are all witnessing in various ways cannot be understood without that analysis. The Krisis group (www.krisis.org) has offered a contemporary reading of Marx, claiming that capitalism is in decay because the basic movement of making money from labor works less and less. This doesn't mean that capitalism must end soon, but it won't ever be able to hold its old promises of wealth for all. A number of people on the Oekonux mailing list have built upon the Krisis theories and carried them onto new ground. On the list among other things we try to interpret Marx in the context of Free Software. It's very interesting that much of what Marx said about the final development of capitalism can be seen in Free Software. In a sense, we try to re-think Marx from a contemporary perspective, and interpret current capitalism as containing a germ form of a new society.

> *According to many circles, Marx is obsolete — he was already obsolete in the sixties, when the mass social upheavals and the so-called new social movements showed that not class but other forms of oppressive power had become determining instances and that the economic base was not the motor that moved contradictions.*

I think that at that time the economic base was not as mature as it has become today. In the last ten to twenty years Western societies started to base their material production and all of society more and more on information goods. The development of computers as universal information processors with ever increasing capacity is shifting the focal point of production from the material side to the immaterial, information side. I think that today the development of the means of production in capitalism has entered a new historical phase.

The most important thing in this shift in the means of production is that information has very different features than matter. First of all, information may be copied without loss — at least digital information using computers. Second and equally important, the most effective way to produce interesting information is to foster creativity. Free Software combines these two aspects, resulting in a new form of production. Obviously Free Software uses the digital copy as a technical basis. Thus Free Software, like any digital information, is not a scarce good; contrary to the IPR (intellectual property rights) people, the Free Software movement explicitly prevents making Free Software scarce. So, scarcity, which has always been a fundamental basis for capitalism, is not present in Free Software: existing Free Software is available for next to zero price.

More importantly, however, the organization of the production of Free Software differs widely from that of commodities produced for maximizing profit. For most Free Software producers there is no other reason than their own desire to develop that software. So the development of Free Software is based on the self-unfolding or self-actualization of the single individual. This form of non-alienated production results in better software because the use of the product is the first and most important aim of the developer — there simply is no profit which could be maximized. The self-unfolding of the single person is present in the process of production, and the self-unfolding of the many is ensured by the availability of high quality Free Software.

Another important factor is that capitalism is in deep crisis.Until the 1970s capitalism promised a better world to people in the Western countries, to people in the former Soviet bloc and to the Third World. It stopped doing it starting in the 1980s and dismissed it completely in the 1990s. Today the capitalist leaders are glad if they are able to fix the biggest leaks in the sinking ship. The resources used for that repair are permanently increasing — be it financial operations to protect Third World states from the inability to pay their debt, or the kind of military operations we see in Afghanistan today.

These processes were not mature in the 1960s but they are today. Maybe today for the first time in history we are able to overcome capitalism on the bases it has provided, by transcending it into a new society that is less harmful than the one we have.

> *How can Free Software "overcome" capitalism from the bases it has provided? The idea of a dialectical negation of capitalism (an immanent critique from the inside that takes over the same presuppositions of the system it negates) has frequently been discredited. Both Marx and Lenin's ideas of a dialectical negation of capitalism preserved the imperative of productivity, the utility of instrumental technology, the repressive apparatus of the State, police and standing army, as a necessary "first stage." And if you start from the inside, you will never get anywhere else... the argument goes.*

Free Software is both inside and outside capitalism. On the one hand, the social basis for Free Software clearly would not exist without a flourishing capitalism. Only a flourishing capitalism can provide the opportunity to develop something that is not for exchange. On the other hand, Free Software is outside of capitalism for the reasons I mentioned above: absence of scarcity and self-unfolding instead of the alienation of labor in a command economy. This kind of relationship between the old and the new system is typical for germ forms — for instance you can see it in the early stage of capitalist development, when feudalism was still strong.

> *In what sense is the production of Free Software not "alienated?" One of the reasons that labor is alienated is because the workers sells a living thing — qualitatively different forms of productive activity which in principle can't be measured — in exchange for a general measure, money. As*

Marx said somewhere, the worker does not care about the shitty commodities he is producing, he just does it for this abstract equivalent, the money he receives as compensation.

It seems you're talking about the difference between use value — the use of goods or labor — and exchange value — reflected in the price of the commodities that goods or labor are transformed into by being sold on the market. It's true that the use value of goods as well as labor is qualitatively different. It's also true that the exchange value of a commodity — be it a commodity or wage labor — is a common measure, an abstraction of the qualitative features of a product. But after all you need a common measure to base an exchange on. One of the problems of capitalism is that this abstraction is the central motor of society. The use of something — which would be the important thing in a society focusing on living well — is only loosely bound to that abstraction. That is the basis of the alienation of work performed for a wage. In Free Software because the product can be taken with only marginal cost and, more importantly, is not created for being exchanged, the exchange value of the product is zero. Free Software is worthless in the dominant sense of exchange.

Free Software may be produced for numerous reasons — but not for exchange. If there is no external motivation — like making money — there must be internal motivations for the developers. These internal motivations, which are individually very different, are what we call self-unfolding (from the German term "Selbstentfaltung," similar but not completly the same as "self-development"). Without external motivations, there is not much room for alienation.

Of course self-unfolding is a common phenomenon in other areas, such as art or hobbies. However, Free Software surpasses the older forms of self-unfolding in several ways and this is what makes it interesting on the level of social change:

* Most products of self-unfolding may be useful for some persons, but this use is relatively limited. Free Software, however, delivers goods which are useful for a large number of persons — virtually everybody with a computer.

* Most products of self-unfolding are the results of outmoded forms of production, like craft-work. Free Software is produced using the most advanced means of production mankind has available.

* Most products of self-unfolding are the fruits of the work of one individual. Free Software depends on collaborative work — it is usually developed by international teams and with help from the users of the product.

* All products of self-unfolding I can think of have been pushed away once the same product becomes available on the market. By contrast, Free Software has already started to push away software developed for maximizing profit in some areas, and currently there seems to be no general limit to this process.

So contrary to older forms of self-unfolding Free Software provides a model in which self-unfolding becomes relevant on a social level. The products of this sort of self-unfolding can even be interesting for commercial use.

> *Some theorists have analyzed the internet as a kind of "gift" economy. In other words, it is not subject to measure and exchange. Things are freely produced and freely taken. And unlike exchange, which has a kind of finality (I pay one dollar I buy one bottle of Coca Cola, and it's over), the gift, since it cannot be measured, is a kind of infinite reciprocity. Gifts are not about calculation of value, but about building social relationships. Do you see Free Software as a "gift economy"?*

I don't like talking about gifts in Free Software or in terms of the Internet in general. There is no reciprocity in Free Software as, similarly, there is no reciprocity on the Internet. I have used thousands of web pages and millions of lines of code contained in Free Software without giving anything back. There simply is no reciprocity and even better: there is no need for reciprocity. You simply take what you need and you provide what you like. It's not by chance, that this reflects the old demand of "Everybody according to his/her needs."

Indeed there are several attempts, which are at best misleading, to understand the Internet and/or Free Software in terms of capitalist dogmas. The talk about "gift economies" is one of them, because it focuses on gifts as some sort of — non-capitalist but nonetheless — exchange. Even worse is the talk of an "attention economy" which defines attention as a kind of currency. The Internet, and especially Free Software are new phenomena which can't be understood adequately by using the familiar thought patterns of capitalism.

> *In what sense is "GPL Society" beyond the familiar thought patterns of capitalism?*

With the term "GPL Society" we named a society based on the principles of production of Free Software. These principles are:

* self-unfolding as the main motivation for production,
* irrelevance of exchange value, so the focus is on the use value,
* free cooperation between people,
* international teams.

Though the term has been controversial for some time, today it is widely accepted in Oekonux. I like the term particularly because you can't associate anything with it that you already know. GPL Society describes something new, which we try to discover, explore and understand in the Oekonux project. Ironically, part of this process of understanding has reached the conclusion that a GPL Society would no longer need General Public License because there won't be any copyright. So at least at this time maybe it should be renamed ;-) .

As I tried to explain Free Software is not based on exchange so neither is a GPL Society. How a GPL Society may look concretely can't be determined fully today. However, at present there are many developments which already point in that direction.

* One development is the increasing obsolescence of human labor. The more production is done by machines the less human labor is needed in the production process. If freed from the chains of capitalism this development would mean freedom from more and more necessities, making room for more processes of self-unfolding — be it productive processes like Free Software or non-productive ones like many hobbies. So contrary to capitalism, in which increasing automation always destroys the work places for people and thus their means to live, in a GPL Society maximum automation would be an important aim of the whole society.

* In every society based on exchange — which includes the former Soviet bloc — making money is the dominant aim. Because a GPL Society would not be based on exchange, there would be no need for money anymore. Instead of the abstract goal of maximizing profit, the human oriented goal of fulfilling the needs of individuals as well as of mankind as a whole would be the focus of all activities.

* The increased communication possibilities of the internet will become even more important than today. An ever increasing part of production and development will take place on the internet or will be based on it. The B2B (business to business) concept, which is about improving the information flow between businesses producing commodities, shows us that the integration of production into information has just started. On the other hand the already visible phenomenon of people interested in a particular area finding each other on the Internet will become central for the development of self-unfolding groups.

* The difference between consumers and producers will vanish more and more. Already today the user can configure complex commodities like cars or furniture to some degree, which makes virtually each product an individual one, fully customized to the needs of the consumer. This increasing configurability of products is a result of the always increasing flexibility of the production machines. If this is combined with good software you could initiate the production of highly customized material goods allowing a maximum of self-unfolding — from your web browser up to the point of delivery.

* Machines will become even more flexible. New types of machines available for some years now (like fabbers) are already more universal in some areas than modern industrial robots — not to mention stupid machines like a punch. The flexibility of the machines is a result of the fact that material production is increasingly based on information. At the same time the increasing flexibility of the machines gives the users more room for creativity and thus for self-unfolding.

* In a GPL society there is no more reason for a competition beyond the type of competition we see in sports. Instead various kinds of fruitful cooperation will take place. You can see that today not only in Free Software but also (partly) in science and for instance in cooking recipes: imagine your daily meal if recipes were proprietary and available only after paying a license fee instead of being the result of a world-wide cooperation of cooks.

> *This sounds very utopian: Free Software as the sign of the end of capitalism and the transformation of the new society? How do you predict this transformation coming about — spontaneously, as the economic basis of capitalist production just withers away?*

I hope these more or less utopian thoughts give an idea of the notion of a GPL Society as it is currently discussed within the Oekonux project. And it's not Free Software in itself which may transform capitalism. Instead, the principles of the production of Free Software — which have developed within capitalism! — provide a more effective way of production on the one hand and more freedom on the other. The main question is how is it possible to translate these principles to other areas.

I tried to explain how Free Software — as a germ form of the GPL society — is inside as well as outside of capitalism. I think Free Software is only the most visible of the new forms which together have the potential to lead us into a different society. Capitalism has developed the means of production to such an extent that people can use them for something new. Of course, the transformation also requires a political process and although historically the preconditions now are better than ever before, there is no automatic step that will lead to the GPL society. People have to want this process. However, I'm quite optimistic that they will, because Free Software shows us, in microcosm, how a better life would look, so the GPL Society is in the best interest of people. And Oekonux is there to understand the process of this change, and perhaps at some point our thoughts may help to push the development forward.

51

New Associationist Movement

Kenta Ohji (Japan/France)

||

AM, New Associationist Movement (www.nam21.org), is an association of individuals who take on the task of organizing effective and non-violent counter-actions to capitalism and the State. Founded by Kojin Karatani in Japan last year, NAM proposes a simple theoretical schema for the critique of capitalism, nation and the State, as well as a practical form of activism in several spheres. Currently, NAM numbers about 600 members, each of whom belongs to at least three sections, according to social category, region and main-interest. Members of diverse ages come from all over Japan and there are twelve regional sections including those overseas. The sections of main interest are agriculture, architecture, art, computer, cooperative, education, environment, gender and sexuality, labor, law, LETS, minority, third world, theory and welfare, etc.

From the debates and discussions made in each section by way of mailing-lists, some concrete action projects have been launched: a project of the education section is now waiting for the legal registration for establishment of a New School, a project of the agriculture section is working on the boycott of genetically-modified products, and the third world section is preparing the immigrant workers' association. *Hihyokukan* (*Critical Space*), a philosophical quarterly edited by two members of NAM, Kojin Karatani and Akira Asada, has been launched by a new publishing company, founded with a view towards a future transformation into a cooperative of producers. But at this time, the main project of NAM is "Q project" (www.q-project.org), formed to establish an internet-run LETS (Local Exchange Trading System): Ippei Hozumi, a system engineer and member of NAM, has already developed the system's prototype (WINDS). We consider the creation of multi-LETS networks as the first step toward the development of a non-capitalist market based on exchanges without the creation of surplus or the fetishization of money.

The phrase "market economy" is often used to conceal the reality of capitalist accumulation behind it. Capital consists of the movement from M (money) to C (commodity) to M'(more money). From a skewed perspective, it seems to consist only of separate individual exchanges, C-M or M'-C. Those who worship the market economy see only these isolated moments, and are blind to the way in which exchanges are carried out only as components of the movement of Capital. The self-reproduction and self-expansion of Capital through the movement M–C-M' is possible only when surplus value can be appropriated. The surplus value appropriated by industrial capital arises from the differences in value that exist when workers buy back the (direct or indirect) products of their own labor. But this requires the creation across time of new value systems through technological innovation (Marx's "relative surplus value"). Because Capital constantly travels the world over in search of cheap labor, surplus value cannot be thought of in terms of an individual corporation or a single nation-state. It must be seen as the total surplus value in global capitalism. Accordingly, surplus value itself remains invisible at the level of a single corporation or state, as if it were locked away in a black box. The only form that people can know empirically is profit. A "profit" that is inseparable from its by products: class divisions, wars, pollution.

The secret of Capital lies in the process M-C-M' — consequently, the phase of resistance to Capital should shift from production to distribution, from workers-as-producers to workers-as-consumers. In its movement, Capital encounters two critical moments: when commodified labor power is purchased and when the products are sold back to the workers. If a failure occurs in either of these moments, Capital is unable to appropriate surplus value — it is unable to function as capital. Workers can counteract capital at either of these two phases. In the first, they can adopt the strategy proposed by Antonio Negri: "Don't work" — which can mean nothing other than, "Don't sell your labor power! Don't perform waged labor under capitalism!" Or in the second, they can follow Mahatma Gandhi's suggestion: "Don't buy the products of capitalism!" Both of these "boycotts" are carried out from positions in which laborers can become active "subjects." But to make it possible for workers-as-consumers to choose not to work and not to buy, an alternative form must be available that can allow them to work and buy in order to live. An exscendent form of activism that aims to go beyond the limits of capitalism by creating non-capitalist forms of production and consumption — such as the non-capitalist market founded on the Local Exchange Trading System and the formation of cooperatives of producers and consumers in that market — is an indispensable complement to the immanent activism that takes place within the capitalist economy. The immanent activism centered on boycotts is also necessary to help push capitalist corporations to reorganize themselves into non-capitalist forms.

Marx sought to unveil the secret of money. But what sort of counter-measures become possible by his analysis of money-form? Engels and Lenin sought to abolish capitalism through state regulation and through a centralized planned economy, which resulted in the abolition of the market economy of free exchanges between indi-

viduals and in the withering away of freedom. They overlooked the specific function that characterizes money. Money is not simply an indicator of value; it actively coordinates the value systems of all products and production as they are exchanged through it. Money functions as the unavoidable medium of this system of relations — it plays an indispensable role. The superiority of market economies over planned economies is due to this function of money; planned economies which hope to establish their value systems without money can't but result in an enormous concentration of power in the hands of the State. In the capitalist market economy, of course, a substanceless money becomes substantialized as a principal object of desire, which results in money fetishism and the movement of capital as the self-reproduction of money. But to abolish the market economy on the grounds that its money transforms into capital is to throw out the baby with the bath water. To echo the antinomy of Marx's Capital: we can't live with money, and we can't live without it. The question is how to overcome the money-form while simultaneously conserving a market that permits free exchanges between individuals.

LETS, Local Exchange Trading System, a proposal initiated by Michael Linton, creates a multilateral balance-of-payments system, under which each participant maintains an individual account. The goods and services that each participant can provide are listed in a catalog, which members use to carry out voluntary exchanges through negotiation of the price; the results of the exchanges are recorded in the accounts of the participants involved. The currency used in LETS is different from the forms of cash issued by various national central banks, in that with each exchange, the currency is issued anew by the purchaser. The sum total of debits and credits in all the accounts of all the participants remains at zero, based on the principle of mutual cancellation between buyer and seller. Although this system may undergo future technical revisions, its basic concept already holds the key to resolving the antinomy of money.

Comparisons with the reciprocal gifts carried out within a closed community and with the capitalist economy highlight the distinguishing features of LETS. LETS resembles a system of reciprocal gifts within a closed community, but its exchanges could occur across a wide area and involve complete strangers (especially when administered on the internet) and the value of goods and services exchanged is not predetermined by communal system of value, but by the negotiation of individual seller and buyer. In this sense, it differs from a closed system of gifts and more closely resembles the characteristics of a market system. But it also differs from a capitalist market economy because LETS currency cannot function as capital. This is not just because it does not bear interest, but also because of the principle of zero-sum (mutual cancellation between assets and expenditures) for the system as a whole. No matter how actively exchanges are carried out, the final result will always be a canceling out of all currency.

This suggests an answer to the inherent antinomy of the money form: under the LETS system, money simultaneously exists and does not exist. LETS currency functions

as a general equivalent, but only as something that enables the relation between services and goods. It has no independent existence beyond that relation, consequently, money fetishism cannot arise. When currency exists only as the condition of possibility for exchange, it becomes meaningless to hoard it, nor is there any need to fear mounting debt. LETS currency enables a relational system of exchange for goods and services, but does reduce it to "commensurability." This means that LETS realizes the possibility of exchange between qualitatively different goods and services without enclosing them in one system of value which is regulated by money in capitalist market. As each member is capable of issuing the currency as s/he wants, and as the price of the goods and services could vary according to each negotiation between individual buyer and seller. In the non-capitalist market of LETS, a good or service could have different price according to each exchange that takes place, and the members themselves create the terms of the exchange — the capacity of evaluation (of creating a standard of value) remains in the hands of buyer and seller.

LETS is well-suited to the principles of our association in NAM, which are not merely economic but also ethical. While a reciprocal exchange system within a closed community requires accepting perpetually the jurisdiction of that community that issues the currency, the social contract implemented under LETS is similar to what Proudhon called "associations" based on the contract between individuals. All individual members are free to leave the LETS network, just as they are also free to belong simultaneously to more than one LETS network (multi-LETS), a development that will be facilitated through an internet system of exchanges. Unlike the single currency issued by a nation-state, the currency in LETS is plural and heterogeneous. And, most importantly, unlike other alternative local currencies, in LETS each individual member has the right to issue currency (in the form of entries into her or his account). As one of the sovereign rights of a state is the right to issue currency, this amounts to a popular sovereignty that goes beyond lip service: it genuinely makes each individual into a sovereign of currency. In this sense, LETS is not simply an alternative local currency, nor simply an economic movement, it crosses into a political dimension.

Since LETS is situated in the distribution and circulation phase, workers as consumers can take the initiative with it. Whereas ordinary cooperatives of producers/consumers are immediately forced into competition with capitalist corporations, LETS is structured to enable them to develop freely and under the self-determination of the individual participants. And it's also well-suited to a gradual creation of a non-capitalist market, as it initially allows a mixed use with national currency (for instance, 50% of the price of a commodity could be paid with LETS, while the other half could be paid with the national currency). Through this form of incremental changes, LETS permits the development of a non capitalist-market to grow out of the midst of the capitalist market.

But no matter how much LETS expands, by itself it cannot halt the self-reproduction of Capital. It remains in the end a complement to the market economy, and its impact is limited. To actualize the potential of LETS requires a movement to be linked with counteractions in various forms against the trinity of Capitalism-Nation-State. An exscendent activism outside the limits of capitalism is insufficient without counteractions immanent to the capitalist economy. The two forms of activism can meet in the distribution phase of the market, where workers take up the position of consumers. We do not want to deny the necessity of traditional forms of counter-acts against capitalism such as labor movements based on workers' unions, but it is also clear that these movements themselves cannot stop the movement of Capital as long as they are separated from each other and opposed to its patron in the determined relation of production. But, as Marx said, when the worker appears in the position of a consumer, he is emancipated from all his determinations as a worker. In other words, it is in this position that the worker appears as an individual subject, and that s/he could actively counter-act the movement of Capital (M-C-M'), and it is from this position that the worker could seek an escape from the cycle of the self-reproduction of Capital. The counter-acts that we propose to organize against capital must be based on the ethical and subjective choice of individuals.

As a young movement, NAM is developing gradually, sometimes in small steps, but effectively. It is not our aim to expand the organization of NAM itself; the only thing of importance is that "NAM-like" counter-actions take root in reality, in diverse places, in diverse forms, and that together, these find a way of communicating with and linking to each other through mutual exchanges and cooperation, thus extending the sphere of non-capitalist and non-statist society.

52

Some Thoughts On the Idea of 'Hacker Culture'

Patrice Riemens *(Netherlands)*

||

he Theory of 'Free Software' as the seed of a post-capitalist society only makes sense where it is understood as the exposure of those very contradictions of the development of productive forces which are relevant to the process of emancipation. It does not, however, make sense as a discovery of a format for their deployment out of which would automatically spring forth a better society. And it does not make sense either as the first stage of a process that one ought to follow as if it were a blueprint." ("Eight Theses on Liberation," Oekonux mailing list, www.oekonux.de/liste/archive/msg04304.html)

As the new information and communication technologies (ICT) entered our lives and became increasingly important in our daily activities, so did all kinds of knowledge, working habits and ways of thinking that were previously the exclusive domain of "geeks" and computer experts. Even though the vast majority of ICT users are passive consumers, a modicum of technological know-how is more and more prevalent among non-professionals, and these days, artists, intellectuals, and political activists have become fairly visible as informed and even innovative actors in what has become known as the public domain in cyberspace.

"Hackers," often inexactly referred to as "computer pirates" or by other derogatory terms, constitute without doubt the first social movement that was intrinsic to the electronic technology that spawned our networked society. Hackers, both through their savvyness and their actions, have hit the imagination and have been in the news right from the onset of the "information age," being either hyped up as bearers of an independent and autonomous technological mastery, or demonized as potential "cyber-terrorists" in the process. More recently they have been hailed in certain "alternative" intellectual and cultural circles as a countervailing power of sorts against the increasingly oppressive onslaught of both monopolistic ICT corporations and regulation-obsessed governments and their experts. Transformed

into role-models as effective resistance fighters against "the system," their garb has been assumed with various degrees of (de)merit by a plethora of cultural and political activists associated, closely or loosely, with the "counter-globalization movement."

Yet, whereas hackers (if we take a broad definition of the term) have been pioneering the opening up of electronic channels of communication in the South, in the North, they initially were held in suspicion by those same circles. Political militants there hesitated for a long time before embarking into computers and the new media, which they tended to view as "capitalist" and hence "politically incorrect." By the mid-nineties, however, "on-line activism" made rapid progress worldwide as more and more groups adopted the new technologies as tools of action and information exchange. The dwindling costs of equipment and communication, the (relative) ease of use, the reliability and security, and the many options that were offered by ICT were a boon to activists of all possible denominations. All this was also a very bad surprise to the people at the helm of corporate and political power, as they saw a swift, substantial, and many-pronged breakdown of their stranglehold on communication and information. For some time, it looked as if a level playing field between hitherto dominators and dominated had come within sight.

The net, as a result, became not only one of the principal carriers of political activism, but also one of its major loci and issues. Once they had overcome their initial shock and surprise, the powers that be were bound to react forcefully. And they did, beefing up the "protection" of so-called intellectual property, erecting ever-higher walls around expert knowledge and techniques, and unleashing all-round measures of control and surveillance on electronic communications. But resistance against this (re)subjugation of the networks also got organized. Almost by necessity, more and more activists became conversant with the new technologies, which in the given circumstances had to be a hands-on learning process. This process saw activists turning "techies" and "geeks" turning activists and has resulted in activist circles (political, but also intellectual, cultural, and artistic) becoming markedly, sometimes completely, ITC-driven. However, as we will see, this does not ipso facto make them hackers.

But it was equally within the domain of ICT itself that the exponential expansion of both range and carrying capacity of the internet, as well of that of the related technologies, and all this within an increasingly aggressive commercial environment made experts think again about the consequences of these developments and even reconsider their methods, opinion, and for quite a few of them, their position within the hitherto obtaining order of things. Rejecting the new enclosures that are being imposed on the dissemination of knowledge and techniques by commercial and/or state interests, they are exploring new avenues of developing, spreading, and also rewarding knowledge-building that are not exploitative and monopolistic or even solely profit-oriented. Hence the flight taken by various software programs, utilities and application modalities that have become known under the generic

name of Linux, Free Software, Open Source, and General Public License (for definitions, see www.gnu.org).

At first glance, these developments suggest that given these technological settings and socio-economic and political circumstances, convergence was bound to take place between the actors involved, meaning a merger between hackers and (political, cultural, etc.) activists since they were spreading the same message, and operated in parallel ways under similar threats. Unfortunately, this interpretation is as unwarranted in its optimism as it is precipitate in its formulation. Following a line of reasoning aptly called by the Dutch "the wish is the mother of the idea," such interpretation is based on the assumed relation, not to say equivalence, between individuals and groups, and between pursuits, motives, and methods whose affinities and linkages, even when viewed under the designation of "new social movements," are far from evident. In fact the alleged congruence is inherently unstable since it is contingent, and the supposedly common positions between those two groups are often absent altogether, and sometimes even contradictory. Whereas it would be excessive to portray hackers and activists in terms of "never shall the twins met," the idea, asserted by many a political activist and certain "public intellectuals," to the effect that their coalescence is both natural and inevitable is equally outlandish. Not only does it run roughshod over the sensibilities of "authentic" hackers — and it does so unfortuitously — it also misrepresents reality hence giving rise to erroneous hypothesizes and unwarranted expectations.

"Hacker culture," a concept one often encounters these days among networked activists, purports to represent this playful confluence between tech wizardry and the moral high ground. Hence, "Open Source" is fast becoming an omnibus framework and a near-universal tool-kit to tackle very diverse social issues, such as artistic production, law, epistemology, education, and a few others, which are but remotely — if at all — related to the field of software research and development, and the social environments from which it originates. There is little wrong in itself with this — imitation being the best of compliments — but it tends to obscure a sticky problem. Between hackers and activists often looms a wide gap in approach and attitude that is just too critical to be easily papered over. And it is precisely this fundamental difference that is usually being hushed up by the evangelists of what I call the "hackers-activists bhai-bhai" gospel – phrased after the celebrated slogan mouthed by Chinese and Indian Ministers in 1953: "Hindi-Chini Bhai-Bhai" ("India and China are Brothers") — nine years later, both countries were at war. A good, if a contrario, example of a real non-equivalence between political activists applying ICT and hackers is provided by that spurious hybrid known as "hacktivism." "Hacktivism" was originally coined by the Boston-based hackers "Cult of the Dead Cow" (www.cultdeadcow.com), whose tag-line read "We put the hack in activism." It was all about using ICT skills to thwart attacks on liberties by powerful institutions. The group later had to defend itself of guilt by association with respect to recent manifestations of "hacktivism" as Distributed Denial of Services (DoDS) attacks.

Behind the so-called "Hacker Ethic" is the usual, daily activity of hackers. To put it very simply, without going deeper into its precise content, the hacker ethic runs strikingly parallel to the formula "l'art pour l'art." What matters here is the realization that, unlike activists, hackers are focused on the pursuit of knowledge and the exercise of curiosity for its own sake. Therefore, the obligations that derive from the hacker ethic are perceived by genuine hackers as sovereign and not instrumental, and always prevail above other aims or interests, whatever these may be — and if there are any at all. This consequently makes the hacker movement wary of any particular blueprint of society, however alternative, and even adverse to embrace particular antagonism (some hackers, and not minor ones, are for instance loath to demonize the Microsoft Corporation). Hence the spread of political and philosophical opinions harbored by individual hackers, without any loss of their feeling of identity and belonging to the "movement" at large or even their particular group, is truly astonishing, and very unlikely to obtain within any other "new social movement." In fact, the militant defense of individual liberties and a penchant for rather unegalitarian economic convictions one encounters in tandem among a good many hackers has provided for bafflement among networked political (i.e. left-leaning) activists coming to be better acquainted with their "natural allies." Yet it is neither fortuitous nor aberrant that the Californian transmutation of libertarianism enjoys such widespread support among hackers.

The existence of such "ideological" positions has its reflection in the daily and usual activities of hackers, which are generally characterized by an absence of preconceived ideas and positions. Despite the avowed "end of the great narratives," this is not the case with political activists, since they do have objectives and aims that precede their actions. Hackers, on the other hand, are usually happy with the "mere," but unrestricted, pursuit of knowledge, which reduces their "political program," if that can be so called, to the freedom of learning and enquiry, and thus would seem to fall very much short of demands for justice, equality, emancipation, empowerment, etc., that are formulated by political militants. Yet they seem to be content with it, and there are good arguments to think that such a program, as limited as it may sound, is essential, not subsequent, to the achievement of the better society we all aspire to.

This being said, the points of convergence between the activities of hackers and those of (political) activists are many, and they increase by the day. It is becoming more and more evident that both groups face the same threats, and the same adversaries. As expert technological knowledge — especially of ICT — that sits outside the formally structured (and shielded) domains of corporate or political power gets ever more vilified in the shape of "(cyber)terrorist" fantasies, paranoia, and finally, repression, while at the same time this very expertise is increasingly being mastered and put to use by the enemies of the neo-liberal "One Idea System," stronger, if circumstantial, links are being welded between hackers and activists. And these linkages are likely to deepen and endure in the same measure as the hostility and risks both groups are likely to encounter augment, it is worthwhile to analyze what

unites as well as what separates them.

"Hacktivist" activities (and I am mostly referring here to the handywork of three groups, Electronic Disturbance Theater, Electrohippies and ®™ark), well advertised by their authors, but also gleefully reported in the mainstream media, are illustrative of the gap that parts activists from hackers. The former usually view "hacktivism," which exploits the innumerable glitches and weaknesses of ICT systems to destabilize the electronic communication supports of "enemy organs" (government agencies, big corporations, international financial institutions, "fascist" groups, etc.), as a spectacular form of resistance and sabotage. The latter (generally) take a much dimmer view, considering these activities as ineffective and futile, and moreover, in most cases, technically inept as well. Such activities (or antics) endanger the integrity of the network which hackers consider to be theirs also. "Denial of Service" attacks, irrespective of aims and targets, amount in their eyes to attacks on the freedom of expression, which they seem to respect in a much more principled manner than most political activists.

The truth is, that by abetting "hacktivism," activists implicitly admit that the net has become a mere corporate carrier, to which they have only a subordinate, almost clandestine, access, as opposed to being stakeholders in, and thus sharing responsibility for it. This constitutes their fundamental divergence from hackers, and it is not easily remediable.

Political activists are also, almost by definition, inclined to seek maximum media exposure for their ideas and actions. Their activities, therefore, tend to be public in all the acceptance of the term. The range of issues that are covered by their ideals, and the variety of means and methods to achieve the same, make them need some form of organization, which is often complex, because of and not despite the fact that they strive for distribution and horizontality. The result is that even in the most alternative of circles, an apparatus and leaders appear, whose very informality obscures rather than prevents hierarchies from arising. This does not suit well the practice and the ethics of hackers, which Pekka Himanen has described as "monastic" (www.hackersethic.org). The *habitus* may be monastic, the behavior of hackers may, however, perhaps be more suitably paralleled with the "Slashta," the Polish gentry. There too we see a desire between equals, that is equals recognized as such beforehand, and hence also elitism. Political activists on the other hand are much more opportunistic when it comes to alliances and associations they engage in.

So does the idea of "hacker culture" represent an effective way to describe and define certain current modes of political activism, especially when those do have a large ICT component? In many instances where the term is being used, to the point of having become one of the "buzz-word du jour," I do not believe so. In many cases, it is the romantic appeal of what is perceived as hacker power and prowess that leads to a superficial adoption of the "hacker attitude" moniker by the cultural and political activists, but not of its underlying methods and values. That does not mean

that there exists an absolute incompatibility between those two groups, and there are fortunately cases suggesting the existence of a continuum – such as the Indymedia tech community's pairing of expertise to a "serve the people" type of operation (tech.indymedia.org, www.anarchogeek.com). But it should caution against a facile (and trendy) assumption of an equivalence, and maybe against the confusion-inducing use of the term "hacker culture" itself.

> *— This article first appeared in French in MULTITUDES, Vol 2, No 8, March–April 2002, (www.samizdat.net/multitudes), and in (an expanded) English translation in CRYPTOME on June 3, 2002 (cryptome.org/hacker-idea.htm).*

53

Open Source Intelligence

Felix Stalder & Jesse Hirsh *(Canada)*

||

In the world of spies and spooks, Open Source Intelligence (OSI) signifies useful information gleaned from public sources, such as newspapers, phone books and price lists. We use the term differently. For us, OSI is the application of collaborative principles developed by the Open Source Software movement to the gathering and analysis of information. These principles include: peer review, reputation- rather than sanctions-based authority, the free sharing of products, and flexible levels of involvement and responsibility.

Like much on the internet in general, including the Open Source Software movement, practice preceded theory also in the case of OSI. Many of the internet's core technologies were created to facilitate free information sharing between peers. This included two-way communication so that information could not only be distributed efficiently, but also evaluated collaboratively. E-mail lists — the most simple of all OSI platforms — have been around since the mid-1970s. In the 1980s, bulletin boards, FidoNet and Usenet provided user-driven OSI platforms with more sophisticated and specialized functionality. In the 1990s, many of these platforms were overshadowed by the emergence of the world-wide web. Tim Berners-Lee's foundational work on web standards was guided by a vision of peer collaboration among scientists distributed across the globe. While OSI's precedents reach back through the history of the internet — and if one were to include peer-reviewed academic publishing, much beyond that — a series of recent events warrant that it be considered a distinct phenomenon that is slowly finding its own identity, maturing from a practice "in itself" to one "for itself." Projects like the Nettime e-mail list, Wikipedia and the NoLogo.org website each have distinct history that led them to develop different technical and social strategies, and to realize some or all of the open source collaborative principles.

The culture of the internet as a whole has been changing. The spirit of free sharing that characterized the early days is increasingly being challenged by commodity-oriented control structures which have traditionally dominated the content industries. At this point, rather than being the norm, free sharing of information is becoming the exception, in part because the regulatory landscape is changing. The extension of copyrights and increasingly harsh prosecution of violations are attempts to criminalize early net culture in order to shore up the commodity model, which is encountering serious difficulties in the digital environment.

Years of experience with the rise and fall of "proto-OSI" forums has accumulated to become a kind of connective social-learning process. Uncounted e-mail lists went through boom and bust cycles, large numbers of newsgroups flourished and then fell apart due to pressures from anti-social behavior. Spam became a problem. Endless discussions raged about censorship imposed by forum moderators, controversial debates erupted about ownership of forums (is it the users or the providers?), difficulties were encountered when attempting to reach any binding consensus in fluctuating, loosely integrated groups. The condensed outcome of these experiences is a realization that a sustainable OSI practice is difficult to achieve and that new specialized approaches must be developed in order to sustain the fine balance between openness and a healthy signal/noise ratio. In other words, self-organization needs some help.

< open source collaborative principles >

One of the early precedents of open source intelligence is the process of academic peer review. As academia established a long time ago, in the absence of fixed and absolute authorities, knowledge has to be established through the tentative process of consensus building. At the core of this process is peer review, the practice of peers evaluating each other's work, rather than relying on external judges. The specifics of the reviewing process are variable, depending on the discipline, but the basic principle is universal. Consensus cannot be imposed; it has to be reached. Dissenting voices cannot be silenced, except through the arduous process of social stigmatization. Of course, not all peers are really equal, not all voices carry the same weight. The opinions of those people to whom high reputation has been assigned by their peers carry more weight. Since reputation must be accumulated over time, these authoritative voices tend to come from established members of the group. This gives the practice of peer review an inherently conservative tendency, particularly when access to the peer group is strictly policed, as it is the case in academia, where diplomas and appointments are necessary to enter the elite circle.

The point is that the authority held by some members of the group — which can, at times, distort the consensus-building process — is attributed to them by the group, therefore it cannot be maintained against the will of the other group members. If we follow Max Weber's theory that power is the ability to "impose one's will upon the behavior of other persons," this significantly limits the degree to which estab-

lished members can yield power. Eric Raymond had the same limitations in mind when he noted that open source projects are often run as "benevolent dictatorships." They are not benevolent because the people are somehow better, but because the dictatorship is based almost exclusively on the people's ability to convince others to follow their lead. This means that coercion is almost non-existent. Hence, a dictator who is no longer benevolent and alienates his or her followers loses the ability to dictate.

The ability to coerce is limited, not only because authority is reputation-based, but also because the products that are built through a collaborative process are available to all members of the group. Resources do not accumulate with the elite. Therefore, abandoning the dictator and developing in a different direction — known as "forking" in the Open Source Software movement — is relatively easy and always a threat to the established players. The free sharing of the products produced by the collaboration among all collaborators — both in their intermediary and final forms — ensures that that there are no "monopolies of knowledge" that would increase the possibility of coercion.

The free sharing of information — in this case code as opposed to software development — has nothing to do with altruism or a specific anti-authoritarian social vision. It is motivated by the fact that in a complex collaborative process, it is effectively impossible to differentiate between the "raw material" that goes into a creative process and the "product" that comes out. Even the greatest innovators stand on the shoulders of giants. All new creations are built on previous creations and themselves provide inspiration for future ones. The ability to freely use and refine those previous creations increases the possibilities for future creativity. Lawrence Lessig calls this an "innovation commons," and cites it as one of the major reasons why the internet as whole developed so rapidly and unexpectedly (*The Future of Ideas*, 2001).

It is also important to note that an often overlooked characteristic of open source collaboration is the flexible degree of involvement in and responsibility for the process that can be accommodated. The hurdle to participating in a project is extremely low. Valuable contributions can be as small as a single, one-time effort — a bug report, a penetrating comment in a discussion. Equally important, though, is the fact that contributions are not limited to just that. Many projects also have dedicated, full-time, often paid contributors who maintain core aspects of the system — such as maintainers of the kernel, editors of a slash site. Between these two extremes — one-time contribution and full-time dedication — all degrees of involvement are possible and useful. It is also easy to slide up or down the scale of commitment. Consequently, dedicated people assume responsibility when they invest time in the project, and lose it when they cease to be fully immersed. Hierarchies are fluid and merit-based, whatever merit means to the peers. This also makes it difficult for established members to continue to hold onto their positions when they stop making valuable contributions. In volunteer organizations, this is often a major problem, as early contributors sometimes try to base their influence on old

contributions, rather than letting the organizations change and develop. None of these principles were "invented" by the open source movement. However, they were updated to work on the internet and fused into a coherent whole in which each principle reinforces the other in a positive manner. The conservative tendencies of peer review are counter-balanced with relatively open access to the peer group: a major difference from academia, for instance.

Most importantly, the practice of open source has proved that these principles are a sound basis for the development of high-end content that can compete with the products produced by commodity-oriented control structures.

< examples of open source intelligence >

| > NETTIME

Nettime is an email list founded in the summer of 1995 by a group of cultural producers and media activists during a meeting at the Venice Biennale. As its homepage states, the list focuses on "networked cultures, politics, and tactics"(www.nettime.org). Its actual content is almost entirely driven by submissions from members. It is a good example of true many-to-many communication. Nettime calls its own practice "collaborative text filtering." The filter is the list itself — or to be more precise, the cognitive capacities of the people on the list. The list consists of peers with equal ability — though not necessarily interest — to read and write. The practice of peer review takes place on the list and in real time.

The list serves as an early warning system for the community, a discussion board for forwarded texts as well as a sizeable amount of original writing, and, equally importantly, an alternative media channel. This last function became most prominent during the war against Yugoslavia, when many of members living in the region published their experiences of being on the receiving end of not-so-smart, not-so-precise bombs.

By March 2002, the number of subscribers grew to 2500. The number of people who read Nettime posts, however, is higher than the number of subscribers to the list. Nettime maintains a public web-based archive that is viewed extensively, and some of the subscriber addresses are lists themselves. Also, as a high-reputation list, many of the posts get forwarded by individual subscribers to more specialized lists (another kind of collaborative text filtering).

The majority of subscribers come from Western Europe and North America, but the number of members from other regions is quite sizeable. Over the years, autonomous lists have been spun off in other languages: Dutch, Romanian, Spanish/Portuguese, French and Manadarin. Despite its growth and diversity, Nettime has retained a high degree of coherent culture discussion by a technology-savvy but critical European-style political left, who stress the importance of cul-

ture and social aspects of technology, as well as the importance of art, experimentation and hands-on involvement. This flexible coherence has been strengthened through a series of real-life projects, such as paper publications including a full-scale anthology, *Readme! ASCII Culture and The Revenge of Knowledge* (1999), and a string of conferences and "Nettime-meetings" in Europe during the 1990s.

Since its inception, the list has been running on majordomo, a popular open source e-mail list package, and assorted web-based archives. Technically, the list has undergone little development. Initially, for almost three years, the list was open and unmoderated, reflecting the close-knit relationships of its still small circle of subscribers and the "clubby" atmosphere of general netculture. However, after spam and flame wars became rampant, and the deteriorating signal/noise ratio began to threaten the list's viability, moderation was introduced. In majordomo, a moderated list means that all posts go into a queue and the moderators — called "list-owners," an unfortunate terminology — decide which posts get put though to the list, and which are deleted. This technological set-up makes the moderation process opaque and centralized. The many list members cannot see which posts have not been approved by the few moderators. Understandably, in the case of Nettime, this has led to a great deal of discussion about censorship and the "power grabbing" moderators. The discussion was particularly acrimonious in the case of traffic-heavy ASCII-art and spam-art that can either be seen as creative experimentation with the medium, or as destructive flooding of a discursive space. Deleting commercial spam, however, was universally favored.

In order to make the process of moderation more transparent, an additional list was introduced in February 2000, Nettime-bold. This channel has been carrying all posts that go into the queue prior to moderators' evaluation. Because this list is also archived on the web, members can view for themselves the difference between what was sent to the list and what was approved by the moderators. In addition to increasing the list's transparency, having access to the entire feed of posts created the option for members to implement parallel but alternative moderation criteria. In practice, however, this has not yet occurred. Nevertheless, giving members this option has transformed the status of the moderators from being the exclusive decision makers to "trusted filters." It has also provided the possibility for forking (i.e., the list splitting into two differently moderated forums).

Nettime is entirely run by volunteers. Time and resources are donated. The products of Nettime are freely available to members and non-members alike. Even the paper publications are available in their entirety in the Nettime archives. Reflecting its history and also the diversity of its contributors and submissions, Nettime has maintained the rule that "you own your own words." Authors decide how to handle redistribution of their own texts, though to be frank, it is hard to have control over a text's after-life once it has been distributed to 2,500 addresses and archived on the web.

Despite its many advantages — ease of use, low technical requirements for participating, direct delivery of the messages into members' inboxes — the format of the email list is clearly limited when it comes to collaborative knowledge creation. Moderation is essential once a list reaches a certain diversity and recognition, but the options for how to effect this moderation are highly constrained. Nettime's solution — establishing an additional unmoderated channel — has not essentially changed the fact that there is a very strict hierarchy between moderators and subscribers. While involvement is flexible (ranging from lurkers to frequent contributors) the responsibility is inflexibly restricted to the two fixed social roles enabled by the software (subscriber and moderator). The additional channel has also not changed the binary moderation options: approval or deletion. The social capacities built into the email list software remain relatively primitive, and so do the options for OSI projects.

| > WIKIPEDIA.COM

Wikipedia is a spin-off of Nupedia. Nupedia, a combination of GNU and encyclopedia as the name indicates, is a project to create an authoritative encyclopedia inspired and morally supported by Richard Stallman (www.gnu.org/encyclopedia/free-encyclopedia.html). However, apart from being published under an Open Content license, Nupedia's structure is similar to the traditional editorial process. Experts write articles that are reviewed by a board of expert editors (with some public input via the "article in progress" section) before being finalized, approved, and published. Once published, the articles are finished. Given the extensive process, it's not surprising that the project has been developing at a glacial pace.

Wikipedia was started in early 2001 as an attempt to create something similar — a free encyclopedia that would ultimately be able to compete with the Encyclopedia Britannica — but it was developed via a very different, much more open process. The two projects are related but independent — Nupedia links to articles on Wikipedia if it has no entries for a keyword, and some people contribute to both projects, but most don't.

The project's technological platform is called Wikiweb, named for the Hawaiian word wikiwiki, which means fast (www.wiki.org). The software was originally written in 1994 and recently rewritten to better handle the rapidly growing size and volume of Wikipedia. The Wiki platform incorporates one of Berners-Lee's original concepts for the Web: to let people not only see the source code, but also freely edit the content of pages they view. In the footer of each Wikipage is the option to "Edit this page," which gives the user access to a simple form that allows them to change the displayed page's content. The changes become effective immediately, without being reviewed by a board or even the original author. Each page also has a "history" function that allows users to review the changes and, if necessary, revert to an older version of the page.

In this system, writing and editing are collective and cumulative. A reader who sees a mistake or omission in an article can immediately correct it or add the missing information. Following the open source peer-review maxim, formulated by Eric Raymond as "given enough eyeballs, all bugs are shallow," this allows the project to grow not only in number of articles, but also in terms of the articles' depth, which improves over time through the collective input of knowledgeable readers. Since the review and improvement process is public and ongoing, there is no difference between beta and release versions of the information (as there is in Nupedia). Texts continuously change. Peer-review becomes peer-editing, resulting in what Larry Sanger hailed as the "most promiscuous form of publishing."

At least as far as its growth is concerned, the project has been very successful. It passed 1,000 pages around February 12, 2001, and 10,000 articles around September 7, 2001. In its first year of existence, over 20,000 encyclopedia entries were created — that's a rate of over 1,500 articles per month. By the end of March 2002, the number of articles had grown to over 27,000. The quality of the articles is a different matter and difficult to judge in a general manner. Casual searching brings up some articles that are in very good shape and many that aren't. Of course, this is not surprising given the given the fact that the project is still very young. Many of the articles function more as invitations for input than as useful reference sources. For the moment, many texts have an "undergraduate" feel to them, which may be appropriate, since the project just finished its "first year." However, it remains to be seen if the project will ever graduate.

Both Nupedia and Wikipedia have been supported by Jimbo Wales, CEO of the San Diego-based search engine company Bomis, who has donated server space and bandwidth to the project. The code-base was rewritten by a student at the University of Cologne, Germany, and for a bit more than one year, Larry Sanger held a full-time position (via Bomis) as editor-in-chief of Nupedia and chief organizer at Wikipedia. In January 2002, funding ran out and Larry resigned. He now contributes as a volunteer. There are currently close to 1,200 registered users, but since it's possible to contribute anonymously, and quite a few people do, the actual number of contributors is most likely higher.

Wikipedia has not suffered from the resignation of its only paid contributor. It seems that it has reached, at least for the moment, the critical mass necessary to remain vibrant. Since anyone can read and write, the paid editor did not have any special status. His contributions were primarily cognitive, because he had more time than anyone else did to edit articles and write initial editing rules and FAQ files. His influence was entirely reputation-based. He could, and did, motivate people, but he could not force anyone to do anything against their will.

The products of this encyclopedia are freely available to anyone. The texts are published under the Open Content License (www.opencontent.org). This states that the texts can be copied and modified for any purpose, as long as the original

source is credited and the resulting text is published under the same license. Not only the individual texts are available, the entire project — including its platform — can be downloaded as a single file for mirroring, viewing offline, or any other use. Effectively, not even the system administrator can control the project.

The scale of people's involvement in the project is highly flexible, ranging from the simple reader who corrects a minor mistake, to the author who maintains a lengthy entry, to the editor who continuously improves other people's entries. These roles depend entirely on each contributor's commitment, and are not pre-configured in the software. Everyone has the same editing capabilities.

So far, the project has suffered little from the kind of vandalism that one might expect to occur given its open editing capabilities. There are several reasons for this. On the one hand, authors and contributors who have put effort into creating an entry have a vested interest in maintaining and improving the resource, and due to the "change history" function, individual pages can be restored relatively easily. The latest version of the platform has an added feature that can send out alerts to people who request them whenever a specific page has been changed. The other reason is that the project still has a "community" character to it, so there seems to be a certain shared feeling that it is a valuable resource and needs to be maintained properly. Finally, in case of differences over content, it's often easier to create a new entry rather than to fight over an existing one. This is one of the great advantages of having infinite space. So far, self-regulation works quite well. It remains to be seen how long the current rate of growth can be sustained, and if it really translates into an improvement over the quality of individually-written encyclopedia entries. So far, the prospects look good, but there are very few examples of the long-term dynamics of such open projects. Given the fact that the Encyclopedia Britannica has been publishing since 1768, long-term development is clearly essential to such a project.

| > NOLOGO.ORG

NoLogo.org is perhaps the most prominent second-generation slash site. This makes it a good example of how the OSI experience, embodied by a specific code, is now at a stage where it can be replicated across different contexts with relative ease. NoLogo.org is based on the current, stable release of Slashcode, an open source software platform released under the GPL, and developed for and by the Slashdot community. Slashdot is the most well-known and obvious example of OSI, since it is one of the main news and discussion sites for the open source movement (www.slashdot.org).

Of particular importance for OSI is the collaborative moderation process supported by the code. Users who contribute good stories or comments on stories are rewarded with "karma," which is essentially a point system that enables people to build up their reputation. Once a user has accumulated a certain number of points, she can

assume more responsibilities, and is even trusted to moderate other people's comments. Karma points have a half-life of about 72 hours. If a user stops contributing, their privileges expire. Each comment can be assigned points by several different moderators, and the final grade (from −1 to +5) is an average of all the moderators' judgments. A good contribution is one that receives high grades from multiple moderators. This creates a kind of double peer-review process. The first is the content of the discussion itself where people respond to one another, and the second is the unique ranking of each contribution.

This approach to moderation addresses several problems that bedevil e-mail lists very elegantly. First, the moderation process is collaborative. No individual moderator can impose his or her preferences. Second, moderation means ranking, rather than deleting. Even comments ranked -1 can still be read. Third, users set their preferences individually, rather than allowing a moderator to set them for everyone. Some might enjoy the strange worlds of -1 comments, whereas others might only want to read the select few that garnered +5 rankings. Finally, involvement is reputation (i.e. karma) based and flexible. Since moderation is collaborative, it's possible to give out moderation privileges automatically. Moderators have very limited control over the system. As an additional layer of feedback, moderators who have accumulated even more points through consistently good work can "meta-moderate," or rank the other moderators.

The social potential embodied in Slashcode was available when Naomi Klein's January 2000 book *No Logo: Taking Aim at the Brand Bullies* became a surprising best-seller. In the wake of the anti-globalization protests in Seattle in November 1999, and after, the book began to sell in the 10,000s and later 100,000s. She found herself caught in a clash of old and new media and facing a peculiar problem. A book is a highly hierarchical and centralized form of communication − there is only one single author, and a very large number of readers. It is centralized because users form a relationship with the author, while typically remaining isolated from one another. This imbalance of the broadcast model is usually not a problem, since readers lack efficient feedback channels.

However, today many readers have e-mail and began to find Naomi's e-mail address on the web. She started receiving e-mails en masse, asking for comments, advice, and information. There was no way she could take all these emails seriously and respond to them properly. The imbalance between the needs of the audience and the capacities of the author were just too great, particularly since Naomi had no interest in styling herself as the leader or guru of the anti-globalization movement. (Of course that didn't stop the mass media from doing so without her consent.) As she explains the idea behind the NoLogo.org: "Mostly, we wanted a place where readers and researchers interested in these issues could talk directly to one another, rather than going through me. We also wanted to challenge the absurd media perception that I am 'the voice of the movement,' and instead provide a small glimpse of the range of campaigns, issues and organizations that make up this pow-

erful activist network — powerful precisely because it insistently repels all attempts to force it into a traditional hierarchy" (nologo.org/letter.shtml).

The book, which touched a nerve for many people, created a global, distributed "community" of isolated readers. The book provided a focus, but nowhere to go except to the author. The Slashcode-based web site provided a readily available platform for the readers to become visible to one another and break through the isolation created by the book. The book and the OSI platform are complementary. The book is a momentary and personal solidification of a very fluid and heterogeneous movement. The coherent analysis that the traditional author can produce still has a lot of value. The OSI platform, on the other hand, is a reflection of the dynamic multiplicity of the movement, a way to give back something to the readers (and others) and a connective learning process. More than the book, Nologo.org fuses action with reflection.

Of course, all the problems that are traditionally associated with public forums are still there, dissent — at times vitriolic and destructive — is voiced, but the moderating system allows members of the group to deal with differences in opinion in ways that do not impede the vitality of the forum. The learning process of Slashdot, in terms of to how to deal with these issues, benefited NoLogo significantly. Within the first year, 3,000 users registered on the site which serves requests of some 1,500 individual visitors per day.

< the future of OSI >

As a distinct practice, Open Source Intelligence is still quite young. However, there are at least three reasons to be optimistic about its future. First, the socio-technological learning process is deepening. The platforms and practices of OSI are becoming better understood, and consequently the hurdles for users as well as providers are getting lower. On the users' side, the experience of learning how to deal with participatory rather than broadcast media is growing. Their distinct character is being developed, mastered and appreciated. For providers, the learning experience of OSI is embedded in sophisticated, freely available GPL software. The start-up costs for new projects are minimal, and possibilities for adapting the platform to the idiosyncratic needs of each project are maximized. The resulting diversity, in turn, enriches the connective learning process. Second, as the mass media converges into an ever smaller number of (cross-industrial) conglomerates, which relentlessly promote and control their multitude of media products, the need for alternative information channels rises, at least among people who invest time and cognitive energy into being critically informed.

Given the economics of advertisement-driven mass media, it is clear that the value of an "alternative newspaper" is rather limited. OSI platforms, by distributing labor throughout the community, offer the possibility of reaching a wider audience without being subject to the same economic pressures that broadcast and print media

face to deliver those audiences to advertisers, particularly considering the fact that paid subscriptions allow access to advertisement-free content.

The more homogenous the mainstream media becomes, the more room opens up for alternatives. And if these alternatives are to be viable, then they must not be limited to alternative content, but must also explore the structure of their production. This is the promise and potential of OSI. Finally, the field itself is becoming more professional. A new middle layer of organizations is emerging, which focuses specifically on the development of OSI, particularly on the mixing of technological platform and social community.

The range of technologies are as wide as the range of communities, and a close relationship exists between the two. Technologies open and close possibilities in the same sense that social communities do. As Lawrence Lessig pointed out, what code is to the online world, architecture is to the physical world (*Code and Other Laws of Cyberspace*, 1999). The way we live and the structures in which we live are deeply related. The culture of technology increasingly becomes the culture of our society.

Making one's potential and one's goals congruent is the goal of this emerging middle layer of professional OSI service providers. The company we founded in December 2000, Openflows (www.openflows.org), is one of those (small) companies providing nodes for the OSI networks. This contributes to the growth of OSI beyond the geeky worlds of Slashdot and many of its knock-offs. What Openflows seeks to provide, and what others will have to address, is the role and presence of social facilitation in the culture of a society immersed in technology.

54

A Hacker Manifesto
Version 4.0

McKenzie Wark (*Australia*)

manifestation >

01. There is a double spooking the world, the double of abstraction. The fortunes of states and armies, companies and communities depend on it. All contending classes — the landlords and farmers, the workers and capitalists — revere yet fear the relentless abstraction of the world on which their fortunes yet depend. All the classes but one. The hacker class.

02. Whatever code we hack, be it programming language, poetic language, math or music, curves or colorings, we create the possibility of new things entering the world. Not always great things, or even good things, but new things. In art, in science, in philosophy and culture, in any production of knowledge where data can be gathered, where information can be extracted from it, and where in that information new possibilities for the world are produced, there are hackers hacking the new out of the old. While hackers create these new worlds, we do not possess them. That which we create is mortgaged to others, and to the interests of others, to states and corporations who control the means for making worlds we alone discover. We do not own what we produce — it owns us.

03. And yet we don't quite know who we are. While we recognize our distinctive existence as a group, as programmers, as artists or writers or scientists or musicians, we rarely see these ways of representing ourselves as mere fragments of a class experience that is still struggling to express itself as itself, as expressions of the process of producing abstraction in the world. Geeks and freaks become what they are negatively, through their exclusion by others. Hackers are a class, but an abstract class, a class as yet to hack itself into manifest existence as itself.

< abstraction >

04. Abstraction may be discovered or produced, may be material or immaterial, but abstraction is what every hack produces and affirms. To abstract is to construct a plane upon which otherwise different and unrelated matters may be brought into many possible relations. It is through the abstract that the virtual is identified, produced and released. The virtual is not just the potential latent in matters, it is the potential of potential. To hack is to produce or apply the abstract to information and express the possibility of new worlds.

05. All abstractions are abstractions of nature. To abstract is to express the virtuality of nature, to make known some instance of its manifold possibilities, to actualize a relation out of infinite relationality. Abstractions release the potential of physical matter. And yet abstraction relies on something that has an independent existence to physical matter — information. Information is no less real than physical matter, and is dependent on it for its existence. Since information cannot exist in a pure, immaterial form, neither can the hacker class. Of necessity it must deal with a ruling class that owns the material means of extracting or distributing information, or with a producing class that extracts and distributes. The class interest of hackers lies in freeing information from its material constraints.

06. As the abstraction of private property was extended to information, it produced the hacker class as a class. Hackers must sell their capacity for abstraction to a class that owns the means of production, the vectoralist class — the emergent ruling class of our time. The vectoralist class is waging an intensive struggle to dispossess hackers of their intellectual property. Patents and copyrights all end up in the hands, not of their creators, but of the vectoralist class that owns the means of realizing the value of these abstractions. The vectoralist class struggles to monopolize abstraction. Hackers find themselves dispossessed both individually, and as a class. Hackers come piecemeal to struggle against the particular forms in which abstraction is commodified and made into the private property of the vectoralist class. Hackers come to struggle collectively against the usurious charges the vectoralists extort for access to the information that hackers collectively produce, but that vectoralists collectively come to own. Hackers come as a class to recognize their class interest is best expressed through the struggle to free the production of abstraction not just from the particular fetters of this or that form of property, but to abstract the form of property itself.

07. What makes our times different is that what now appears on the horizon is the possibility of a society finally set free from necessity, both real and imagined, by an explosion in abstract innovations. Abstraction with the potential once and for all to break the shackles holding hacking fast to outdated and regressive class interests. The time is past due when hackers must come together with all of the producing classes of the world — to liberate productive and inventive resources from the

myth of scarcity. "The world already possesses the dream of a time whose consciousness it must now possess in order to actually live it."

08. Production produces all things, and all producers of things. Production produces not only the object of the production process, but also the producer as subject. Hacking is the production of production. The hack produces a production of a new kind, which has as its result a singular and unique product, and a singular and unique producer. Every hacker is at one and the same time producer and product of the hack, and emerges in its singularity as the memory of the hack as process.

09. Production takes place on the basis of a prior hack which gives to production its formal, social, repeatable and reproducible form. Every production is a hack formalized and repeated on the basis of its representation. To produce is to repeat; to hack, to differentiate.

10. The hack produces both a useful and a useless surplus, although the usefulness of any surplus is socially and historically determined. The useful surplus goes into expanding the realm of freedom wrested from necessity. The useless surplus is the surplus of freedom itself, the margin of free production unconstrained by production for necessity.

11. The production of a surplus creates the possibility of the expansion of freedom from necessity. But in class society, the production of a surplus also creates new necessities. Class domination takes the form of the capture of the productive potential of society and its harnessing to the production, not of liberty, but of class domination itself. The ruling class subordinates the hack to the production of forms of production that may be harnessed to the enhancement of class power, and the suppression or marginalization of other forms of hacking. What the producing classes — farmers, workers and hackers — have in common is an interest in freeing production from its subordination to ruling classes who turn production into the production of new necessities, who wrest slavery from surplus. The elements of a free productivity exist already in an atomized form, in the productive classes. What remains is the release of its virtuality.

< class >

12. The class struggle, in its endless setbacks, reversals and compromises returns again and again to the unanswered question — property — and the contending classes return again and again with new answers. The working class questioned the necessity of private property, and the communist party arose, claiming to answer the desires of the working class. The answer, expressed in the Communist Manifesto was to "centralize all instruments of production in the hands of the state." But making the state the monopolist of property has only produced a new ruling class, and

a new and more brutal class struggle. But perhaps this was not the final answer, and the course of the class struggle is not yet over. Perhaps there is another class that can pose the property question in a new way — and offer new answers to breaking the monopoly of the ruling classes on property.

13. There is a class dynamic driving each stage of the development of the vectoral world in which we now find ourselves. The pastoralist class disperses the great mass of peasants who traditionally worked the land under the thumb of feudal landlords. The pastoralists supplant the feudal landlords, releasing the productivity of the land which they claim as their private property. As new forms of abstraction make it possible to produce a surplus from the land with fewer and fewer farmers, pastoralists turn them off their land, depriving them of their living. Dispossessed farmers seek work and a new home in cities. Here farmers become workers, as capital puts them to work in its factories. Capital as property gives rise to a class of capitalists who own the means of production, and a class of workers, dispossessed of it — and by it. Dispossessed farmers become workers, only to be dispossessed again. Having lost their land, they lose in turn their culture. Capital produces in its factories not just the necessities of existence, but a way of life it expects its workers to consume. Commodified life dispossesses the worker of the information traditionally passed on outside the realm of private property as culture, as the gift of one generation to the next, and replaces it with information in commodified form.

14. Information, like land or capital, becomes a form of property monopolized by a class of vectoralists, so named because they control the vectors along which information is abstracted, just as capitalists control the material means with which goods are produced, and pastoralists the land with which food is produced. Information circulated within working class culture as a social property belonging to all. But when information in turn becomes a form of private property, workers are dispossessed of it, and must buy their own culture back from its owners, the vectoralist class. The whole of time, time itself, becomes a commodified experience.

15. Vectoralists try to break capital's monopoly on the production process, and subordinate the production of goods to the circulation of information. The leading corporations divest themselves of their productive capacity, as this is no longer a source of power. Their power lies in monopolizing intellectual property — patents and brands — and the means of reproducing their value — the vectors of communication. The privatization of information becomes the dominant, rather than a subsidiary, aspect of commodified life. As private property advances from land to capital to information, property itself becomes more abstract. As capital frees land from its spatial fixity, information as property frees capital from its fixity in a particular object.

16. The hacker class, producer of new abstractions, becomes more important to each successive ruling class, as each depends more and more on information as a resource. The hacker class arises out of the transformation of information into

property, in the form of intellectual property, including patents, trademarks, copyright and the moral right of authors. The hacker class is the class with the capacity to create not only new kinds of object and subject in the world, not only new kinds of property form in which they may be represented, but new kinds of relation beyond the property form. The formation of the hacker class as a class comes at just this moment when freedom from necessity and from class domination appears on the horizon as a possibility.

< property >

17. Property constitutes an abstract plane upon which all things may be things with one quality in common, the quality of property. Land is the primary form of property. Pastoralists acquire land as private property through the forced dispossession of peasants who once shared a portion of it in a form of public ownership. Capital is the secondary form of property, the privatization of productive assets in the form of tools, machines and working materials. Capital, unlike land, is not in fixed supply or disposition. It can be made and remade, moved, aggregated and dispersed. An infinitely greater degree of potential can be released from the world as a productive resource once the abstract plane of property includes both land and capital — such is capital's "advance."

18. The capitalist class recognizes the value of the hack in the abstract, whereas the pastoralists were slow to appreciate the productivity that can flow from the application of abstraction to the production process. Under the influence of capital, the state sanctions forms of intellectual property, such as patents and copyrights, that secure an independent existence for hackers as a class, and a flow of innovations in culture as well as science from which development issues. Information, once it becomes a form of property, develops beyond a mere support for capital — it becomes the basis of a form of accumulation in its own right.

19. Hackers must calculate their interests not as owners, but as producers, for this is what distinguishes them from the vectoralist class. Hackers do not merely own, and profit by owning information. They produce new information, and as producers need access to it free from the absolute domination of the commodity form. Hacking as a pure, free experimental activity must be free from any constraint that is not self-imposed. Only out of its liberty will it produce the means of producing a surplus of liberty and liberty as a surplus.

20. Private property arose in opposition not only to feudal property, but also to traditional forms of the gift economy, which were a fetter to the increased productivity of the commodity economy. Qualitative, gift exchange was superseded by quantified, monetized exchange. Money is the medium through which land, capital, information and labor all confront each other as abstract entities, reduced to an abstract plane of measurement. The gift becomes a marginal form of property, everywhere invaded by the commodity, and turned towards mere consumption.

The gift is marginal, but nevertheless plays a vital role in cementing reciprocal and communal relations among people who otherwise can only confront each other as buyer and sellers of commodities. As vectoral production develops, the means appear for the renewal of the gift economy. Everywhere that the vector reaches, it brings into the orbit of the commodity. But everywhere the vector reaches, it also brings with it the possibility of the gift relation.

21. The hacker class has a close affinity with the gift economy. The hacker struggles to produce a subjectivity that is qualitative and singular, in part through the act of the hack itself. The gift, as a qualitative exchange between singular parties allows each party to be recognized as a singular producer, as a subject of production, rather than as a commodified and quantified object. The gift expresses in a social and collective way the subjectivity of the production of production, whereas commodified property represents the producer as an object, a quantifiable commodity like any other, of relative value only. The gift of information need not give rise to conflict over information as property, for information need not suffer the artifice of scarcity once freed from commodification.

22. The vectoralist class contributed, unwittingly, to the development of the vectoral space within which the gift as property could return, but quickly recognized its error. As the vectoral economy develops, less and less of it takes the form of a social space of open and free gift exchange, and more and more of it takes the form of commodified production for private sale. The vectoralist class can grudgingly accommodate some margin of socialized information, as the price it pays in a democracy for the furtherance of its main interests. But the vectoralist class quite rightly sees in the gift a challenge not just to its profits but to its very existence. The gift economy is the virtual proof for the parasitic and superfluous nature of vectoralists as a class.

< vector >

23. In epidemiology, a vector is the particular means by which a given pathogen travels from one population to another. Water is a vector for cholera, bodily fluids for HIV. By extension, a vector may be any means by which information moves. Telegraph, telephone, television, telecommunications: these terms name not just particular vectors, but a general abstract capacity that they bring into the world and expand. All are forms of telesthesia, or perception at a distance. A given media vector has certain fixed properties of speed, bandwidth, scope and scale, but may be deployed anywhere, at least in principle. The uneven development of the vector is political and economic, not technical.

24. With the commodification of information comes its vectoralization. Extracting a surplus from information requires technologies capable of transporting information through space, but also through time. The archive is a vector through time just as communication is a vector that crosses space. The vectoral class comes into its own

once it is in possession of powerful technologies for vectoralizing information. The vectoral class may commodify information stocks, flows, or vectors themselves. A stock of information is an archive, a body of information maintained through time that has enduring value. A flow of information is the capacity to extract information of temporary value out of events and to distribute it widely and quickly. A vector is the means of achieving either the temporal distribution of a stock, or the spatial distribution of a flow of information. Vectoral power is generally sought through the ownership of all three aspects.

25. The vectoral class ascends to the illusion of an instantaneous and global plane of calculation and control. But it is not the vectoralist class that comes to hold subjective power over the objective world. The vector itself usurps the subjective role, becoming the sole repository of will toward a world that can be apprehended only in its commodified form. The reign of the vector is one in which any and every thing can be apprehended as a thing. The vector is a power over all of the world, but a power that is not evenly distributed. Nothing in the technology of the vector determines its possible use. All that is determined by the technology is the form in which information is objectified.

26. The vectoral class struggles at every turn to maintain its subjective power over the vector, but as it continues to profit by the proliferation of the vector, some capacity over it always escapes control. In order to market and profit by the information it peddles over the vector, it must in some degree address the vast majority of the producing classes as subjects, rather than as objects of commodification. The hacker class seeks the liberation of the vector from the reign of the commodity, but not to set it indiscriminately free. Rather, to subject it to collective and democratic development. The hacker class can release the virtuality of the vector only in principle. It is up to an alliance of all the productive classes to turn that potential to actuality, to organize themselves subjectively, and use the available vectors for a collective and subjective becoming.

< education >

27. Education is slavery, it enchains the mind and makes it a resource for class power. When the ruling class preaches the necessity of an education it invariably means an education in necessity. Education is not the same as knowledge. Nor is it the necessary means to acquire knowledge. Education is the organization of knowledge within the constraints of scarcity. Education "disciplines" knowledge, segregating it into homogenous "fields," presided over by suitably "qualified" guardians charged with policing the representation of the field. One may acquire an education, as if it were a thing, but one becomes knowledgeable, through a process of transformation. Knowledge, as such, is only ever partially captured by education, its practice always eludes and exceeds it.

28. The pastoralist class has resisted education, other than as indoctrination in obedience. When capital required "hands" to do its dirty work, the bulk of education was devoted to training useful hands to tend the machines, and docile bodies who would accept as natural the social order in which they found themselves. When capital required brains, both to run its increasingly complex operations and to apply themselves to the work of consuming its products, more time spent in the prison house of education was required for admission to the ranks of the paid working class.

29. The so-called middle class achieve their privileged access to consumption and security through education, in which they are obliged to invest a substantial part of their income. But most remain workers, even though they work with information rather than cotton or metal. They work in factories, but are trained to think of them as offices. They take home wages, but are trained to think of it as a salary. They wear a uniform, but are trained to think of it as a suit. The only difference is that education has taught them to give different names to the instruments of exploitation, and to despise those their own class who name them differently.

30. Where the capitalist class sees education as a means to an end, the vectoralist class sees it as an end in itself. It sees opportunities to make education a profitable industry in its own right, based on the securing of intellectual property as a form of private property. To the vectoralists, education, like culture, is just "content" for commodification.

31. The hacker class have an ambivalent relationship to education. The hacker class desires knowledge, not education. The hacker comes into being though the pure liberty of knowledge in and of itself. The hack expresses knowledge in its virtuality, by producing new abstractions that do not necessarily fit the disciplinary regime of managing and commodifying education. Hacker knowledge implies, in its practice, a politics of free information, free learning, the gift of the result to a network of peers. Hacker knowledge also implies an ethics of knowledge subject to the claims of public interest and free from subordination to commodity production. This puts the hacker into an antagonistic relationship to the struggle of the capitalist class to make education an induction into wage slavery.

32. Only one intellectual conflict has any real bearing on the class issue for hackers: Whose property is knowledge? Is it the role of knowledge to authorize subjects through education that are recognized only by their function in an economy by manipulating its authorized representations as objects? Or is it the function of knowledge to produce the ever-different phenomena of the hack, in which subjects become other than themselves, and discover the objective world to contain potentials other than it appears?

< hacking >

33. The virtual is the true domain of the hacker. It is from the virtual that the hacker produces ever-new expressions of the actual. To the hacker, what is represented as being real is always partial, limited, perhaps even false. To the hacker there is always a surplus of possibility expressed in what is actual, the surplus of the virtual. This is the inexhaustible domain of what is real without being actual, what is not but which may be. To hack is to release the virtual into the actual, to express the difference of the real.

34. Through the application of abstraction, the hacker class produces the possibility of production, the possibility of making something of and with the world — and of living off the surplus produced by the application of abstraction to nature — to any nature. Through the production of new forms of abstraction, the hacker class produces the possibility of the future — not just "the" future, but an infinite possible array of futures, the future itself as virtuality.

35. Under the sanction of law, the hack becomes a finite property, and the hacker class emerges, as all classes emerge, out of a relation to a property form. Like all forms of property, intellectual property enforces a relation of scarcity. It assigns a right to a property to an owner at the expense of non-owners, to a class of possessors at the expense of the dispossessed.

36. By its very nature, the act of hacking overcomes the limits property imposes on it. New hacks supersede old hacks, and devalues them as property. The hack as new information is produced out of already existing information. This gives the hacker class an interest in its free availability more than in an exclusive right. The immaterial nature of information means that the possession by one of information need not deprive another of it.

37. To the extent that the hack embodies itself in the form of property, it gives the hacker class interests quite different from other classes, be they exploiting or exploited classes. The interest of the hacker class lies first and foremost in a free circulation of information, this being the necessary condition for the renewed statement of the hack. But the hacker class as class also has an interest in the representation of the hack as property, as something from which a source of income may be derived that gives the hacker some independence from the ruling classes.

38. The very nature of the hack gives the hacker a crisis of identity. The hacker searches for a representation of what it is to be a hacker in the identities of other classes. Some see themselves as vectoralists, trading on the scarcity of their property. Some see themselves as workers, but as privileged ones in a hierarchy of wage earners. The hacker class has produces itself as itself, but not for itself. It does not (yet) possess a consciousness of its consciousness. It is not aware of its own virtuality. It has to distinguish between its competitive interest in the hack, and its col-

lective interest in discovering a relation among hackers that expresses an open and ongoing future.

< information >

39. Information wants to be free but is everywhere in chains. Information is the potential of potential. When unfettered it releases the latent capacities of all things and people, objects and subjects. Information is indeed the very potential for there to be objects and subjects. It is the medium in which objects and subjects actually come into existence, and is the medium in which their virtuality resides. When information is not free, then the class that owns or controls it turns its capacity toward its own interest and away from its own inherent virtuality.

40. Information has nothing to do with communication, or with media. "We do not lack communication. On the contrary, we have too much of it. We lack creation. We lack resistance to the present." Information is precisely this resistance, this friction. At the urgings of the vectoralist class, the state recognizes as property any communication, any media product with some minimal degree of difference recognizable in commodity exchange. Where communication merely requires the repetition of this commodified difference, information is the production of the difference of difference.

41. The arrest of the free flow of information means the enslavement of the world to the interests of those who profit from information's scarcity, the vectoral class. The enslavement of information means the enslavement of its producers to the interests of its owners. It is the hacker class that taps the virtuality of information, but it is the vectoralist class that owns and controls the means of production of information on an industrial scale. Privatizing culture, education and communication as commodified content, distorts and deforms its free development, and prevents the very concept of its freedom from its own free development. While information remains subordinated to ownership, it is not possible for its producers to freely calculate their interests, or to discover what the true freedom of information might potentially produce in the world.

42. Free information must be free in all its aspects — as a stock, as a flow, and as a vector. The stock of information is the raw material out of which history is abstracted. The flow of information is the raw material out of which the present is abstracted, a present that forms the horizon the abstract line of an historical knowledge crosses, indicating a future in its sights. Neither stocks nor flows of information exist without vectors along which they may be actualized. The spatial and temporal axes of free information must do more offer a representation of things, as a thing apart. They must become the means of coordination of the statement of a movement, at once objective and subjective, capable of connecting the objective representation of things to the presentation of a subjective action.

43. It is not just information that must be free, but the knowledge of how to use it. Information in itself is a mere thing. It requires an active, subjective capacity to become productive. Information is free not for the purpose of representing the world perfectly, but for expressing its difference from what is, and for expressing the cooperative force that transforms what is into what may be. The test of a free society is not the liberty to consume information, nor to produce it, nor even to implement its potential in private world of one's choosing. The test of a free society is the liberty for the collective transformation of the world through abstractions freely chosen and freely actualized.

< representation >

44. All representation is false. A likeness differs of necessity from what it represents. If it did not, it would be what it represents, and thus not a representation. The only truly false representation is the belief in the possibility of true representation. Critique is not a solution, but the problem itself. Critique is a police action in representation, of service only to the maintenance of the value of property through the establishment of its value.

45. The politics of representation is always the politics of the state. The state is nothing but the policing of representation's adequacy to the body of what it represents. Even in its most radical form, the politics of representation always presupposes an abstract or ideal state that would act as guarantor of its chosen representations. It yearns for a state that would recognize this oppressed ethnicity, or sexuality, but which is nevertheless still a desire for a state, and a state that, in the process, is not challenged as an statement of class interest, but is accepted as the judge of representation.

46. And always, what is excluded even from this enlightened, imaginary state, would be those who refuse representation, namely, the hacker class as a class. To hack is to refuse representation, to make matters express themselves otherwise. To hack is always to produce a difference, if only a minute difference, in the production of information. To hack is to trouble the object or the subject, by transforming in some way the very process of production by which objects and subjects come into being and recognize each other by their representations.

47. The politics of information, of knowledge, advances not through a critical negation of false representations but a positive politics of the virtuality of statement. The inexhaustible surplus of statement is that aspect of information upon which the class interest of hackers depends. Hacking brings into existence the inexhaustible multiplicity of all codes, be they natural or social, programmed or poetic. But as it is the act of hacking that composes, at one and the same time, the hacker and the hack, hacking recognizes no artificial scarcity, no official license, no credentialing police force other than that composed by the gift economy among hackers themselves.

48. A politics that embraces its existence as statement, as affirmative difference, not as negation can escape the politics of the state. To ignore or plagiarize representation, to refuse to give it what it claims as its due, is to begin a politics of statelessness. A politics which refuses the state's authority to authorize what is a valued statement and what isn't. A politics which is always temporary, always becoming something other than itself. Even useless hacks may come, perversely enough, to be valued for the purity of their uselessness. There is nothing that can't be valued as a representation. The hack always has to move on.

49. Everywhere dissatisfaction with representations is spreading. Sometimes its a matter of breaking a few shop windows, sometimes of breaking a few heads. So-called "violence" against the state, which rarely amounts to more than throwing rocks at its police, is merely the desire for the state expressed in its masochistic form. Where some call for a state that recognizes their representation, others call for a state that beats them to a pulp. Neither is a politics that escapes the desire cultivated within the subject by the educational apparatus.

50. Sometimes direct democracy is posited as the alternative. But this merely changes the moment of representation — it puts politics in the hands of claimants to an activist representation, in place of an electoral one. Sometimes what is demanded of the politics of representation is that it recognize a new subject. Minorities of race, gender, preference demand the right to representation. But soon enough they discover the cost. They must now police the meaning of this representation, and police the adherence of its members to it. Even at its best, in its most abstract form, on its best behavior, the colorblind, gender-neutral, multicultural state just hands the value of representation over to the commodity form. While this is progress, particularly for those formerly oppressed by the state's failure to recognize their identity as legitimate, it stops short at the recognition of expressions of subjectivity that seeks to become something other than a representation that the state can recognize and the market can value.

51. But there is something else hovering on the horizon of the representable. There is a politics of the unrepresentable, a politics of the presentation of the non-negotiable demand. This is politics as the refusal of representation itself, not the politics of refusing this or that representation. A politics which, while abstract, is not utopian. In its infinite and limitless demand, it may even be the best way of extracting concessions precisely through its refusal to put a name — or a price — on what revolt desires.

< revolt >

52. The revolts of 1989 are the signal events of our time. What the revolts of 1989 achieved was the overthrow of regimes so impervious to the recognition of the value of the hack that they had starved not only their hackers but also their workers and farmers of any increase in the surplus. With their cronyism and kleptocra-

cy, their bureaucracy and ideology, their police and spies, they starved even their pastoralists and capitalists of innovative transformation and growth.

53. The revolts of 1989 overthrew boredom and necessity. At least for a time. They put back on the world historical agenda the limitless demand for free statement. At least for a time. They revealed the latent destiny of world history to express the pure virtuality of becoming. At least for a time, before new states cobbled themselves together and claimed legitimacy as representations of what revolt desired. The revolts of 1989 opened the portal to the virtual, but the states that regrouped around this opening soon closed it. What the revolts really achieved was the making of the world safe for vectoral power.

54. The so-called anti-globalization protests of the 90s are a ripple caused by the wake of these signal events, but a ripple that did not know the current to which it truly belonged. This movement of revolt in the overdeveloped world identifies the rising vectoral power as a class enemy, but all too often it allowed itself to be captured by the partial and temporary interests of local capitalist and pastoralist classes. It was a revolt is in its infancy that has yet to discover the connection between its engine of limitless desire and free statement, and the art of making tactical demands.

55. The class struggle within nations and the imperial struggle between nations has taken shape as two forms of politics. One kind of politics is regressive. It seeks to return to an imagined past. It seeks to use national borders as a new wall, a neon screen behind which unlikely alliances might protect their existing interests in the name of a glorious past. The other form is the progressive politics of movement. The politics of movement seeks to accelerate toward an unknown future. It seeks to use international flows of information, trade or activism as the eclectic means for struggling for new sources of wealth or liberty that overcomes the limitations imposed by national coalitions.

56. Neither of these politics corresponds to the old notion of a left or right, which the revolutions of 1989 have definitively overcome. Regressive politics brings together luddite impulses from the left with racist and reactionary impulses from the right in an unholy alliance against new sources of power. Progressive politics rarely takes the form of an alliance, but constitutes two parallel processes locked in a dialogue of mutual suspicion, in which the liberalizing forces of the right and the social justice and human rights forces of the left both seek non-national and transnational solutions to unblocking the system of power which still accumulates at the national level.

57. There is a third politics, which stands outside the alliances and compromises of the post-'89 world. Where both progressive and regressive politics are representative politics, which deal with aggregate party alliances and interests, this third politics is a stateless politics, which seeks escape from politics as such. A politics of the hack, inventing relations outside of representation.

58. Expressive politics is a struggle against commodity property itself. Expressive politics is not the struggle to collectivize property, for that is still a form of property. Expressive politics is the struggle to free what can be free from both versions of the commodity form — its totalizing market form, and its bureaucratic state form. What may be free from the commodity form altogether is not land, not capital, but information. All other forms of property are exclusive. The ownership by one excludes, by definition, the ownership by another. But information as property may be shared without diminishing anything but its scarcity. Information is that which can escape the commodity form.

59. Politics can become expressive only when it is a politics of freeing the virtuality of information. In liberating information from its objectification as a commodity, it liberates also the subjective force of statement. Subject and object meet each other outside of their mere lack of each other, by their desire merely for each other. Expressive politics does not seek to overthrow the existing society, or to reform its larger structures, or to preserve its structure so as to maintain an existing coalition of interests. It seeks to permeate existing states with a new state of existence, spreading the seeds of an alternative practice of everyday life.

— Version 4.0 edited by Joanne Richardson for SUBSOL. A much longer Version 2.0 can be found online at textz.com (www.textz.com) Version 3.0 is still off-line.

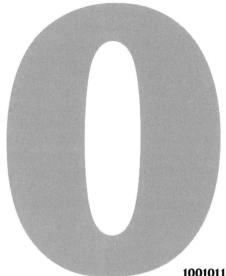

Contributors

||

100101110101101.ORG (es) /
www.0100101110101101.ORG / 01001@0100101110101101.ORG
Anonymous net.art group whose work (mock-site of the Vatican, copy of Hell.com, a closed Net art museum and of Art.Teleportacia, the first art gallery on the Net) raises questions about the relation between the copy and the original and the transparency of data. Most recent project life_sharing gives all users free 24/7 access to their computer.

Alex Adriaansens, V2_ (nl) / www.v2.nl / alex@v2.nl
Until 1994 active as an artist working in the field of mediatechnology. One of the founders and currently the director of V2_Organisation, Institute for Unstable Media and organizer of DEAF (Dutch Electronic Art Festival). Serves on the advisory board of the Berlage Architecture Institute, and the editorial board of ARCHIS, an international magazine for art and architecture.

Kestutis Andrasiunas, Institutio Media (lt) / www.o-o.lt / ke_an@o-o.lt
Born 1973, studied philosophy and sculpture. Co-founded Institutio Media with Mindaugas Gapsevicius in 1998. Institutio Media, which has no real place, but was founded in Vilnius, is an attempt to transfer the structure of an institution to the Internet and study its functioning. The institution includes a mailing list, web magazine, and internet radio.

Inke Arns, mikro (de) / www.mikro.org, www.v2.nl/~arns / inke@snafu.de
Theorist, independent media art curator, currently writing her PhD at Humboldt University. Founding member of the Syndicate network, the Berlin-based "mikro" association for the advancement of media cultures, and of SPECTRE, a mailing list for media culture in Deep Europe. Author of numerous essays and of the books Neue Slowenische Kunst and Net Cultures.

Association Apsolutno (yu) / www.apsolutno.org / apsolutno@apsolutno.org
Apsolutno was founded in 1993 in Novi Sad, Yugoslavia and includes Zoran Pantelic, Dragan Rakic, Bojana Petric and Dragan Miletic. Productions in various media (video, printed mate-

rials, installations, site specific projects, audio and web) reflect an interdisciplinary research into cultural, social and political absolutely real facts.

Autonome a.f.r.i.k.a Gruppe (de) / www.contrast.org/KG / afrika@contrast.org
Anonymous group of communication guerillas, activists and non-artists living in different German peripheries (neither in Berlin nor in Hamburg nor in the internet). In 1997 a.f.r.i.k.a published their *Kommunication Guerilla Handbook* (in German, 2001 translated in Spanish and Italian).

Franco Berardi Bifo (it) / www.rekombinant.org / lop1912@iperbole.bologna.it
Philosopher and political activist since the days of autonomia and Radio Alice. Co-founder of Rekombinant, a web environment of informal communication that does not add up to identity. Author of numerous books, including *Cyberpunk, The Panther and the Rhizome, Politics of Mutation, Philosophy and Politics in the Twilight of Modernity,* and *The Factory of Unhappiness.*

Luther Blissett (it) / www.lutherblissett.net / someone@lutherblissett.net
The Luther Blissett multiple name project was initiated in 1994 in Italy, and has since then been joined by dozens of mail-artists, underground reviews, poets, performers and squatters' collectives in cities throughout Europe. Luther Blissett committed ritual suicide at the end of 1999 and no longer exists.

Brett Bloom (us) / www.temporaryservices.org / nobudget@megsinet.net
Artist and activist working with the Chicago-based Temporary Services and Department of Space and Land Reclamation, and the Hamburg-based projektgruppe. He helps run Groups and Spaces, a platform for collecting and distributing information on independent groups and non-commercial spaces. He is a regular contributor to *TENbyTEN* and *NU* magazines.

Luchezar Boyadjiev (bg) / luchezb@cblink.net
Trained as an art historian and theorist, became an "artist" after 1989. Founding member of Institute of Contemporary Art. Has exhibited and lectured internationally, including After the Wall (Moderna, Stockholm), Temp-Balkania (Kiasma, Helsinki), Revolting (Manchester), Money/Nations (Zurich), Communication Front (Plovdiv), and Hybrid Workspace, documenta X (Kassel).

Alexander Brener & Barbara Schurz (ru/at) / brener_schurz@yahoo.com
Alexander Brener and Barbara Schurz are poets, cartoonists, novelists, theorists, interventionists, political activists, singers. Together they published books in German, Russian and English, among others: *Demolish Serious Culture!!!* (Vienna 2000), *Tattoos auf Gefängnissen* (Vienna 2000) and *Bukaka Spat Here* (London 2002).

Kristine Briede, K@2 (lv) / www.karosta.org / kristal@parks.lv
Member of Locomotive, a filmmaker's collective. In 2000 co-founded, along with Carl Biorsmark, The Culture and Information Center K@2 in Karosta, Liepaja, a former Soviet army base. K@2 organizes workshops for children under the Art for Social Change program, filmmakers meetings and other cultural events in collaboration with RIXC, the New Media and Culture Center in Riga.

Vanni Brusadin, d-i-n-a (es/it) / www.d-i-n-a.net / dina@d-i-n-a.net
Member of d-i-n-a, an informal network of 5 artists and researchers working on network communication as a basis for public actions and artistic experimentation. The group has organized the international net.art and net culture festival digital-is-not-analog (2000 and 2001) and events and workshop on net culture, hacktivism and net art. Born in Italy, he lives now in Barcelona.

Candida TV (it) / macchina@kyuzz.org, candida@tiscalinet.it
Candida is a group of 12 people, fusing the experiences of self-managed social centers and technical knowledge in cinema and video production. Organized the O.F.F (Overground Fiction Festival) in Forte Prenestino, had a program on television for 9 weeks (tried to destroy the simulation mainstream) and works in suburban areas of Rome teaching people video and computer technologies.

Eda Cufer (si) / www.ljudmila.org/embassy / eda@mail.ljudmila.org
Co-founder of Scipion Nasice Sisters Theater and Red Pilot Theater (1983-1988), and has been part of the NSK collective since 1984. Since 1989 collaborated with Irwin on various conceptual projects, including NSK State in Time, the NSK Embassy Moscow and Transnacionala. Editor of the follow-up books to the latter two projects. Lives and works in Ljubljana.

CUKT (pl) / cukt.art.pl / peter_style@cukt.ikp.pl, drakcukt@idg.com.pl
The Central Office of Technical Culture, C.U.K.T was established in 1995 as a meta-national institution that has made real manifestations in socio-political life, contributing to educational programs, using its own stamps and official paraphernalia, and promoting its own presidential candidate. They work in techno clubs, not galleries, and do not consider themselves artists.

Francesca da Rimini (au) / sysx.org/gashgirl, www.thing.net/~dollyoko / dollyoko@thing.net
Aka GashGirl. Has been working in the field of new media since 1984 as an arts manager, curator, corporate geisha girl, cyberfeminist, puppet mistress and ghost. One of the original members of VNS Matrix, the Australian cyberfeminist group. Squandered time investigating the artistic and erotic potential of email relationships, online virtual communities and web-based narrative architectures.

Manuel DeLanda (us/mx) / delanda@pipeline.com
Born in 1952 in Mexico City, has lived in Manhattan since 1975, working as an independent filmmaker, computer artist, programmer, and autodidactic philosopher. Author of numerous essays on nonlinear dynamics, theories of self-organization, artificial intelligence and of the books *War in the Age of Intelligent Machines* and *A Thousand years on Nonlinear History*.

Ricardo Dominguez, EDT (us) / bbs.thing.net / www.thing.net/~rdom / rdom@thing.net
Former member of Critical Art Ensemble and co-founder of Electronic Disturbance Theater (EDT), a group who developed virtual-sit-in technologies in solidarity with the Zapatistas. Senior editor of The Thing. Has collaborated on a number of international net-art projects: with Francesca da Rimini on Dollspace and with Diane Ludin on the Aphanisis Project.

Miklos Erhardt (hu) / www.c3.hu/collection/homeless / mikloserhardt@yahoo.com
Born in Budapest, 1966. Intermedia artist. Has been collaborating with Dominic Hislop on different art projects since 1997 ('Inside Out', 1998-99). Other collaborations include the doc-

umentary 'Enzima Rosso' (2001), directed with Claudio Feliziani. Former board director member of the Balazs Bela Studio, the oldest artist-organized independent film studio in Central-Europe.

Matthew Fuller (uk) / bak.spc.org/iod / fuller@xs4all.nl
Worked with Simon Pope and Colin Green as I/O/D in 1990s. Currently working with Graham Harwood of Mongrel on TEXT-FM, the software for an open radio system where any text message sent to a certain number will be immediately spoken by a computer and broadcast. Author of numerous essays and the novel *ATM*. Lives in South London.

Coco Fusco (us) / www.thing.net/~cocofusco
New York-based interdisciplinary artist and writer. Author of *English is Broken Here* (1995), *The Bodies That Were Not Ours and Other Writings* (2001) and editor of *Corpus Delecti: Performance Art of the Americas* (1999). Director of graduate study for the Visual Arts Division of Columbia University's School of the Arts.

Alexander R. Galloway (us) / www.rhizome.org / alex@rhizome.org
Director of Content & Technology at Rhizome.org, a leading online platform for new media art. Currently working on a web-based artwork called Carnivore — after the FBI software of the same name — that uses packet-sniffing technologies to create vivid depictions of raw data.

David Garcia (nl) / www.next5minutes.org / davidg@xs4all.nl
Founding member of Amsterdam's Time Based Arts, initiator of Next 5 Minutes (1994-2003), a series of international conferences and exhibitions on electronic communications and political culture, and co-editor of Net.congestion (International Festival of Streaming Media). Contributor to Virtual Case Book (NYU Center for Media), a project analyzing the impact of September 11th on tactical media.

Rishab Aiyer Ghosh (in/nl) / www.firstmonday.org, www.dxm.org / rishab@dxm.org
One of the founders (1995) and current Managing Editor of First Monday, the peer-reviewed journal of the internet. Worked as analyst, journalist and researcher and has been widely published in India and abroad. Programme Leader at the International Institute of Infonomics, University of Maastricht, where he researches non-monetary economic activity with a focus on free/open source software.

Heidi Grundmann, Kunstradio (at) / kunstradio.at / hgrundmann@thing.at
Created the radio program Kunstradio (in 1987), a 55 minute weekly program broadcast on O1, the cultural channel of the Austrian National Radio/TV. Organized several international symposia and exhibitions related to art practice in the electronic media, especially radio, TV and the internet. Author and editor of publications on new media and telecommunications.

Jesse Hirsh (ca) / www.openflows.org, jesse.openflows.org, www.tao.ca / jesse@openflows.org
Activist and analyst of open media based in Toronto. Founder of the media collective TAO, and director of Openflows.org, a professional services firm specializing in free software for open source intelligence. Educated at the McLuhan Program at the University of Toronto, he has been speaking and publishing in Europe, North & South America on the political economy of culture and technology.

Institute for Transacoustic Research (at) / www.iftaf.org / iftaf@iftaf.org
IFTAF explores the borders between acoustics and science, art and everyday life. IFTAF is
Nikolaus Gansterer (experimental media designer), Matthias Meinharter (former ethnologist,
performance artist, invention designer), Jörg Piringer (computer scientist, sound poet, musi-
cian) and Ernst Reitermaier (constructive realist, saxophone- and cucumber-player, percus-
sionist, sometime samurai).

Institute of Construction & Deconstruction (ro) / office@theinstitute.ro
The Institute (Ioan Godeanu, Cosmin Gradinaru, Sergiu Negulici and Dan Panaitescu) is not an
institution with policies, regulations, or functions. It was born as a reaction to a rigid and
intolerant regime, out of a desire to create a free space for exchanging ideas and a way of
sustaining an independent stream of opinions. Supported entirely by private means.

Irwin (si) / www.ljudmila.org/embassy / miran@kud-fp.si
Irwin (Dusan Mandic, Miran Mohar, Andrej Savski, Roman Uranjek and Borut Vogelnik) came
together as a group in Ljubljana in 1983, and has been a co-founder of NSK. The group's
work is based on "retro principle" – the syncretic coexistence of various artistic styles from
the historical avant-gardes, popular national imagery, modernism and the visual production
of totalitarian regimes.

Alexei Isaev, MediaArtLab (ru) / www.danet.ru, www.da-da-net.ru /
mediatheque@danet.ru
Media artist, theorist and co-founder of MediaArtLab in 1997 along with Olga Shisko and Tania
Gorucheva. Currently MediaArtLab also includes Olga Rumyantseva, Irina Lavrukhina, and
Antonina Titova. MediaArtLab organizes workshops, conferences and festivals on internet
and electronic media to bring public attention to the impact of new technologies upon gen-
eral cultural processes in Russia.

Oleg Kireev (ru) / www.getto.rema.ru / kireev2000@cityline.ru
Critic, curator, and editor of the "ghetto" project dedicated to cultural and political analyses. Has
produced two books, *Against all P's* and *Lifestyle*, authored several essays on arts, politics and
new media (in Russian and international press) and participated in a number of civil dis-
obedience actions & campaigns. Lives in Moscow.

Eric Kluitenberg (nl) / www.balie.nl, www.next5minutes.org, net.congestion.org /
epk@xs4all.nl
Theorist, writer, and organizer, currently based at De Balie – Centre for Culture and Politics in
Amsterdam. Published extensively on culture, new media, and cultural politics. Organized
P2P – New Media Culture conference, third Next 5 Minutes conference on tactical media,
Tulipomania DotCom – A Critique of the New Economy, and net.congestion –
International Festival of Streaming Media.

Tetsuo Kogawa (jp) / anarchy.k2.tku.ac.jp / tetsuo@goethe.or.jp
Introduced free radio to Japan in the 1980s, and is widely known for his blend of criticism, per-
formance and activism. Author of over 30 books on media culture, film, urban space and
micro politics. Most recently he has combined the experimental and pirate aesthetics of the
Mini-FM movement with internet streamed media.

CONTRIBUTORS

Piotr Krajewski, WRO Center (pl) / wro@wro.getin.pl
Co-founder of Open Studio Co-operative (1988) an independent organization devoted to media art and artistic communication. Founder of WRO Foundation (1998) and artistic director of WRO International Media Art Biennale. Author and commissioner of art programs for Channel 2 of Polish State TV and of several publications in arts magazines, catalogues in Poland and abroad.

Joasia Krysa (uk/pl) / www.i-dat.org/projects/hybrid, caiia-star.net / joasia@caiia-star.net
Researcher at STAR (Science, Technology, Art Research), I-dat (Institute of Digital Art and Technology) and Senior Lecturer in Interactive Media at University of Plymouth, UK. Collaborated with WRO Media Centre on several editions of WRO Biennale. Currently devising series of projects investigating relationship between digital art, industry and new models of cultural practices.

Michael Linton (ca) / www.openmoney.org / mwl@openmoney.org
Active in community currency development since 1982 when he designed and began the first LETSystem. Previously he was a physicist, chemical engineer, computer programmer, research psychologist, truck-driver, ski instructor, builder, fisherman, logger and retailer. Now a systems designer, working primarily on systems for open money and open society.

Geert Lovink (au/nl) / www.nettime.org, www.waag.org / geert@xs4all.nl
Worked as independent theorist, producer, publisher, radio-maker. Member of Adilkno, from which two books have appeared in English translation: *Cracking the Movement* and *The Media Archive*. In 1995, co-founded the international mailinglist Nettime, and co-edited the Nettime anthology *README!*. Recently working on topics related to the New Economy. Based in Canberra, Australia.

Sebastian Luetgert (de) / www.rolux.org / www.textz.com / sebastian@textz.com
Co-moderator of Nettime, member of mikro and bootlab. Projects: rolux.org, textz.com and project Gnutenberg, and "Last Tuesday", where people can "exchange mp3 files, beta-test new viruses from Asia or vote for the most stupid new dot-com brand." Author of "2 x 5 Years of German Internet" and other texts on the contradictions of the network society.

Kristian Lukic, kuda.org (yu) / specimen@eunet.yu
Art and media explorer, working in New Media Center kuda.org since 2001. Kuda members include artists, theorists, media activists and informatics engineers who are committed to fostering a media-conscious society. The center provides participants and audiences with a unique platform for producing, understanding, and simply enjoying new media arts and new technologies.

Mia Makela, FiftyFifty (es) / www.fiftyfifty.org / mia@fiftyfifty.org
Works with video, multimedia, performance. Performs realtime visuals under the artist name SOLU. Her latest cd-rom PASSenger has been widely presented in European media festivals. Other activities include organizing shows, presentations, and workshops on media culture as part of FiftyFifty.org. Lives in Barcelona, Spain.

Nathan Martin, CDL (us) / www.carbondefense.org, www.hactivist.com / nathan@hactivist.com
Founding member of the Carbon Defense League (CDL) and the Hactivist.com tactical media network. Since 1997, the CDL has been working with deviants from multiple disciplines to

stimulate discourse through writing, touring, and tampering. The CDL directs much of its work towards traditional activists in an aim to celebrate diverse tactics in the underground.

Duna Maver (hu/ro/us) / dunamaver@yahoo.com
Grew up in Hungary, Romania and the US. Was a member of the art/activist group Metapole in the late 1980s in Brooklyn, worked as a sometime graphic designer, and now employed as part-time theorist. Current performance piece: living without a home, center or routine for two years. In between, wrote *Twilight of the Idols*, a book on the dialectic of the net.avant.garde.

Stefan Merten, Oekonux (de) / www.oekonux.de, www.oekonux.org / smerten@oekonux.de
Computer scientist, software engineer, and activist engaged in the political scene in Germany. Founded Oekonux (oekonomie + linux), a project that explores the possibilities of the principles of free software to lead to a form of production and society beyond capitalism. Oekonux activities include maintaining the mailing list (German and English) and periodic international conferences.

Nat Muller, V2_ (nl) / www.v2.nl, www.axisvm.nl, f0.am / nat@v2.nl
Former sex educator, bookshopkeeper and free-lance journalist writing on the subjects of gender, new media and art. Project coordinator and events organizer at V2_Organisation. Editor of Ctrl+Shift Art - Ctrl+Shift Gender: Convergences of New Media, Art and Gender (Axis, 2000). Researcher at Theory Dept. of Jan van Eyck Academy, Maastricht, and founding member of Dutch division of F0am.

Multimedia Institute [mi2] (hr) / mama.mi2.hr / zblace@mi2.hr
Net.culture center mama is [mi2]'s public interface – an internet cafe and presentation space for contemporary artistic, social, political, organizational, and technological experiments. [mi2] also houses a media lab, provides net services and infrastructural support to other NGOs in the area, publishes texts and newsletters, and invades other media with "tactical" issues.

Sylvie Myerson & Vidyut Jain, Sandbox (us) / sandbox@echonyc.com
Sylvie Myerson is the editor and Vidjut Jain the art director of *Sandbox Magazine*. The magazine is part of Sandbox Open Arts, an NGO that encourages experimentation in the visual arts, performing arts, music, video, media arts and literature. Each issue is theme-based and released in conjunction with a performance or installation event. The organization is run entirely by volunteers.

Kenta Ohji, NAM (fr/jp) / www.q-project.org / kentao@noos.fr
Philosopher and co-author of the book *Éprouver l'universel, Essai de géophilosophie*. Member of NAM, an association of individuals in Japan who engage in counter-acts against the Capitalist-Nation-State by gathering dispersed social movements in different sectors (labor, gender, environment, art). Q-project, one of the NAM initiatives, is now establishing an internet-run LETS community.

Cesare Pietroiusti (it) /www.undo.net/oreste / cesarepietroiusti@hotmail.com
Artist whose work focuses on problematic and paradoxical situations that are hidden in common relationships and ordinary acts. Author of the small book *Non-functional thoughts*. Works with the Oreste project, a variable group of people who try to create free and operative spaces

for developing ideas and projects, artworks and exhibitions, through meetings and communitarian experiences.

Simon Pope (uk) / bak.spc.org/iod, bak.spc.org/ice / spope@uwic.ac.uk
Artist, writer, lecturer, software designer, former member of I/O/D, the group that won a Webby in 2000 for 'The Web Stalker'. Currently Senior Lecturer in Interactive Media at UWIC Business School, Cardiff. Producer for BBC's 'Art for Networks' site which explored the work of artists creating both physical and virtual networks. Author of *London Walking*, a handbook for survival.

Joanne Richardson (ro/us) / subsol.c3.hu / subsol@mi2.hr
Born in Bucharest. Ex-philosopher, film and media theorist and freelance organizer. Organized some large festivals & conferences on new tech and independent media in Croatia & Romania. Lives in Cluj, Romania, coordinating a media education and production project. Editor of subsol. Author of essays on sovereign and tactical media, experimental video, net.art and activism.

Patrice Riemens (nl) / www.waag.org / patrice@antenna.nl
Born 1950, lives in Amsterdam when not traveling abroad with his pet dinosaur, Dino. A geographer by formation and a private intellectual (and sometimes internet activist) by choosing. Works with De Waag Center for Old and New Media, an old castle in Amsterdam on the cutting edge of technology, culture, education and industry.

®™ark (us) / www.rtmark.com / rtmark@rtmark.com
Parallel corporation that funds creative subversion of corporate culture. ®™ark projects have included organizing the 1999 eToy Fund campaign that helped destroy eToys, rogue sites for G.W.Bush and the WTO, the pirated and remixed Deconstructing Beck CD, and funding the Barbie Liberation Organization to switch the voiceboxes of GI Joe and Barbie dolls and return them to stores.

Sarai: The New Media Initiative (in) / www.sarai.net / shuddha@sarai.net
Sarai is a public space where different intellectual, creative and activist energies can intersect in an open and dynamic manner so as to give rise to an imaginative reconstitution of urban public culture, new/old media practice, research and critical cultural intervention. Members include Jeebesh Bagchi, Monica Narula, Shuddhabrata Sengupta, Ravi Sundaram and Ravi Vasudevan.

Greg Sholette (us) / www.repohistory.org / gsholette@artic.edu
Founding member of PADD (Political Art Documentation and Distribution) and REPO History, which began 1989 as a study group of artists, scholars, teachers, and writers focused on the relationship of history to contemporary society. Curator, writer and commentator on activist art and art theory. Currently teaching at the School of the Art Institute of Chicago.

Howard Slater (uk) /datacide.c8.com
London-based writer and researcher whose texts on media, film, the music scene and politics have appeared in *Datacide, Autotoxicity, Obsessive Eye,* and under pseudonyms in *Alien Underground, Shimmer* and *The Techno Connection*. Editor of *Break/Flow*.

Space Hijackers (uk) / www.spacehijackers.co.uk / mail@spacehijackers.co.uk
Group of Anarchitects working since 1999 to battle the oppressive encroachment into public
 spaces by institutions, corporations and urban planners by raising awareness of how spaces
 are used and perceived. Projects include hijacking of a Circle line carriage on London
 Underground, building miniature city farms all over the square mile and producing experi-
 mental pedestrian schemes.

Felix Stalder, Openflows (ca/ch) / www.openflows.org, felix.openflows.org / felix@open-
 flows.org
Researcher and pragmatist working on the intersection of new media, politics and culture. Has
 lectured and published extensively on these issues in academic and popular venues in North
 Amerika and Europe. Director of Openflows and a moderator of the Nettime mailing list.
 Holds a PhD from the University of Toronto.

Janos Sugar (hu) / sj@c3.hu
Works include sculpture, installations, performances, video, film, and theoretical writing. Former
 member of Indigo, an interdisciplinary art group, and of the Bela Balazs Film Studio board.
 Started Media Research Foundation with Geert Lovink and Diana McCarty. Has been teach-
 ing at the Intermedia Department of the Hungarian Academy of Fine Arts since 1990.

Krassi Terziev, InterSpace (bg) / www.i-space.org, www.cult.bg / krassi@i-space.org
Founder and artistic director of InterSpace Media Art Center. InterSpace seeks to establish a
 social attitude to new media art forms through the development of alternative means and
 possibilities of artistic expression in new technologies. Projects include organization of
 forums, exhibitions, conferences, workshops, vocational training courses and the develop-
 ment of the cult.bg server.

Vakuum TV (hu) / vakuumtv.c3.hu / vakuumtv@c3.hu
Vakuum TV (founded 1994, Budapest) is Dora Csernatony, Ferenc Grof, Laszlo Kistamas
 (founder) and Attila Till. Shows create a large frame that simulates an interactive television
 experience, with post-dadaistic-media content. Vakuum TV has also produced videos, tele-
 vision programs, a video-telescope, and transformed a Budapest subway car into a moving
 broadcast vehicle.

Sfear von Clauswitz (us) / www.collusion.org / time@digitalconfusion.org
Sfear is one of the founding members of the Collusion what-hat hacker group in Austin, Texas
 (4n7i). He worked with Stefan Wray to found the Austin Indymedia chapter and was the
 moderator of the 2002 SPI (Subliminal Propaganda Institute) Roundtable on the Nature of
 Art in 2025. He is suspected of being German; however, these claims have never been sub-
 stantiated.

Marko Vukovic, Autonomous Culture Factory (hr) / www.attack.hr / marko@zamir.net
Born in Zagreb, 1974. Lost his youth and good name with desperate projects like Zagreb
 Anarchist Movement, Antiwar Campaign Croatia, and Autonomous Culture Factory. Lately
 works in front of a computer screen as a programmer and web site builder. Into sailing and
 skiing. Also likes hiking. Overweight. Cynic.

McKenzie Wark (us/au) / www.dmc.mq.edu.au/mwark/home/homepage.html / mw35@nyu.edu
Co-editor of the Nettime anthology *README!* Author of *Virtual Geography, The Virtual Republic, Celebrities, Culture and Cyberspace,* and most recently *A Hacker Manifesto.* With Brad Miller, co-produced the multimedia work *Planet of Noise.* Lives and works in New York.

Peter Lamborn Wilson (us) / www.autonomedia.org
PLW's reputation goes back to as early as the late sixties when he wandered North Africa, India and Asia reading heretical texts and studying the historical and mystical dimensions of Sufism. Involved in a range of initiatives, including 'Moorish Orthodox Radio Crusade' on WBAI, lectures at the New York Open Center, participating in the Autonomedia collective.

Ernie Yacub (ca) / www.openmoney.org / ey@openmoney.org
Worked (still works) with Michael Linton for the last 7 years designing and developing community money systems, in North America, Europe, and recently in Japan. Has been involved in peace, social justice, and environmental advocacy since the 60s — thus the addled brain. He lives in a backwater burg on the west coast of Brutish Kolumbia, Kanada, but not for much longer.

Jaka Zeleznikar (si) / www.jaka.org / jaka@jaka.org
Born in 1971 in Ljubljana, Slovenia. Media artist whose work is based on text, and relates to visual poetry, ascii art and interactive computer art. His most recent work, Poem for Echelon, is a combination of a generative visual poetry aesthetic and net activism, a protest against the violation of communication privacy that is perpetrated by intelligence agencies.

More Books from Autonomedia

Between Dog and Wolf: Essays on Art & Politics *David Levi Strauss* $8
T.A.Z.: The Temporary Autonomous Zone *Hakim Bey* $8
This World We Must Leave, and Other Essays *Jacques Camatte* $8
Pirate Utopias:
 Moorish Corsairs & European Renegadoes *Peter Lamborn Wilson* $8
Flesh Machine: Cyborgs, Designer Babies
 & the New Eugenic Consciousness *Critical Art Ensemble* $8
The Electronic Disturbance *Critical Art Ensemble* $8
Electronic Civil Disobedience *Critical Art Ensemble* $8
Digital Resistance *Critical Art Ensemble* $12
Whore Carnival *Shannon Bell, ed.* $8
Crimes of Culture *Richard Kostelanetz* $8
Invisible Governance:
 The Art of African Micropolitics *David Hecht & Maliqalim Simone* $8
Cracking the Movement: Squatting Beyond the Media
 Foundation for the Advancement of Illegal Knowledge $8
Social Overload *Henri-Pierre Jeudy* $8
Millennium *Hakim Bey* $8
Marx Beyond Marx: Lessons on the Gründrisse *Antonio Negri* $12
Scandal: Essays in Islamic Heresy *Peter Lamborn Wilson* $14
On Anarchy & Schizoanalysis *Rolando Perez* $12
File Under Popular: Theoretical & Critical Writing on Music *Chris Cutler* $10
Horsexe: Essay on Transsexuality *Catherine Millot* $14
Media Archive *Foundation for the Advancement of Illegal Knowledge* $14
Film and Politics in the Third World *John Downing, ed.* $12
God and Plastic Surgery:
 Marx, Nietzsche, Freud & the Obvious *Jeremy Barris* $12
Enragés & Situationists: The Occupation Movement, May '68 *René Viénet* $14
Midnight Oil: Work, Energy, War, 1973–1992 *Midnight Notes Collective* $10
Gone to Croatan: Origins of North American Dropout Culture
 James Koehnline & Ron Sakolsky, eds. $14
About Face: Race in Postmodern America *Timothy Maliqalim Simone* $14
The Arcane of Reproduction:
 Housework, Prostitution, Labor & Capital *Leopoldina Fortunati* $10
Dreamer of the Day: Francis Parker Yockey & the Postwar Fascist Underground
 Kevin Coogan $17
The Rotting Goddess: The Origin of the Witch in Classical Antiquity
 Jacob Rabinowitz $14
Caliban & the Witch *Silvia Federici* $14
Chron!ic!Riots!pa!sm! *Fly* $10
Read Me!: ASCII Culture and the Revenge of Knowledge *Nettime* $18
Against the Megamachine: Essays on Empire and its Enemies
 David Watson $14
Auroras of the Zapatistas *Midnight Notes* $14
Digital Resistance *Critical Art Ensemble* $12
Surrealist Subversions *Ron Sakolsky, ed.* $23
Work of Love *Giovanna Franca Dalla Costa* $14
Revolutionary Writing *Werner Bonefeld, ed.* $15
Communists Like Us *Félix Guattari and Antonio Negri* $8
Bolo'Bolo *p.m.* $8
Domain Errors *subRosa Collective* $15
Behind the Blip: Essays on the Culture of Software *Matthew Fuller* $15

Visit our web site for online ordering, topical discussion, events listings, book specials, and more.
www.autonomedia.org

Autonomedia • PO Box 568
Williamsburgh Station
Brooklyn, NY 11211-0568
T/F 718-963-2603
info@autonomedia.org